Holbein in England

Holbein in England

Susan Foister

With contributions by Tim Batchelor

Tate Publishing

First published 2006 by order of the Tate Trustees
by Tate Publishing, a division of Tate Enterprises Ltd,
Millbank, London SW1P 4RG
www.tate.org.uk/publishing

on the occasion of the exhibition
Holbein in England
Tate Britain, London
28 September 2006 – 7 January 2007

Sole Sponsor The British Land Company PLC

 British Land

British Library Cataloguing in Publication Data
A catalogue record for this book is available from the
British Library

ISBN-10: 1 85437 645 4
ISBN-13: 978 185437 645 9

Distributed in the United States and Canada by
Harry N. Abrams, Inc., New York

Library of Congress Cataloging in Publication Data
A Library of Congress Control Number has been applied for

Designed by Fraser Muggeridge studio
Printed in Bruges by Die Keure

Cover: *Henry VIII c.*1537 (detail, no.105)

Contents

Sponsor's Foreword

The *Holbein in England* exhibition at Tate Britain is an
event of true historical significance.

In the first major UK exhibition devoted to Hans
Holbein the Younger for more than half a century,
Tate Britain celebrates the work and cultural significance
of this German master.

Widely believed to have brought the Renaissance
in painting from Continental Europe to British shores,
Holbein is also credited for pioneering the trend in
portraiture. His iconic portrait of King Henry VIII will
be reunited for the first time in centuries with portraits
of his third wife Jane Seymour and their son Edward,
Prince of Wales.

British Land has provided sponsorship to Tate Britain
since 1990 and, in this our 150th Anniversary year, we are
delighted to support this important and groundbreaking
exhibition of work by this eminent figure in Britain's
artistic heritage, which is sure to have wide international
appeal.

Sir John Ritblat
Chairman, The British Land Company PLC

Director's Foreword

Histories of British art have traditionally opened with the career of Hans Holbein the Younger (1497/8–1543), the Augsburg-born painter who worked in England between 1526 and 1528 under the patronage of Sir Thomas More, and again between 1532 and 1543 for the court of Henry VIII. He has been variously celebrated as father of 'the British school' and the man who brought the European Renaissance to these shores, changing the course of native art forever. Nowadays, our increasing understanding of the strands of continuity between native late-medieval art and the artistic achievements of the Tudor and Stuart periods renders such shorthand less sustainable in many respects. But Holbein's astonishing influence upon his contemporaries, successors and British culture generally remains indisputable. The sheer visual impact of his work in the present exhibition – not least the profoundly affecting, focused realism of his portraiture – will, I believe, prove as powerful as ever to twenty-first-century eyes.

The exhibition aims to cast new light on Holbein's work in England and its interaction with cultural and political environs at home and abroad. We hope to show that he was much more than a portraitist – though he was certainly a great one – and to demonstrate, for example, that traditional religious art was very much alive in early Tudor England despite the unfolding upheavals of the Reformation. Moreover, our inclusion of many of his decorative designs provides a means of exploring his individualistic and innovative response to the impact of humanist learning at Henry VIII's court. A substantial group of decorative drawings from Basel, for instance, reunited with those from the British Museum and elsewhere, reveals something of the level of sophistication of the court and the extent of its European connections. A sense also emerges of Tudor London as a thriving international community in which Holbein forged links with some painters and worked alongside many others (including John Bettes, author of the earliest work in Tate's collection: no. 128), as well as goldsmiths, merchants and printers. This suggests the great potential of considering British art of the sixteenth and seventeenth centuries in closer relation to its varied international contexts.

The 1995 Tate exhibition *Dynasties: Painting in Tudor and Jacobean England 1530–1630* did much to establish the extent of that field and the variety of production within it. As *Dynasties'* successor, we hope that the present exhibition will prove to be a further step in fostering an understanding of this undoubtedly rich vein of British art as well as revealing the spectacular range and distinctive ability of Holbein himself. The core conception and selection of the show has been entirely the work of leading Holbein scholar Dr Susan Foister, Curator of Early Netherlandish, German and British Paintings and Director of Collections at the National Gallery, London. It has been a great privilege to work with her over several years in the realisation of this project: she has been a delightful, model colleague, clear of purpose, incisive in judgment, ever patient. We are very grateful to the National Gallery for allowing her to work on the exhibition for us and also for supporting us with loans, including the incomparable *Christina of Denmark, Duchess of Milan* (no. 157), paying its first visit to Millbank. And though the absence of the National Gallery's *The Ambassadors* (see p. 12), the subject of an exhibition of its own in 1997–8 and a work too fragile to move from their building, may be keenly felt, we hope that many of the exhibition's visitors will visit Trafalgar Square to see it, forming a kind of spectacular postscript to our show.

Dr Foister's acknowledgements reveal the extent of support we have received from colleagues around the world in implementing this project but I would also like to add Tate's particular gratitude to Her Majesty The Queen, whose early agreement to lend 41 works to the exhibition provided the bedrock for the whole undertaking, and to the Kunstmuseum Basel and its director Bernhard Mendes Bürgi, who agreed to part with a great many works never before released on loan abroad. The Kunstmuseum's own exhibition,

Hans Holbein the Younger – the Years in Basel 1515-1532, directly preceded ours and provided a perfect complement; these two 2006 projects together provide the deepest and most extensive survey to date of Holbein's complete career. At Tate Britain I would like to thank above all Judith Nesbitt, Chief Curator, for once more overseeing the delivery of a notably complex project, Tim Batchelor, who is a very remarkable Assistant Curator, and also the staff across our many support departments – from conservation, registrars and art handling through to the indefatigable press office and front of house teams.

We are delighted that British Land has chosen to sponsor this exhibition. Their Chairman, Sir John Ritblat, is a great patron of the arts in Britain. He has supported a remarkable succession of major exhibitions at Millbank – *Wright of Derby* in 1990, *Ben Nicholson* in 1993, *Gainsborough* in 2003 and *Degas, Sickert and Toulouse-Lautrec* in 2005 – and we deeply appreciate his commitment to our ambitious programme and his consistent encouragement of our efforts. It is with great pleasure that, together, we present *Holbein in England*.

Stephen Deuchar
Director, Tate Britain

Acknowledgements

I am most grateful to Stephen Deuchar, Director of Tate Britain, and Sheena Wagstaff, formerly Head of Exhibitions and Displays, for inviting me to undertake this exhibition, and for the support of Judith Nesbitt, Chief Curator of Tate Britain, and Tim Batchelor, Assistant Curator in preparing it. Tim Batchelor has offered tirelessly efficient and thoughtful support in every aspect of the preparation of the exhibition, as well as undertaking the contributions to this catalogue, and it has been a great pleasure to work with him. It has also been a pleasure to work with Alice Chasey, Tim Holton and their colleagues at Tate Publishing as well as with the designers Fraser Muggeridge and Sarah Newitt on the creation of this catalogue. Alan Farlie and Debby Kuypers of RFK Architects have taken immense pains to produce an elegant and lucid setting for the works in the exhibition, along with the graphic designers Crispin Rose-Innes and Grita Rose-Innes of Rose-Innes Associates. Other Tate staff who have contributed to the exhibition are: Helen Beeckmans, Susan Breen, Gillian Buttimer, Claire Eva, Lillian Davies, Annabel Fallon, Pete Gomori, Richard Humphreys, Anne Low, Patricia O'Connor, Lara Raymond, Andy Shiel and the art handling team, Piers Townshend and Victoria Walsh.

I am particularly indebted to Christian Müller and his colleagues in the Kunstmuseum, Basel, organisers of the sister exhibition *Hans Holbein the Younger – the Years in Basel 1515-32*; they have supported the London exhibition with an exceptionally generous number of loans as well as answering many queries. I am also most grateful for the generous support of Christopher Lloyd, formerly Surveyor of the Queen's Pictures, and his successor, Desmond Shawe-Taylor, and for that of Jane Roberts (the Hon. Lady Roberts), the Royal Librarian, and her colleagues in the Royal Print Room, Windsor Castle. I owe a great deal to Giulia Bartrum of the British Museum Department of Prints and Drawings and her colleagues, for patient assistance in selecting and researching the loans from the collection. Without the support of these three collections it would have been impossible to exhibit Holbein's English career in such depth.

The exhibition has also benefited from the support of a number of other British institutions and colleagues. For advice on goldsmiths' work, which forms an important part of the conception of this exhibition, and the answering of numerous queries, I am particularly indebted to Philippa Glanville as well as to Marian Campbell of the Victoria and Albert Museum and Dora Thornton of the British Museum. I must also thank Rica Jones of Tate for discussing with me the investigations she and Karen Hearn have recently undertaken of John Bettes' *Portrait of an Unknown Man*, including the new infrared reflectograms produced by Jacqueline Ridge, and for generously allowing the reproduction of a new infrared reflectogram detail in advance of the publication of their Tate collection catalogue. At the National Portrait Gallery Tarnya Cooper and Catharine MacLeod arranged an illuminating examination of the Holbein cartoon. All those in London with an interest in Holbein and the subject of portrait miniatures also greatly benefited from the earlier examination of miniatures organised by Catherine MacLeod with the co-operation of The Royal Collection and the Victoria and Albert Museum.

This exhibition and its catalogue would not have been possible without the exceptional interest and support of numerous other colleagues in institutions in various parts of the world. I thank all of them for their assistance, in particular:

Catherine Whistler, Ashmolean Museum; Bernd Lindemann, Gemäldegalerie Berlin; Michael Roth, Kupferstichkabinett, Berlin; Reginald P. Carr and Dr B.C. Barker-Benfield, Bodleian Library, University of Oxford; Silke Gätenbröcker, Herzog –Anton Ulrich Museum Braunschweig; Kristian Jensen, Barbara O'Connor and Robert Davies, The British Library; Harald Marx and Uta Neidhardt, Gemäldegalerie Dresden; Lee Hendrix, Scott Schaefer, Stephanie Schrader and Yvonne Szafran, Getty Museum;

Julius Bryant, formerly of English Heritage; Pieter van den Ploeg and Quentin Buvelot, the Mauritshuis, The Hague; Michael Clarke, National Gallery of Scotland; Alastair Laing, National Trust; Meinolf Trudzinski, Landesmuseum, Hanover; Bodo Brinckmann and Jochen Sander, Stadelsches Künstinstitut Frankfurt; Vincent Pomarède, Cécile Scaillierez and Elisabeth Foucart, the Louvre; Maryan Ainsworth, George Goldner and Larry Kanter, The Metropolitan Museum New York; Xanthe Brooke, The Walker, Liverpool; Tomas Llorens, Thyssen Museum; Karl Schütz, Elke Oberthaler and Monika Strolz, Kunsthistorisches Museum Vienna; Annamaria Petrioli Tofani and Marzia Faietti, the Uffizi; Tarnya Cooper and Emma Chambers, University College London; Mark Evans, Alan Derbyshire and Victoria Button, Victoria and Albert Museum; John Hand, National Gallery of Art Washington; Professor John Last, Mr Francis Read and Col. Peter Durrant, The Worshipful Company of Barbers; Sir Jerry Wiggins, Mr RG Melly and Rosemary Ransome Wallis of the Worshipful Company of Goldsmiths. I am also deeply grateful to those lenders to the exhibition from private collections, not least His Grace the Duke of Buccleuch, for permitting a close examination of his portrait of Sir Nicholas Carew, and for his hospitality on this occasion.

At the National Gallery I am grateful to the Director, Charles Saumarez Smith, for his support, and to my colleagues Lorne Campbell, Elena Greer, Giorgia Mancini, Lois Oliver, Carol Plazzotta and Martin Wyld for their helpful advice and assistance with particular aspects of research for this exhibition; Elspeth Hector and her staff in the library have also frequently helped with bibliographical enquiries. In studying Holbein I have benefited greatly from the insights gleaned from projects undertaken with my colleagues in the Conservation and Scientific Departments, and especially from the examinations made with the aid of infrared reflectography undertaken by Rachel Billinge. We have together examined a number of the paintings included in this exhibition, and I am pleased that it has been possible to publish several of the relevant reflectograms for the first time in this catalogue.

Finally, for advice and information I would also like to thank: Alan Donnithorne; Gabriel Finaldi; Maurice Howard; Judy Mann; John Marciari; Julia Marciari-Alexander; Richard Marks; Eric Smith; Eleanor Townsend; Angus Trumble.

Susan Foister

Catalogue Note

The catalogue entries aim to provide up to date, concise discussions of such issues as subject matter, the identities of the sitters in the portraits, technical and attributional issues.

The bibliographies provided for each entry are highly selective, and aim to guide users of the catalogue to sources which provide fuller literature, as well as more extensive discussion of some of the issues raised. The most recent catalogues raisonnés and exhibition catalogues of Holbein's paintings and drawings have generally been cited. Other exhibition catalogues have been cited selectively in relation to specific information discussed here: there is no attempt to offer comprehensive exhibition histories; this should be noted particularly with reference to those drawings from The Royal Collection which have been included in a number of exhibitions in recent decades. This exhibition immediately follows the sister exhibition shown at the Kunstmuseum, Basel, *Hans Holbein the Younger: the Basel Years 1515–1532*; as a few works have been shown in both exhibitions it has been possible to cite the relevant catalogue entries for these.

Provenances are given in as full a form as possible, space permitting, but in some cases more detailed information may be found, for example in the collection catalogues of lending institutions. References are given to the sources of new information presented here or to information not otherwise easily located in the literature on individual paintings; where there is more than one such reference in a single catalogue entry these references are ordered in the sequence in which the citations occur in the text.

Catalogue entries designated with the initials TB are by Tim Batchelor, who has also compiled the Chronology on p. 160; all other entries are by Susan Foister.

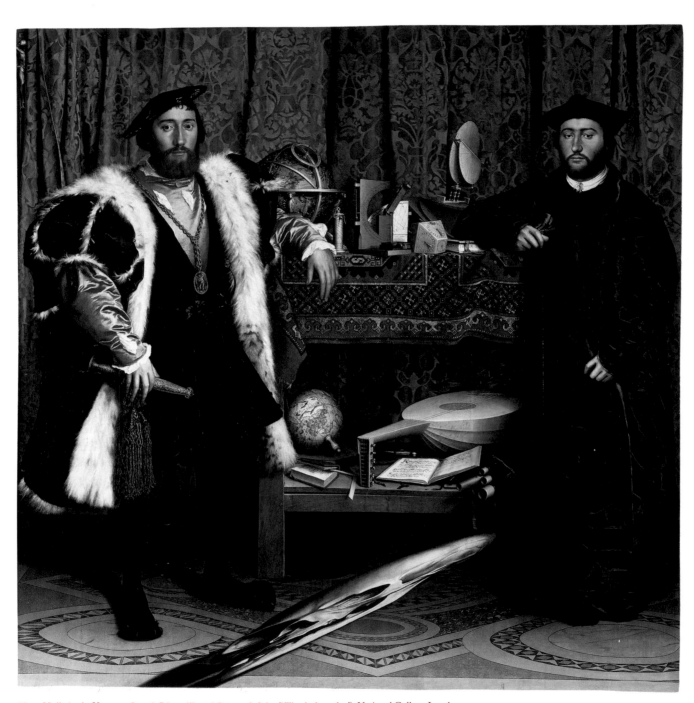

Hans Holbein the Younger, *Jean de Dinteville and Georges de Selve* ('*The Ambassadors*'), National Gallery, London

Introduction

Like many other immigrants from Germany and the Low Countries in the sixteenth and seventeenth centuries, Hans Holbein came to England to better his fortunes. In Augsburg, Southern Germany, where Holbein was born in 1497/8, his artist father had offered him training in drawing, painting and collaborative work with sculptors, glasspainters and metalworkers. His adopted city of Basel, where he settled in 1515, had profited from his ability to design prints for the burgeoning printing industry, as well as stained glass and illusionistic murals, and the humanist scholars there had exploited his sensitivity to wit and ambiguity. England and the court of Henry VIII offered Holbein considerable opportunities to exploit his imagination and consummate technical skills. As a designer of goldsmiths' work, of which the English were notable consumers, as an inventor of painted compositions large and small, and as a portraitist, a genre into which, extraordinarily, he had made only a few forays before his arrival in London, Holbein was eagerly patronised and swiftly celebrated.

Arriving in England in the autumn of 1526 Holbein looked forward to the opportunities a prosperous court might offer, while keeping his options open in Basel. As a Basel citizen he was allowed an absence of two years, but service to a foreign court would mean forfeiting citizenship. After a successful couple of years in London, which included working on royal festivities at Greenwich as well as for Sir Thomas More, Holbein therefore returned to Basel in 1528. Encountering violent icono-clastic riots in 1529, he journeyed to England once more in 1531/2. This time he remained, resisting the pleas of the Basel town council, while allowing them hope of his return.[1] As his design for a precious metalwork fountain with Anne Boleyn's badge indicates (no.93), he was working for the English court again soon after his return. His visit to Basel in 1538 confirmed his prosperity: Holbein wore fine clothes of silk and velvet, and could afford his own supplies of wine. But his hand was forced when in 1541, along with many other foreigners panicked by rumours of stringent enforcement of the laws against

foreign workers, he became an English denizen.[2] Only two years later, on 7 October 1543, he made a hasty will (revealing the existence of a second family) and was dead before the end of November.[3] His will also reveals some of Holbein's network of fellow immigrants: Anthoney Snecher, one of the Germans working at the royal armoury at Greenwich, Olrych Obynger, a German merchant, the goldsmith Hans of Antwerp, and Harry Maynert, painter, of whom nothing is known. Holbein's English associates also included the King's astronomer Nikolaus Kratzer from Bavaria, the royal goldsmith Cornelis Hayes, a 'Dutchman' and the Netherlandish printer Reynold Wolf.

Few works of art survive from Holbein's England and a vast number have been lost: Henry VIII's Whitehall Palace with Holbein's dynastic mural (from which only part of the preparatory cartoon remains, no.104), Henry's treasure house with its massive gold and silver pieces, including those designed by Holbein, as well as the contents of monasteries and parish churches.[4] Yet despite the dissolution of the monasteries and the introduction of forms of Protestant belief during the 1530s, there was in this period little wholesale change in English attitudes to imagery to resemble that which in Basel and parts of Germany was dramatically affecting artistic production and patronage. In England, far from recoiling from imagery, traditional religious images were still in demand alongside some newer ones, while secular subject matter and Renaissance-style designs were highly fashionable. Native English artisans were fearful of foreign competition, but they alone could not keep the home market supplied. England imported carved wooden altarpieces and other work from the Low Countries, while the skills of German metalworkers and Netherlandish glass painters, though deeply resented by native London guild members, were welcomed at court.[5] Although the London Painter-Stainers Company occupied key positions and carried out much decorative work at court, there was an increasing number of foreign painters on the royal payroll.[6]

No single document sets out the tasks which Holbein was to perform for his court salary of £30 a year, but these must have included designing precious metal cups, fountains, jewellery and daggers as well as painting the Whitehall mural and providing portraits of Henry, his family and potential royal brides. Holbein's position at court evidently allowed him the freedom to seek out additional commissions from a wide market including those at court and in the city. His clients ranged from poets to merchants, both English and German, and from the grandest of nobles to relatively humble servants of the royal household, portrayed in their court livery. Among them were the most influential political figures of the time, including Henry VIII's minister, Thomas Cromwell,[7] for whom Holbein's German language contacts may have been useful in gathering information, as well as his abilities to design imagery in the cause of the Protestant Reformation.

Holbein provided designs for jewellery and gold-smiths' work for his courtly clients. His work included both religious and secular subject matter as well as pure decoration, and he may well have painted more of such subjects than the very few examples which survive. However, his most evident success as a painter was in portraiture, work acclaimed in Latin by his humanist friends, and which can be judged today from over sixty surviving paintings and miniatures and nearly a hundred preparatory drawings for these and other paintings now lost. No contracts, letters or payments survive to illuminate the circumstances in which they were made, though some vivid inferences can be drawn from other documents of the time, for example Sir Brian Tuke's reference to his portrait of his young daughter, which he offered in support of her availability for marriage, or the confession by Lord Thomas Howard that Lady Margaret Douglas had given him her portrait during their love affair.[8] Although many English nobility and gentry were accustomed to including their portraits in devotional and memorial contexts such as stained glass and tombs, during Holbein's stays in England other, secular uses for portraits burgeoned. In response, Holbein reworked and invented portrait formats large and small, from the radical new group portrait type he created for the More family on his first visit (no.23), to the innovative small portrait miniatures which, although in format remarkably close to the large-scale portrait

paintings, and just as eloquent, would have been used as portable objects, placed in precious settings of goldsmiths' work like the many portraits recorded in Henry VIII's collection which are engraved or carved from precious materials.

Holbein's exceptional abilities make him seem unique. Yet his working methods, combining both observation from the life, and imitation, using prints and pattern books, resemble those of other artists working in Northern Europe throughout the sixteenth century. Many of the works in this exhibition are drawings, portrait drawings taken from the life, the outlines of which were traced onto the panel to provide accuracy for the painted likeness. There are varying stages of designs for goldsmiths' work, from the first ideas, accompanied by both clarifications and doodles, to finished presentation drawings. Holbein followed traditional methods in creating these designs and in his painting techniques. Collaborative working was also usual. Holbein clearly collaborated with goldsmiths such as Hans of Antwerp and Cornelis Hayes, and creating such networks – which mirrored those his father had had in Augsburg – was probably a vital means of establishing himself in London, where immigrant communities included German goldsmiths and clockmakers. Holbein would also have been used to assistance in his painting, especially when working on a large scale, and although until 1541 his lack of denizen status would officially have forbidden him from establishing a workshop, it is likely he did have assistants who cannot be identified by name today. There would have been no practical barriers to Holbein working in England with both English and foreign artists: they laboured side by side at Greenwich in 1527, and as the extensive records of work there demonstrate, similar pigments and materials were available in England to those used in the rest of Northern Europe.[9] Other documentary evidence, such as the wills of English painters, indicate many similarities to the European workshop tradition in ownership of equipment and arrangements for the continuation of workshops.

Holbein's powers of design, his ability to rework, reuse and reproduce motifs with conviction on any scale, were vital elements in his success as a court artist and in his large private practice. His mastery of outline was key: as a designer of black-and-white woodcuts or of small

motifs for decorative work he could inject fluidity of motion with great economy. Designing woodcuts and goldsmiths' work, Holbein appropriated motifs from the new Renaissance decorative vocabulary sweeping through Europe which would have been known through prints to other artists working at court, including the Italians employed by Henry VIII, but he combined them in novel ways, with clarity and balance and with an extraordinary expressive energy and rhythm. These qualities so animate his decorative designs, whether individual motifs, such as his favoured serpentine mermen and women, or the larger shapes of cups, frames and fountains, that they scintillate on paper even before their transformation into precious metal and stone. Consolidating his position in London, Holbein's talents enabled the best goldsmiths to guarantee the court a supply of precious metalwork of a quality that would ensure the English king could hold his head high among his European rivals.[10]

As a portrait painter Holbein relied on drawings which defined the individual characteristics of the key features of nose, eyes and mouth and placed them in the proper relationship to each other, frequently recording his observation that, unlike the designs he made for cups or bowls, human faces are not symmetrical. Yet Holbein's spatial understanding ensures his figures and portraits are not flat: just as the small, energised figures in his decorative designs are thrust forward on a diagonal, heads gazing upwards, precisely balanced, so individuals in the portraits are given a sense of presence and vitality by the way in which Holbein positions the direction of eyes (often adjusted while painting) and expresses the tension or relaxation of lips with economy and precision, or subtly counterbalances opposing head, body and limbs. The sense of implied rather than overt movement adds greatly to the illusion of individual presence.

Holbein's intensely vivid and immediate portraits place before us recognisably individual and even contemporary-seeming faces which, despite our distance of nearly five centuries from Holbein's England, seem remarkably unconstrained by the ideals and conventions of a distant and hierarchical society, and by the strangeness of their clothing and headgear. They are nevertheless the result of careful artistic manipulation, subtly emphasising the facial features and diminishing the sense of the spaces that the sitters occupy. Two of

the most ostensibly documentary English portraits are also the most contrived, undermining their apparent solidity with spatial games to create multiple meanings for their subjects. In the portrait of the Hanseatic merchant Georg Gisze, the instability and mutability of the material world is signalled: a balance (calling attention to the Last Judgement) is not properly suspended, and the glass vase of flowers (themselves offering symbolic meanings) is placed too close to the edge of the table. In *The Ambassadors* (see p.12), painted in London in 1533 and in part a compositional dress rehearsal for Holbein's Whitehall mural, the two Frenchmen Jean de Dinteville and Georges de Selve stand at full length in apparent relaxation on either side of a plethora of objects – astronomical instruments capable of telling the time (but not doing so clearly), a lute with a broken string, a Lutheran hymnbook – all signalling the dissatisfaction with life Dinteville makes plain in his letters from London, while the distorted skull boldly concealed between them – revealed only by angled viewing or optical devices – and the angled silver crucifix partly hidden behind the carefully folded curtain look towards eternity.[11]

Holbein had no real successors and few imitators in England. The disparity between his subtle, interrogatory portraits of men and women whose gazes follow us, and the stylised portraits of Elizabeth I and her courtiers can seem extreme, the more so as it is difficult to trace a proper stylistic succession to Holbein's work to bridge the middle of the century. But the immigrant painters of the second half of the sixteenth century who settled in London, mostly from the Low Countries, many Protestant exiles from religious persecution, still worked in ways that Holbein would have recognised, though tastes in portraiture and design altered. Holbein's reputation, however, remained unchanged. Elizabethan artists and collectors knew his name and greatly valued his work. Most of it – decorative paintings, metalwork after his designs, portraits – then still remained as a memorial to him in England, his adopted country, which had provided the opportunities Holbein seized for the creation of his extraordinary works of art.

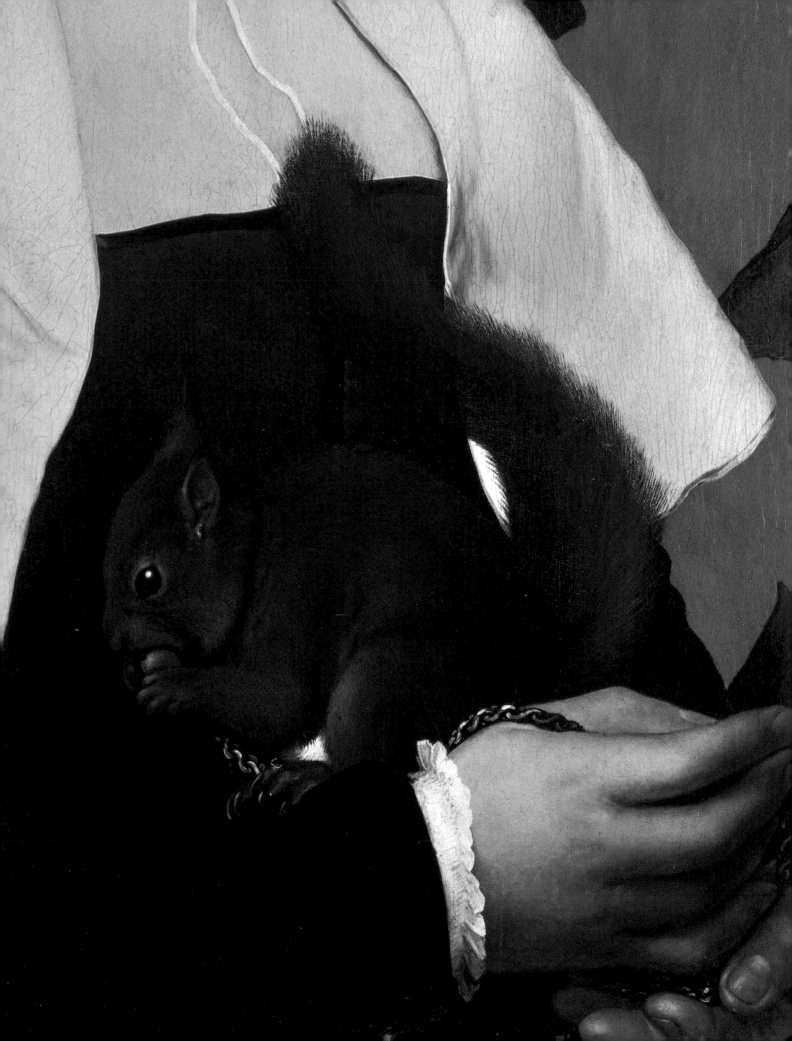

Holbein's First Visit to England 1526–8

Holbein had produced only a few portraits before he arrived in England for the first time in 1526, but for a decade he had pursued a highly successful career as an artist in Basel. His ability to design and paint wall-paintings and altarpieces and to produce patterns for woodcuts, metalwork and stained glass was founded on the training he must have received in the successful Augsburg workshop of his father Hans Holbein the Elder, himself a designer of elegance and sophistication and an incisive portraitist (nos. 1, 2).

It was often difficult or expensive to move to another town or country: although many artists did so, the rules of painters' guilds were weighted in favour of the natives. But it was common for young German artists to travel for a period. Holbein arrived in Basel in 1515, perhaps, like Dürer earlier, attracted by the designing opportunities offered by the printing industry. By 1521 his title-page designs for books were being imitated by English printers attracted by the inventive use of Renaissance motifs (no. 10). Objects with such designs were desired by English courtiers such as the Guildfords (nos. 16–18), who owned hangings decorated with 'antique work'.

Holbein's main motivation for coming to England must have been to seek a lucrative career as a court artist, which would have used his talents as a designer as much or more than as a painter. He appears to have visited France unsuccessfully for this reason in 1523–4. But in autumn 1526 he arrived in London with the support of his Basel patron, the humanist Erasmus. He spent the early part of 1527 painting a battle scene and cosmic ceiling design for the court banqueting hall and theatre at Greenwich, work now lost (see nos. 31, 32). He also illuminated a book (no. 33). But these two years in England saw him produce more portraiture than ever before.

The pivot of Holbein's career as a portraitist, and the source of his introductions to England, was his relationship with the humanist Erasmus, a Basel resident, of whom he had made three portraits in 1523,

two in profile, and another in three-quarter face (nos. 11, 12). Images of Erasmus were in demand even beyond those which the humanist sent to his friends, including William Warham, Archbishop of Canterbury (no. 15): smaller versions were desired from Kulm to London (no. 14). But the 1523 portrait of Erasmus also provided a portrait template. Its half-length formula and its verticals and ambiguities of space formed a pattern for other portraits executed in Holbein's years in England.

Yet Holbein continued to experiment, adjusting traditional portrait forms to the desires of his English patrons. In the portrait of the More family, piety was expressed not through the formal religious source of the composition but through human engagement. In England Holbein also experimented with a new drawing technique, using the single medium of coloured chalk with freedom and delicacy. Employing large sheets of paper, he sought to fix the features of his sitters and record their individuality in glance and expression before turning them into paint.

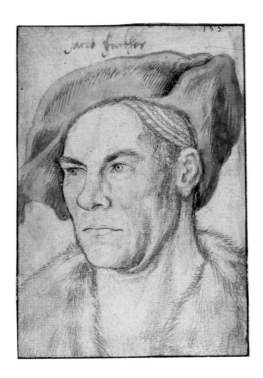 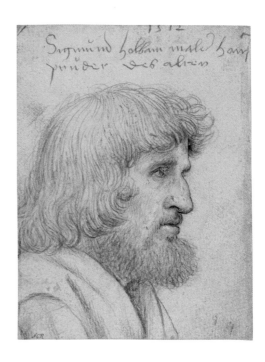

Hans Holbein the Elder (*c.*1460/70–1524)

1 *Jakob Fugger* *c.*1509

Silverpoint with black ink, grey wash and white bodycolour
on light grey prepared paper 13.4 × 9.3 cm
Inscribed: Jacob Furtger
Staatliche Museen zu Berlin (Kupferstichkabinett)

Jakob Fugger 'the rich' (1459–1525) was the most famous
member of the Augsburg merchant family, bankers to the
Habsburg family. This subtle and delicate drawing appears to
date from 1509, the year inscribed on a version in Copenhagen.
No painted portrait survives, and it is uncertain if one was
intended. The ink reinforcements resemble the manner in
which Hans Holbein the Younger added ink to many of his
own later drawings, but the effect here is harsh rather than
clarifying. A member of the Holbein workshop may have
been responsible.

Provenance: Von Nagler collection sale (Lugt 2529); acquired 1835
Literature: Berlin 1997–8 (8.10), pp. 70, 75–6; Krause 2002, pp. 270, 389

Hans Holbein the Elder (*c.*1460/70–1524)

2 *Portrait of Sigmund Holbein* dated 1512

Metalpoint with black ink and white chalk, white bodycolour,
on white prepared paper 12.9 × 9.6 cm
Inscribed in metalpoint: 1512 / Sigmund holbain maler hans [?s] /
pruder des alten
The British Museum, London

Sigmund Holbein evidently worked with his brother Hans the
Elder on the altarpiece of the Passion for the Dominican church
in Frankfurt-am-Main in 1501, when his presence there is
documented; he was in Augsburg from 1504. He died in Bern in
1540, leaving his painter's tools to his nephew Hans Holbein the
Younger. The format of this drawing is similar to the many other
surviving vivid portrait drawings by the elder Hans Holbein,
which were often used as the basis for figures in altarpieces
rather than individual portrait paintings. There is another
version of the drawing in Berlin.

Provenance: J. von Sandrart; F. Fagel; Sir T. Lawrence; S. Woodburn;
Sir J.C. Robinson; J. Malcolm
Literature: Augsburg 1965 (92), pp. 112ff; London 1988 (165), pp. 192–4;
Rowlands 1993 (302), p. 139; Krause 2002, p. 284

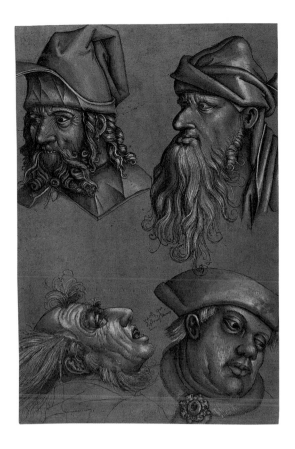

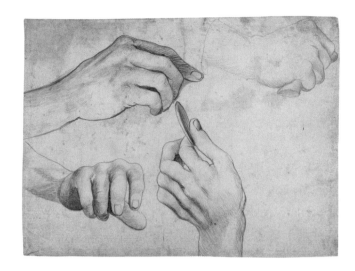

Workshop of Hans Holbein the Elder

3 *Studies of Four Heads* c.1500–15

Pen and black ink with grey wash and white body colour
on reddish brown prepared paper 27.5 × 17.8 cm
Inscribed: vach qui / destruis demp / lum
UCL Art Collections, University College, London

These strongly characterised male heads were to be copied for
reuse in the workshop. The head top left is an exaggerated
version of one used in reverse by Hans Holbein the Elder in his
'Grey Passion' (Staatsgalerie, Stuttgart), itself adapted from the
work of the Netherlandish artist Dirk Bouts. On the verso in
black ink the names 'hensly' and 'brosy' are inscribed separately,
abbreviations for the names Hans and Ambrosius. These must
refer to Hans Holbein the Younger and his brother, suggesting
a date before their departure for Basel in 1515. However these
names might alternatively refer to a drawing facing the verso
of this one when they were bound in a workshop pattern book.
The drawing has been attributed to Hans the Elder's brother
Sigmund (see no.2), but there are no documented works by him.

Provenance: George Grote bequest, 1872
Literature: Augsburg 1965 (186); London 1988 (166), p.194;
Krause 2002, pp.194–215; Cooper n.d.

Hans Holbein the Elder (*c.*1460/70–1524)

4 *Study of Four Hands* c.1500?

Metalpoint; three hands reinforced with black ink and red chalk
on prepared paper 13.9 × 18.5 cm
Staatliche Museen zu Berlin (Kupferstichkabinett)

One hand grasps a coin, another holds a rolled paper (or stick).
Similar sheets of studies of hands which Holbein the Elder
made at different periods can be related to his preparations
for specific painting commissions, but the purpose of these
sketches is unknown. Like the portrait of Jakob Fugger (no.1)
the drawing has been reinforced with ink, evidently by
another hand.

Provenance: Von Nagler collection sale (Lugt 2529); acquired 1835
Literature: Lieb and Stange 1960 (144), p.89

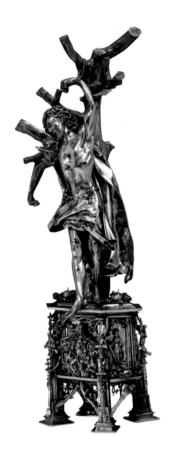

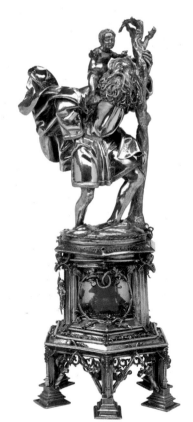

Unidentified Augsburg Goldsmiths

5 *Reliquary of St Sebastian* dated 1497

Silver, parcel-gilt, hammered, cast and engraved, set with glass,
pearls, sapphires and rubies Height 50 cm; base 15.2 cm
Victoria and Albert Museum, London. Purchased with the assistance
of the National Art Collections Fund and the National Heritage
Memorial Fund

6 *Reliquary of St Christopher* dated 1493

Silver, parcel gilt, hammered, cast and engraved Height 46 cm; base 18 cm
Private collection

These two reliquaries, both commissioned by Abbot Georg
Kastner of the Cistercian Abbey of Kaisheim near Augsburg,
as inscriptions on them declare, are extremely rare surviving
examples of the magnificent pieces of late medieval goldsmiths'
work for which Augsburg was renowned. Such reliquaries were
designed to contain the bones of saints, visible in the bases. The
inscription on the base of the St Sebastian reliquary shows it was
made as a votive offering in time of plague; both St Sebastian and
the Virgin of Pity on the base were believed to offer protection
against the disease.

The figure of St Sebastian follows a drawing (no.7) by Hans
Holbein the Elder, who may also have provided designs for
figures on the base; conceivably he contributed to the design
of the St Christopher, which is made by a different goldsmith.
Holbein the Elder collaborated in Augsburg with the goldsmith
Jörg Seld (*c.*1448–1527), of whom he made a portrait drawing,
now in Bayonne (Musée Bonnat). Seld made the silver
centrepiece of the Virgin and Child for the lost altarpiece in
Augsburg Cathedral for which Holbein the Elder provided the
painted cover. Similar precious metal figures were common at
the court of Henry VIII, representing religious as well as secular
figures. A lost Adam and Eve adorned with precious metal and
coral was made for Henry VIII by the goldsmith Cornelis Hayes
in 1533–4, which 'Master Hans', Hans Holbein the Younger,
was paid twenty shillings for painting.

Provenance: Kaisheim; Solytoff collection; Sir Julius Wernher;
acquired by present owners 2001
Literature: Manchester 1961 (59, 56); Augsburg 1965 (275, 276);
London 1988 (162) (St Sebastian only)
Reference: Chamberlain 1913 (vol. 2), pp. 92–3

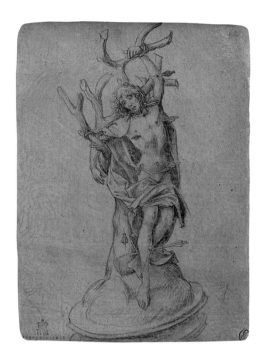

Hans Holbein the Elder (*c.*1460/70–1524)

7 *St Sebastian c.*1497

> Metalpoint on white prepared paper 13.1 × 9.6 cm
> Inscribed upper right in pencil: 69
> Verso (not exhibited): *Head of a Man turned to the Left*
> The British Museum, London

Hans Holbein the Elder's design for the reliquary of St Sebastian dated 1497 (no.5) shows some differences to the finished work, notably in the relationship between the saint's arms and the forking of the tree branches to which they are attached; also, in the drawing the saint is shown standing on a small mound whereas in the reliquary he stands on a flat surface. The drawing does not include the figures of the Virgin and saints on the base, presumably the subject of a separate study.

> Provenance: A. Grahl; Sotheby's 27 April 1885 (lot 118)
> Literature: Manchester 1961 (68), p.30; Augsburg 1965 (64), p.47, p.101; London 1988 (161), pp.190–1; Rowlands 1993 (300), p.138

Workshop of Hans Holbein the Younger?

8 *Copy of a design for the façade of House of the Dance 1520s?*

> Pen and ink with watercolour washes on paper 57.1 × 33.9 cm
> Staatliche Museen zu Berlin (Kupferstichkabinett)

The Basel goldsmith Balthasar Angelroth (*c.*1480–1544) commissioned Holbein to paint the façades of his house on the corner of the Eisengasse, associated since 1401 with dancing. The drawing shows one side of the façade, with a frieze of dancing peasants above an arcade. To the left is Bacchus and above is the figure of a soldier who may be intended to be Mars. The spectacular design contributed greatly to Holbein's reputation in Basel, showing brilliant manipulation of illusionistic space and the most daring uses of perspective. Holbein clearly took some inspiration from Bernardo Prevedari's famous architectural print after Donato Bramante, in particular the deep arches over the colonnade, motifs he reused nearly twenty years later in the design for the Whitehall mural for Henry VIII (nos.103, 104). The quality of this copy suggests a possible origin in Holbein's Basel workshop, and its colouring may reflect that of the original mural.

> Provenance: Acquired in Karlsruhe
> Literature: Rowlands 1985 (L4b); Basel 1988, pp.109–10; Müller 1996, pp.82–3

Ambrosius Holbein (1494?–1519)

9 *Utopia*, Sir Thomas More published 1518

[NOT ILLUSTRATED]

Johannes Froben, Basel 1518
The British Library, London

Ambrosius Holbein was the elder brother of Hans Holbein.
Working in Basel from 1515, both brothers supplied printers
with numerous woodcut designs, and became closely associated
with the humanist scholars living in or visiting the city, notably
Erasmus (nos. 11–14), the friend of Sir Thomas More (no. 24).

This woodcut was designed for Johannes Froben's 1518 Basel
edition of *Utopia*, Sir Thomas More's immensely successful
satire of an ideal community whose name means nowhere but
has come to mean an unattainable ideal society. In the book
the description of the ideal island is framed by the device
of the seafarer Hythlodaeus telling Thomas More and his
friend Peter Gilles his story in the garden of a house in
Antwerp. Here Raphael Hythlodaeus is shown lower left
pointing past his ship to the island, with its town of
Amaurotum, Dream City.

> Literature: Basel 1960 (120), p. 156; London 1977–8 (52), p. 41;
> Hollstein 14 (13a), pp. 53–4

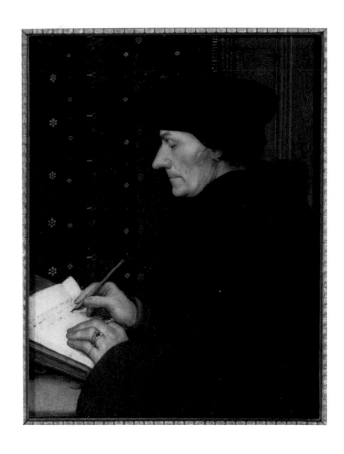

After Hans Holbein the Younger

10 *Assertio Septem Sacramentorum* published 1521

[NOT ILLUSTRATED]

Richard Pynson, London 1521
The British Library, London

The Defence of the Seven Sacraments was written (in part)
by Henry VIII to refute Martin Luther's assertion that only
three were valid, as well as other arguments that became
fundamental to Protestant beliefs. To adorn the title-page
of the book, for which Pope Leo X awarded Henry the title
of 'Defender of the Faith', the king's printer Richard Pynson
chose a copy of a title-page design by Holbein first published
in 1516, and subsequently in use in England up to 1552.
The border illustrates the classical story of Mucius Scaevola
who put his hand in the fire to prove his indifference to Lars
Porsenna's threats of death by burning. Of particular interest
to the fashionable in England at this time would have been the
Renaissance-style candelabra to left and right, which Holbein
and other artists were to propagate in the coming decades.
The copyist has omitted some parts of the inscriptions.

> Literature: McKerrow and Ferguson 1932 (8)

11 *Erasmus* c. 1523

Limewood 42 × 33 cm
Musée du Louvre, Paris, Département des Peintures

The humanist Erasmus (c. 1467–1536) settled in Basel in 1521,
following periods in England from 1509 to 1514 and the
Netherlands. It was as a result of his close friendship with Sir
Thomas More that he recommended Holbein to him in August
1526: 'the man who bears these letters is the one who painted
me'. Erasmus is shown writing in an interior, in the traditional
profile pose of a scholarly churchman, often used for depicting
saints. A second version at Basel, on paper, with a plain
background, includes the text which is no longer properly legible
here, Erasmus's *Commentary on the Gospel of St Mark*, dedicated
to Francis I of France, and completed in 1523; this suggests that
the portrait was made in the same year in which Holbein also
painted Erasmus in three-quarter face view (no. 12), or shortly
after. That portrait was evidently one of the two Erasmus
mentioned in June 1524 he had sent to England, and this may
be the other. Its simpler, more intimate character suggests
it was sent to a friend rather than a patron.

> Provenance: Sir Adam Newton; Charles I; Louis XIII;
> Count de Brienne; Everard Jabach; Louis XIV
> Literature: Paris 1985, pp. 9–26; Rowlands 1985 (15);
> Hague 2003 (1); Sander 2005, pp. 178–184, 462–4

Opposite: *Erasmus* (detail of no. 12)

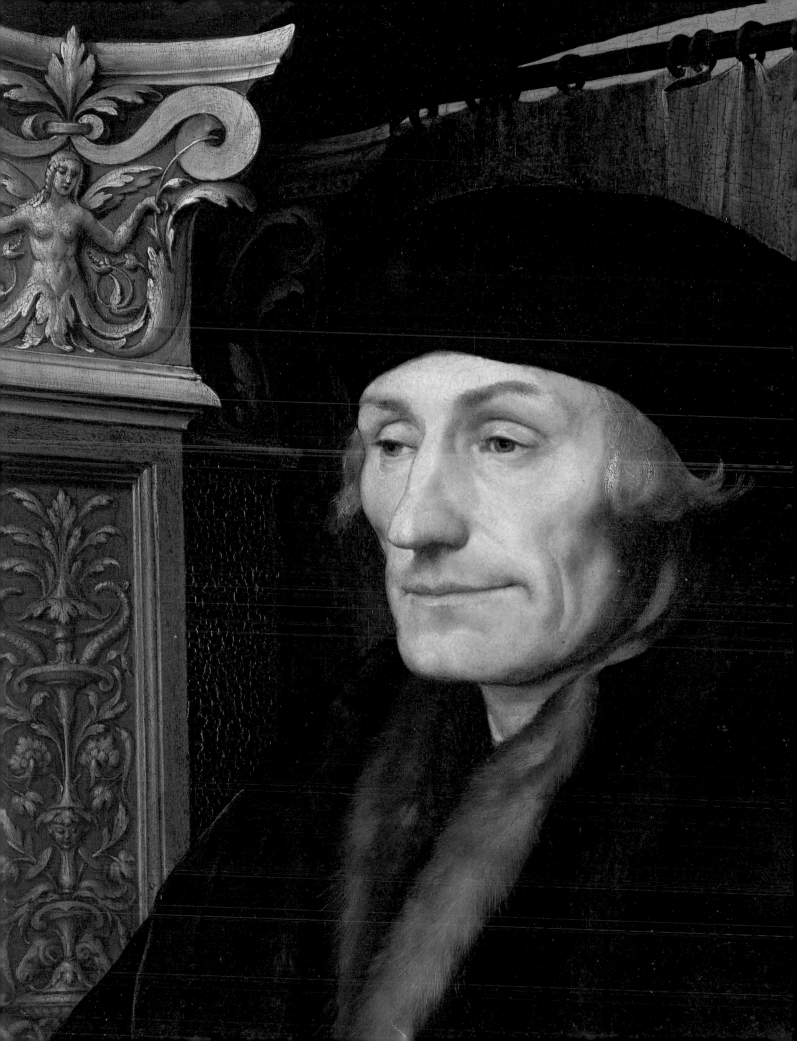

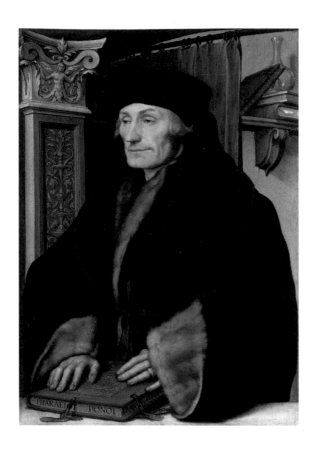

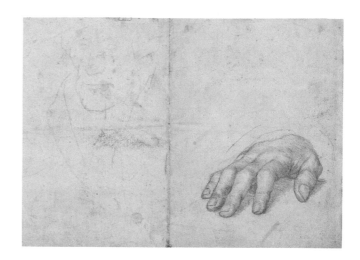

12 *Erasmus* dated 1523

Oil on oak 76 × 51 cm
Inscribed: M D XX III; [IL]LE EGO IOANNES HOLBEIN NON
FACILE[VLL]VS / TAM MICHI MIMVS ERIT QVAM MICHI MOMVS
ERAT. HPAKLEIOI PONOI ERASMI ROTERO
Private collection

In a letter of 3 June 1524 Erasmus (*c.*1467–1536) refers to
having sent two portraits to England, and a letter from his
patron William Warham (no.15) confirms one was sent to him
so he might have 'a little piece of Erasmus' if God summoned
him away. Erasmus must have composed the Latin inscriptions:
that on his book refers to his 'Herculean labours', the completion
of an edition of the New Testament; that on the shelf is a
punning tribute to Holbein's skill: it is easier to denigrate me
than to imitate me. Around a powerful depiction of the ageing
humanist's face Holbein constructed a many-layered image
of the scholar, the classical column a glancing reference to his
achievements, while other aspects draw on traditional images
of the depiction of Christian scholarship. Holbein was able to
transmute this composition many times during the course of his
work in England, beginning with the portrait of Archbishop
Warham himself (no.15).

Provenance: Probably William Warham, Andreas de Loo;
Earl of Arundel; 6th Duke of Norfolk; Dr Richard Mead;
1st Viscount Folkestone and by descent
Literature: Heckscher 1967, pp.41–8; Rowlands 1985 (13);
Jardine 1993, pp.41–8; Winner 2001; Foister 2004, pp.174–5;
Sander 2005, pp.171–8, 456–8

13 *Study of the Head and Right Hand of Erasmus*

Metalpoint, red and black chalk on white prepared paper 20.1 × 27.9 cm
Musée du Louvre, Paris, Département des Arts Graphiques

On the left is a faint outline drawing of the head of Erasmus, on
the right a detailed study of the right hand. Both are evidently
part of the preparation for Holbein's portrait of Erasmus dated
1523 (no.12), although no detailed drawing for the face of
Erasmus survives, and it has been suggested that this untypical,
cartoon-like image might instead record the finished portrait,
a reminder of how the main sketch was used. However, the eyes
and nose are positioned more frontally by comparison with the
painting. The study of the hand was transferred to the painting
but with the aid of infrared photographs and X-radiographs it
can be seen that Holbein then made a series of alterations, in
particular to the thumb, which was lengthened and shortened
again. These adjustments were evidently required as a result of
the higher viewpoint Holbein chose for the painted portrait.

Provenance: P. Vischer; acquired at sale Basel, 19 April 1852 (lot 44)
Literature: Paris 1991–2 (143)

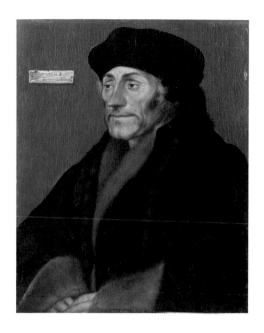

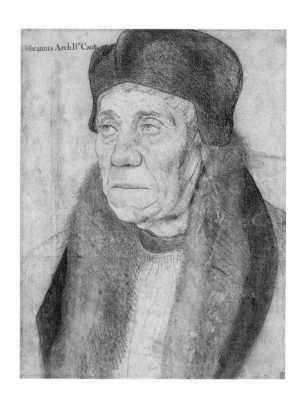

Hans Holbein the Younger and workshop?

14 *Erasmus* c.1532

Oil on wood 18.7 × 14.6 cm
The Metropolitan Museum of Art, New York,
Robert Lehman Collection, 1975

According to an old inscription on the reverse, this small image
of Erasmus was owned by John Norris who gave it to Edward
Banister, both of whom held positions at the court of Henry
VIII; Norris (c.1502–1577) was a gentleman usher of the privy
chamber by 1536. The image was evidently developed from the
three-quarter portrait Holbein made in 1523 (no.12), and the
supply of such images by Holbein (and presumably assistants) to
admirers of the great humanist is documented in contemporary
correspondence; the humanist John Leland had seen one of
Holbein's depictions of Erasmus, conceivably this one. The
underdrawing of this painting reveals it has been transferred
by pricking from a pattern. The planes of the face are slightly
exaggerated by comparison to the portrait of 1523, the nose
highlighted to a point.

Provenance: John Norris; Edward Banister; John 1st Baron Lumley;
Earl of Arundel; Charles Howard; the Howards of Greystoke;
J. Pierpont Morgan; Robert Lehman
Literature: Chamberlain I, pp.177–9; Rowlands 1985 (34);
Ainsworth 1990; Sander 2005, p.366
Reference: ODNB, 'William Norris 1522/3–1591', J. Andreas Löwe

15 *William Warham, Archbishop of Canterbury* 1527

Coloured chalks on paper 40.1 × 31 cm
The Royal Collection, The Royal Library, Windsor

In this preparatory study for the painting of 1527 now in the
Louvre, Holbein, as in other such portrait drawings, defines
only the head and shoulders of his subject, William Warham
(1450?–1532), who had been Archbishop of Canterbury since
1504, and was, according to the Louvre portrait, in his seventieth
year. The direct, slightly upward glance animates the study,
which, like the image of the Archbishop's friend Erasmus, is an
unsparing study of old age. Warham, who supported Erasmus's
scholarship, had himself painted in a composition which mirrors
that of the portrait of Erasmus Holbein made in 1523 to send to
Warham (no.12), replacing the Renaissance pilaster with a cross,
the flask with a mitre. It appears that Warham then returned the
compliment, sending Erasmus a version of the painting which
no longer survives.

Provenance: Henry VIII?; Edward VI; John 1st Baron Lumley;
3rd or 4th Earl of Pembroke; Thomas Howard Earl of Arundel;
Charles II by 1675
Literature: Parker 1983 (12); Rowlands 1985 (27)

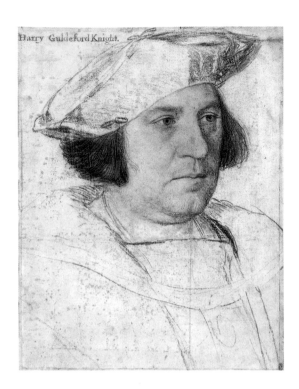

Harry Guldeford Knight.

16 *Sir Henry Guildford* 1527

Black and coloured chalks on paper 38.8 × 29.8 cm
The Royal Collection, The Royal Library, Windsor

The portrait drawing of Sir Henry has been cut down and the
paper used was presumably originally similar in size to the sheet
on which Lady Guildford is drawn. Little indication is given
of the portrait composition beyond head and shoulders, but
a position for the staff is noted lower right, and parallel lines
sketch the position of the collar of the Order of the Garter.
The drawing shows a man with a slightly fatter face than in
the painting (no.18). Close comparison of drawing and painting
reveals a considerable adjustment in the distances between eyes,
nose and mouth established in the drawing, and suggests that
Holbein might have moved a tracing of the lower features
further down the face after establishing the position of the eyes,
extending its length. The portrait was not altered at the painting
stage – no changes are visible in the X-radiograph or in the
infrared reflectogram (see Appendix fig. i, p. 152). Agreement
on this change must have been reached before painting began,
and it seems possible that Guildford instructed Holbein to
make his face appear somewhat slimmer.

Provenance: See no. 5
Literature: Parker 1983 (10); Foister 2003

17 *Mary Wotton, Lady Guildford* 1527

Black and coloured chalks on paper 55.2 × 38.5 cm
Kunstmuseum Basel, Kupferstichkabinett

In this study from life for the painted portrait of 1527
(St Louis Museum of Art), Lady Guildford smiles, glancing
almost flirtatiously towards her husband Sir Henry Guildford
(nos. 16, 18), whom she married in 1525. Holbein used red chalk
with great subtlety to suggest the plumpness of her mouth,
varying the depth of shading from the strong red of the left hand
side to the lighter, cushioned effect of the lower lip, where the
chalk diminishes to form a highlight.

In the painting the smile is abbreviated, and Lady Guildford's
expression is muted, suiting the devotional book she holds.
Holbein achieved this change without a second sitting:
reinforcement of the lines of the mouth to the left hand side of
the contours and in the dual lines of the eyelids agree precisely
with those of the painting, and appear to have been strengthened
as part of the process of transferring the outlines to the panel
(see Appendix fig. ii, p. 153). Holbein then altered the pupils
and corners of mouth, to achieve the sober expression of
the painting.

Provenance: Amerbach-Kabinett
Literature: Ainsworth and Faries 1986; Ainsworth 1990;
Basel 1988 (6); Müller 1996 (159), pp. 108–9; Basel 2006 (125)

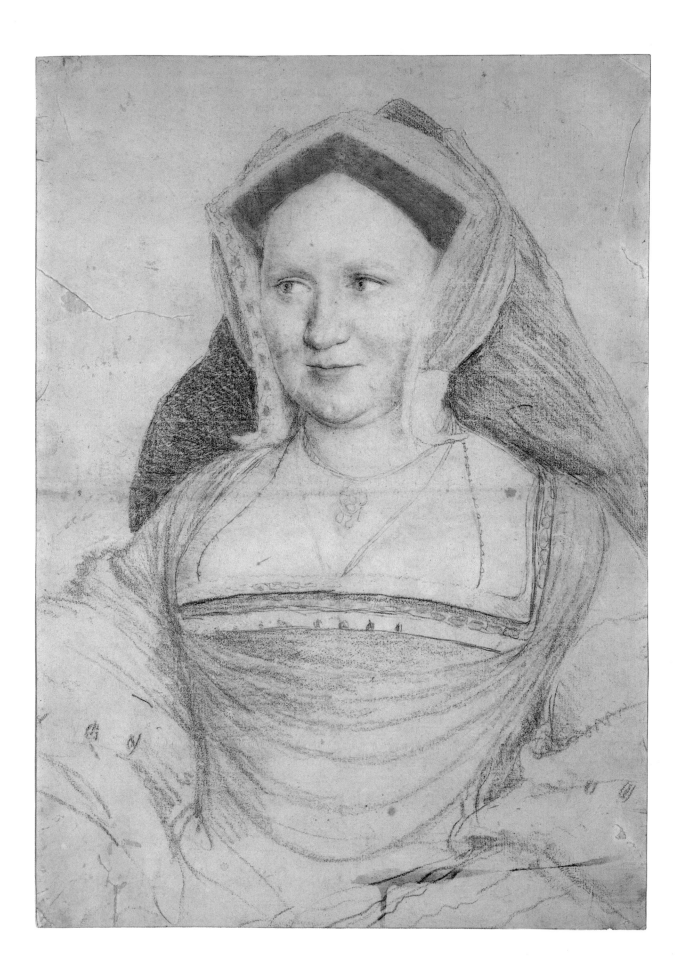

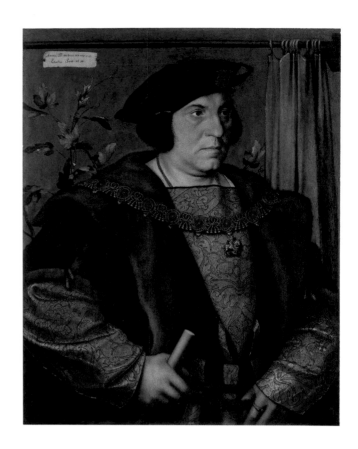

18 *Sir Henry Guildford* dated 1527

Panel 82.6 × 66.4 cm
Inscribed: in later cartellino Anno. d:mccccccxvii. / Etatis / Suae.xl ix:
The Royal Collection

The portrait of Sir Henry Guildford (1489–1532), bulky and
magnificent in costly cloth of gold, represents a first step in the
production of Holbein's overpowering image of Henry VIII
a decade later. Born in 1489, according to his own testimony,
and therefore thirty-eight when his portrait was painted (the
inscription on the painting is a later interpolation), Guildford
is presented with attributes of power and success: the collar and
badge of the royal Order of the Garter, to which he was elected
in 1526, and the white staff of the important post of Controller
of the Household. On his hat he wears a fashionable badge
depicting surveying instruments and a clock. The curtain rail
at the top of the painting links the composition to its pair,
a portrait of Lady Guildford (see no. 17). The motif of an
imaginary plant seen in the background of both portraits,
its leaves decoratively combining fig leaves and fruit with vine
tendrils, is visible in other portraits (nos. 34, 158). Holbein
indicated the directions of the branches in his underdrawing,
but edited them at the painting stage.

Provenance: John 1st Baron Lumley; Earl of Arundel; Viscount Stafford;
Earl of Stafford by 1726; bought by Crown 1734
Literature: Millar 1963 (28), pp. 58–9

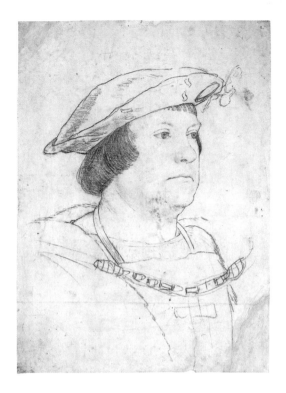

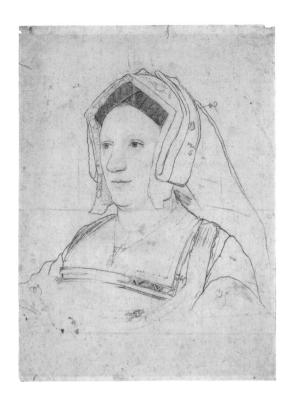

19 *Portrait of an Unknown Englishman* c.1527

> Black and coloured chalk and leadpoint on prepared paper;
> outlines traced blind 38.9 × 27.7 cm
> Kunstmuseum Basel, Kupferstichkabinett

20 *Portrait of an Unknown Englishwoman*

> Black and coloured chalk and leadpoint on prepared paper;
> outlines traced blind 38.9 × 27.7 cm
> Inscribed: atlas (silk) g[e]l[b] rot s[chwarz] w[eiss]
> (yellow, red, black, white)
> Kunstmuseum Basel, Kupferstichkabinett

The dress of this unidentified couple suggests they are English courtiers. The man wears a jewelled cap and a substantial chain with a large cross hanging from it (compare nos. 141, 142). The woman wears a gable headdress similar to that worn by Lady Guildford (no. 17). The flap of her headdress is to be red, the back yellow, the upper sleeve white and the edge of the square neckline is silk.

The female sitter's lips are given their distinctive shape with red chalk, but elsewhere in both drawings the modelling of the face has been lost and the outlines of eyelids, mouth and nose stand out disproportionately. These outlines were traced over with a stylus, to prepare the drawings to be transferred to panels for painted portraits, which do not survive. The indented circles around the head and shoulders of each sitter could have served Holbein as a guide to the proportions of the finished portraits, or, as Christian Müller has suggested, they might indicate that the portraits were to be roundels.

> Provenance: Amerbach-Kabinett
> Literature: Basel 1988 (68a, b), pp. 218–21; Müller (160, 161), p. 109; Basel 2006 (127, 128)

21 *A Lady with a Squirrel and a Starling (Anne Lovell?)*
*c.*1527

Oil on oak 56 × 38.8 cm
The National Gallery, London. Bought with contributions from the
National Heritage Memorial Fund and The Art Fund and Mr J. Paul
Getty Jnr (through the American Friends of the National Gallery), 1992

The sitter has been plausibly identified as Anne Lovell, wife
of Sir Francis Lovell (d. 1551) of East Harling, Norfolk, an
esquire of the body to Henry VIII. Squirrels appear on the Lovell
family coat of arms: the chained red pet squirrel, nibbling a nut,
convincingly integrated into the portrait at a late stage, evidently
also serves a heraldic purpose. The starling may be a punning
reference to the family seat at East Harling. The foliage in the
background mirrors that seen in the 1527 portraits of Sir Henry
Guildford (no. 18) and his wife. It is unlikely that Anne Lovell's
portrait formed part of such a pair since she looks to the right,
and women in such paired portraits generally face left, the
portrait pair of Sir Thomas and Lady Elyot (nos. 45, 46) however
providing a notable exception. The portrait may have been
commissioned in celebration of the birth of the Lovells' son
in spring 1526.

Provenance: Probably Earl of Arundel; Jan Six, probably 1658, and
subsequently members of the Six family; Sir William Hamilton sale,
20 February 1761 (lot 75); 3rd Earl of Cholmondeley and by descent;
bought 1992 with the help of the National Heritage Memorial Fund,
NACF and Mr J. Paul Getty Jr (though the American Friends of
the National Gallery)
Literature: Ganz 1925; Rowlands (28), p. 134; Foister, Wyld and Roy 1994;
King 2004, 1985

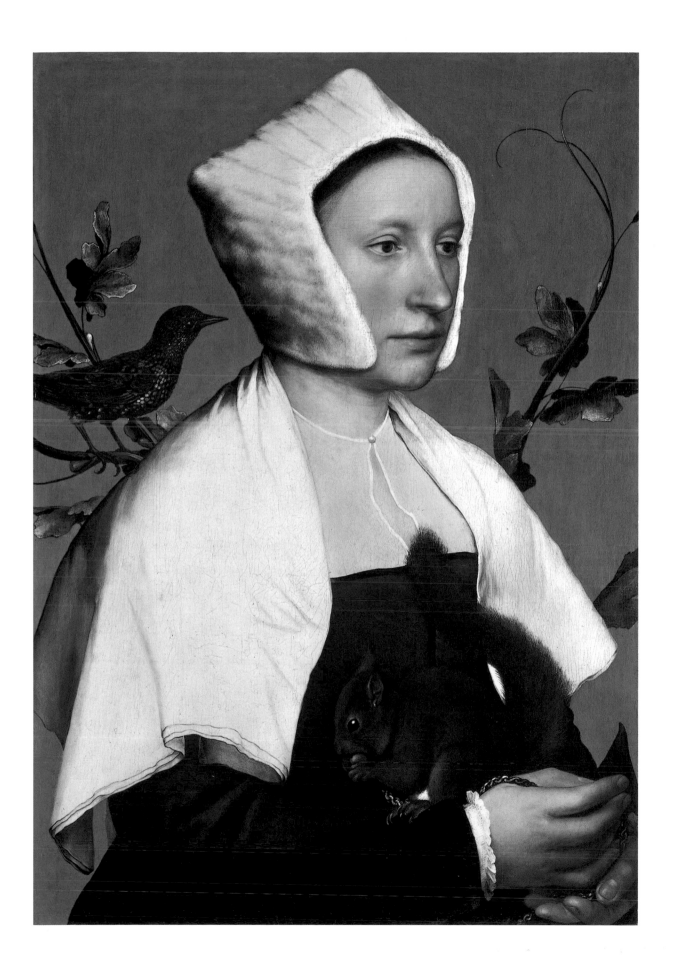

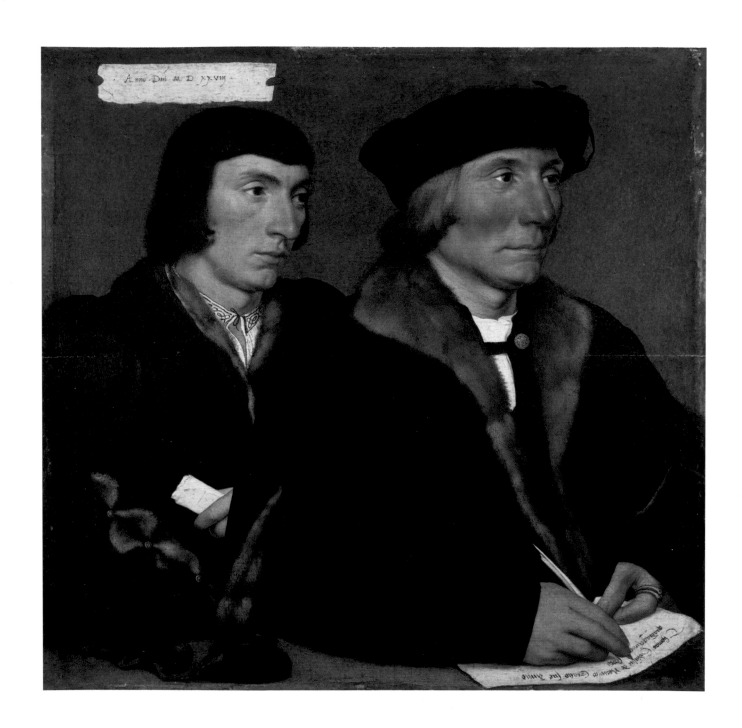

22 *Thomas and John Godsalve* dated 1528

Oak 35 × 36 cm
Inscribed lower right: 'Thomas Godsalve de Norwico Etatis sue Anno /
quadragesimo septo; upper left Anno. Dmi M.D. xxviii
Gemäldegalerie Alte Meister, Staatliche Kunstsammlungen Dresden

Thomas Godsalve (*c.*1481–1545) was a prosperous Norfolk land-
owner and registrar of the consistory court at Norwich. Ambitious
for his son John (*c.*1510–1557/8, see also no. 44), he cultivated the
future king's secretary Thomas Cromwell, sending him a gift of
swans in gratitude when in 1531 John Godsalve became one of the
four clerks to the signet. By 1540 he described himself to Cromwell
as 'half crokid'. Holbein may have gained the commission through
other Norfolk connections such as the Lovells (see no. 21).

The Godsalves' orientation in this unusual, slightly cramped
format suggests the hierarchical arrangement of the kneeling
donor figures of tomb sculpture and memorial paintings, but this
is mitigated by the careful characterisation and positioning of
the heads, as well as by the spatial interpolation of the desk with
inkwell and pencase. John's painted head was slightly enlarged
from the preparatory underdrawing revealed by infrared reflec-
tography. The cartellino top left may be a later addition, possibly
including information transcribed from an original frame.

Provenance: Earl of Arundel; E. Jabach; P. Crozat;
Elector of Saxony 1749; Gemäldegalerie Dresden 1889
Literature: Rowlands 1985 (31); Hague 2003 (8);
Foister 2005; Sander 2005, pp. 291–4; Basel 2006 (129)

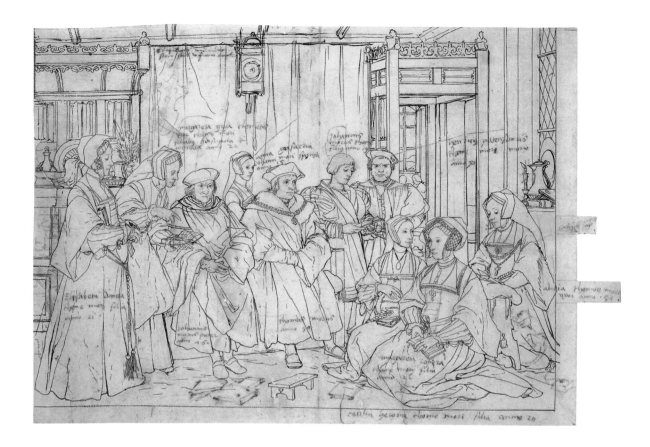

23　*Design for the More Family Group* 1526–7

Pen and brush with black ink over chalk preparatory drawing on paper;
inscriptions and additional motifs in brown ink 38.9 × 52.4 cm
(on the right two projecting pieces about 2 × 4 cm)
Inscribed with identifications and ages in the hand of Nikolaus Kratzer;
presumably in Holbein's hand (on the right): Dise soll sitze; upper left:
Claficordi und ander / seyte spill uf dem buvet
Kunstmuseum Basel, Kupferstichkabinett

This unique compositional drawing records Holbein's design for
a lost life-size group portrait of Sir Thomas More and his family,
and, in addition, documents the changes More told Holbein he
wished to incorporate when it was presented to him for his
approval. It also includes inscriptions identifying the subjects
made by Holbein's associate the royal astronomer Nikolaus
Kratzer (see nos. 33, 80), evidently in preparation for making
a gift of the drawing to More's great friend Erasmus, who wrote
in 1529 of his delight at receiving it. The finished painting
was made on canvas in pigments mixed with glue, a common
technique at the time, and was destroyed by fire in the
eighteenth century.

Holbein prepared for the composition by making individual
portrait studies (see nos. 24–30). He arranged the figures into
a composition which was evidently inspired by traditional
groupings of the 'Holy Kindred' or the extended family of
Christ, with More taking the place of the Virgin Mary and
his father in the position of the Virgin's mother, St Anne.

The drawing is carefully executed with great clarity and control
of the outlines using an inked brush over an initial chalk sketch.
The spareness of the drawing emphasises the way in which
Holbein has connected the figures: glances are particularly
important, especially the way in which Margaret Giggs looks
up and gestures to John More.

The inscriptions and alterations in brown ink show More
preferred his wife on the far right to sit, not kneel and asked
that the lute on the left should be moved not hung on the wall.
The candle on the still life is crossed through, as are the books
on the floor in front. The monkey is added, as is the lacing to
Margaret Roper's bodice.

Some of these changes are seen in a copy of the painting by
Rowland Lockey (Nostell Priory). Other differences were
evidently also the result of further discussions with More:
Margaret Giggs no longer leans over but is shown as in
the individual drawing (no. 30, presumably made after the
discussion) which detracts from the rhythm of the composition.
Books are changed to classical texts, Lady More no longer
kneels, and rosaries prominent in the drawing are banished,
so the family appears learned rather than devout.

Provenance: Amerbach-Kabinett
Literature: Müller 1996 (157), pp. 106–8; Basel 2006 (120)

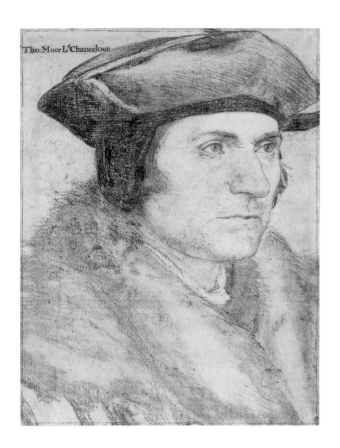

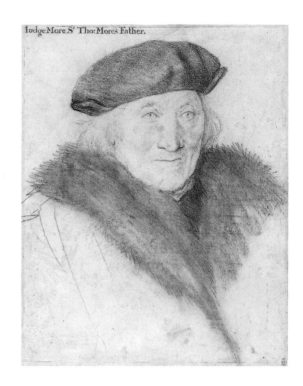

24 *Sir Thomas More* 1526–7

> Black and coloured chalks on paper 40.2 × 30.1 cm
> Inscribed: Tho: Moor Ld Chancelour
> The Royal Collection, The Royal Library, Windsor

On 18 December 1526 Sir Thomas More (1477/8–1535), then Chancellor of the Duchy of Lancaster and a judge in Star Chamber, wrote to Erasmus that his painter (Holbein) was 'a wonderful artist'; possibly he had already made this and other images of the More family.

Holbein produced two individual portrait drawings of More, as well as a painting (Frick Collection, New York). This particularly large drawing is on the same scale as the painting, and, unusually for Holbein, its outlines are pricked for transfer, following closely details such as the iris and tear ducts. However, although the holes viewed from the reverse of the drawing are darkened from contact with black chalk of charcoal, and the underdrawn contours of the Frick portrait have been transferred from a pricked cartoon, these dotted outlines do not correspond precisely to the holes of this drawing: Holbein may have used the drawing to create a pattern which he adjusted slightly before transferring its outlines to the panel for the portrait.

> Provenance: See no. 15
> Literature: Parker 1983 (3); London 1977–8 (177), p. 89;
> Ainsworth 1990; Edinburgh 1993 (2), p. 28; Hague 2003 (3),
> pp. 56–8; Sander 2005, pp. 278–80

25 *Sir John More* 1526–7

> Black and coloured chalks on paper 35.4 × 27.6 cm
> Inscribed: Iudge More Sr Tho: Mores Father
> The Royal Collection, The Royal Library, Windsor

At the time of Holbein's first visit to England Sir John More, father of Sir Thomas More, was aged about seventy-five; he died in 1530 after a career as a lawyer and judge. He is shown in the group composition at the heart of the family whereas his wife, Sir Thomas's stepmother, appears lower right, detached from the group. Here he wears a gown with a deep fur collar but in the group he is shown in his judge's robes. The drawing demonstrates Holbein's great facility with the chalk medium and variation of touch, from the quick zigzags of the fur to the softness of hair and eyebrows, and the subtle shading in red and black suggesting the sagging flesh around the deep eye-sockets and cheekbones.

> Provenance: See no. 15
> Literature: Parker 1983 (1); London 1977–8 (9), pp. 24–5;
> Houston 1987 (1), p. 28; Edinburgh 1993 (1), p. 26

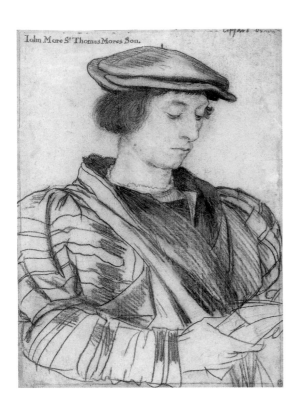 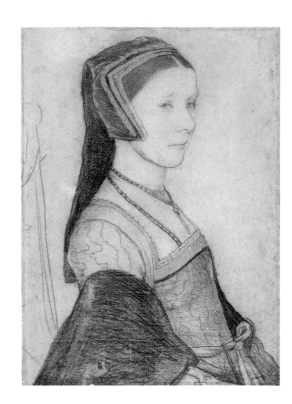

26 *John More the Younger* 1526–7

Black and coloured chalks on paper 38.3 × 28.4 cm
Inscribed: Iohn More Sr Thomas Mores Son;
lipfarb brun [complexion brown]
The Royal Collection, The Royal Library, Windsor

John More (1508–1547) was the only son of Sir Thomas More;
he married Anne Cresacre (no. 27) in 1529. After More's
execution he was briefly imprisoned in the Tower.

This is a study for the family group portrait (no. 23) in which
John is shown standing in the background of the composition
next to his wife Anne Cresacre. He is shown wearing a hat which
has been removed in the group drawing, presumably because it
disrupted the composition. The drawing makes unusually free
and vigorous use of black chalk, for the swift, almost jagged
outlining of the hand and wrist and for the slashing diagonals
of the striped sleeves.

Provenance: See no. 15
Literature: Parker 1983 (6); London 1977–8 (178) pp. 89–90;
Edinburgh 1993 (4), p. 32; Basel 2006 (122)

27 *Anne Cresacre* 1526–7

Black and coloured chalks on paper 37.5 × 26.8 cm
The Royal Collection, The Royal Library, Windsor

Anne Cresacre (1511–1577) became Sir Thomas More's ward
as a baby after the death of her father in 1512, and in 1527 was
betrothed to More's son John (no. 26); they married in 1529.

In this drawing for the More family group painting she is shown
seated in a chair, the struts of its back clearly visible. However,
in the preparatory drawing for the group (no. 23) she is shown
standing, at the same level as other standing figures in the back
row, and the chair back has been removed.

Provenance: See no. 15
Literature: Parker 1983 (7); London 1977–8 (179) p. 91;
Edinburgh 1983 (5), p. 34

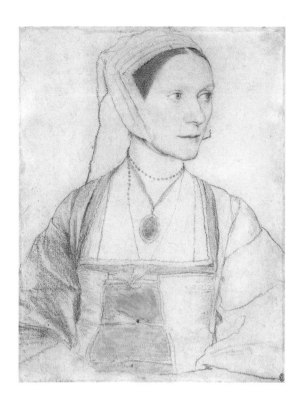

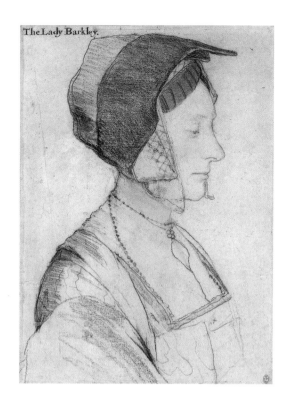

28 *Cecily Heron* 1526–7

Black and coloured chalks on paper 38.4 × 28.3 cm
The Royal Collection, The Royal Library, Windsor

Cecily Heron (b. 1507) was Sir Thomas More's youngest
daughter and married to Giles Heron, who was hanged for
treason in 1540. With Elizabeth Dauncey's husband, he was MP
for Thetford. Cecily Heron is shown in the study for the group
portrait with her arm across her body in the pose of Leonardo
da Vinci's portrait of Cecilia Gallerani, now in Krakow
(Czatoryski Museum). The pose serves partially to mask her
pregnancy, made visible by the manner in which her lacing
is let out across her body. Holbein must have seen a drawing
in which this motif is copied and saved it in his own notebooks
to reuse here.

Provenance: See no. 15
Literature: Parker 1983 (5); London 1977–8 (183), p. 94;
Edinburgh 1993 (3), p. 30

29 *Elizabeth Dauncey* 1526–7

Black and coloured chalks on paper 37.1 × 26.2 cm
Inscribed: The Lady Barkley; rot [red]
The Royal Collection, The Royal Library, Windsor

Elizabeth Dauncey (b. 1506) was the second daughter of
Sir Thomas More. In 1525 she married William Dauncey.
A Knight of the Body and Privy Councillor to Henry VIII,
he was MP for Thetford in the Reformation Parliament.
The inscription is one of the small number added to Holbein's
English portrait drawings which are demonstrably false, since
this drawing is clearly a study for the portrait in the More family
group (no. 23), where she is identified by Nikolaus Kratzer.
Holbein has indicated that the border of Elizabeth Dauncey's
bodice is to be red.

Provenance: See no. 15
Literature: Parker 1983 (4); London 1977–8 (182), p. 93;
Houston 1987 (5), p. 38; Basel 2006 (121)

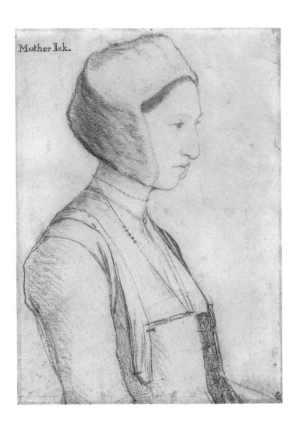

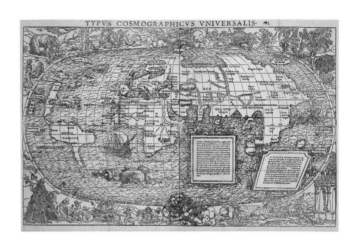

30 *Margaret Giggs* 1526–7

> Black and coloured chalks on paper 38.5 × 27.3 cm
> Inscribed: Mother Iak
> The Royal Collection, The Royal Library, Windsor

Margaret Giggs was Sir Thomas More's foster daughter, and in 1526 married her tutor, John Clement, soon a court physician. She had eleven children and died in exile in the Netherlands in 1570.

This drawing appears to be a study for the portrait of the More family. In the drawing for the group (no. 23) the woman named Margaret Giggs leans towards John More and wears a different headdress. However, in the copy of the painting by Rowland Lockey (Nostell Priory) she is shown with the fur hat and upright pose of the present drawing, suggesting the drawing was made to reflect a further amendment to the composition requested by More.

The drawing is inscribed 'Mother Iak', assumed to refer erroneously to a nurse to Edward VI, but conceivably referring to the wife of 'Jack' Clement. The portrait of Anne Lovell (?) (no. 21) includes a similar fur cap, and, following the drawing, was also identified as 'Mother Iak' in the seventeenth century, but the features of the two women, especially their noses, are quite distinct.

> Provenance: See no. 15
> Literature: London 1977 (184) pp. 94–5; Parker 1983 (8)
> Reference: ODNB, M. Bowker

31 *Map of the World* 1532

> Woodcut 35.3 × 55 cm
> The British Museum, London

In spring 1527 Holbein spent several weeks executing a painting of the map of the world which formed the ceiling of a theatre at Greenwich Palace where Henry VIII would entertain a French embassy in May. He worked in collaboration with the royal astronomer Nikolaus Kratzer, and the resulting scene, which, with theatrical sleight of hand, incorporated scenes of the 'earth environed by the sea' as well as the heavens, may have had some resemblance to this woodcut. Peter Barber has suggested that this design itself may have been carried out in collaboration with Kratzer, and thus designed in England, although the map was first published in Simon Grynaeus, *Novus Orbis regionum ac insularum veteribus incognitarum*, Basel 1532.

> Literature: London 1991 (vol. 12), p. 69; London 1995 (237), pp. 234–6;
> Hollstein 14 (90a); Foister 2001

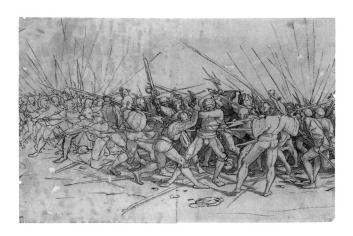

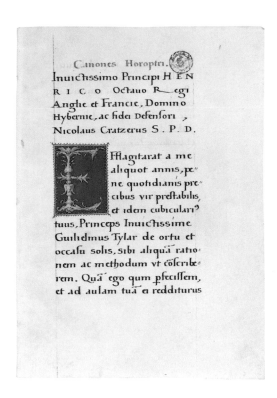

32 *Battle Scene* c.1523–4?

> Pen and brush, black ink, grey wash on paper 28.6 × 44.1 cm
> Kunstmuseum Basel, Kupferstichkabinett

The function of this vigorous drawing with a strong sense of diagonal movement is unknown; a copy in Vienna suggests it once extended further to the left and right. The watermark of the paper is of a type similar to others found on French paper used for drawings Holbein made in England. In 1527 Holbein painted the English defeating the French at the battle of Thérouanne for the reverse of a triumphal arch in the dining hall of a temporary building at Greenwich Palace. However he was paid for a 'plat' which suggests a map or aerial view rather than this energetic criss-crossing of radiating pikes arranged around the central struggling pair. The style of the drawing, as well as the watermark, suggests Holbein could have made it in France, in 1523–4.

> Provenance: Amerbach-Kabinett
> Literature: Müller 1996 (178), pp.119–20; Basel 2006 (102)

Hans Holbein the Younger and Peter Meghen 1528

33 *Canones Horoptri*

> Manuscript with bodycolour and gold on vellum 33 × 28 cm
> Bodleian Library, University of Oxford

This small green velvet-bound book was composed by Nikolaus Kratzer, astronomer to King Henry VIII and Holbein's friend and collaborator. It formed the manual for the use of astronomical instruments, the *horoptrum*, for finding the times of sunrise and sunset, which Kratzer intended as a New Year's gift for Henry VIII in 1529.

The illuminated lettering of the title page (and the small E on f.4v) is clearly the work of Holbein, the lively and elegant Renaissance-style grotesques most closely resembling the jewellery designs of the 1530s (see nos.143,144) and quite distinct from the Netherlandish style popular in England at this period. This is the only surviving example of a manuscript illuminated by Holbein, but the technique was essentially the same as that which Holbein used later in England to paint portrait miniatures.

> Provenance: Henry VIII?; Johannes Bayley; given to Bodleian Library by William Bayley 1602
> Literature: Pächt 1944; London 1977–8 (188), p.96; London 1991 (vol.14), p.71

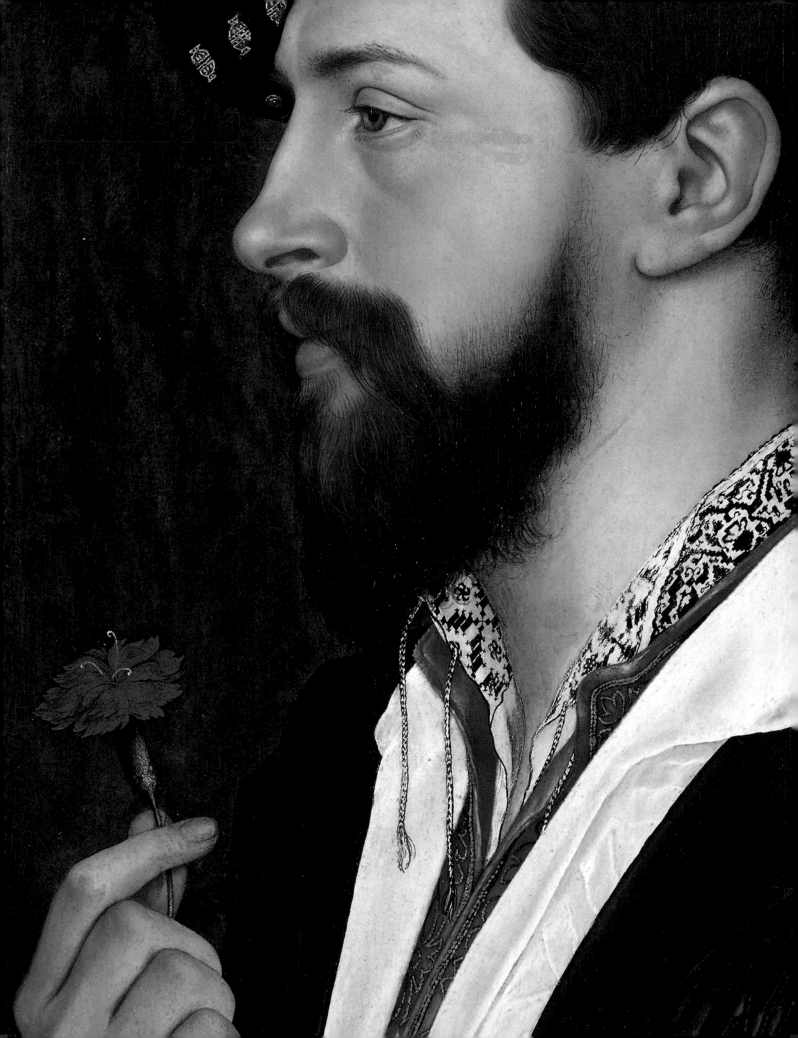

2

London 1532–43: Court and City

A Latin letter written in 1536 by the Frenchman Nicolas Bourbon (nos. 47, 48) offers a brief insight into Holbein's circle of friends and associates, including the Netherlandish goldsmith Cornelis Hayes and the German astronomer Nikolaus Kratzer. Poems by Bourbon also mention a great number of courtiers, and many of these were portrayed by Holbein, who was now well established among those who attended Henry VIII at his new palace of Whitehall. The patrons of his first visit to England were dead or disgraced (though More's daughter Margaret Roper returned for another portrait with her husband, nos. 37, 38), but there was a need for portraits at court to facilitate or celebrate marriage, to cement love affairs and to commemorate the worthy. Holbein quickly found courtiers eager for their likenesses to be taken. These included not only members of the court such as Lord Bergavenny, Thomas Wriothesley, William Reskimer and Robert Cheseman but those with humanist and literary interests such as Sir Thomas Elyot and the poets Sir Thomas Wyatt and the Earl of Surrey (nos. 51, 50). Bourbon and fellow Tudor humanists such as John Leland were fascinated by the phenomenon of the skilful artist as well as by the portraits he produced, naming Holbein the Tudor Apelles, and celebrating his work in Latin poetry.

At the same time Holbein produced portraits of those in the uniform of the king's household servants, some of whom may have been personal friends. Though we have no information concerning the prices Holbein charged for the small turned wooden roundels on which he painted, such portraits (nos. 39, 40, 42, 43) were presumably cheaper than larger portraits on panel. Small portrait miniatures in a watercolour technique on vellum, which would have been set into jewellery, may have been more expensive, although Holbein's clients for these first portrait miniatures included the Ropers and Mrs Small, the wife of a London merchant. The technique needed to create such miniatures was akin to that of manuscript illumination, of which Holbein had demonstrated his mastery in 1528 (no. 33), but in Holbein's portrait miniatures, unlike those associated with his rival as court painter, Lucas Horenbout, the small format is not permitted to restrict the focus to the face alone: instead Holbein produces perfectly balanced half-length compositions which draw on his experience of full-size compositions. Both roundels and miniatures mimic fashionable small portraits in other media, such as medals or sculpture, as does Holbein's woodcut portrait of Sir Thomas Wyatt (no. 52).

The portrait drawings Holbein produced during his second visit to England were different in technique from those of the first: on pink primed paper, they may have speeded up the production of portraits by providing a ready made flesh tone. But the drawings of this period are also more elaborate, using mixtures of coloured chalks as well as ink, and adding precise detailing of contours and features with the pen and brush, as well as vivid painterly washes of ink, and the bright colouring seen in the portrait of John Godsalve.

34 *William Reskimer* c.1534

Panel 46.4 × 33.7 cm
The Royal Collection

The portrait was painted after the preparatory drawing in
The Royal Collection executed on the pink prepared paper
characteristic of Holbein's second English visit. Inscribed simply
'Reskemeer a Cornish Gent:', the sitter is identifiable as William
Reskimer via the direct family connection between his children
and the subsequent owner of the portrait, Sir Robert Killigrew.
William Reskimer became Page of the Chamber to Henry VIII in
1526 and attended Wolsey in 1527. Granted land in Warwickshire
in 1532 and property in Blackfriars in 1542, he was made 'havenator'
or keeper of the ports of his native duchy of Cornwall in 1543,
and in 1546 he became one of the King's Gentleman Ushers.

The background to the portrait shows the leaves with the charac-
teristics of both vines and figs that Holbein employed in varied
formation in portraits made during his first visit to England. The
composition, with its strongly shadowed twisting hands anchoring
the corner, also resembles that of Holbein's earlier portrait of Anne
Lovell (?) (no. 21), but in reverse; hatched shading is seen in the
underdrawing (see Appendix fig. iii, p. 154). The portrait probably
therefore dates from early in Holbein's second visit to England.

Provenance: Presented to Charles I by Sir Robert Killigrew (d. 1633);
recovered at Restoration for Charles II perhaps from Philip Lord Lisle
later 3rd Earl of Leicester
Literature: Millar 1963 (31), pp. 60–1; Rowlands 1985 (39);
Edinburgh 1993 (16), p. 56; Hague 2003 (15), pp. 88–9

35 *Simon George* c.1535

Oak Diameter 31 cm (the original roundel cut down and reconstituted)
Städel Museum, Städelsches Kunstinstitut Und Städtische Galerie,
Frankfurt am Main

A preparatory study for the portrait at Windsor on the pink
paper Holbein used on his second English visit identifies
Simon George as the subject, according to its later inscription.
He is not recorded at court but seventeenth-century records
indicate he settled in Quotoule in Cornwall and married
Thomasina Lanyon. Like Sir Thomas Wyatt (no. 52) George
is shown in near profile within the roundel format that evokes
the coinage of classical antiquity, admired at the Tudor court as
elsewhere in Europe. His expensive courtly clothing however is
contemporary, and is painted with exquisite attention to texture
and detail, in the depiction of light glancing off the stitched
pattern of his silk sleeve, the precision of the rendering of the
blackwork embroidery and the soft fronds of the feather curling
over his cap, which is fashionably decorated with gold tags, violas
and a badge. The badge depicts Leda and the swan in a design
also seen on a plaquette in Berlin by Giovanni Bernardi da
Castelbolognese (1494 – 1553).

Simon George holds a carnation, and it is tempting to assume
that this may refer to his betrothal and that the portrait once
had a pair; however, it was more usual for the man in such paired
portraits to face left (the Elyots, nos. 45, 46 being notable
exceptions), and carnations also symbolised the crucifixion;
violas or pansies could refer to melancholy. The preparatory
drawing shows George still in the process of growing a beard,
while an X-radiograph of the painting shows it in a less luxuriant
form than in the final image.

Provenance: M. Birkenstock sale Vienna 1810;
A. von Brentano-Birkenstock sale, Kohlbacher, Frankfurt 1870,
where acquired
Literature: Rowlands 1985 (63); Hague 2003 (25), pp. 110–1;
Brinkmann and Kemperdick 2005, pp. 430–41

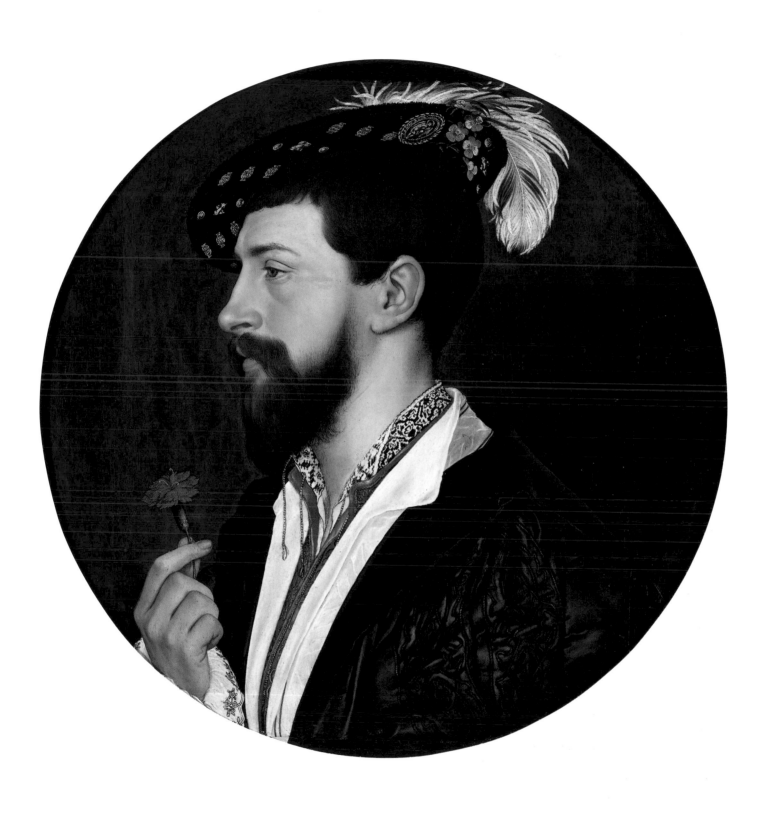

36 *Robert Cheseman* dated 1533

Wood 58.8 × 62.8 cm
Inscribed: ROBERTVS CHESEMAN. ETATIS. SVAE XLVIII.
/ ANNO DM M. D. XXXIII
Royal Cabinet of Paintings, Mauritshuis, The Hague

Robert Cheseman (1485–1547) is shown stroking the soft breast
feathers of an expensive hooded gyrfalcon. Holbein has placed
this quiet gesture at the heart of an unusual, almost square, half-
length portrait composition, creating a sense of expectancy in
the contrast between the bird of prey's momentary poise and
Cheseman's distant glance, the side of his face and the top
of the bright pink satin of his sleeve dramatically illuminated.
The texture and markings of the bird's variegated feathers are
skilfully evoked by dragging the brush through wet paint.

Cheseman's father Edward had been cofferer and keeper of the
wardrobe to Henry VII; Cheseman himself acted as the King's
representative in Middlesex and in 1540 went to meet Anne
of Cleves on her arrival in England. In the inventory of pictures
owned by Charles II Cheseman is referred to as the King's
'Master Falconer', but there is no contemporary corroboration
of this title: the relevant accounts for 1533 are missing, and
Cheseman is not mentioned in later accounts as a royal falconer.

Provenance: Charles II; James II; William III, Het Loo;
Johan Willem Friso, Het Loo 1702–11; Stadholder William V
after 1770–95; Mauritshuis 1822
Literature: Rowlands 1985 (46); Hague 2003 (19), p.100;
Foister 2004, p.233

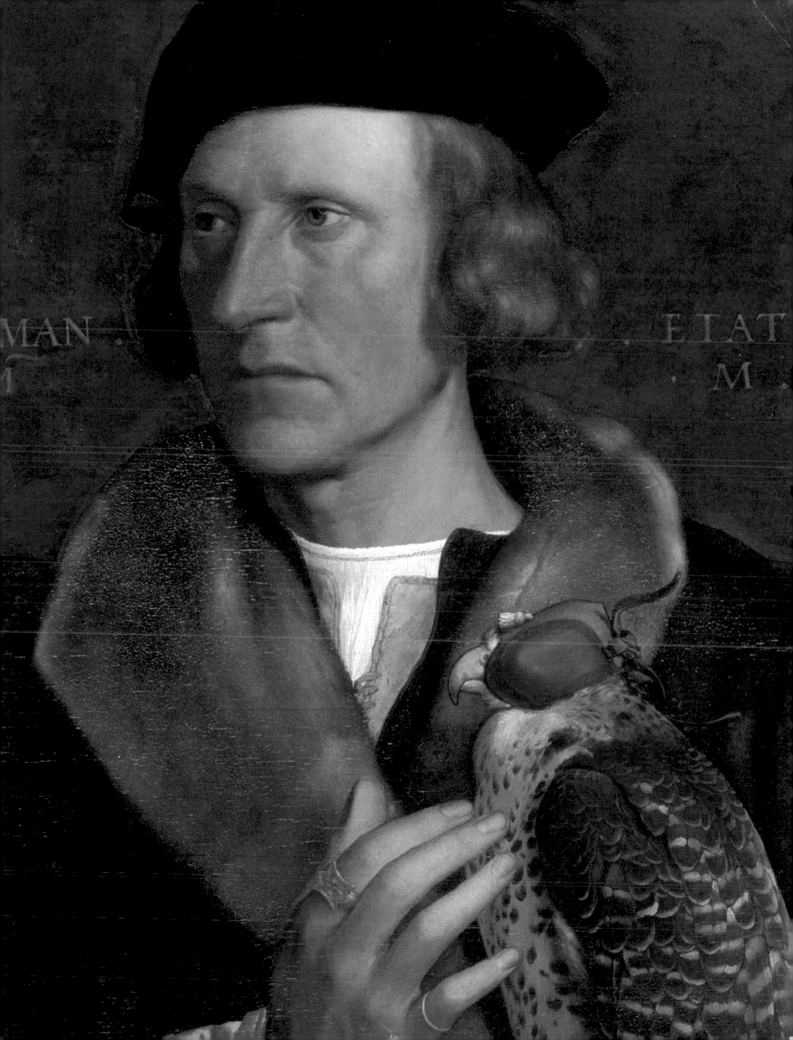

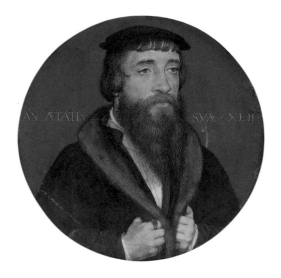 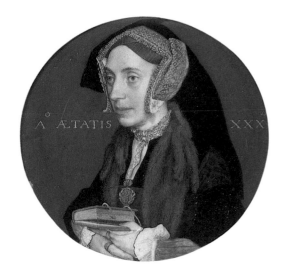

37 *William Roper* c.1536

> Bodycolour on vellum mounted on card Diameter 4.5 cm
> Inscribed: AN AETATIS SVAE XLII
> The Metropolitan Museum of Art, New York, Rogers Fund, 1950

38 *Margaret Roper* c.1536

> Bodycolour on vellum mounted on card Diameter 4.5 cm
> Inscribed: AO AETATIS XXX
> The Metropolitan Museum of Art, New York, Rogers Fund, 1950

Margaret Roper (1505–1544), the eldest child of Sir Thomas More, married William Roper (1493/8–1578) in 1521. Roper lodged with the Mores when he was studying law and later became a bencher, Governor, Pronothary and MP. An early enthusiast for Luther, he remained a Catholic.

Margaret Roper is shown at full-length in the preparatory study for Holbein's lost life-size painting of the family of Sir Thomas More of 1526–8 (no. 23) but this portrait appears to have been based on a new sitting of about 1536, after More's execution. She holds a book, possibly a prayer book, and wears a medallion which appears to show a male saint, possibly St Michael or St George; the minute figure appears to hold aloft a shield in his right hand and there is a long shape at his feet which might indicate a dragon. Her collar is embroidered with fine green and black patterns, and she wears fur pelts around her neck. The details of her headdress are picked out with gold. The faces of both sitters are extensively hatched with flesh-coloured paint.

> Provenance: Roper family; Lord Rothschild; Lord Carnarvon;
> Mrs H. Goldman, New York; purchased, Rogers Fund 1950
> Literature: London 1977–8 (174), pp.89–91; Rowlands 1985
> (M3) (M4); London 2003 (163)

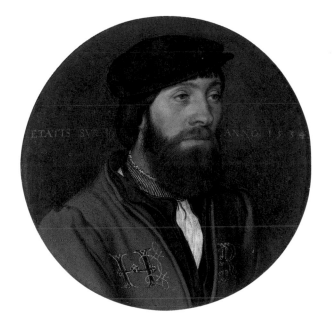

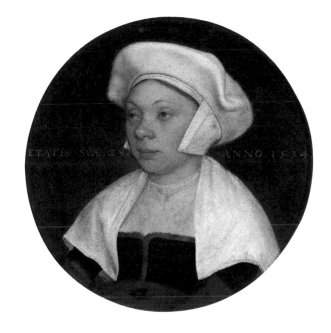

39 *An Unidentified Man* c.1534

Wood (possibly limewood) Diameter 11.8 cm
Inscribed: AETATIS SVAE 30. ANNO 1534;
Kunsthistorisches Museum, Vienna, Gemäldegalerie

The man wears a red coat embroidered with an elaborately decorated HR (for Henricus Rex); his wife wears a simple white headdress and chemise, comparable to those worn by Mrs Small (no. 41) and by an unidentified woman (no. 56). Those who wore the royal livery included Grooms of the Chamber, Royal Guards and Yeomen, the Serjeant Painter and those employed by the Office of Works who worked on the fabric of the royal palaces, and whom Holbein is likely to have known: the livery worn by the latter is described in Wardrobe warrants as 'oon Cooate of brood cloth colored Redd every Cooate …lined with black Cotton and enbraudered with our letters of H. and R/like as other servaunts have'. Footmen wore 'footmens' cootes of crymsen and blacke velvett embrodered with Stafford knots – iiii', the type of decoration seen here, although the coat does not seem to be velvet.

Chamberlain suggested that the pair might represent the artist sister and brother-in-law of the painter Lucas Horenbout. Susanna Horenbout married John Parker, Yeoman of the Robes and Keeper of the Palace of Westminster, who owned the footmens' coats cited above, along with other clothing given him by the king; but according to Dürer, she was about eighteen in 1521 and so already in her thirties by 1534. Another possibility

40 *An Unidentified Woman* c.1534

Wood (possibly limewood) Diameter 11.8 cm
Inscribed: AETATIS SVAE 28. ANNO. 1534
Kunsthistorisches Museum, Vienna, Gemäldegalerie

is the Serjeant Painter, in 1534 Andrew Wright, and his wife Annes [*sic*]; however, since his elder son was old enough to take on part of his business at his death in 1543 he was probably slightly older than this sitter. It is possible that the man is not a painter, but another craftsman or royal servant.

Holbein began to paint small roundels such as this in Basel, and portrayed Erasmus in this format, perhaps influenced by Lucas Cranach. Cranach's small paired roundels of Luther and his wife were intended to be screwed together as lid and base and it is possible that these roundels were also intended to screw together in this way; however, only the innermost profile now survives from the original frames, which have been cut away (my thanks to Elke Oberthaler and Monika Stroltz for this information). The reverses of the turned wood supports are painted black. Although such small works might have been less costly, these well-preserved examples are nevertheless portraits of a quality which matches that of the miniatures and larger portraits.

Provenance: Schloss Ambras by 1806, when transferred
to Imperial Gallery, Vienna
Literature: Chamberlain 1913 (vol.2) pp.70–1; Ganz 1950 (78, 79);
Rowlands 1985 (50, 51); Foister 2004, p.15
Reference: Campbell and Foister 1986

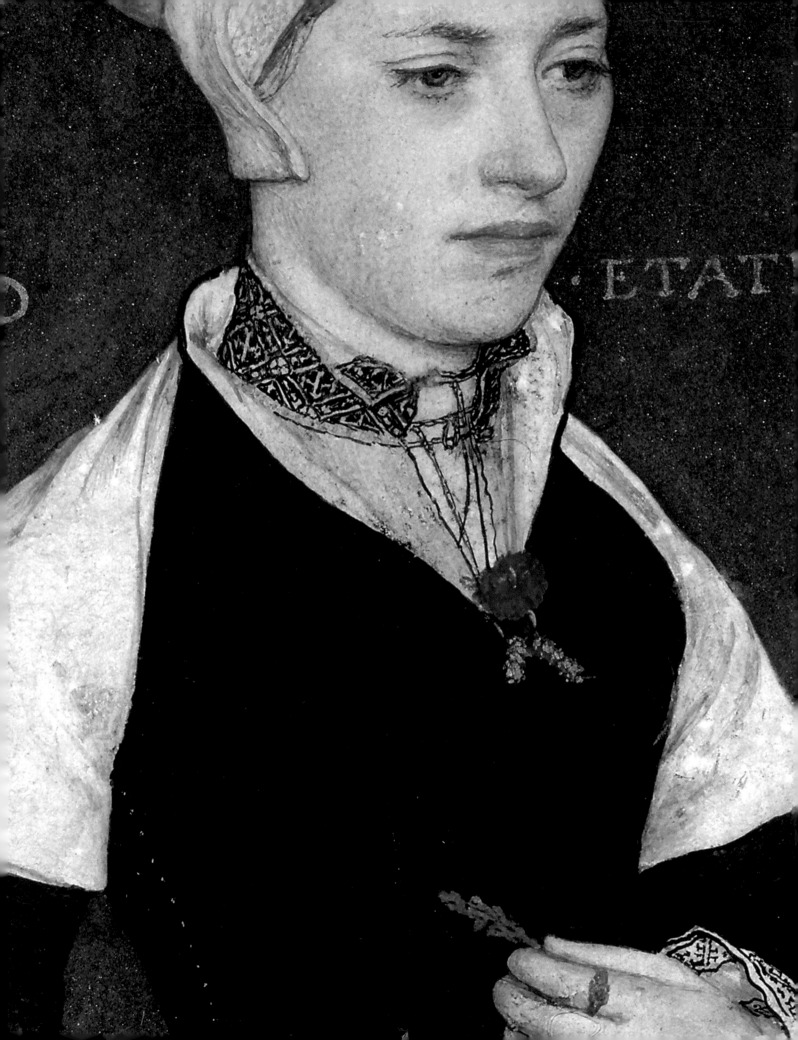

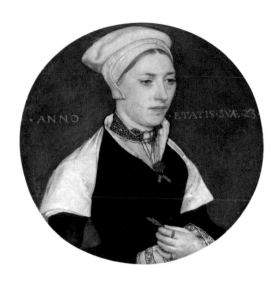

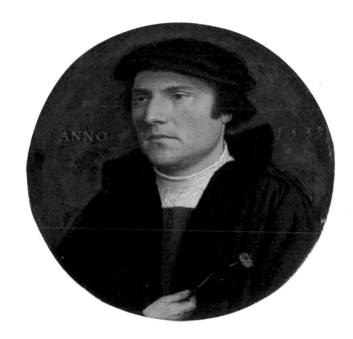

41 *Mrs Nicholas Small* c.1540

> Bodycolour on vellum Diameter 5.3 cm
> Inscribed: ANNO.AETATIS SVAE 23
> Victoria and Albert Museum, London

The coat of arms kept with the portrait identifies the sitter as Jane Pemberton (c.1518–1602), daughter of Christopher Pemberton, a Northamptonshire gentleman, and wife of Nicholas Small (d.1565/6), a City of London cloth merchant. Nicholas Small was not a courtier, but Holbein's portraiture might have come to their attention via Robert Cheseman (no.36): his cousin Emma, widow of a prosperous fishmonger, was godmother to their daughter.

Mrs Small holds a leaf, and at her bosom is a red carnation, perhaps a reference to her betrothal, which is likely to have taken place in about 1540, and which may have provided the occasion for the portrait commission. Her white cap and shawl and black dress are relatively simple, reflecting her social status, comparable to the dress worn by nos. 40 and 56.

As with other portrait miniatures, Holbein constructs a half-length composition resembling those of his full-size portraits, including the hands; he balances it carefully around a vertical axis running through the right eye and right cuff.

> Provenance: John Heywood Hawkins by 1865; J. Pierpont Morgan 1904; sold to Duveen 1935 and acquired for the V&A with the help of the NACF, Viscount Bearsted and the Captain H.B. Murray Bequest
> Literature: Campbell 1987; Campbell 1990

42 *Portrait of a Young Man with a Carnation* dated 1533

> Oak Diameter 12.5 cm
> Inscribed: ANNO 1533
> Upton House, The Bearsted Collection (The National Trust)

This small portrait is similar in format to those in which the male sitters wear the livery of Henry VIII, and of the same period, but this man wears his own clothing of a plain type, his shirt resembling that worn by John More (no.26). Like Simon George (no.35) and Mrs Small (no.41) he holds a carnation, possibly in connection with a betrothal, although he is not turned to the left in the manner which would normally suggest a paired female portrait (though see nos. 45, 46), and carnations are also associated with the crucifixion.

> Provenance: Franz Jaeger, Vienna 1841; F.J. Gsell, Vienna 1872; G. Przibram, Prague by 1891; L. Goldschmidt-Przibram, Brussels; F. Müller, Amsterdam 1924; Viscount Bearsted; presented to National Trust 1948
> Literature: Rowlands 1985 (48)

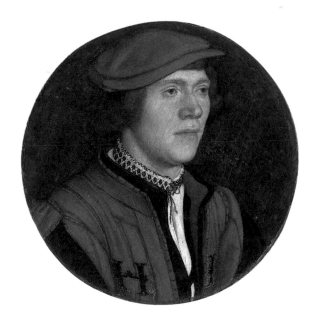

43 *Portrait of a Man in a Red Cap* c.1532–5

> Oil on wood Diameter including engaged frame 12.7 cm;
> painted surface 9.5 cm
> The Metropolitan Museum of Art, New York,
> Bequest of Mary Stillman Harkness, 1950

Like no. 39 the sitter wears the livery of Henry VIII, with the
initials H[R] for Henricus Rex embroidered in black on his red
coat. This identifies him as a court official but the black lettering,
the cut of his red coat with its slashed sleeve opening, as well
as his red hat, are of a different type from those worn by no. 39.
His shirt is embroidered with a finely detailed blackwork
pattern. His hairstyle indicates a date in the early 1530s.

The reverse is painted black and decorated with engraved circles;
it is likely the portrait originally had a painted lid (see no. 151).

> Provenance: ? Art dealer, Paris; Frédéric Engel-Gros; his daughter,
> Madame E. Paravicini, Basel 1921; Mrs Edward S. Harkness, New York
> 1940; bequest of Mary Stillman Harkness, 1950
> Literature: Rowlands 1985 (52)

44 *Sir John Godsalve* c.1532–3

> Black and coloured chalks, watercolour and body colour,
> brush, pen and ink on pink prepared paper 36.7 × 29.6 cm
> Inscribed: Sr Iohn Godsalve (twice)
> The Royal Collection, The Royal Library, Windsor

By 1532, the date of Holbein's return to England, John Godsalve
(c.1510–1556) (see also no. 22), who took up the important post
of Clerk of the King's Signet in 1531, had been appointed to the
Office of Common Meter of Precious Tissues. He was elected
MP for Norwich in 1537, was knighted in 1547 and in 1548
became Comptroller of the Royal Mint.

Despite the finished appearance of the portrait with its bright
blue background, it was executed on pink-grounded paper
and is most probably a study for a painted portrait which does
not survive. Few other surviving drawings include such dense
and extensive working in ink on the face and hair using both
pen and brush, including hatched shadows, in a manner which,
as Jane Roberts has noted, is close to the technique of the
miniatures. The pose and manner in which Godsalve's right arm
seems to overhang a parapet recalls the portraits of Hermann
von Wedigh of 1532 (no. 62) and Derich Born of 1533 (no. 158).
Godsalve's glance back towards the viewer is particularly vivid;
experimentation with the direction of the eyes is characteristic
of Holbein's portraits of the early 1530s.

> Provenance: See no. 15
> Literature: Parker 1983 (22); Edinburgh 1993 (14), p. 52;
> Hague 2003 (13), pp. 84–6

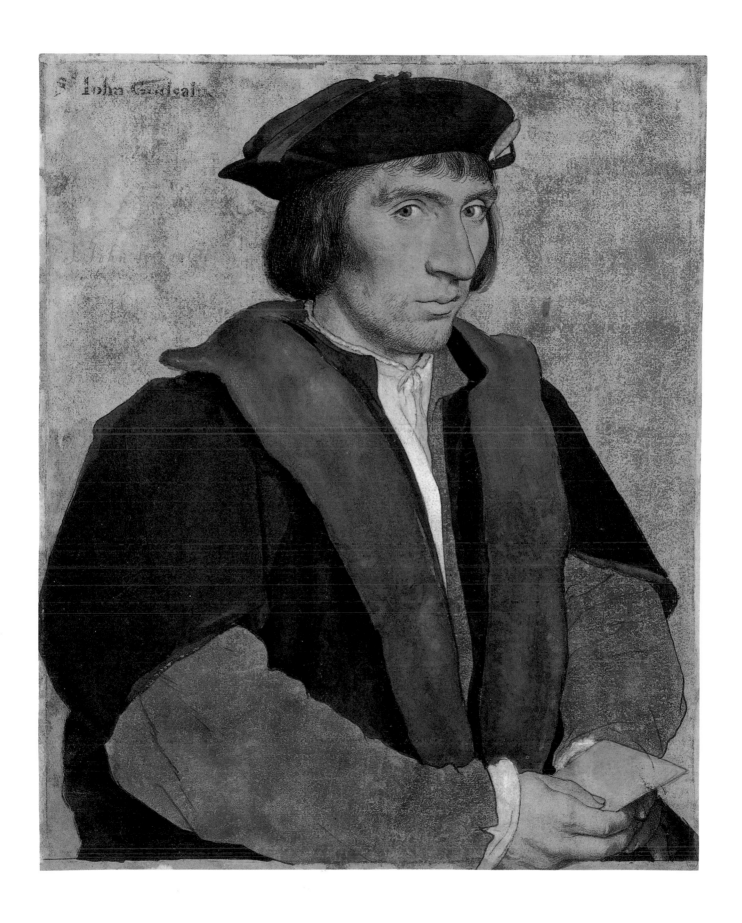

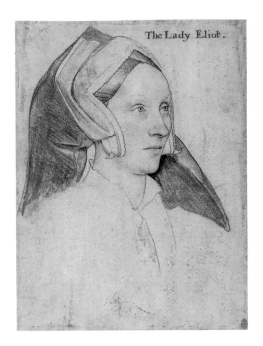

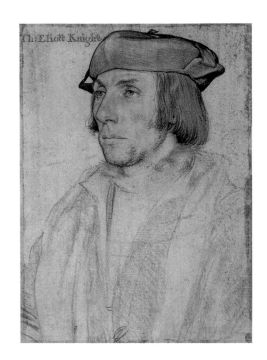

45 *Margaret a Barow, Lady Elyot* c.1532−4

Black and coloured chalks, bodycolour, ink with pen and
brush on pink prepared paper 28 × 20.9 cm
Inscribed: The Lady Eliot
The Royal Collection, The Royal Library, Windsor

46 *Sir Thomas Elyot* c.1532−4

Black and coloured chalks, bodycolour, ink with pen and
brush on pink prepared paper 28.6 × 20.6 cm
Inscribed: Th: Eliott Knight
The Royal Collection, The Royal Library, Windsor

Sir Thomas Elyot (*c.*1490–1546) pursued a career as a diplomat,
MP and humanist writer. In 1531 his *A Boke called the Governour*
was published, giving humanist advice on the education of
potential rulers of society. Margaret a Barow (*c.*1500−1560)
married Elyot in about 1522. Both evidently belonged to the
humanist circle around Sir Thomas More.

These studies for painted portraits which do not survive place
husband and wife facing each other, but on different sides than
is usual: normally the wife would face to the left in such a pair.
This may be because Holbein had begun the portrait of one
or the other and it was only then decided to make a pair.
The drawings are exceptionally well-preserved, especially in
the white heightening used on the faces, seen on the tip of
Sir Thomas's nose and on Lady Elyot's forehead. Ink is used
extensively, for example in the shading of the iris of Sir Thomas's
right eye and to add definition to the carefully shaded red chalk
shaping Lady Elyot's lips.

Provenance: See no.15
Literature: Parker 1983 (13,14); Houston 1987 (13,14), pp.60–2;
Edinburgh 1993 (10,11), pp.45–6; Hague 2003 (10,11), pp.76–7

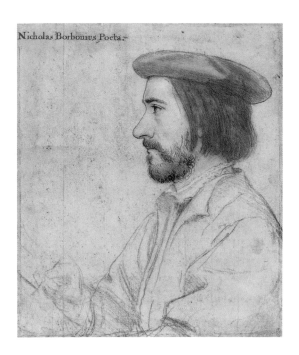

Nicholas Borbonius Poeta

47 *Nicolas Bourbon* 1535

Black and coloured chalks, pen and ink on pink prepared paper
38.4 × 28.3 cm
Inscribed: Nicholas Borbonius Poeta
The Royal Collection, The Royal Library, Windsor

The French poet and courtier Nicolas Bourbon
(*c.*1503–1549/50) was imprisoned at Paris following the
publication of his Latin poems *Nugae* 1533, in which he attacked
those unfavourable to humanism and religious reform. On his
release by Francis I he came to the English court in early 1535
where Anne Boleyn appears to have assisted him in finding
work as a tutor to young noble boys. In the preface to his,
Paidagogeion, 1536 (no. 48), he explains that he lodged with
the royal goldsmith Cornelis Hayes and mentions among
others the astronomer Nikolaus Kratzer (see nos. 23, 33, 80)
and Holbein.

Bourbon holds a pen, as he does in reverse in the woodcut
dated 1535 (no. 48) which first appeared in *Paidagogeion* in 1536.
However, the drawing has been amended by Holbein to include
the hand, and the frontal gaze is at odds with the act of writing.
This and Bourbon's praise for Holbein in a later edition of
Nugae, 'Hansus, me pingens major Apelle fuit' (Hans in painting
me was greater than Apelles), might suggest there was also a lost
painted portrait.

Provenance: See no. 15
Literature: Parker 1983 (37); Phillips 1984; Edinburgh 1987 (47), p. 132

48 *Nicolas Bourbon* dated 1535

[NOT ILLUSTRATED]

Woodcut 7.3 × 5.9 cm
Published in Nicolas Bourbon, *Paidagogeion*, Lyon 1536
The British Library, London

The first piece of evidence for Holbein's status as a royal painter
is provided by Nicolas Bourbon in *Paidagogeion*, his poems about
his English experiences, published in 1536. The title page of
the book is illustrated with a woodcut portrait of Bourbon by
Holbein, based on his earlier portrait drawing (no. 47), and dated
1535. The French poet is shown in profile to the right with pen in
hand, writing on paper, the figure contained in a small roundel set
in a rectangular plaque with a coat of arms at its base supported
by putti. In a prefatory letter to Henry VIII's French secretary,
Thomas Soulament, Bourbon addresses the friends he made at the
English court, including Holbein, the King's Painter: 'D. Hansi
pictori Regio, huius aevi Apelli' (Hans, the King's painter, the
Apelles of his age). This suggests that Holbein's appointment
dates from at least 1535, when Bourbon was in England.

In a poem in *Paidagogeion*, Bourbon also praises a painting by
Holbein, which he states is on ivory and shows a sleeping boy,
like a reposing cupid.

Literature: Dodgson 1938–9, pp. 5–6; Hollstein 14A (97), p. 200;
Phillips 1984
Reference: Foister 2004, p. 110

TB

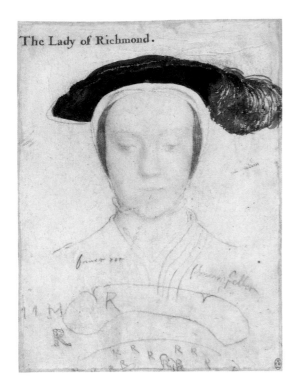

The Lady of Richmond.

49 *Mary, Duchess of Richmond and Somerset* c.1533

Black and coloured chalks, ink with brush on pink prepared paper
26.7 × 20.1 cm
Inscribed: The Lady of Richmond and samet rot [red velvet] and
Schwarz felbet [black velvet]
The Royal Collection, The Royal Library, Windsor

The drawing of Surrey is incorrectly inscribed, as it cannot show
either the Earl of Surrey's father the Duke of Norfolk (no.164)
or his son, born 1537/8, both named Thomas, but must represent
Henry Howard (1516/17–46). His sister Mary (1519–1555?)
married in 1533 Henry Fitzroy, Duke of Richmond, the
illegitimate son of Henry VIII by Elizabeth Blount. Brother
and sister shared an interest in poetry. Surrey, like Sir Thomas
Wyatt (nos.51,52), experimented with assimilating Italian
and classical verse forms into English; he wrote directly of the
vicissitudes of court life and developed heroic blank verse. He
was extravagant in his quest for personal magnificence, and is
the subject of several portraits including three by Holbein, this
and another drawing, possibly taken at the same time, as well
as a painting of 1541/2 now in Sao Paolo (Museu de Arte).

The Duchess of Richmond is shown with eyes downcast,
and with a plumed hat drawn with the brush with swift bravura.
Below are two outlines of the hat with jewelled initials for R and
MH. Her dress is to be expensively-dyed red and black velvet,
edged with gold as the yellow chalk indicates.

Her brother gazes straight ahead, though the right eye, on the
shadowed side of the face, is subtly differentiated from the left.
The chalk of the drawing is well preserved, particularly around
the mouth, which is also reinforced with a number of separate
ink lines, adding to a sense of mobility. The drawing of the
Earl of Surrey has a pair, a similarly posed drawing of Frances
de Vere, Countess of Surrey; they married in 1532.

It is likely that all three drawings were intended to celebrate the
recent family dynastic alliances; the resulting paintings may have
been included in the series of individual painted portraits which
their father the Duke of Norfolk owned: twenty-eight portraits
of 'dyverse noble persons' are listed in his possession in 1547.
A portrait of the Duchess of Richmond 'with Darbie sitting
upon her knees' is recorded in the inventory of Henry VIII;
'Darbie' is perhaps a pet dog or other pet animal.

Provenance: See no.15
Literature: Parker 1983 (17,16); Houston 1987 (20, 21), pp.74–7;
Campbell 1990, p.14; Edinburgh 1993 (12), p.48
Reference: Foister 2004, p.89; Starkey 1998 (15406)

50 *Henry Howard, Earl of Surrey* *c.*1533

Black and coloured chalks, pen and ink, watercolour
on pink prepared paper 25.1 × 20.5 cm
Inscribed: Thomas Earl of Surry
The Royal Collection, The Royal Library, Windsor

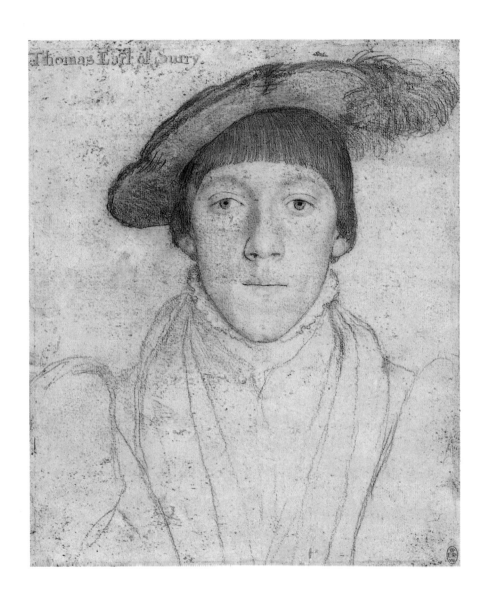

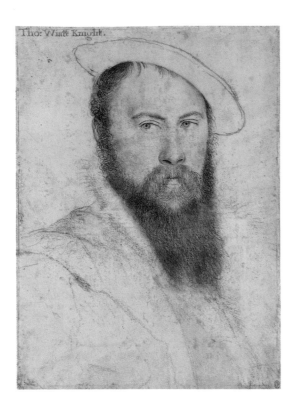

51 *Sir Thomas Wyatt* c.1535–7

Black and coloured chalks, pen and ink on pink prepared paper
37.3 × 27.2 cm
Inscribed: Tho: Wiatt Knight
The Royal Collection, The Royal Library, Windsor

Sir Thomas Wyatt (1503?–1542), the son of Sir Henry Wyatt
(no. 142), became clerk of the King's Jewels in 1524, undertook
diplomatic missions and was knighted in 1535. He was
imprisoned at the time of the fall and execution of Anne Boleyn
in 1536 but regained his position at court, acting as ambassador
to the Emperor Charles V in 1537–9; in 1541 he was imprisoned
again. Wyatt was also a poet of great variety and invention:
an inspiration to the Earl of Surrey (no. 50), he introduced the
Italian sonnet form to English, satirised court life in verse based
on classical models and composed simple and direct lyric poems.
Wyatt evidently commissioned Holbein to make designs for
goldsmiths' work (no. 90) as well as being the subject of another,
profile portrait (see no. 52). The direction of Wyatt's glance and
the angling of head against body resembles the format of some
painted portraits of 1532 and 1533 but Wyatt's short hair and long
beard suggests the drawing dates from a slightly later period.
The pen reinforcements imply preparation for a lost portrait.

Provenance: See no. 15
Literature: Parker (64); Houston 1987 (45), p. 128; Edinburgh (25), p. 74

52 *Sir Thomas Wyatt* 1542

[NOT ILLUSTRATED]

Woodcut Diameter 6.2 cm
Published in John Leland, *Naeniae in mortem Thomae Viati*, London 1542
The British Library, London

Following the death in 1542 of the celebrated poet Sir Thomas
Wyatt, there were several literary outpourings of grief and
commemoration. Amongst them was this collection of poems,
Naeniae in mortem Thomae Viati, by the Tudor historian and
Royal Antiquary, John Leland (c.1503–1552), dedicated to the
Earl of Surrey (no. 50), described by Leland as Wyatt's literary
heir. The title-page of this book includes a roundel with a
woodcut bust of Thomas Wyatt by Holbein. Wyatt is shown
in three-quarters profile to the right and bareheaded, suggesting
that he was drawn again by Holbein subsequent to his study
of the mid-1530s (no. 51), which shows Wyatt face-on and with
a noticeable fringe. The woodcut is accompanied with verses
from Leland celebrating Holbein's drawing of the poet.

The book was printed by Reynold or Reyner Wolf, a
Netherlandish printer and bookseller settled in London,
with whom Holbein collaborated on a number of other
books and designs (see no. 147).

Literature: Dodgson 1938–9; Hollstein 14B (105)
Reference: ODNB, 'John Leland', J. Carley; ODNB, 'Reyner Wolf',
A. Pettegree

TB

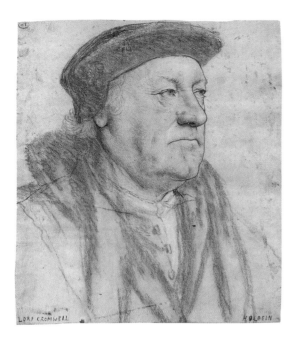

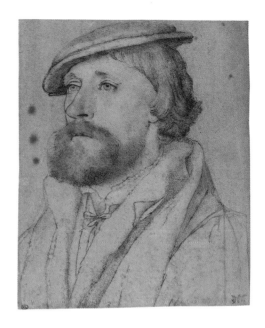

53 *George Neville, 3rd Baron Bergavenny* c.1532–5

> Black and coloured chalks, black pen and ink, yellow wash,
> white bodycolour on pink prepared paper 27.3 × 24.1 cm
> Inscribed by a later hand in pen and brown ink lower left:
> Lord Cromwell; lower right: Holbein
> The Earl of Pembroke, Wilton House, Wilton, Salisbury

Lord Bergavenny (c.1469–1535) is identified from the inscription
on the miniature following this drawing in the collection of the
Duke of Buccleuch. A keen jouster and close friend of Henry
VIII, Lord Bergavenny succeeded to the barony in 1492.
He was elected to the Order of the Garter in 1513 and made a
Privy Councillor in 1515 but in 1521 was implicated in the treason
of his father-in-law the Duke of Buckingham. By the early 1530s,
when this drawing was made, he had regained the confidence of
king and court. Bergavenny was in his sixties when Holbein drew
him, and he is shown slightly from below, a viewpoint Holbein
sometimes adopted when portraying older men, perhaps to
emphasise their authority. Here the ink reinforcements define
the loosened flesh of the face and stress the bulk of Bergavenny's
nose. The initial chalk drawing, in its freedom and vigour
resembling those of Holbein's first visit to England, has defined
Bergavenny's neck and shoulders unencumbered by the two fur
collars, the positioning of which remained unresolved.

> Provenance: Presumably as no.15 until 3rd or 4th Earl of Pembroke
> 1627–8, when removed
> Literature: London 1987 (199), p.233
> Reference: ODNB, 'George Neville, Third Baron Bergavenny',
> A. Hawkyard

54 *Thomas Wriothesley, Earl of Southampton* c.1536–40

> Black and coloured chalks on pink-primed paper; silhouetted
> 24.2 × 19.2 cm
> Musée du Louvre, Paris, Département des Arts Graphiques

Thomas Wriothesley (1505–1550) was, like John Godsalve
(see nos.22,44), Clerk to the Signet by 1530 and close to
Thomas Cromwell. He became prominent at court and in
1540 was knighted and made joint Secretary to the King. From
1544–7 he was Lord Chancellor and was created Earl in 1547.
Like two others from the small group of those removed from
The Royal Collection (nos.56,162), the drawing has been cut
from its background; all three belonged to the artist Jonathan
Richardson the Elder (1667–1745). A miniature portrait in
the Metropolitan Museum of Art in New York is a truncated
version of an image based on the drawing but is not the work
of Holbein himself. This drawing may rather have been
intended for a full-size portrait.

> Provenance: J. Richardson the Elder; Fairfax Murray;
> bought at François Flameng sale, 26 May 1919 (lot 61).
> Literature: Louvre 1991 (147)
> Reference: Rowlands 1985 (RM1)

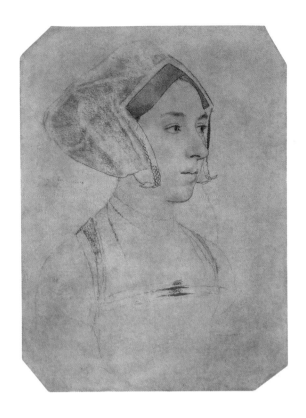

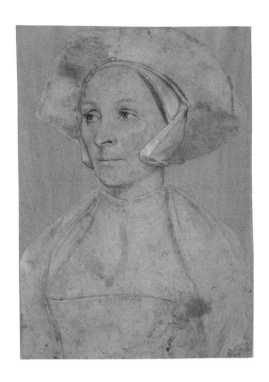

55 *Portrait of a Lady, thought to be Anne Boleyn* c.1532–5

Black and red chalk, black ink and brush, yellow wash
on pink prepared paper 32.1 × 23.5 cm
Inscribed in a seventeenth-century hand:
Anna Bullen de collato / Fuit Londoni 19 May 1536
The British Museum, London

The identification as Anne Boleyn arose when the drawing was
in the Arundel collection and was etched by Hollar in 1649. It
appears to have been based on a superficial similarity to portraits
which have a reasonable claim to represent Anne. However, the
sitter in this drawing faces in the opposite direction and specific
details of her features such as her large lips are not evident in the
paintings. Whether Holbein portrayed Anne remains an open
question: a drawing at Windsor (Parker 63) inscribed with her
name shows a fair-haired woman whose appearance differs
greatly from the painted portraits.

No painted portrait survives connected with this drawing.
The woman's dress is similar to that of representations of those
of the More family but also those of higher status: the jewels
on her hood and on her bodice indicate she might have been
a member of a noble family. Her arched eyebrows and large eyes
with densely clumped eyelashes are particularly beautifully
executed with ink and brush.

Provenance: Earl of Arundel; J. Richardson Senior, 3rd Earl of Bradford;
by descent; purchased with aid of NACF 1975
Literature: London 1988 (203), p.236; Rowlands 1993 (324), pp.148–9

56 *Portrait of an Englishwoman* c.1532–5

Black and red chalk, white bodycolour, black ink with brush
on pink prepared paper; silhouetted 27.6 × 19.1 cm
The British Museum, London

The sitter is not Margaret Roper as has sometimes been
suggested: the features Holbein delineates in both the family
group and the miniature (nos. 23, 38) differ, particularly in the
larger, deeper set eyes of this sitter. She wears a large bonnet over
a closer fitting cap, probably attached with the pin visible, and
a shawl around her shoulders; her upper body is covered with
fabric fastened at the neck, similar to that worn by Anne Lovell (?)
(no. 21). An unidentified woman in a drawing in The Royal
Collection (Parker 9) has a closely similar hat and costume, and
there are also resemblances with the dress of Mrs Small (no. 41);
the wife of a man wearing Henry VIII's livery (no. 40) wears
a comparable hat. This subject might therefore have been from
a merchant family or from the rank of court servants and
craftspeople.

The direction of her gaze and the way in which her head is turned
further than her body suggests that her portrait might have been
paired with that of a husband (compare no. 40), but there is no
surviving male drawing which seems to match this one.

Provenance: J. Richardson Senior 1746; G. Knapton; 1st Duke
of Sutherland; Lord Ronald Sutherland Gower; G. Salting 1905;
Salting bequest 1910
Literature: London 1988 (202), p.234; Rowlands 1993 (323)

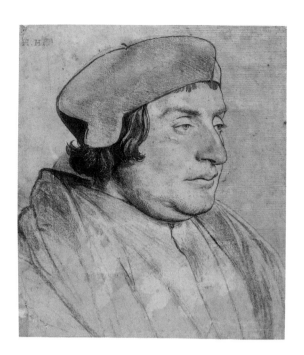 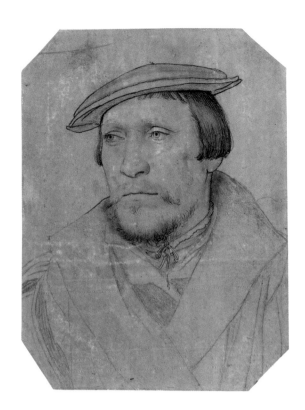

57 *Portrait of a Man* c.1532–5

> Black and red chalk with pen and brush and black ink
> on pink prepared paper 21.9 × 18.4 cm
> Inscribed: HH; a pricked initial H
> The J. Paul Getty Museum, Los Angeles

The sitter in this drawing has not been identified. His shaped
cap of blocked or stitched felt of the type worn by clerics such
as Archbishop Warham and Bishop Fisher (nos.15,132) and his
hooded robe indicate that he too is likely to be a cleric. The style
of the drawing suggests a date in the mid-1530s. Considering
possible candidates and comparing surviving portraits it is
tempting to speculate that the sitter might be Stephen Gardiner
(c.1495/8–1555), Bishop of Winchester, author of *De Vera
Obedientia*, 1535, and a reluctant defender of the royal supremacy.
He resided often at his episcopal palace at Southwark, just
south of the Thames, although from 1535–8 he was absent
on a diplomatic mission to France.

> Provenance: Earls of Devonshire, Chatsworth; acquired 1984
> Literature: London 1993
> Reference: ODNB, 'Stephen Gardiner', C.D.C. Armstrong

58 *An Unidentified Man* c.1534–6

> Black and coloured chalk and ink on pink primed paper 32.1 × 23.9 cm
> Staatliche Museen zu Berlin (Kupferstichkabinett)

It has been suggested that this man is a Hanseatic merchant,
although his cap and clothing are similar to those worn by Sir
Thomas Wriothesley (no.54), and if so this would be a notable
exception to the disappearance of all preparatory studies for
Hanseatic merchants. The trimmed corners of the drawing
are seen in other examples by Holbein which once formed
part of The Royal Collection but which were dispersed in
the seventeenth and eighteenth centuries (for example no.55);
the other two belonged to Jonathan Richardson the Elder,
but the trimming may have taken place earlier.

The chalk drawing shows a variety of reinforcement in ink
with the brush, from the thickly shaded hair to the emphasising
of eyes, nose and mouth, the latter characteristically defined
with a careful series of small lines. The presence of harder lines
in the coat suggests preparation for transfer to the panel.

> Provenance: Le Roy-Ladurie, Paris; Suermondt, The Hague;
> acquired 1874
> Literature: Ganz 1937 (90); Foister 1983, pp.3–5

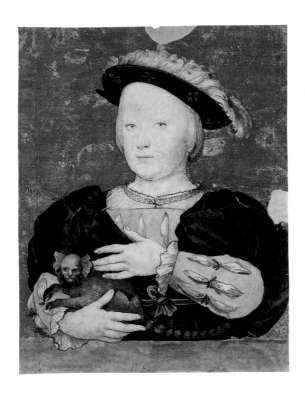

59 *A Boy with a Marmoset* c.1532–6

> Chalk, black ink and wash with pen or brush, red chalk on paper
> 40 × 30.7 cm
> Kunstmuseum Basel, Kupferstichkabinett

The boy is wearing courtly dress and is stroking a pet marmoset. He is not Edward Prince of Wales (nos.108–110), as has sometimes been suggested, but his dress bears some resemblance to a drawing said to represent Henry VIII as a child (now in Bibliothèque de Mejanès, Aix-en-Provence). It is conceivable that he did not belong to the English court, and that he was a visitor to it or was even portrayed during Holbein's travels.

The drawing is not made on pink prepared paper and the wash technique of the sleeves and the feather recalls the manner of Holbein's studies for the Basel town hall paintings of the late 1520s. However, in its extensive use of colour including the blue background it most closely resembles the drawing of Sir John Godsalve (no.44). It too was probably a study for a painting as the characteristic use of ink reinforcing on eyes, nose and mouth suggests. Like the drawing of Godsalve, the sitter's right hand overlaps what appears to be a parapet, again typical of portraits of the early 1530s.

> Provenance: Faesch Museum?
> Literature: Müller 1996 (182), pp.121–2
> Reference: London 1991 (II.18), p.37

60a *A Courtly Couple* c.1532–6

> Pen and ink over chalk on paper 3.4 × 4.5 cm
> Kunstmuseum Basel, Kupferstichkabinett

60b *A Nobleman holding an Astronomical Globe* 1530s

> Pen and black ink on paper 3 × 2.9 cm
> Kunstmuseum Basel, Kupferstichkabinett

These drawings were perhaps to be included in small ornaments such as engravings on metal or stone, possibly even the reverses of or embellishments to other images or jewels, as suggested by some entries in the inventories of Henry VIII. The nobleman gazes on his armillary sphere, perhaps fruitlessly, like the astronomer Holbein mocked in his marginal illustration to Erasmus's *Praise of Folly* of 1515 (Kunstmuseum Basel, Kupferstichkabinett). In the other sketch a man offers a cup with a heart to a woman in the gable headdress seen in many large drawings by Holbein; the headdress had become unfashionable by 1540. The heart is used in French courtly manuscripts of the period to symbolise friendship, but the need for such imagery may also be a reflection of the actions of lovers at the Tudor court who gave each other gifts: Henry VIII gave Anne Boleyn his portrait in a bracelet and his inventory lists a 'Harte of golde enameled with the kinges picture in it'.

> Provenance: Amerbach-Kabinett 'English sketchbook'
> Literature: Müller 1996 (226, 223); Foister 2004, p.95; Starkey 1998 (2925)
> Reference: Bomford 2004

61 *E Cosi Desio me Mena* c.1533–6

Oil on oak 45 × 45 cm
The J. Paul Getty Museum, Los Angeles

The Italian inscription, 'And so desire carries me along', is taken from Petrarch's 125th canzone, written about 1342: the unbridled horse was a symbol of passion. The rider is dressed in classical dress and boots, suggesting the picture was made for a patron interested in Renaissance poetry and imagery, as were some of those whom Holbein portrayed, for example the poets Wyatt and Surrey (nos. 51, 50). The lozenge format was more frequently used to depict a coat of arms, but here the imagery seems personal, the type of image more often seen on small hat badges (nos. 35, 79, 83) or other personal emblems. Lorne Campbell (unpublished comment) has pointed out the resemblance of the subject to a painting owned by Margaret of Austria in 1524: 'Une fantaisie d'ung home courant en poste sur ung cheval blanc, ayant deux bras nuz, devant son cheval et une devise en ung rondeau et une marguerite en chef'. Possibly an English courtier had seen such an image and had adopted it as his own device. Here the quotation from Petrarch has replaced Margaret of Austria's device of a daisy or 'marguerite'.

The gold arabesque design resembles that used by Holbein for the Wyatt book cover (no. 90), while the blue background is painted with smalt combined with small amounts of the precious pigment ultramarine (compare no. 111). The back of the panel has a maker's (or collector's) mark in the form of a figure of

eight. The same mark appears on the back of Holbein's portrait of the Earl of Surrey in Sao Paolo (Museu de Arte) and on the back of a small Holbeinesque roundel portrait of Thomas Cromwell recorded in a French private collection (my thanks to Jochen Sander and Yvonne Szafran for this information). The underdrawing revealed by infrared reflectography shows how Holbein altered the position of horse and rider and changed the latter's pose from the profile used for figures in many of the designs for goldsmiths' work.

Provenance: Henry Prince of Wales (d. 1612) (monogram brand on reverse); presumably Earl of Arundel; Arundel House 1653
Literature: Frederickson 1982; Szafran 1999; Foister 2004, pp. 106–8
Reference: Laborde 1850, p. 28 (183); Ganz 1922

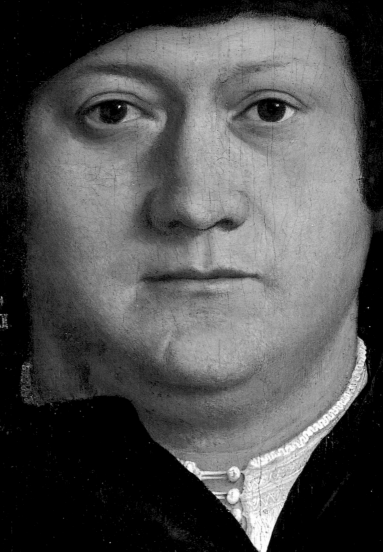

DO LTIG SIS ALT
INO · J

3
Hanseatic Commissions and Designs for Goldsmiths

Since portraiture made up only a small part of Holbein's work before his arrival in England, he must have expected to continue to make large-scale compositions and create designs for those in other industries including goldsmiths, as his father had done in Augsburg. Accordingly, the London Hanseatic merchants – men from German cities who resided in London to supervise their trade in goods from cloth to wine – commissioned Holbein to design their city pageant for the coronation of Anne Boleyn in 1533 and to provide moralising paintings for their hall in their headquarters at the Steelyard. Holbein also painted their portraits. These are in many ways significantly different from those Holbein made for his English sitters: they emphasis memory and piety, suitably for men living abroad, and include numerous inscriptions, rarer in surviving English portraits.

The Hanseatic merchants formed part of Holbein's network of fellow foreigners, and may have played a role in forging important working relationships with others. The skills of German and Netherlandish metalworkers were prized in London: Henry VIII employed them as armourers and clockmakers. Holbein probably provided the Greenwich-based armourers with decorative designs (see no. 91); the Hanseatic merchant Derich Born supplied military equipment to Henry VIII's armourer Erasmus Kyrkener (see no. 158).

When Holbein worked on the royal festivities at Greenwich in 1527 there were German and Netherlandish goldsmiths gilding cloth including Cornelis Hayes, probably the goldsmith of the same name. In 1533/4 Hayes made a cradle for the infant Elizabeth I and figures of Adam and Eve incorporating silver, gold and coral, which were painted by 'Master Hans', evidently Holbein. The goldsmith Hans of Antwerp, who is mentioned in Holbein's will of 1543 and with whom Holbein collaborated on an elaborate cup (no. 91), enjoyed a long career in London and was working for the court in the late 1530s. He is later, in 1547, named in association with the Netherlandish goldsmith Peter Richardson, appointed in 1536 to make jewels for Jane Seymour, who ran a large

workshop. The works these skilled men made are lost, though a rock crystal and gold bowl in the Residenz, Munich, once owned by Henry VIII and a dish from the Steelyard (Landesmuseum, Bremen), have some claim to be considered as after designs by Holbein. Henry's inventories list his ownership of metalwork in 'the Almayne making' and 'Almayn' (German) style.

As these inventories demonstrate, during Holbein's residences in England taste moved sharply towards Renaissance-style designs, which favoured Holbein's extensive and highly inventive repertoire of both forms and motifs for metalwork, much of which must have required great skill in the goldsmiths to execute. His decorative and figurative vocabulary was derived partly from print sources, such as those by the Italians Zoan Andrea and Antonio Veneziano, but these are imbued with an extraordinary sense of fluid movement, seen in Holbein's paintings as well as in his designs for metalwork and jewellery.

Most of the designs were preserved in two collections, one of which returned to Basel, conceivably for the use of Holbein's sons, both of whom became goldsmiths. The surviving drawings show many different stages of design and production. Some drawings may have been presented for the approval of the king or other patrons, while others were perhaps ready for execution by the goldsmith. A few drawings of jewellery suggest Holbein was following popular patterns (no. 87), while others raise intriguing questions concerning the relationship between these and jewellery in the portraits (no. 86).

62 *Hermann von Wedigh* dated 1532

Oil on wood 42.2 × 32.4 cm
Inscribed: ANNO.1532. AETATIS.SVAE.29.; HH; HER WID.;
Veritas odiu[m] parit:
The Metropolitan Museum of Art, New York,
Bequest of Edward S. Harkness, 1940

The sitter's ring displays the arms of the Wedighs of Cologne, and the inscription suggests he is Hermann von Wedigh III (d. 1560), a London Hanseatic merchant. An altarpiece he commissioned also includes his portrait. On the book are the initials HH, probably a rare instance of Holbein's signature (if not another allusion to the sitter's name). One of the gilded clasps is open to allow the insertion of a sheet of paper: its Latin inscription, 'Truth breeds hatred' (Terence) may be an allusion to the truth of Protestantism, and the book may be a Bible (the Hanseatic merchants had imported Lutheran books into England).

In this exceptionally well-preserved portrait Holbein introduces the spatial ambiguity of gilded lettering against a blue background suggestive of the sky, while in the foreground the carefully angled book projects over the green-covered table, towards the viewer. Von Wedigh engages our attention with the central placing of his enlarged right eye, and arched eyebrow. His face, with its large nose and high colour, is also large relative to his body, increasing the impact of his presence. The veins and protuding bones of the back of von Wedigh's right hand are carefully described, as are the varied effects of light on the black silk damask weave of his sleeve.

Provenance: The Counts Schönborn, Vienna by 1746; Mr and Mrs Frank D. Stout, Chicago, 1923; Edward S. Harkness, New York, 1936; bequest of Edward S. Harkness, 1940; acquired 1950
Literature: Rowlands 1985 (37); Holman 1979; Hague 2003 (12), pp. 80–2
Reference: Martens 2005

ANNO.1532. ÆTATIS.SVÆ.29

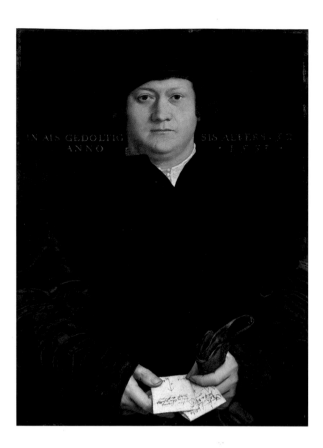

63 *Cyriacus Kale* dated 1533

Panel 60 × 44 cm
Inscribed: IN ALS GEDOLTIG / SIS ALTERS.32 / ANNO.1533.
Dem Ersame[n] syriacus / Kalen yn Lu[n]den up stulhof /
sy desse breff Deme Ersamenn F[u]rssichtig Kallenn te
lunde[n] [up] Staelhuef sy desse …'
Herzog Anton Ulrich-Museum, Kunstmuseum des Landes Niedersachsen,
Braunschweig

Cyriacus Kale is not documented as a Hanseatic merchant in
London, but the letters he holds are addressed to him there. The
uppermost letter also includes his merchant's mark of an arrow with
crosses. He may have been the son, or perhaps another relative, of
Gerloff Kale (1446–1532), mayor of Braunschweig in 1521. Against
the plain background is inscribed his age and the motto 'Patient
in all things'. As with other Hanseatic portraits, Kale is shown full-
face, his arms lengthened to frame his corpulent body which the
panel can scarcely contain, his face lit from the right, emphasising
his bulging right eye and the scar on his chin. The black fur and
damson-coloured silk damask of his sleeves are sumptuously
depicted. The bold simplicity of the presentation, which anticipates
the later English portraits of similarly bulky male sitters, belies the
sophistication of its design, in which even the beautifully painted
gloves are carefully placed, the curves of their folded ends and strap
a counterpoise to the curving patterns of the adjacent sleeve.

Provenance: Acquired before 1737, probably purchased by
Duke Anthon Ulrich (1633–1714)
Literature: Rowlands 1985 (42); Löcher 1985 (vol.2) (735), p. 837;
Hague 2003 (18)

64 *A Member of the von Wedigh Family (called Hermann Hillebrandt von Wedigh)* dated 1533

Oak 39 × 30 cm
Inscribed: ANNO 1533. ATATIS SVAE. 39
Staatliche Museen zu Berlin (Gemäldegalerie)

Like Hermann von Wedigh (no. 62) the sitter wears a ring
bearing the von Wedigh family coat of arms, and both portraits
were in the same Viennese collection in the eighteenth century,
suggesting they originally belonged to the same family. However,
the identity of this sitter has not been firmly established: the
Hillebrandts were related to the von Wedighs, but no individual
with London Hanseatic connections has been identified.

In the early 1530s Holbein experimented with completely frontal
portrait compositions, particularly in his portraits of Hanseatic
merchants, who perhaps wished to be shown full-face because
their portraits were designed to be sent home as a complete record
of their appearance *in absentia*; the pose may also be associated
with their piety and desire to follow Christ, particularly evident
in the portrait of Dirk Tybis (Vienna, Kunsthistorisches
Museum). Here, Holbein evidently took the manner in which
the right hand rests within a cloak from Roman portrait busts;
he used it again in his portrait of the Earl of Surrey of 1541/2
(Sao Paolo). As in the portrait of Hermann von Wedigh (no. 62),
Holbein has emphasised the size of the head and features, and
exaggerated the right eye. Lorne Campbell has elucidated the
tension between eyes and mouth in the portrait: 'If concentration
is fixed on Wedigh's right eye or the left side of his mouth his
aspect is quite friendly; but his left eye and the right side of
his mouth are more forbidding'.

Provenance: Counts Schönborn, Vienna by 1746;
B. Suermondt Aachen 1865; transferred to Berlin
Literature: Rowlands 1985 (41); Campbell 1990, pp. 30–4;
Hague 2003 (12), p. 80; Foister 2004, p. 207

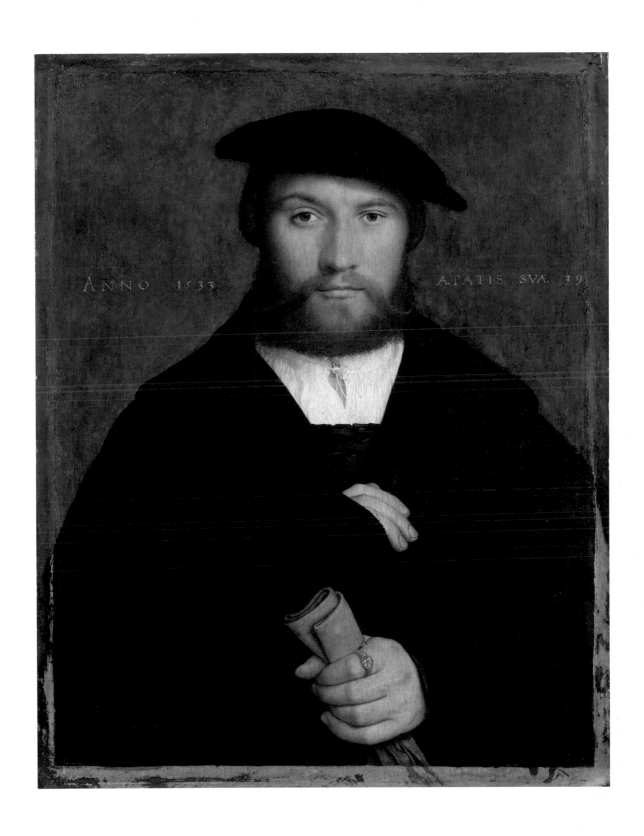

ANNO 1533 ÆTATIS SVÆ 39

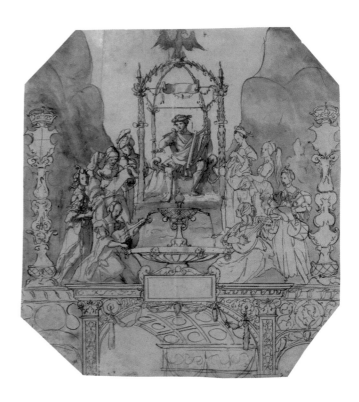

65 *Parnassus* 1533

Pen and black ink, grey brown wash and blue green watercolour
on paper 42.3 × 38.4 cm
Staatliche Museen zu Berlin (Kupferstichkabinett)

On 31 May 1533 Anne Boleyn was welcomed into the City
of London for her coronation procession with nine pageants
along her route: costumed figures against staged backdrops
recited poetry with classical themes composed by court poet
John Leland and playwright Nicholas Udall. One of these, the
pageant organised by the Hanseatic merchants on the theme of
Apollo and the muses, is reflected in this drawing in which the
elegantly grouped muses wear a mixture of classical and Tudor
dress. As the musicians played, wine flowed from the fountain
on mount Parnassus which was situated over an arch spanning
Gracechurch Street. The drawing is very freely executed, but
includes at its heart a motif seen in Holbein's decorative designs,
the basketwork design of the fountain, taken from a favourite
engraving by Zoan Andrea, which is drawn in outline without
the sense of depth and movement imbued to the rest. Holbein's
relationship with the Hanseatic merchants at this period – as
well as with the court poets – suggests he provided this design
for this pageant – and perhaps for more.

Provenance: Crozat and Weigel; acquired 1885
Literature: Berlin 1997–8 (25.25)
Reference: Anglo 1969, pp. 247–61

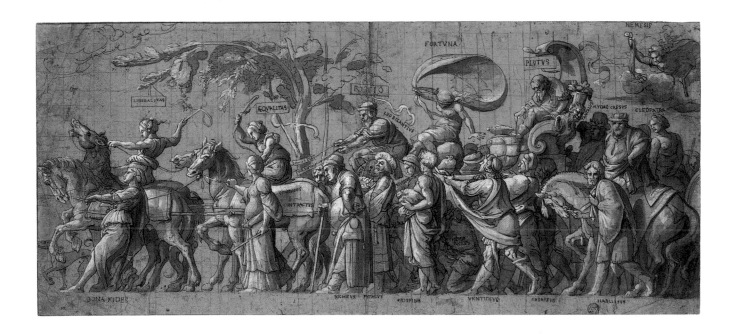

66 *The Triumph of Riches* c.1533–5

Pen and brown ink and wash with white heightening over black chalk; squared in black chalk 25.1 × 56.9 cm
Inscribed: BONA FIDES / LIBERALITAS / AEQVALITAS / NOTITIA / VOLVNTAS / SIMONIDES / CONTRACTVS / SICHEVS / PITHIVS / CRISFINS / BASSA / RATIO / VIVIDIVS / LEO BIZANTIVS / FORTVNA / THEMISTOCLES / VENTIDIVS / GADAREVS / NARCISSVS / PLVTVS / TANTALVS / MYDAS / CRESVS / CLEOPATRA / NEMESIS
Musée du Louvre, Paris, Département des Arts Graphiques

Holbein's canvas paintings of *The Triumph of Riches* and *The Triumph of Poverty* were made for the dining hall on the upper floor of the Hanseatic merchants' residence in the London Steel-yard. Subsequently sold, they were destroyed by fire in 1752. Copies were made (see nos. 68, 69) but this is Holbein's only surviving drawing for the pair. Stephanie Buck has suggested that a drawing of a disorderly and disorientated ship in Frankfurt might represent another lost commission for the merchants. The inscriptions on the copies make clear the moral: money is the source of sorrow, whether too much or too little. Holbein seems to have taken some inspiration from Dürer's woodcut of *The Triumph of Maximilian* (where there is also a charioteer Ratio). The scene was clearly intended to be viewed from below. Copies (see no. 68) suggest Holbein went on to make several changes, orientating some central figures towards the viewer, and revolving Fortune upwards.

Provenance: Everhard Jabach; Louis XIV, 1671
Literature: Rowlands 1985 (L13c), p. 224; Louvre 1991 (147); Frankfurt 2004 (93), pp. 240–2

After Hans Holbein the Younger

67 *The Triumph of Riches* published by Johannes Borgiani Florentino, Antwerp 1561

[NOT ILLUSTRATED]

Etching 16.3 × 33.8 cm
Kunstmuseum Basel, Kupferstichkabinett

This etching closely resembles Holbein's preparatory drawing (no. 66), showing the design before the changes to the figures recorded by Vorsterman (no. 68), but differs in some respects, adding figures on the far right, repositioning some inscriptions and adding others. Most of the latter recur in copies of the finished version, although 'Lucullus' appears nowhere else, and a few of the inscriptions are only otherwise found on the copy of *Riches* by Jan de Bisschop in the British Museum. Other copyists placed the verses on the subject top left, and this position may have been chosen by the printmaker, who could also have had access to information from the finished paintings. However the differences in the inscriptions suggest that this etching could have been based on a second, lost preparatory drawing by Holbein. Borgiani is recorded in the Antwerp guild of St Lucas in 1560 as 'Johan Florentino, boeckvercooper' (my thanks to Ger Luijten and Christian Müller for this information).

Provenance: Johann Georg Zobel von Gibelstadt, Bishop of Würzburg (1543–77); by descent; purchased 1999
Literature: Koegler 1931–2; Rowlands 1985 (under L13c ii); Foister 2004, p. 130

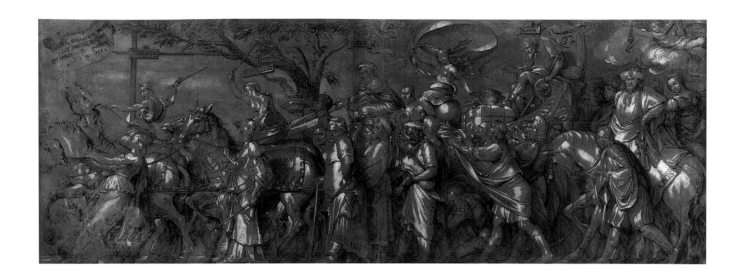

Attributed to Lucas Vorsterman the Elder
(1595–1675) after Hans Holbein

68　*The Triumph of Riches*　1624–30

Pen and black ink with black and red chalk and blue bodycolour with
touches of green, heightened with white bodycolour on paper
44.4 × 119.3 cm
Ashmolean Museum, Oxford
Provenance: Earl of Arundel?; Sir Peter Lely; 1st Duke of Buckingham;
Horace Walpole; Sir Charles Eastlake; Harry Quilter; Francis S.
MacNalty; Hans Calman; purchased 1970
Literature: Brown 1982, p.130; Rowlands 1985 (L13a ii) p.224

These are the only copies after Holbein's lost paintings for the
hall of the Hanseatic merchants at the Steelyard in London
which appear to record the colouring of the originals. They
reveal that the original paintings were partly in grisaille, the
figures heightened with gold and set against a blue background
with touches of green, a colour scheme closely resembling
Holbein's miniature of *Solomon and the Queen of Sheba* (no.146).
The differences in proportions and compositions suggest they
were designed for one long and one shorter wall.

Lucas Vorsterman the Elder, in England from 1624 to 1630,
was one of the artists who engraved works owned by the Earl
of Arundel, then the owner of Holbein's *Triumphs*. Vorsterman
mentioned in a letter of 1632 that he was to engrave this subject
in a print to be dedicated to the Earl of Arundel, apparently
never executed. A print of *Poverty* of 1652–76, evidently by
Vorsterman's son Lucas the Younger (1624–67), may be based
on his father's copies of the originals. Vorsterman the Elder may
have made these copies in England or when they were taken
to the Low Countries by the Earl of Arundel in the 1640s.

Provenance: ?Earl of Arundel; Sir Peter Lely; 1st Duke of Buckingham;
Horace Walpole; Sir Charles Eastlake; J.P. Richter
Literature: Rowlands 1985 (L13a i); Rowlands 1993 (381), p.178

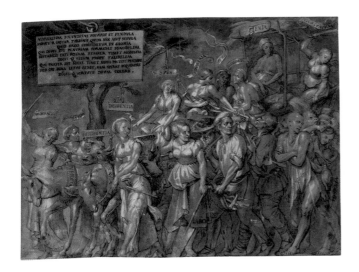

69 *The Triumph of Poverty* 1624–30

Pen and brown ink with brown wash and black and red chalk heightened
with cream bodycolour; green wash and blue bodycolour on paper
43.7 × 58.5 cm
The British Museum, London

Agostino dei Musi (Agostino Veneziano)
(c.1490–after 1536)
after Baccio Bandinelli (1493–1560)

70 *Cleopatra* 1515

[NOT ILLUSTRATED]

Engraving on paper 21.5 × 17.5 cm
The British Museum, London

The subject is the suicide of Cleopatra, who is shown naked, applying a serpent to her breast. This is an early work by Agostino Veneziano, an Italian engraver and draughtsman, whose monogram 'A.V.' appears on 141 prints, along with his full name in five instances. He began his career in Venice, hence the origin of his name. His earliest prints, dating from 1514, are copies after Giulio Campagnola's *The Astrologer* and Dürer's *Last Supper*. In 1516 he travelled to Rome, where over the next ten years he produced numerous prints after Raphael, Michelangelo and Rosso Fiorentino.

TB

Marcantonio Raimondi (c.1470–82 – c.1527–34)
after Raphael (1483–1520)

71 *Adam and Eve* c.1513–15

[NOT ILLUSTRATED]

Engraving on paper 23.9 × 17.6 cm
The British Museum, London

One of the most important printmakers of the Renaissance, Raimondi helped to establish engraving as a reproductive medium. He trained in Bologna and from about 1510 he was living and working in Rome, the most productive part of his career. It was here, by 1513, that he met Raphael and formed his most important and fruitful partnership. He made many engravings after Raphael's work as well as this one, including *Massacre of the Innocents* and *The Judgement of Paris* (c.1517–20). After Raphael's death in 1520 Raimondi continued to engrave designs by other artists, especially Giulio Romano. But the sack of Rome in 1527 ruined him, and none of his prints or activities can be securely dated after this event. Holbein may have owned a number of his engravings after Raphael (see nos.136,139).

TB

72 *The Stone Thrower* c.1532–4

Grey brush and pen and black ink, grey wash and white heightening on red prepared paper 20.3 × 12.2 cm
Kunstmuseum Basel, Kupferstichkabinett

The function of this exceptionally finished drawing is unclear. The presence of the column and the stones the woman holds have suggested the subject might be allegorical, perhaps an embodiment of Fortitude or Anger. The careful description of the weight of the body reflects Holbein's interest in movement, perspective and proportion, but the drawing appears to depend on the study and subtle adaptation of two Italian engravings, Agostino Veneziano's inspiring the upper part of the body in reverse, Marcantonio Raimondi's the lower (see nos.70,71). Holbein's innovative depiction of Mary Magdalen in his *Noli me tangere* (no.136) reflects such study. The use of pinkish-red prepared paper similar to that used for the portrait studies Holbein made in England from 1532 suggests that the drawing was made there, as does the sinuous, slightly flattened figure which resembles those in the relief-like processions of *The Triumph of Riches* (no.66) and *Solomon and the Queen of Sheba* (no.146).

Provenance: Amerbach-Kabinett
Literature: Grossmann 1950; Müller 1996 (188)

Wenceslaus Hollar (1607–1677)
after Hans Holbein the Younger

73 *Hans von Zürich* 1647

[NOT ILLUSTRATED]

Etching 18.5 × 13 cm
The British Museum, London

The Bohemian artist Wenceslaus Hollar was brought over to
England in 1636 by Thomas Howard, 14th Earl of Arundel.
One of his many commissions was to make etchings of the
paintings in the Earl's collection. Produced in 1647, this is
an etched copy of a painted portrait by Holbein, now lost.
According to the inscription Hans of Zurich was a goldsmith,
and probably another of Holbein's craftsmen or merchant
friends. Wüthrich (cited in Eissenhauer 1996) has suggested
he might be identical with the Zürich painter Hans Asper,
but Jakob Stampfer's profile likeness in a medal of 1540
shows a bearded man with a broad nose without an evident
resemblance to Holbein's portrait. Hollar shows the original
painting dating from 1532, the year of Holbein's return to
London and the same time he was taking commissions from
the Hanseatic merchants. In its composition – the simple
dress, angled body and frontal view – it shares much with
the portraits of the Hanseatic merchants, such as that
of Derich Born (no. 158).

Literature: Grossmann 1951; Pennington 1982 (1411);
Eissenhauer 1996
Reference: Habich 1929 (854), pp. 125–6

TB

74 *The Rochester Cathedral Tazzas and Cover* 1528–9;
cover 1532–3

[NOT ILLUSTRATED]

a) Tazza made in London 1528–9; cover 1532–3
Silver-gilt Diameter 21.5 cm
The British Museum, London

b) Tazza made in London 1528–9
Silver-gilt Diameter 20.7 cm
The British Museum, London

These tazzas or 'flat cups' are a pair recorded at Rochester
Cathedral in 1670, though they were probably there much
earlier, possibly soon after the Reformation. Exceptionally
rare pieces, they are inscribed around the lip with the Latin
Benedicamus Patrem et Filium cum Sanctu Spiritu (Let us bless the
Father and the Son together with the Holy Spirit). The Tudor
rose on the finial of the cover is a later replacement. The shape
of these ornate cups with their wide shallows bowl resting on
a large ornate knop, from which extends a decorated spreading
foot, is very close in appearance to Holbein's drawing, *Covered
Cup, Inscribed with the Name of Hans of Antwerp* (no. 91).

Provenance: Rochester Cathedral from at least *c.*1670; acquired 1971
Literature: London 1991 (IX.13); London 2004 (189)

TB

75 *The Barber Surgeons Grace Cup* 1543–4

[NOT ILLUSTRATED]

London hallmark 1543–4
Silver-gilt Height 26.7 cm
The Worshipful Company of Barbers, Barber-Surgeons' Hall, London

In 1541 the Company of Barbers and Fellowship of Surgeons
united to form the The Worshipful Company of Barber-
Surgeons. This ornate cup was presented by Henry VIII to the
newly united company to commemorate this event, in or shortly
after 1543. It includes the maker's mark H.M., perhaps for
Hubert Morett. The cover and foot are chased with Tudor roses,
fleurs-de-lis and portcullises within scrolling foliage, and the
cover is surmounted with Henry VIII's coat of arms flanked by
his supporters. Its appearance shares many aspects of Holbein's
designs for ornamental cups. At the same period Holbein
was also commissioned to produce a large painting to mark
the formation of the new Livery Company, *Henry VIII and
the Barber-Surgeons* (no. 129).

Provenance: Worshipful Company of Barbers
Literature: London 1991 (IX.10)

TB

76 The Barbers Instrument Case c.1520–5

[NOT ILLUSTRATED]

English
Silver, parcelgilt and enamel, with wood and leather lining and with
original leather case Height 18 cm
The Worshipful Company of Barbers, Barber-Surgeons' Hall, London

The enamelled royal coat of arms, together with the engraved
figures of Saint George and Saint Thomas Becket on the back,
suggests that this small instrument case was a gift from Henry
VIII to a royal surgeon such as Thomas Vicary, with whom it
is traditionally associated. The royal arms are supported on the
left by a greyhound, indicating that it was produced before 1525
(when this was replaced by the lion). The side panels contain
Renaissance motifs such as dolphins and floral scrolls, the earliest
surviving example of Renaissance ornament on an English piece
of silver. Holbein used similar decorative motifs in his designs,
such as his *Design for a Cup with Dolphins* (no. 92).

Provenance: The Worshipful Company of Barbers
Literature: London 1991 (XI.5)

TB

77 The Croke Girdle Book c.1530s

[NOT ILLUSTRATED]

Illuminated manuscript on vellum in a gold filigree and
black enamel binding 4 × 3.5 cm
The British Library, London

This very small book, containing an English translation of the
Penitential Psalms, is similar in size, binding and contents to the
now lost Wyatt girdle book, based on Holbein's surviving design
(no. 90). Its cover is likewise made of gold with black enamel,
which survives only in traces. The rings allowed the book to
be suspended from a woman's girdle for easy consultation.
The translation of the Psalms was made by Master John Crook,
clerk in Chancery during the reign of Henry VIII for his wife,
Prudentia Cave, who must have owned the book.

Literature: Tait 1985, pp. 45–6; London 1991 (V.43)

78 Pair of Panels from the Speke Girdle Prayer Book
c.1530s

[NOT ILLUSTRATED]

Gold panels, embossed and enamelled 6.6 × 4.4 cm
The British Museum, London

This pair of panels for the cover of a small girdle prayer book
shows the Judgement of Solomon, and Susanna accused by the
Elders with the Judgement of Daniel. A portrait of Lady Speke
dated 1592 (Private Collection) shows her with a girdle prayer
book at her waist, the front cover of which is almost identical
to the panel showing the Judgement of Daniel. It is possible,
therefore, that these loose panels come from the now lost Speke
girdle prayer book, which would have probably been made for
Anne, wife of Sir Thomas Speke (1508–1551), one of Henry
VIII's Gentlemen of the Privy Chamber. The composition and
execution suggest that it was produced around 1530, probably
by an English goldsmith.

Provenance: Bequeathed by Sir A.W. Franks, 1897
Literature: London 1980 (12); Tait 1985, pp. 46–52;
London 1991 (VII.17)

TB

79 Hat Badge depicting Christ and the Woman of Samaria
c.1540

[NOT ILLUSTRATED]

Gold with coloured enamel Diameter 5.7 cm
The British Museum, London

Hat badges were an important element of Tudor jewellery, often
projecting religious and political symbolism or personal devices
relating to the wearer. This small gold and enamel hat badge
shows the scene of Christ talking to the Woman of Samaria
at Jacob's Well (St John IV, 4–42), Jesus depicted in a dark blue
robe, with the woman in a red enamelled dress. The subject was
popular with Protestants, and the English inscription suggests
an allusion to Protestant truth. A rare survival, it is an example
of the type of hat badges Holbein shows some of his sitters
wearing, such as Simon George (no. 35), who wears a gold badge
of Leda and the Swan, and Sir Richard Southwell (no. 114),
who wears a cameo relief badge from which the bust of a woman
projects. Holbein makes a detailed sketch of such a hat badge,
along with other jewellery, in his drawing of *William Parr,
Marquess of Northampton* (no. 83).

Provenance: Purchased 1955 with the aid of the
NACF and the Christy Trustees
Literature: Tait 1962, pp. 228–9; London 1980 (9);
Hackenbroch 1996, pp. 355–63

TB

80 *Design for Anthony Denny's Clocksalt* 1543

Pen and black ink on paper with grey wash and red wash on the compass
41 × 21.3 cm
Inscribed by Nikolaus Kratzer: coniunctis / sive novi / lunium pro /
20 Annis and compassa / superiarus; oppöscu. Inscribed in another hand:
[s]trena facta pro Anthony / deny camerario Regis quod / in intio novi
anni 1544 / regi dedit
The British Museum, London

The inscription records that Anthony Denny (no. 81) gave a
clocksalt after this design to Henry VIII as a New Year's gift in
1545 (old calendar 1544). Two notes in the hand identifiable as
that of the royal astronomer Nikolaus Kratzer shows that this was
one of the three documented occasions on which he collaborated
with Holbein (for the others see nos. 31, 33).

The clocksalt was a complex instrument. In the centre was an
hourglass, its doors open to show a satyr; two more support the
base, while on top two putti hold curved metal sheets forming
sundials. A clock, a blazing sun at its centre, rests on their heads,
surmounted by a crown. A compass, shown in the separate drawing
to the left, would have been placed above the hourglass. Holbein
has used wash to suggest the three-dimensional presence of the
various elements, including the bulbous hourglass reflected against
its doors and the feet of the instrument on a flat surface. Made
in precious metal, this would have been an expensive gift, highly
appealing to Henry VIII who owned several clocksalts and clocks.

Provenance: P.J. Mariette, Paris 1775; H.Walpole, sold 1842.
Literature: London 1991 (IX.15); Rowlands 1993 (328)

81 *Sir Anthony Denny* 1647

[NOT ILLUSTRATED]

Etching 13.3 × 10.8 cm
The British Museum, London

This etching of Sir Anthony Denny (1501–1549) was made by
the Bohemian artist Wenceslaus Hollar in 1647, from a portrait
by Holbein in the collection of the Earl of Arundel which is now
lost. The inscriptions after the original painting indicate that
it was painted in 1541, with the age of Denny stated as twenty-
nine. However, given his probable date of birth and his
appearance in the portrait, this is likely to be a mistake of about
ten years, Denny being around thirty-nine or forty at the time
of the portrait.

The second surviving son of Sir Edmund Denny of Cheshunt,
Denny was a highly important member of the court of Henry
VIII and the most intimate of the king's few friends. A member
of the Privy Council, in 1538 he was promoted to the highest
court position as one of the two chief gentlemen of the chamber.
In 1546, in the king's final years, he was given control of the
'dry stamp', which allowed him to act independently of the king
on his behalf. Denny used the 'dry stamp' to sign the royal will
after Henry's death in 1547.

Literature: Pennington 1387

TB

82 *Henry VIII's Clocksalt* c.1530–5

French
Silvergilt, enamel, set with precious stones and agates Height 39 cm
The Worshipful Company of Goldsmiths, London

One of only three surviving pieces of goldsmiths' work owned by Henry VIII, the clocksalt was made by the French goldsmith Pierre Mangot, evidently as a gift to Henry VIII from Francis I. Mangot was also the author of a magnificent surviving mother of pearl casket (Musée Louvre, Paris). Hackenbroch has suggested the clocksalt was a wedding gift on Henry's marriage to Anne Boleyn in 1533.

The present top of the clocksalt is a replacement: the salt well formed part of the original top of the piece which was originally crowned with a figure of Jupiter and an eagle (as is Holbein's design for a fountain, no. 94). The clocksalt was listed in the Inventory of the Rebels 1649 ordered by Cromwell, as one of 'Two faire large salts of silver gilt with a clock in it, garnished with 6 ivory heads about the bottom and enriched with stones and little gold heads enamelled, with a man upon a falcon on the top of it, valued at £40'. The clock in the base was originally a flat tableclock, the dial visible within the transparent case, which is a later replacement of rock crystal.

Although the style and decorative repertoire of this clocksalt is different from Holbein's own design for a clocksalt for Sir Anthony Denny (no. 80), there are points of similarity with his designs. The classical style cameo heads, probably of ivory, as the 1649 description implies, are set against blue enamel gilded with fashionable arabesque designs, also used on Holbein's design for a book cover and casket (no. 90). They resemble the similar heads included in Holbein's design for a cup for Jane Seymour (no. 95). The round agate feet are similar to those of his dolphin cup (no. 92).

Provenance: Henry VIII; by descent to Charles I; sold to Mr Smith 31 December 1649; W.P. Stopford 1862; by descent; sold Christie's 12 July 1967; purchased from Ronald Lee 1968
Literature: London 1991 (IX.9), p. 131; Hackenbroch 1996, p. 342
Reference: Starkey 1998 (1353); Collins 1955 (914), p. 450; Bimbenat-Privat 1992, pp. 245–6

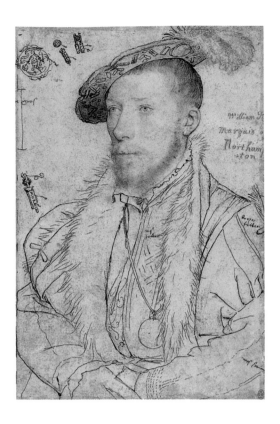

83　*William Parr, Marquess of Northampton* c.1538–40

Black and coloured chalks with pen and Indian ink, white bodycolour
on pink primed paper　31.7 × 21.2 cm
Inscribed: wis felbet burpur felbet wis satin W, gl gros; MORS;
William Pa.. Marquis o(f) Northam(p): ton
The Royal Collection, The Royal Library, Windsor

William Parr (1513–1571), younger brother of Queen Catherine
Parr became Marquess of Northampton in 1547. The extensive
colour notes in Holbein's hand show that he was dressed in costly
clothing with textiles and colours that only the nobility were
officially allowed to wear: white satin and white and purple velvet.
Parr wears a highly fashionable hat badge and a medallion
suspended from a chain. A sketch left indicates details of the links
of a chain including the word 'MORS', death. Another shows a
figure in classical armour: a sword piercing a sphere connected to an
elongated shape suggests the subject is St George and the dragon;
with projecting fastenings this may be intended for the hat badge.
A scale top left indicates size ('gros') though its purpose is unclear.

The portrait has been associated with the refounding of the
Band of Gentleman Pensioners in 1539, but Parr's Captaincy dates
from after Holbein's death in autumn 1543, and the colours of his
dress differ from those of the portrait of Sir William Palmer as
a gentleman pensioner (Christie's, 24 November 1998); nor are
the details of chains and badges the same.

Provenance: See no.15
Literature: Parker 1983 (57); Houston 1987 (33), p.102; Edinburgh 1993 (24),
p.72; Hackenbroch 1996, pp.360–3; James 1998, p.19

84　*Roundels with Old Testament Scenes* c.1534–8

Pen and black ink and chalk on paper　20.2 × 10.4 cm
Kunstmuseum Basel, Kupferstichkabinett

These four roundels were evidently designs for jewelled
pendants. The top three show sketches for the Old Testament
story of Hagar and Ishmael, her son by Abraham: driven into the
desert their thirst was relieved by an angel and the miraculous
appearance of a well. Separate sketches for a jewelled well are
seen to the left. The fourth design shows Abraham making
a treaty with King Abimelech over an altar with an inset jewel.
The sketches vividly demonstrate Holbein's working processes.
Starting with circles drawn with a compass, as the hole visible
in the empty circle top right shows, he invented three dynamic
alternatives for composing the small figures within them, while
clarifying poses and details in the sketches outside. While doing
so he doodled the comic figures alongside. A different, more
finished version of the Hagar design survives at Chatsworth.

Provenance: Amerbach-Kabinett 'English sketchbook'
Literature: Müller 1996 (199); London 1993 (204d)

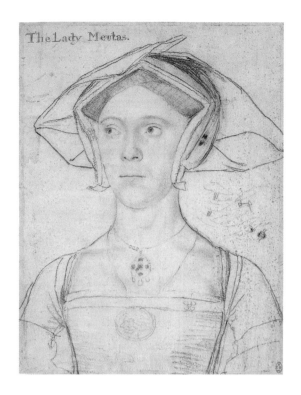

85 *Lady Meutas* c.1536

> Black and coloured chalks on pink prepared paper 28.2 × 21.2 cm
> Inscribed: Gl (for gold) on headdress; The Lady Meutas
> The Royal Collection, The Royal Library, Windsor

The startled looking Joan or Jane Ashley or Astley, Lady Meutas
(d. 1577) married the courtier Peter Meutas before 9 October
1537, after the marriage had several times been postponed. The
sister of a London mercer, John Astley, she gave birth in 1539.
Peter Meutas, like Holbein, became involved in Henry VIII's
quest for potential brides and was sent to France in 1537–8;
he was knighted in 1544.

To the right of the portrait drawing is a schematic sketch of
hands, including a heart-shaped leaf used by German painters
as a symbol for green: here it symbolises an emerald in a ring.
The same sign also appears in the centre of Lady Meutas's large
oval medallion, sketched with a design closely resembling one
of Holbein's three drawings for a Mary Magdalen jewel (no. 86).

> Provenance: See no. 15
> Literature: Parker 1983 (21)
> Reference: Foister 1981, p. 485

86 *Three Drawings of the Penitent Mary Magdalen*
 c.1536

> a) Pen and black ink with grey wash on paper 5.2 × 4.8 cm
> Kunstmuseum Basel, Kupferstichkabinett
>
> b) Pen and black ink with grey wash on paper 4.4 × 5.7 cm
> Kunstmuseum Basel, Kupferstichkabinett
>
> c) Pen and black ink with grey wash on paper 4.2 × 5.7 cm
> Kunstmuseum Basel, Kupferstichkabinett

These three drawings of the penitent Mary Magdalen in the
wilderness were probably originally on the same sheet but have
been cut out separately. A very similar image to the third of
these drawings is seen in reverse on the medallion worn by Lady
Meutas (no. 85). An etching by Hollar may record the existence
of a fourth, more finished version in the Arundel collection, or
may simply reproduce the third design in tidier form. It is not
clear whether Holbein designed such a medallion for Lady
Meutas and she then wore it in her portrait or whether these
sketches represent a series of sketches for part of her portrait.
In that case the variations would suggests that this was an
imaginary medallion rather than an actual one.

> Provenance: Amerbach-Kabinett 'English sketchbook'
> Literature: Müller 1996 (207, 209, 208); Foister 2004, pp. 140–1
> Reference: Pennington 1982 (180)

[I OF II ILLUSTRATED]

a) *Pendant with a half-length female figure and two cornucopias,*
set with stones and pearls, and a hanging pearl
Pen and black ink with black wash background 5.8 × 4.3 cm
The British Museum, London

b) *Pendant with lady holding a stone*
[NOT ILLUSTRATED]
Pen and black ink with wash and watercolour 6.6 × 3.4 cm
Inscribed by a later hand: WELL / LAYDI / WELL
The British Museum, London

c) *Pendant with leaf ornament, entwined ribbons and a pendant pearl,*
set with a central stone surrounded with pearls
[NOT ILLUSTRATED]
Pen and black ink with black wash background 4.7 × 4.1 cm
The British Museum, London

d) *Pendant with central leaf ornament, flanked by ribbons,*
set with stone and pearls
[NOT ILLUSTRATED]
Pen and black ink with black wash background 5.9 × 4.3 cm
The British Museum, London

e) *Pendant as a stylised plant, with leaf ornament entwined with ribbons,*
and four stones and three pearls as flowers, surmounted by a grotesque figure
[NOT ILLUSTRATED]
Pen and black ink with black wash background 6.7 × 4.4 cm
The British Museum, London

f) *Pendant with leaf ornament entwined with ribbons,*
and set with stones and pearls and a single hanging pearl
[NOT ILLUSTRATED]
Pen and black ink with black wash background 5.6 × 3.8 cm
The British Museum, London

g) *Pendant with inscribed scrolls in the form of a lyre, surmounted*
by a grotesque head, and at the centre, a stone within leaf ornamant,
and below a hanging pearl
[NOT ILLUSTRATED]
Pen and black ink with black wash background 6 × 4.1 cm
The British Museum, London

h) *Pendant with ribbon work set with four stones and five pearls,*
and a hanging pearl
[NOT ILLUSTRATED]
Pen and black ink with black wash background 5.8 × 4.9 cm
The British Museum, London

i) *Pendant with leaf ornament, set with four stones and three pearls,*
and a hanging pearl
[NOT ILLUSTRATED]
Pen and black ink with black wash background 5.7 × 4.3 cm
The British Museum, London

j) *Lozenge-shaped pendant entwined with ribbon work,*
set with stones and pearls, and a hanging pearl
[NOT ILLUSTRATED]
Pen and black ink with grey and light yellow wash 6.3 × 4.1 cm
The British Museum, London

k) *Pendant, set with a lozenge and an oval stone, with three hanging pearls*
[NOT ILLUSTRATED]
Pen and black ink 5.3 × 5 cm
The British Museum, London

l) *Pendant, set with a lozenge and an oval stone, with three hanging pearls*
[NOT ILLUSTRATED]
Pen and black ink 5 × 3.2 cm
The British Museum, London

Two of these designs, one including cornucopia, illustrated
above (87a), are similar to marriage pendants and brooches
known from extant examples and portraits of the late fifteenth
century, probably made in Germany for export. Holbein may
have been producing variants of a well-known type for German
goldsmiths in London serving the English market.

The pendant with a woman in Tudor dress (no. 87b) has
been associated with the jewel worn in a portrait of 1569
(Tate T00400) that may represent Helena Snakenborg,
third wife of William Parr, Marquess of Northampton (no. 83);
her family may possibly have commissioned the jewel.

Provenance: Sir Hans Sloane by 1713–21; British Museum 1753
Literature: Rowlands 1993 (338 a–h, 339 a, 340 b, c)
Reference: Syson and Thornton 2001, pp. 44–7; Sjogren 1980, p. 699

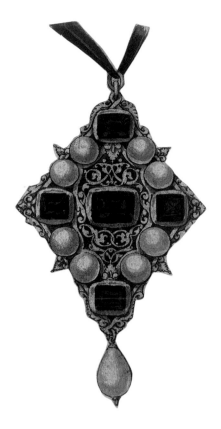

88 *Designs for Pendants Jewels* c.1536–8

[1 OF 5 ILLUSTRATED]

a) *Pendant set with sapphires and pearls*
Pen and black ink with black, grey and light brown wash, touched with white bodycolour. Silhouetted. 13.5 × 6.6 cm
The British Museum, London

b) *Pendant set with a ruby and sapphires*
[NOT ILLUSTRATED]
Pen and black ink with grey and black wash and watercolour, touched with white bodycolour. Silhouetted. 11.6 × 6.4 cm
The British Museum, London

c) *Pendant set with sapphires and pearls*
[NOT ILLUSTRATED]
Pen and black ink with black, grey and light brown wash, touched with white bodycolour. Silhouetted. 9 × 5.3 cm
The British Museum, London

d) *Pendant set with sapphires and pearls*
[NOT ILLUSTRATED]
Pen and black ink with black, grey and light brown wash, touched with white bodycolour. Silhouetted. 11.2 × 6.2 cm
The British Museum, London

e) *Pendant set with sapphires and pearls*
[NOT ILLUSTRATED]
Pen and black ink, with black, grey and light brown wash, touched with white bodycolour. Silhouetted. 12.2 × 6.3 cm
The British Museum, London

These very finished designs for pendant jewels all include either chains or ribbons. Similarities to jewels worn by Henry VIII in portraits by Holbein have been observed (see no. 105) and it seems conceivable that these drawings are records of actual objects rather than designs, as other artists of the period such as the German Hans Mielich were instructed to make. The black stones are probably intended to represent sapphires.

Provenance: Sir Hans Sloane by 1713–21; British Museum 1753
Literature: Rowlands 1993 (337 a–e)

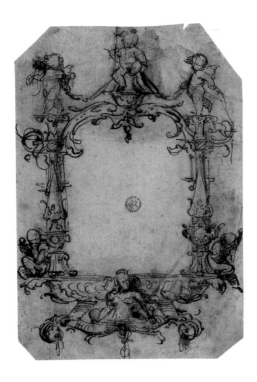

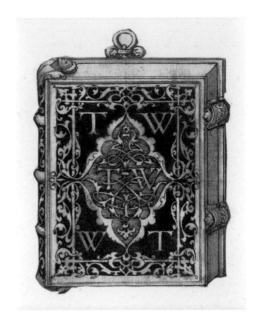

89 *Design for a Frame* c.1533–6

> Pen and black ink over chalk on paper 15.4 × 10.4 cm
> Kunstmuseum Basel, Kupferstichkabinett

This fluid working drawing shows Holbein's early indications of foreshortening and direction in the crosses he draws on the faces of the small cherubs. The decorative style of the support of the columns on the right with their criss-cross basket work is closely comparable to designs of around 1535 (see nos. 150, 151). A mermaid adorns the lower part of the frame, with a pearl below, an indication of the small scale of the work which, it has been suggested, was perhaps intended to be worn on a chain to frame a miniature, but was possibly a small mirror frame: Henry VIII's sixth queen, Katherine Parr, owned 'Item a Tablet of golde on thone side therof is a lardge Ballas or a Robas partely lozenged and on the other side a loking glasse with a meane rounde perle pendaunt'. The dynamism of the design would have required a highly skilled goldsmith.

> Provenance: Amerbach-Kabinett 'English sketchbook'
> Literature: Müller 1996 (230); Foister 2004, pp. 143–4
> Reference: Starkey 1998 (2655)

90 *Designs for Metalwork Covers and Caskets* c.1537

> [1 OF 4 ILLUSTRATED]
>
> a) Pen and black ink with black, grey and yellow wash on paper 8.1 × 6 cm
> The British Museum, London
>
> b) Pen and black ink with black, grey and yellow wash on paper 7.9 × 5.9 cm
> [NOT ILLUSTRATED]
> The British Museum, London
>
> c) Pen and black ink with black and yellow wash on paper 11.5 × 7.9 cm
> [NOT ILLUSTRATED]
> The British Museum, London
>
> d) Pen and black ink with black and yellow wash on paper 11.3 × 7.9 cm
> [NOT ILLUSTRATED]
> The British Museum, London

All four designs are evidently intended to be executed in black enamel over gold, allowing the gold to create a series of newly fashionable interlaced arabesque designs. The two book covers feature clasps to close the book and a ring by which such small books were usually attached to a woman's girdle. A number of sixteenth-century portraits show such books being worn, and a few examples of the books or the covers survive (see nos. 77, 78). Both books bear the initials T, W and I, which probably stand for those of Sir Thomas Wyatt the Younger and his wife Jane Haute, who were married in 1537. A girdle book belonging to the Wyatt family with a very similar design but without the initials was recorded in the eighteenth and nineteenth centuries (present whereabouts unknown).

> Provenance: See no. 87
> Literature: Marsham 1875, pp. 259–72; London 1988 (207 a and b), p. 241;
> Rowlands 1993 (333 a–b); (334 a–b)

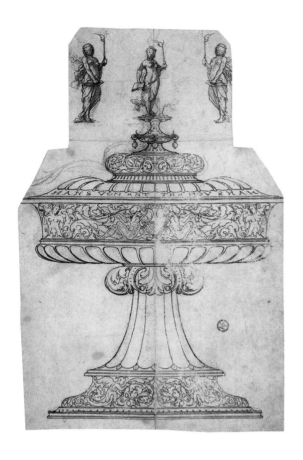

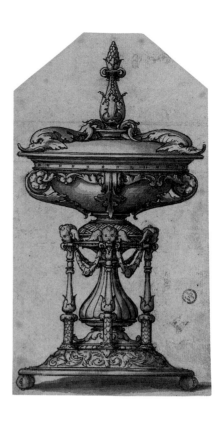

91 *Covered Cup, Inscribed with the Name of*
Hans of Antwerp c.1537?

Pen and black ink over chalk, grey wash on paper; right-hand side offset
25.1 × 16.4 cm Inscribed: HANS VON ANT
Kunstmuseum Basel, Kupferstichkabinett

The inscription refers to the goldsmith Hans of Antwerp, named
in Holbein's will of 1543, who settled in London in 1515, and
is documented executing work for the court in the 1530s. The
conventional shape of the cup resembles the Rochester tazza
(no. 74) but it was to be elaborately decorated, the languid male
reclining figure and female torso on the bowl typical of Holbein's
figurative repertoire. A simplified version of the arabesque
ornament on the lid appears on armour made for Henry VIII
(Kunsthistorisches Museum, Vienna), suggesting the possibility
that Holbein also supplied designs to the German armourers
who worked at Greenwich. On top of the lid is a female figure
representing Truth, shown from three different angles to ensure
that the goldsmith could replicate it in three dimensions. The
drawing is probably the same size as the cup. Holbein drew only
the left-hand side, creating a mirror-image on the right-hand side
by offsetting, transferring the outlines by pressure. The cup was
presumably made for presentation by Hans of Antwerp himself,
possibly in connection with his application for the freedom
of the Goldsmiths' Company in 1537.

Provenance: Amerbach-Kabinett 'English sketchbook'
Literature: Gamber 1963, p. 24; Müller 1996 (239)
Reference: Chamberlain 1913 (II), pp. 10–13; London 1991, pp. 113–14

92 *Covered Cup with Dolphins* 1532–6

Pen and black ink and grey wash over chalk on paper 18.3 × 10 cm
Kunstmuseum Basel, Kupferstichkabinett

This very finished drawing makes extensive use of wash to give
a three-dimensional appearance, mimicking the gleam of metal
on the bowl of the cup and representing the shadow underneath
the ball feet. The drawing has the appearance of a presentation
drawing rather than one a goldsmith could work from: Christian
Müller has noted the difficulty in discerning whether the form
of the cup is round or oval, and the need for further feet, without
which it would be unstable. The dolphins are taken from a print
by the Italian Zoan Andrea. Henry VIII owned a similar 'cruse'
(or drinking vessel) with 'three antique dolphins' on the lid.

Provenance: Amerbach-Kabinett 'English sketchbook'
Literature: Müller 1996 (240)
Reference: Starkey 1998 (1277)

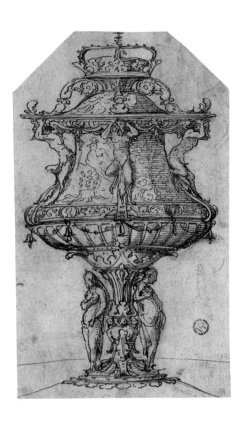

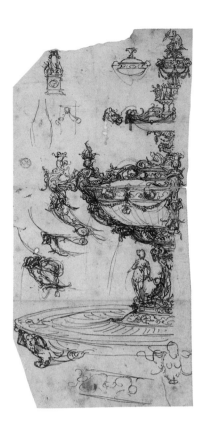

93　*Design for a Table Fountain with the*
　　Badge of Anne Boleyn　1533

Pen and black ink over chalk on paper　25.1 × 16.4 cm
Kunstmuseum Basel, Kupferstichkabinett

Only the upper part of this large piece is shown in this drawing
with its carefully hatched indications of light and shade. The
badge of Anne Boleyn, the crowned white falcon with Tudor
roses growing from a tree stump, is visible between the satyrs
who support the top, while standing women at the base squeeze
their breasts to let water flow. The drawing closely resembles
the description of a table fountain decorated with rubies and
pearls given to Henry VIII by Anne Boleyn at New Year 1534,
although the absence from the description of the satyrs shown
here might suggest it was not the final version of the design.

Provenance: Amerbach-Kabinett 'English sketchbook'
Literature: Ives 1994; Müller 1996 (243)
Reference: Collins 1955 (998), pp. 468–9

94　*Table Ornament with Jupiter*　*c.*1533–6

Pen and black ink over chalk on paper　26.5 × 12.5 cm
Kunstmuseum Basel, Kupferstichkabinett

Like the drawing with the arms of Anne Boleyn (no. 93)
this vigorous working drawing for an elaborate table fountain
includes female figures with water issuing from their breasts,
and might also be related to the queen's New Year gift. At the
top is the figure of Jupiter with an eagle hurling a thunderbolt,
while just below people dance around an altar. Winged caryatids
support the base, as in a more finished drawing for the stem of
a cup in the British Museum. Traces of chalk lines show Holbein
first establishing the proportions, while beside the main sketch
he reworked and clarified details of its parts, such as the altar
with a fire top left.

Provenance: Amerbach-Kabinett 'English sketchbook'
Literature: Ives 1994, p. 38; Müller 1996 (244)
Reference: Rowlands 1993 (331e)

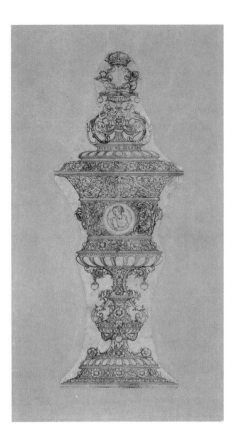

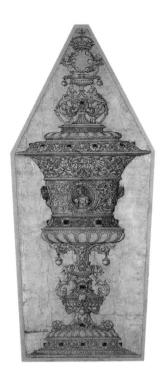

Holbein and workshop?

95 *Design for a Cup for Jane Seymour* 1536–7

Pen and point of the brush and black ink on white paper 37.6 × 15.5 cm
Inscribed: BOVND TO OBEY AND [SERVE] and BOVND TO OBEY
The British Museum, London
Provenance: Sir T. Lawrence; W. Beckford; Smith
Literature: Rowlands 1993 (326); Müller 1990

Holbein and workshop?

96 *Design for a Cup for Jane Seymour* 1536–7

Ink and chalk on paper with grey and pink washes and gold heightening
37.6 × 15.5 cm
Inscribed: BOVND TO OBEY AND [SERVE] on the cover and
BOVND TO OBEY twice on the cup
Ashmolean Museum, Oxford, Douce Bequest, 1834
Provenance: Loggan; Douce; acquired 1863
Literature: Brown 1982 (3), p. 4; Müller 1990
Reference: Starkey 1998 (55); Collins (47), p. 279

No. 95 is the preliminary design and no. 96 shows the final
design for a magnificent gold cup evidently to be given by Henry
VIII to Queen Jane Seymour; they married on 30 May 1536.
The queen's motto, 'bound to obey and serve', is repeated on
the lid and on the foot, while the king and queen's initials are
intertwined with love knots. On the lid two putti hold a shield
surmounted with the royal crown. A 'faier standing cuppe of
gold garnished with diamounts and pearle' with the Queen's
motto, the initials 'H and I knytt togethers' and a cover matching
the details of this design is described in the inventory of
Henry VIII.

As with the design for the Hans of Antwerp cup (no. 91)
Holbein began by drawing the left-hand side of the design,
which has been repeated on the right-hand side, and also made
a number of alterations, including that for the putto upper right.
Christian Müller has suggested that the right-hand side of the
preliminary design, executed more hastily and with less detail

and elegance than the left, is the work of an assistant, who had
difficulty with the proper spacing of the initials H and I. The
alterations were carried into the final, more elaborate drawing
of the cup, where the arabesques are strengthened in vigour and
the projecting antique busts are more detailed. Müller has argued
that this design is the work of an assistant or a later copy, since
some of the details of the British Museum drawing appear
to be misinterpreted.

[1 OF 5 ILLUSTRATED]

a) *Guard of a ballock-dagger with top mount of the scabbard into which the knife and bodkin could have fitted*
Pen and black ink with grey wash on paper 7.3 × 7.1 cm
The British Museum, London

b) *Pommel of a dagger with the head of a man and leaf ornament*
Pen and black ink with grey wash on paper 5.2 × 4.6 cm
[NOT ILLUSTRATED]
The British Museum, London

c) *Vase-shaped pommel of a dagger*
Pen and black ink with grey wash on paper 5.3 × 4.6 cm
[NOT ILLUSTRATED]
The British Museum, London

d) *Dagger hilt with mushroom-shaped pommel and recurved quillions with ends scrolled like rams' horns towards the pommel*
Pen and black ink with grey wash on paper 12.7 × 8.6 cm
[NOT ILLUSTRATED] ·
The British Museum, London

e) *Guard of a ballock-dagger*
Pen and black ink with grey wash on paper 6 × 7.8 cm
[NOT ILLUSTRATED]
The British Museum, London

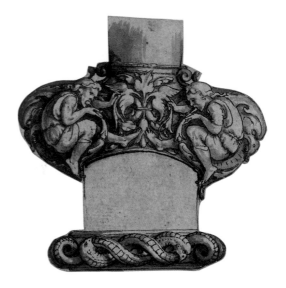

The ballock-dagger was named after the rounded forms at the base of the grip, ornamented here with two crouching men. A knife and bodkin, useful for cutting up food, were sometimes carried alongside a dagger or sword and fitted within the scabbard.

Holbein has shaped the pommels and guards of these highly finished designs from a variety of motifs in his repertoire, fitting grotesque heads, musicians, acanthus leaves, scaly tentacles and rams horns with flowing ease into the required forms of the dagger hilts. The designs are similar to the ceremonial dagger worn by Henry VIII in the cartoon for the Whitehall wall painting (no.104) and suggest the design of such weaponry was among Holbein's tasks as court artist.

Provenance: Sir Hans Sloane by 1713–21; British Museum 1753
Literature: Rowlands 1993 (360 a–e)

98–101 *Four Designs for a Dagger and a Sword* c.1534–8

No. 98 is a drawing for a baselard, a type of ceremonial dagger worn suspended from a girdle, and is exceptionally rich in its ornamentation with jewels and figures. It is the only record of a design for a complete weapon by Holbein including both hilt and blade. In no. 99 Holbein sketches the principal ideas for the hilt, incorporating arching male figures left and right with serpent tails that stretch and twist around the projecting sides of the guard and extend into foliage suggestive of cornucopiae. The female figures on the pommel are sketched with shorter, more rapid strokes of the pen. No. 100 is a design for the hilt of a sword incorporating similar motifs and developing the ideas of a curling tail and a cornucopia more strongly. The stages of work are clearly visible, from chalk outlines to details in pen, finally accented with broader pen strokes. No. 101 is an offset recording a lost alternative design for the hilt of the dagger, perhaps made up of individual motifs preserved on separate sheets by Holbein. Holbein or an assistant created the design by transferring the impression of one or more drawings onto a fresh sheet of paper. Müller has argued that the lack of the animated quality visible in the sketches (no. 99) and (no. 100) suggests that the complete design for the dagger (no. 98) is a copy after a lost design, made by a workshop assistant instructed to preserve an important design.

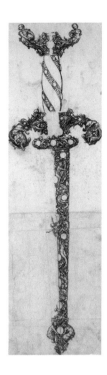

98　*Design for a Dagger*

Brush drawing in black ink on paper　45.5 × 12.6 cm
The British Museum, London
Provenance: Earl of Wicklow
Literature: Müller 1990; Rowlands 1993 (325)

99　*Design for a Dagger Hilt*

Pen and ink over chalk preparatory drawing on paper;
brown ink by another hand　18.4 × 14.1 cm
Kunstmuseum Basel, Kupferstichkabinett
Provenance: Amerbach-Kabinett 'English sketchbook'
Literature: Müller 1996 (235)

100　*Design for a Sword Hilt*

Pen and ink over chalk preparatory drawing on paper　20.1 × 15.1 cm
Kunstmuseum Basel, Kupferstichkabinett
Provenance: Amerbach-Kabinett 'English sketchbook'
Literature: Müller 1996 (234)

101　*Offset of a Design for part of a Dagger or Knife*

Pen and ink, grey wash on paper　20.8 × 9 cm
Kunstmuseum Basel, Kupferstichkabinett
Provenance: Amerbach-Kabinett 'English sketchbook'
Literature: Müller 1996 (236)

102 *Design for a Chimney-piece* c.1538–40

Pen and black ink with grey, blue and red wash on paper 53.9 × 47 cm
The British Museum, London

This drawing provides the only evidence that Holbein made
architectural designs in England. It shows an elaborate fireplace
with roundels including figures of blind Justice and of Charity
as a mother with children on the left and a battle scene between
them. Below is a roundel with Esther before Ahasuerus,
surrounded again by a battle scene.

The royal arms indicates that the design was made for Henry
VIII. In the seventeenth century Henry Peacham associated
this drawing with Bridewell Palace, completed in about 1523,
three years before Holbein first arrived in England; Henry
abandoned it after 1530. The detail of the drawing is most closely
comparable to decorative designs of the later 1530s, including a
design for a covered cup at Basel which also shows Justice, and to
the architecture of the miniature of Solomon and Sheba (no. 146),
although the arrangement of columns, decorative architraves
and arches also recalls the architectural paintings and drawings
of the early Basel years (no. 8). However Holbein now includes
the 'strapwork' motifs particularly fashionable in France at this
time. Henry VIII employed French craftsmen on the making
of the fireplace in his Privy Chamber at Whitehall Palace.

Provenance: Earl of Arundel; J. Richardson the Elder;
T. Hudson; H., Walpole, sold 1842
Literature: London 1988 (327)
Reference: Thurley 1993, pp. 40–4, 53; Müller 1996 (242);
Foister 2004, p. 18

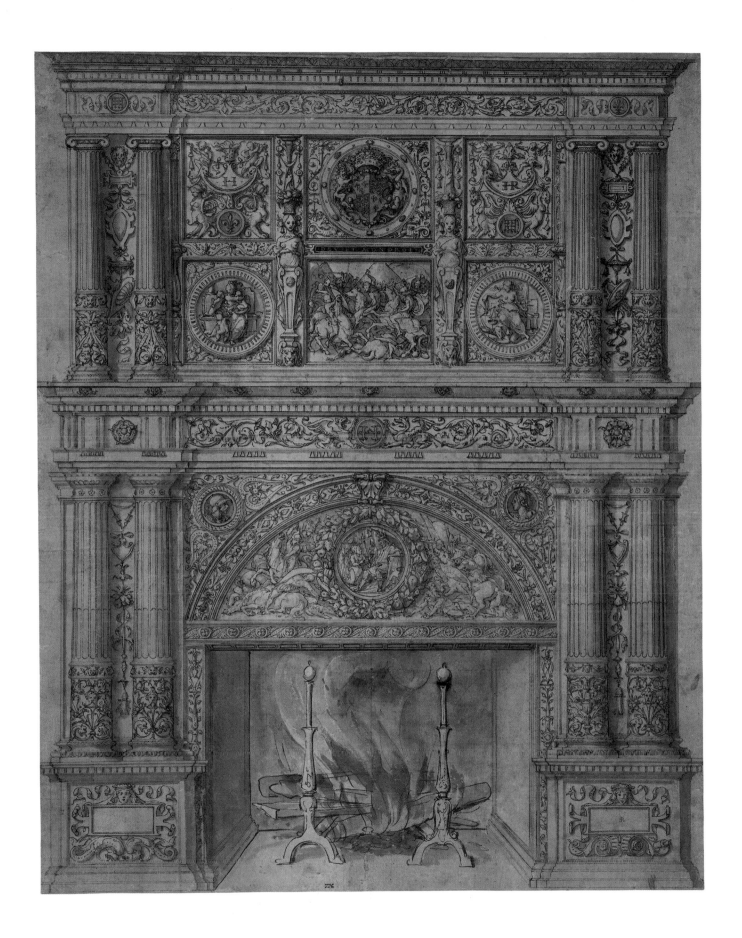

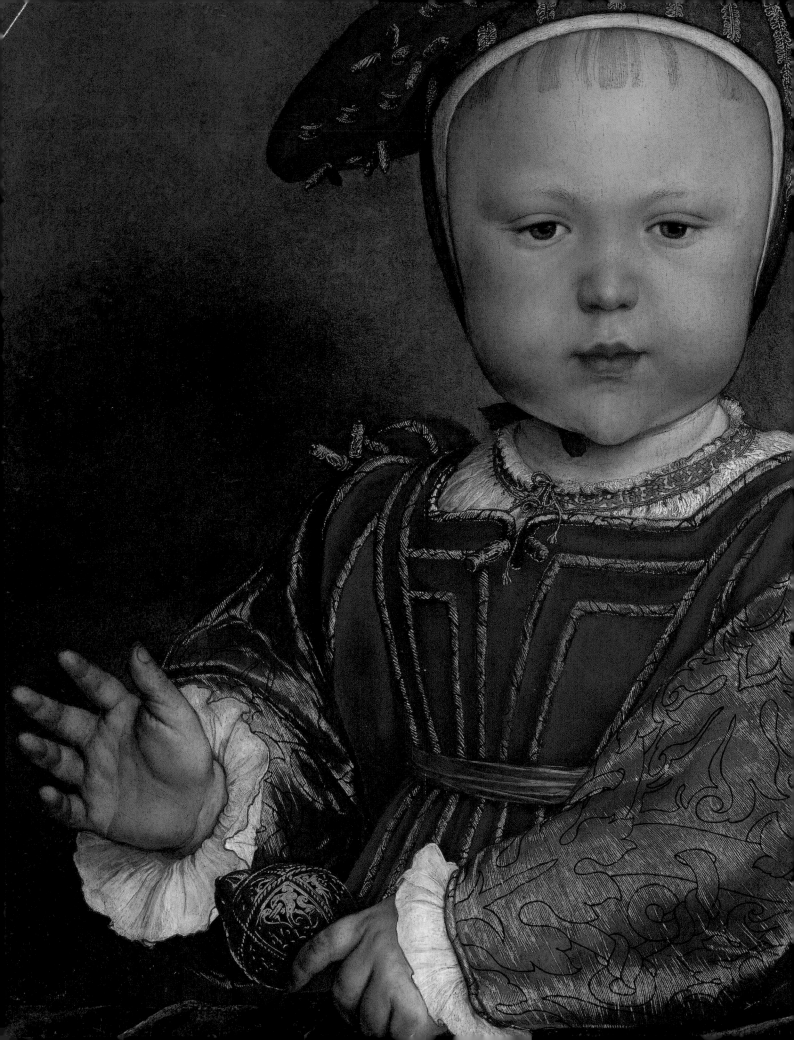

4

Holbein and Henry VIII

Although Holbein was well paid for making decorative paintings for Henry VIII for the festivities at Greenwich in 1527, no salary payments survive from this period, so the question as to whether Holbein also joined the royal payroll at this period remains open. The payment in 1533/4 to 'Master Hans' for painting an Adam and Eve adorned with precious metal, and the drawing of a table fountain with the arms of Anne Boleyn (no. 93) indicate Holbein was working for the king again soon after his return to England in 1532. Payment books survive from 1537 onwards, and show Holbein received £30 a year paid quarterly until his death, but there is no document which tells us what his duties were, or indeed those of the other painters from Northern Europe and Italy in royal employment.

The responsibilities of the Serjeant Painter are clearer: usually at this period a senior member of the London Painter-Stainers Company, he had general responsibility for decorative painting of all kinds in the king's palaces, from window frames to funeral banners. During Holbein's time in England the post was held by John Brown (d.1532) and then by Andrew Wright (d.1543). Henry also employed the Netherlandish painter Lucas Horenbout, who at £33 a year was paid slightly more than Holbein; evidently the author of a number of portrait miniatures of Henry and his family, Horenbout seems also to have carried out decorative work, and along with other monthly paid royal servants, including royal musicians, was probably in closer attendance on the king than Holbein, whose position evidently did not preclude his extensive private practice as a portraitist.

Holbein participated in many of the tasks required of court artists in fifteenth- and sixteenth-century Europe: as well as producing the Greenwich paintings in 1527 he designed precious metalwork used by the King, from daggers to table fountains, and even a fireplace (no. 102), but there is little evidence that he was required to produce portraits until the period 1537–40. The dynastic wall painting of 1537 depicting Henry with Jane Seymour and his parents Henry VII and Elizabeth of York (nos. 103, 104) was one of several Tudor murals which once existed at Whitehall palace, all destroyed by fire in 1698. Holbein's mural was in the privy chamber, a semi-private room with a crystal fountain and elaborate fireplace of French workmanship, in which the King would dine and receive visitors. Its inscription asserted the triumph of the Tudor dynasty over the disorder of the previous century and over the power of the pope, while Holbein's overbearing image of Henry ensured his immortality as king. Following Jane Seymour's death, Holbein was sent on several missions to paint the portraits of her prospective successors as queen. Portraits of three French noblewomen and Amelia of Cleves do not survive, but those of Christina of Denmark and Amelia's sister Anne do (nos. 157, 111). Holbein's winningly staged portrait of Prince Edward (no. 108) was evidently a personal gift from the artist at New Year rather than a commission.

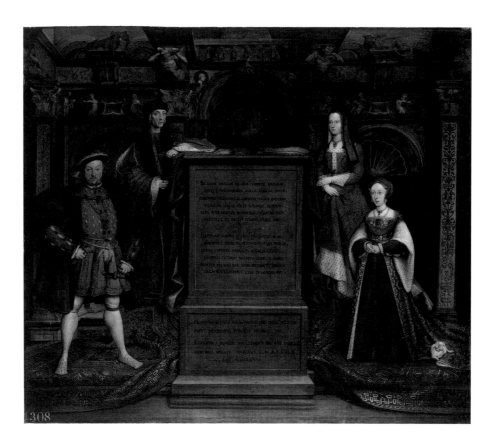

Remigius van Leemput d.1675

103 *Copy after Holbein's Whitehall Mural* 1667

Oil on canvas 88.9 × 98.7 cm
Inscribed: SI IVVAT HEROVM CLARAS VIDISSE FIGVRAS, / SPECTA
HAS, MAIORES NVLLA TABELLA TVLIT. / CERTAMEN MAGNVM, LIS,
QVAESTIO MAGNA PATERNE, / FILIVS AN VINCAT. VICIT. VTERQVE
QVIDEM. / ISTE SVOS HOSTES, PATRIAEQVE INCENDIA SAEPE /
SVSTVLIT, ET PACEM CIVIBVS VSQUE DEDIT. / FILIVS AD MAIORA
QVIDEM PROGNATVS AB ARIS / SVBMOVET INDIGNOSI
SVBSTITVITQVE PROBOS. / CERTAE, VIRTVTI, PAPARVM AVDACIA
CESSIT, / HENRICO OCTAVO SCEPTRA GERENTE MANV / REDDITA
RELIGIO EST, ISTO REGNANTE DEIQVE / DOGMATA CEPERVNT ESSE
IN HONORE SVO. [If it pleases you to see the illustrious images of heroes,
look on these: no picture ever bore greater. The great debate, competition
and great question is whether father or son is the victor. For both indeed
were supreme. The former often overcame his enemies and the
conflagrations of his country, and finally brought peace to its citizens.
The son, born indeed for greater things, removed the unworthy from
their altars and replaced them by upright men. The arrogance of the
Popes has yielded to unerring virtue, and while Henry VIII holds the
sceptre in his hand religion is restored and during his reign the doctrines
of God have began to be held in his honour.]
The Royal Collection

This painting is the only record of the whole of Holbein's wall
painting for the Privy Chamber of Whitehall Palace, destroyed
when the Palace burned down in 1698. It includes the date 1537,
the inscription on the stone tablet in the centre and reveals the
parts of the painting which cannot be seen in the surviving
cartoon for the left-hand part (no.104), including the figures
of Elizabeth of York, Henry's mother and Queen Jane Seymour,

Henry VIII's third queen, who may have died during the
painting's execution or even before the commission was begun.
Above is illusionistic vaulting taken from Prevedari's engraving
after Bramante, which also inspired Holbein's Haus zum Tanz
design in Basel (no.8).

There is one highly significant difference in the figure of Henry
himself: here he is shown full face, as in copies after the image
(no.131) rather than three-quarter face as shown in the cartoon;
as Buck has noted, this change may have followed the queen's
death, after which Henry was the only living figure represented.
In the cartoon the king's head is a separate piece of paper.
A full-face head could easily have been substituted for this three-
quarter face view at the next stage of preparation. It was perhaps
amended without needing a further sitting, as Holbein had
contrived with Lady Guildford's portrait (see no.17).

The Latin inscription, debating whether the achievements
of Henry VII or Henry VIII were greater (the former bringing
peace to the country, the latter religious reform), underlines
the dynastic intentions of the composition, a celebration of the
achievements of the Tudors. It was subject matter also applied
to small objects such as the steel mirror with the 'phisnomy of
King Henry theight and his progenitours', inventoried in 1547.

Provenance: Painted for Charles II; thereafter in The Royal Collection
Literature: Millar (216), p.117; Buck 1997, pp.139–50, 193–5
Reference: Starkey 1998 (3096)

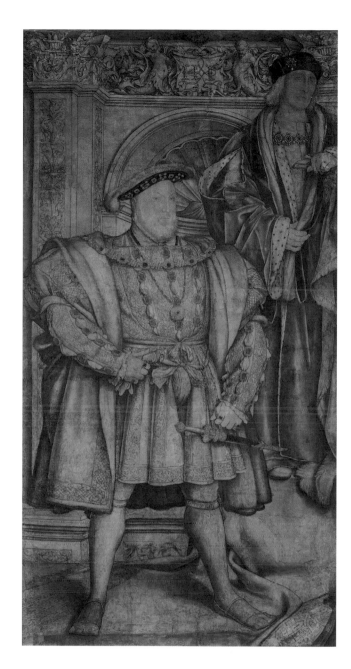

104 *King Henry VII and King Henry VIII* 1537

Ink and watercolour on paper 257.8 × 137.2 cm
National Portrait Gallery, London

Only the left-hand portion survives of the preparatory cartoon
Holbein made for his lost wall-painting in the Privy Chamber
at Whitehall Palace (see no.103). It was assembled from twenty-
five separate pieces of paper: the figures were cut out, pasted
separately onto the background and this was then cut away,
presumably to avoid a doubling of thickness. Since the cartoon
shows no traces of charcoal dust in the tiny pricked holes
still clearly visible around the outlines of the drawing it was
presumably pricked through to make an auxiliary cartoon
(see no.129), which could then be amended and used directly
on the wall, preserving the original. Not all the outlines were
pricked, especially those of the architecture, and Lois Oliver
has suggested (oral comment) that this may have been because
the right-hand side could have been copied from the left as is
evident in some of Holbein's goldsmiths drawings (nos. 91, 95).

Provenance: John, Lord Lumley by *c.*1590; William Cavendish,
2nd Duke of Devonshire at Chatsworth House by 1727 and by
descent; presented to the National Portrait Gallery 1957 under
the acceptance-in-lieu scheme
Literature: Strong 1969, pp.153–5; Rowlands 1985 L14(b);
Fairbrass and Holmes 1986; London 1988 (213), p.252;
Buck 1997, pp.110–24

105 *Henry VIII* c.1537

Oak 28 × 20 cm
Museo Thyssen-Bornemisza, Madrid

Holbein's image shows Henry dressed in magnificent cloth
of silver and of gold, his shirt collar embroidered with gold
thread. Holbein used powdered gold in his paint and for the
background the expensive ultramarine pigment usually seen
in the background of miniature portraits: this image was clearly
intended to be handled and gazed at closely. The painting
technique is correspondingly detailed, as shown in the
representation of the face with its carefully modulated flesh
tones, deep rose cheeks, and wrinkles at the corners of the eyes.

Both this portrait and the Privy Chamber cartoon (no.104)
were probably based on a single original drawing, as is suggested
by the alteration to the right hand: Holbein originally painted
the thumb pointing upward, just slightly lower than it is seen in
the cartoon. The function of the portrait is unknown. Similarities
to portraits of Francis I have suggested it might have been sent
as a reciprocal gift to the King of France, of whom Henry owned
a portrait 'set in a rounde Tablet of golde enamelede'. Bevelled
and unpainted on the reverse, it is unlikely to be the portrait
recorded in Henry VIII's inventory as part of a diptych joined
to a portrait of Jane Seymour.

Provenance: Robert, Earl of Sutherland; Earl Spencer,
by descent until 1933; Thyssen-Bornemisza collection 1934
Literature: Lubbeke (53), pp. 250–5; Buck 1997, pp. 101–2
Reference: Starkey 1998 (2917, 10613)

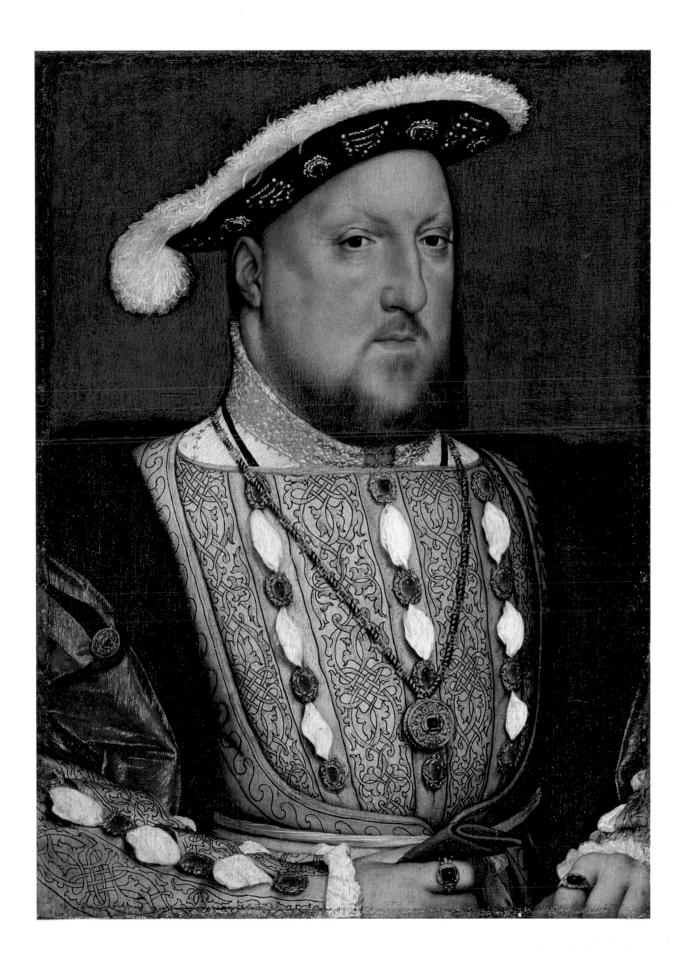

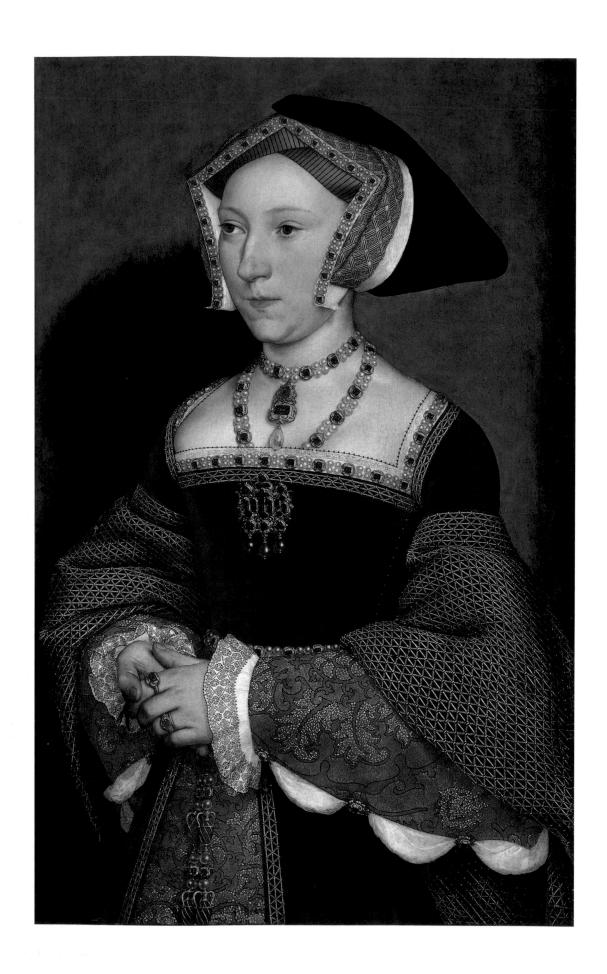

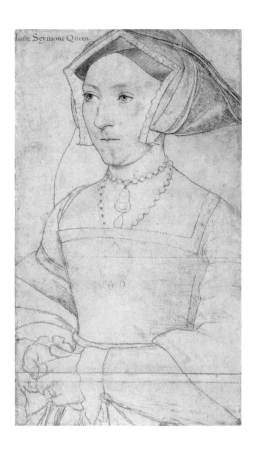

106 *Queen Jane Seymour* 1536–7?

Oil on oak 65.4 × 40.7 cm
Kunsthistorisches Museum, Vienna, Gemäldegalerie

Jane Seymour (1508/9–1537) married King Henry VIII as his third wife on 30 May 1536. She died on 24 October 1537, twelve days after giving birth to Edward Prince of Wales (nos.108–110). The function of this painting is unknown, and it is not identifiable in the royal inventories; possibly it was made to be sent abroad.

Jane Seymour is shown in the three-quarter view image of Holbein's portrait drawing (no.107), which it matches precisely in size. The underdrawing revealed by infrared examination follows the drawing in some details which were then adjusted during the execution of the painting, for example the omission of the large jewel at her wrist, the extension of her left thumb and the adjustment of the folds of her cuff at the waist. Her clothes and jewellery differ from the drawing: she wears a necklace of pearls and precious stones set in gold rather than the large pearl necklace of the drawing, and has undersleeves of looped metallic pile created by painting over silver leaf, rather than the pleated undersleeves seen in the drawing. The composition was prepared with great care: as well as a salmon-pink priming Holbein used grey underpainting to indicate areas of the composition including the shadow to the left.

Provenance: Possibly Amsterdam before 1604; Hofburg Vienna 1720
Literature: Rowlands 1985 (62); Hague 2003 (27); Strolz 2004

107 *Jane Seymour* 1536–7

Coloured chalks reinforced with pen and ink and metalpoint on pink prepared paper 50.3 × 28.7 cm with a join 6.4 cm from lower edge
Inscribed: Iane Seymour Queen
The Royal Collection, The Royal Library, Windsor

This drawing established the basis for portraits in which the Queen wore variants of the dress and jewellery shown here. In the Whitehall wall painting (see no.103) she is shown at full length and in a richer costume: the image must have been enlarged to match that of Henry (no.104). The proportions of this drawing have been transferred exactly to the portrait now at Vienna (no.106) but the clothing and jewellery were altered. In a small portrait at the Mauritshuis, The Hague, the image is half the size of this drawing and the clothes and jewellery follow closely; that portrait may have been produced in Holbein's workshop. The drawing is well worn and has been extensively traced over with metalpoint as part of the process of transferring its outlines; the folds in the lower part were perhaps made to indicate the extent of versions of the portrait. The sheet has been slightly extended to include the hand.

Provenance: See no.15
Literature: Parker 1983 (39); Edinburgh 1993 (21), p.66; Hague 2003 (26)

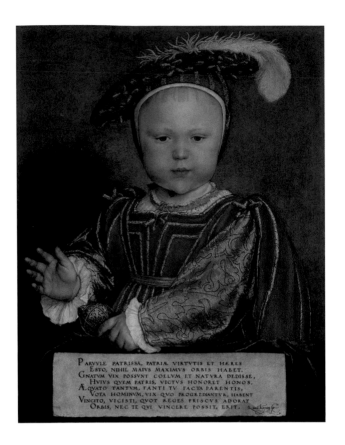

108 *Edward Prince of Wales* 1538

Oil on panel 56.8 × 44 cm
Inscribed: PARVVLE PATRISSA, PATRIÆ VIRTVTIS ET HÆRES / ESTO, NIHIL MAIVS MAXIMVS ORBIS HABET. / GNATVM VIX POSSVNT COELVM ET NATVRA DEDISSE, / HVIVS QVEM PATRIS, VICTVS HONORET HONOS. / ÆQVATO TANTVM, TANTI TV FACTA PARENTIS, / VOTA HOMINVM, VIX QVO PROGREDIANTVR, HABENT / VINCITO, VICISTI. QVOT REGES PRISCVS ADORAT / ORBIS, NEC TE QVI VINCERE POSSIT, ERIT. Ricard: Morysini. Car: [Little one, emulate your father and be the heir of his virtue; the world contains nothing greater. Heaven and earth could scarcely produce a son whose glory would surpass that of such a father. Only equal the deeds of your parent and men can wish for no more. Surpass him and you have surpassed all the kings the world ever revered and none will surpass you.]
National Gallery of Art, Washington, Andrew W. Mellon Collection

Henry VIII's sole male heir Edward Prince of Wales (1537–1553) was born on 12 October 1537 to his third wife Jane Seymour (nos. 106, 107). He was crowned Edward VI in 1547. The painting is almost certainly the 'table of the picture of the prince's grace' that Holbein gave King Henry VIII at New Year 1539, for which he received a gold cup in return. The inscription was composed by Richard Moryson, a humanist writer in the service of Thomas Cromwell. Image and inscription flatter Henry VIII: just as the text urges the infant prince to imitate his father, so Holbein shows him as an adult monarch, his rattle held like a sceptre, a courtly joke.

The background to the portrait was originally blue (smalt, the pigment used, has discoloured over time) and the prince's cap was glazed with red over silver leaf, of which only fragments now remain. The paint was applied over a salmon-pink priming layer similar to that of the drawings. The ostrich feather adorning the cap, which Holbein has depicted with bravura, was presumably the work of Paul Freland, the kings's 'oystregefederer'.

Provenance: Henry VIII; Earl of Arundel; probably William III; Het Loo; Ernest Augustus, Duke of Cumberland and King of Hanover, Royal Castle, Georgengarten, Hanover, by 1844; by descent to Crown Prince of Hanover (d. 1923); purchased Andrew W. Mellon; gift 1937
Literature: Hand with Mansfield 1993, pp. 83–91; London 1995–6 (6), pp. 41–2; London 1997, p. 84; Mauritshuis 2003 (33), pp. 130–2

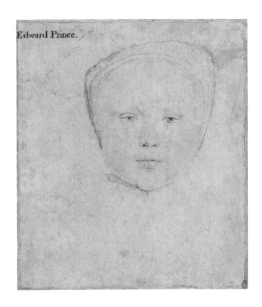

109 *Edward Prince of Wales* 1538

 Coloured chalks, retouched with pen and ink 26.7 × 22.6 cm
 Inscribed: Edward Prince
 The Royal Collection, The Royal Library, Windsor

This now somewhat faint drawing records a sitting with the very young Prince Edward, who is unlikely to have remained still for a sufficiently long period for Holbein to record his features in great detail. The face of the drawing is slightly smaller in all its dimensions than that of the painted portrait it resembles (no.108). The underdrawn eyelids of the painting were originally higher and as on other occasions such as the making of the portraits of Sir Henry and Lady Guildford (nos.16–18) Holbein may have transferred his drawing directly before amending it, or he perhaps made use of a second, intermediary pattern drawing which included the enlarged facial contours to transfer the outlines of the features, finally adjusting the position of the features during painting.

 Provenance: See no.15
 Literature: Parker 1983 (46); Houston 1987 (25), p.86;
 Hand with Mansfield 1993, pp.83–91

110 *Portrait of Prince Edward in a Roundel* 1538

 Pen and black ink on paper, compass point Diameter 5.1 cm
 Kunstmuseum Basel, Kupferstichkabinett

The identity of Prince Edward can be established by comparison with his painted portrait (no.108), although he appears younger here, barely sitting on a cushion. On the right is a pet dog on a lead. Surrounding him are oak leaves and acorns, a symbol of renewal, suggesting Edward's significance in the perpetuation of the Tudor lineage. The drawing, with its precise outlines and roundel format, was probably intended to be engraved onto precious metal or stone as for example the agate portrait of Edward in the inventory of Henry VIII: 'Item an Agathe of the kinges face that now is' (i.e. Edward). In 1540 the Queen of Navarre urged Henry VIII to send portraits 'in a lyttyll rounde tablet', including his own and Prince Edward's.

 Provenance: Amerbach-Kabinett 'English sketchbook'
 Literature: Müller 1996 (228); Starkey 1998 (2147), p.68;
 Nichols 1857, I, p.cccxliii

III *Anne of Cleves* 1539

> Gum on vellum in ivory case Diameter 4.6 cm
> Victoria and Albert Museum, London

In August 1539 Holbein took the portraits of the two daughters of the Duke of Cleves, Amelia, and Anne (1514–1557), who became Henry VIII's fourth wife in 1540. Henry's ambassadors had rejected other portraits as the 'monstruouse' apparel worn by the sisters displayed 'but a parte of theyr faces'. Here Anne's whole face is evident, and the size of her headdress has been reduced by comparison with Holbein's full-size, three-quarter length painting (Louvre). This miniature, possibly in its original ivory case in the form of a Tudor rose, and making use of expensive ultramarine pigment in the background and on the headdress, was perhaps made for Henry's private perusal. Anne herself appears alluring to modern eyes, but Henry VIII found her unappealing, and the marriage was annulled after six months. However, Holbein continued to receive his salary as a royal painter and there is no evidence he was blamed, while Thomas Cromwell, who promoted the marriage, was executed.

> Provenance: Apparently Mr Alexander 1720; Colonel James Seymour 1732; Thomas Barret of Lee Priory, Kent *c.*1739; sold by Thomas Barret 1826; Francis Douce; Sir Samuel Rush Meyrick; Eleanor Davies; George Salting Bequest 1910
> Literature: Murdoch 1981, p.37; Rowlands 1985 (M.6); London 1995 (66), p.119; London 1997–8, p.85; London 2003 (18); Foister 2004, pp.203–4

112 *Queen Catherine Howard*? *c.*1540

> Vellum on playing card Diameter 6.4 cm
> The Royal Collection

Catherine Howard (1518/24–1542) was Henry VIII's fifth queen. The daughter of Lord Edmund Howard and niece to the 3rd Duke of Norfolk (no.164), she married Henry in 1540 after his divorce from Anne of Cleves (no.111) but was executed for adultery in 1542.

There are no certain portraits of Catherine Howard, but a miniature said to be of the Queen by Holbein was recorded in the seventeenth century in the collection of the artist Pieter Stevens. Hollar etched a similar portrait in the mid-seventeenth century, but included no identification. This portrait image has been identified as Catherine Howard since the engraving by Houbraken of *c.*1735–40 after the version now owned by the Duke of Buccleuch. The cloth of gold and silver and the jewels the sitter wears are indicative of very high status. Her ruby and emerald pendant and pearl necklace are very similar to those one worn by Jane Seymour (no.111) and the jewelled border of her dress has been compared to one Henry VIII gave to Catherine Howard, but conclusive evidence for the identification is lacking.

> Provenance: Possibly Charles II; first certainly recorded *c.*1837
> Literature: London 1980–1 (P6), p.101; Rowlands 1985 (M.8); Edinburgh 1993 (31), p.90; Reynolds 1999 (6), pp.50–2
> Reference: Briels 1980, p.223

5
Holbein the Portraitist at Work

The only document that described a sitting for a portrait with Holbein mentions a period of 'three hours space'. However, as this sitting took place in Brussels in March 1538 in order for Holbein to take the portrait of Christina of Denmark with whom Henry VIII was contemplating marriage, it may not have been typical: Holbein may have felt the need to make more drawings than usual, and he must certainly have paid attention to the need for a full-length likeness, otherwise rare in his work (no. 157). He may have needed to make costume drawings, very few of which otherwise survive (nos. 122, 123). Yet, as the example of the portrait of John Colet (no. 103) shows, as well as that of Philip Melancthon (no. 151), Holbein's images can be deceptively animated: artists did not always work from life where portraits of the famous were concerned.

Nevertheless, Holbein's individual portrait paintings are nearly all based on studies from life that have survived as a group (notable exceptions are those for the Hanseatic merchants, who perhaps wished to keep them). Comparisons between surviving pairs of portrait drawings and paintings have established – by for example placing tracings of one over the other – such close correspondences that Holbein must have used a method of transferring his drawings directly to the panel. Several such methods were well known in the sixteenth century: pricking outlines and shaking charcoal dust through to create a dotted outline was one (see nos. 24, 104, 129), but for the majority of his portrait commissions Holbein is likely to have employed a method which involved making a sandwich of his drawing and the prepared panel, with the filling a piece of paper covered in chalk or charcoal: only light pressure with a stylus was required to transfer the outlines. Studies with infrared reflectography, revealing the preparatory under-drawing of Holbein's paintings under the painted surface, have rarely revealed any adjustments to the contours of the features, and such underdrawing shows the linear restraint characteristic of a drawing following a traced line. These are often concealed under the painted outlines, which follow them closely, though there is sometimes some admendment to the external contours of the head,

particularly to hats, and frequently to the hands. The surviving drawings have been trimmed, but it is evident that most do not extend beyond heads and shoulders, and would not have included the hands. Only one separate drawing for the hands in a portrait survives, those for the portrait of Erasmus of 1523 (no. 13).

It has been suggested that Holbein made use of an apparatus consisting of a peephole attached to a pane of glass: the artist looked through the peephole with one eye and traced the likeness of the sitter onto the glass, sometimes using a sticky pigment. The image could then be transferred to paper, though this would mean that the image would be reversed; a second process of transfer or tracing would be needed to ensure it was as originally drawn. If Holbein used this method this would have been particularly important as he paid great attention to the differences between the left and right-hand sides of the face. However, the inconsistency in the sizes of the drawn heads Holbein produced and the fact that using such an apparatus would generally have produced heads on a rather smaller scale argues against his use of the device. Never-theless, some portrait drawings include lines which have the quality of an off-set produced by pressure, particularly in the figures rather than the faces (see no. 49). Holbein used this technique for his goldsmiths' drawings (no. 101) and it is likely that he sometimes made use of his own drawings in this way to establish and re-create poses.

Although by the time of his second visit to England Holbein had developed a consistent method of taking a likeness, using pink primed paper to give the flesh tones, probably for speed, he would sometimes need to enlarge or reduce his drawings. For portrait miniatures for which drawings of the usual size survive (nos. 115, 116), it is likely that he employed a geometrical method of reduction rather than a mechanical one. As with the drawing of the More family (no. 23), Holbein probably offered his own ideas for a finished composition, but may also have kept notebooks of possible compositions in which ideas were repeated, as they are in the miniature of Henry Brandon and the compositional drawing of a family group (no. 121).

113 *Sir Richard Southwell* dated 1536

Coloured chalks, pen and ink, metalpoint on pink prepared paper
37 × 28.1 cm
Inscribed: ANNO ETTATIS SVAE / 33 and Die augen ein wenig gelbatt
Rich: Southwell Knight
The Royal Collection, The Royal Library, Windsor

The drawing, which has been trimmed, is unique in including
the inscription that appeared on the painting (no.114) that
followed it. Holbein has turned the sheet at right angles
to annotate the drawing with his observation of the colour
of Southwell's eyes: a little yellow. The painting follows the
drawing precisely, including the adjustment to the back of the
neck; the drawing also provided the positions for the tubercular
scars on Southwell's neck and face. Although the red chalk
stripes of the sleeve are not reproduced, the silhouettes of the
precisely angled buttons are followed exactly in the painting,
where they form a striking counterpoint to the description of
the facial features. Southwell's chain is indicated only in outline.
His hat badge is blank, no doubt to be the subject of another
drawing: a sketch for a similar badge appears on the drawing
for the portrait of Sir Thomas Parry (Parker 81), and likewise
on the drawing of Lady Audley (no.115). The drawing
shows signs of transfer to the panel by reinforcement of
the outlines with metalpoint.

Provenance: See no.15
Literature: Parker (38); Edinburgh 1993 (20), pp.64–5;
Hague 2003 (21), pp.104–5

114 *Sir Richard Southwell* 1536

Oil on panel 47.5 × 38 cm
Inscribed: .X°. IVLII.ANNO. / .H. VIII. XXVIII°. ETATIS SVAE /
ANNO XXXIII.
Galleria degli Uffizi, Florence

The significance of the date in the inscription is not known, but
its precision is highly unusual in Holbein's portraits of English
sitters. Sir Richard Southwell (1503/4–1564), of Norfolk origin
like others among Holbein's sitters, was an MP, administrator
and diplomat and evidently a religious conservative, despite his
association with Thomas Cromwell. He was nevertheless
involved in the suppression of the monasteries from 1535 and
in 1536 was appointed receiver for the Court of Augmentations,
which dealt with the proceeds.

The half-length composition is reminiscent of those of Holbein's
first visit to England (see nos. 21, 22) and includes a hint of a
brilliant red tablecloth on which Southwell rests his hands, but
its use of shadow increases the sense that the sitter shares our
space rather than occupying his own; the illusionism of Holbein's
painting of the black silks and satins of Southwell's coat as well
as the subtle transitions between shadows and highlights in the
flesh painting heightens this sense. On Southwell's hat is a badge
with the bust of a moorish woman of gold and agate.

Provenance: Earl of Arundel; Grand Duke Cosimo II de Medici 11620/1
Literature: Rowlands 1985 (58); Hackenbroch 1996, pp.343–4;
Hague 2003 (22), pp.104–5

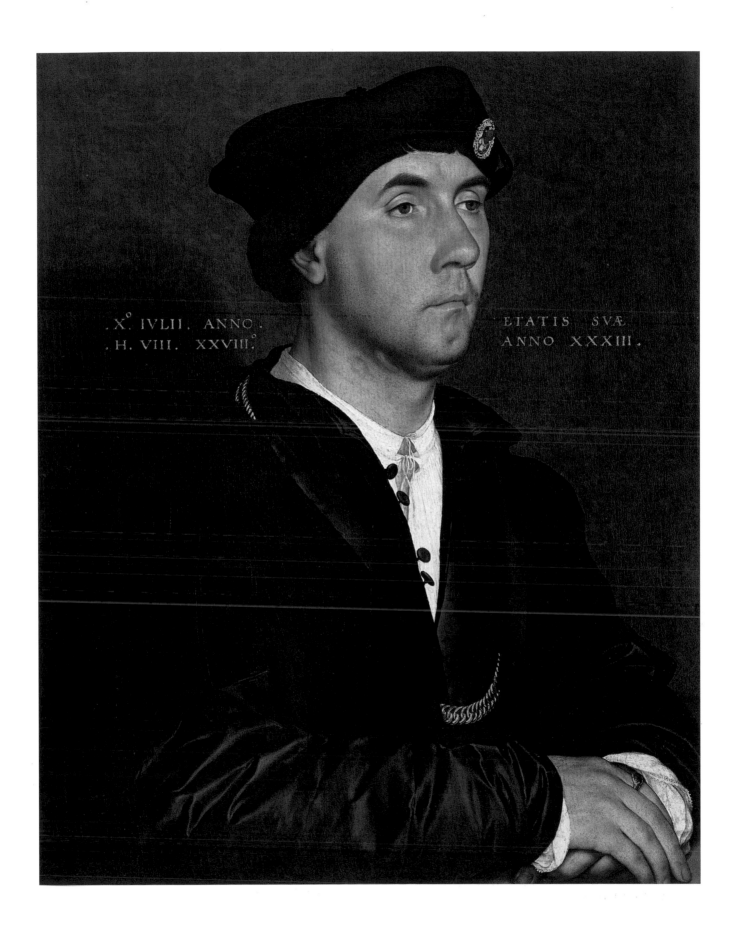

115 *Lady Audley* c.1538

> Vellum on playing card Diameter 5.6 cm
> The Royal Collection

There were two Lady Audleys in Holbein's time at court.
One was Elizabeth Tuke, daughter of Sir Brian Tuke (no.141),
who had a portrait of her made in connection with her marriage.
She became the wife of George Touchet, future 9th Lord
Audley, but the couple was impoverished and probably did not
come to court; moreover she did not become Lady Audley until
1557. The sitter is therefore likely to be Elizabeth Grey (d.1564),
daughter of the 2nd Marquess of Dorset and wife of Thomas
Lord Audley of Walden. Their marriage in 1538 may have been
the inspiration for the portrait.

The red dress follows the annotations of the drawing (no.116)
but the jewellery departs from it: the necklace differs in design,
the stones in the brooch meant to be green are painted black,
perhaps representing diamonds, and the pendant pearls are
absent. The headdress is also more elaborate.

> Provenance: Possibly Charles II or Duchess of Portsmouth 1692;
> Queen Victoria by 1866
> Literature: London 1977–8 (44), p.79; Rowlands (M9);
> London 1997–8, pp.70, 102; Reynolds 1999 (5), pp.49–50;
> Hague 2003 (32), pp.125–7; Foister 2004, pp.25–6

116 *Lady Audley* c.1538

> Coloured chalks, metalpoint, pen and ink on pink primed paper
> 29.2 × 20.7 cm
> Inscribed: The Lady… Audley; annotated samet rot damast rot w Gl
> and with the symbol for green
> The Royal Collection, The Royal Library, Windsor

The drawing is closely related to the miniature (no.115), though
the two differ in some details. Whether there was also a full-size
portrait on panel is unknown, but Holbein may have used a
simple geometrical method to decrease the size of his portrait
drawings until they matched the size of likeness needed for his
miniatures: the device known as the pantograph which made
such diminutions in size mechanically is not known before the
seventeenth century but differences in the size of images could
be achieved with the aid of compasses.

There is a small drawing of a woman with naked breasts top
right, conceivably a detail for the architectural background of
a full-size portrait (though such backgrounds would be unusual
in Holbein's portraits of this date) or for a jewel similar to the hat
badge of Sir Richard Southwell (no.113); two similar sketches
are at Basel.

> Provenance: See no.15
> Literature: Parker 1983 (58); Hague 2003 (31), pp.126–7;
> Reference: Müller 1996 (219 and 220)

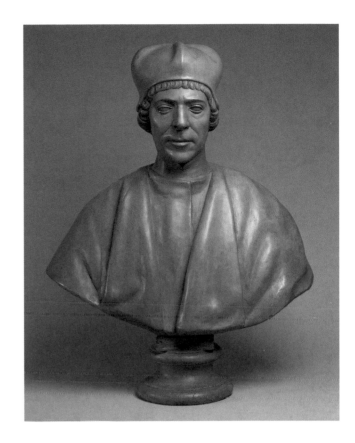

117　*John Colet*　c.1535

> Coloured chalks, reinforced with pen and ink and metalpoint
> on pink prepared paper　26.8 × 20.5 cm
> Inscribed: Iohn Colet Dean of St Paul's
> The Royal Collection, The Royal Library, Windsor

This drawing was not made from life but from the bust of Colet attributed to Pietro Torrigiano (see no. 118). The lower part of the drawing describes the lower margin of the bust, making it evident that it could not have been created from life; in any case Colet (1467–1519) had died before Holbein first came to England. John Colet, humanist scholar and founder of St Paul's School, was a close friend of Erasmus and Sir Thomas More. The drawing was presumably made in preparation for a posthumous painted portrait of Colet, perhaps a commission for one of the generation of humanists who admired him in the 1530s, such as John Leland who wrote a poem in praise of his sculpted image ('statua') (see no. 52). The idea of animating sculpture would have appealed to humanists and Holbein had already made drawings in France of the monuments of the Duke and Duchess of Berry who endowed them with eyelashes and the general appearance of life. No painted portraits of Colet are recorded.

> Provenance: See no. 15
> Literature: Parker 1983 (59); Grossmann 1950;
> Houston 1987 (44), pp. 124–6

After Pietro Torrigiano (1472–1528)

118　*John Colet*　after original of c.1519

> Plaster cast　Height 83.8 cm
> National Portrait Gallery, London

The lost original has been attributed to the Italian sculptor Pietro Torrigiano or Torrigiani, who worked in England from 1511 to the early 1520s, designing the tomb of Henry VII in Westminster Abbey as well as other sculpture including marble, bronze and terracotta busts and tombs. Only casts of the bust survive, which was probably made after a death mask. The original evidently inspired the portrait which formed part of the second monument to Colet in St Paul's Cathedral, erected in the sixteenth century but destroyed in the Great Fire of 1666.

> Provenance: Acquired from the Victoria and Albert Museum 1970
> Literature: London 1977–8 (11, 12), pp. 25–6; London 1990 (II.13), p. 34
> Reference: ODNB, 'John Colet', J.B. Trapp; ODNB, 'Pietro Torrigiani', A. Darr

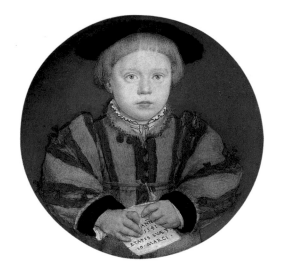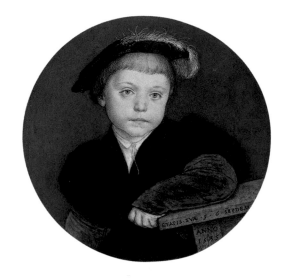

119 *Charles Brandon, 3rd Duke of Suffolk* c.1541

> Inscribed: ANN / 1541 / ETATIS.SVAE.3 / .10 MARCI
> Vellum on playing card Diameter 5.6 cm
> The Royal Collection

120 *Henry Brandon, 2nd Duke of Suffolk* 1541

> Inscribed: ETATIS SVAE 5.6 SEPDEM. / ANNO / 1535
> Vellum on playing card Diameter 5.6 cm
> The Royal Collection

Henry Brandon (1535–1551) and his brother Charles (1537/8–1551) were the sons of Charles Brandon, Duke of Suffolk by his fourth wife Katherine Willoughby; Henry succeeded his father in 1545. Precocious in learning, Henry was educated with Edward Prince of Wales (nos.108–110). In 1551 both Henry and Charles fell ill from sweating sickness and died within an hour of each other.

Henry's pose, his arm resting on a pillar, mimics that of portraits of adults such as Derich Born in the portrait of 1533 (no.158); the pillar recalls the portrait of Sir Thomas More of 1527. His sleeve is hatched with red to represent shot green silk. Charles too is shown in a pose reminiscent of many adult portraits. The inscription on his portrait probably refers to the year of his birth and to his age on his birthday in 1541 (the date inscribed on the miniature of his brother), although his birthday was either 16 or 18 September.

> Provenance: Gift of Sir Henry Fanshawe to Charles I; sold and recovered for Charles II
> Literature: Rowlands 1985 (M.10, 11); Edinburgh 1993 (32, 33), p. 92; Reynolds 1999 (7, 8), pp. 52–3

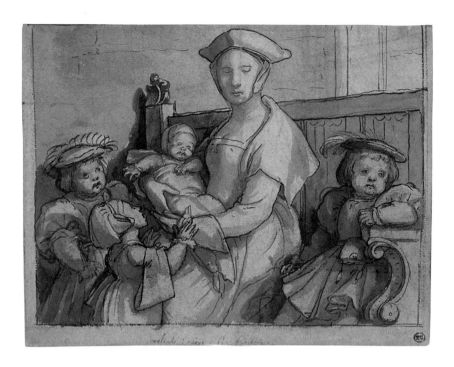

121 *A Woman Seated on a Settle with Four Children*

c.1540

Pen and black ink, with grey and black wash over traces
of an underdrawing in black chalk 13.4 × 16.9 cm
Inscribed by a later hand. exaltate Cedrus H. Holbein
The British Museum, London

The similarity between the pose and appearance of the boy
on the right of the drawing and that of Henry Brandon, the
future Duke of Suffolk, in Holbein's miniature (no.120) has
often been noted, but it is unlikely that there is any connection
between this drawing and the miniature. The drawing, like
that for the More family group (no.23), is carefully composed,
and is likely to be a preparatory sketch for a painting or other
work. The wooden panelled bench resembles that in the
background of the portrait of a woman at the Detroit Institute
of Arts, and of the portrait of Thomas Cromwell at the Frick
Collection, New York of 1532–4; the woman's costume is also
similar to the former portrait, as well as to others of the early
1530s (see no.40). Rowlands has compared the style to that
of the drawing of *The Triumph of Riches* (no.66), and the pose
of the right-hand boy resembles that of the portrait of Derich
Born of 1533 (no.158). It is therefore likely that the drawing
dates from the early 1530s, and shows a child in a pose that
Holbein was to select again nearly a decade later for the
miniature of Henry Brandon. It is notable that the woman,
nurse or mother, has her eyes closed, and the small girl is trying
to attract her attention; it is possible therefore that the drawing
was not intended for a portrait but for a subject composition of
a different type, or conceivably, that the central figure is a nurse
who was to be substituted by her mistress in the final stages
of the commission.

Provenance: R. Cosway sale, 16 Feb 1822; E.V. Utterson,
Sotheby's 30 April 1852 (lot 277)
Literature: London 1988 (198), pp.230–1; Rowlands 1993
(320), pp.146–7

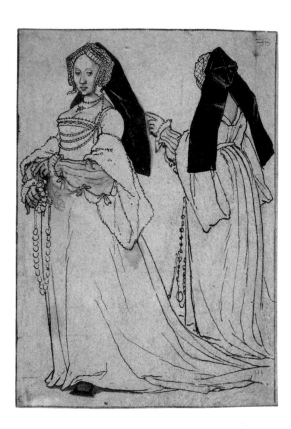

122 *Two Views of a Lady wearing an English Hood*
1526–8 or *c.* 1532–5

Brush drawing in black ink, tinted with pink and grey wash
on off-white paper 15.9 × 11 cm
Inscribed by a later hand: HHB and HH
The British Museum, London

Costume drawings made by artists including Holbein and
Dürer were a useful part of a workshop repertoire, as aids to
understanding changing fashions, as well as variations of costume
among different occupations and social groups. Holbein's Basel
costume drawings are more detailed, with extensive use of wash
but also include a back view as seen here. This careful and
beautifully fluid study appears to date from Holbein's first visit
to England or possibly from early in the second. The costume
is very similar to that worn by Lady Guildford (no. 17) in the
finished portrait now in the St Louis Art Museum. This suggests
that this may be a second study for the portrait, in which Holbein
recorded the dress, probably modelled by a servant. The fact that
he drew a back view as well as the front shows he was particularly
concerned to understand the structure of English costume:
he was unlikely to show such a view in a portrait, and the drawing
of John Poyntz at Windsor (Parker 54) is highly unusual in
showing a partial back view.

Provenance: Sir T. Lawrence; Sir J.C. Malcolm
Literature: Rowlands 1993 (319), p. 146
Reference: Müller 1996, pp. 95–8; Parker 1983 (54); Basel 2006 (150)

123 *A Young Englishwoman* 1526–8 or *c.* 1532–5

Pen and black ink and watercolour on paper 16 × 9.2 cm
Ashmolean Museum, Oxford, Douce Bequest, 1834

This coloured costume study is one of only two that survive from
Holbein's visits to England (the other is no. 122). Unlike that
study, in which the subject appears to pose, this seems not to be
connected with a specific portrait, but is drawn as if to record the
dress of a passer-by, holding her dress above the ground as she
walks. Her rosary beads are prominent. The costume resembles
those seen in the More family drawing (no. 23), and the drawing
may date from the first visit to England or, as Christian Müller
has argued, from early in the second. This air of an informal
study may have inspired the drawing after it attributed to
Rembrandt, now in Oslo; the original is likely to have been in
the Netherlands at the time, but Rembrandt may have worked
from a copy.

Provenance: In the collection of Francis Douce by 1813
and bequeathed to the museum 1834
Literature: Brown 1982 (4), p. 5; Manuth 1998, pp. 327, 329;
Basel 2006 (151)

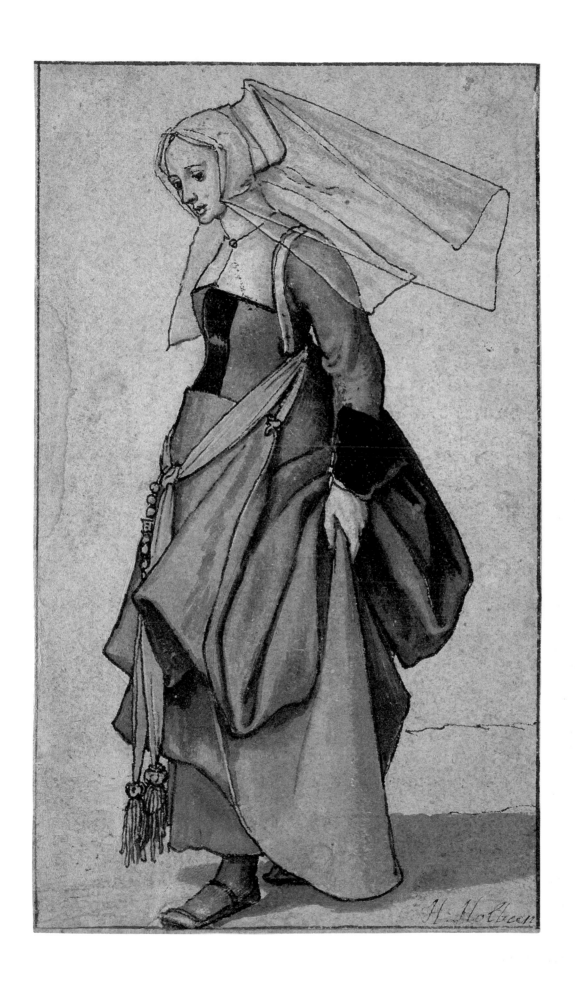

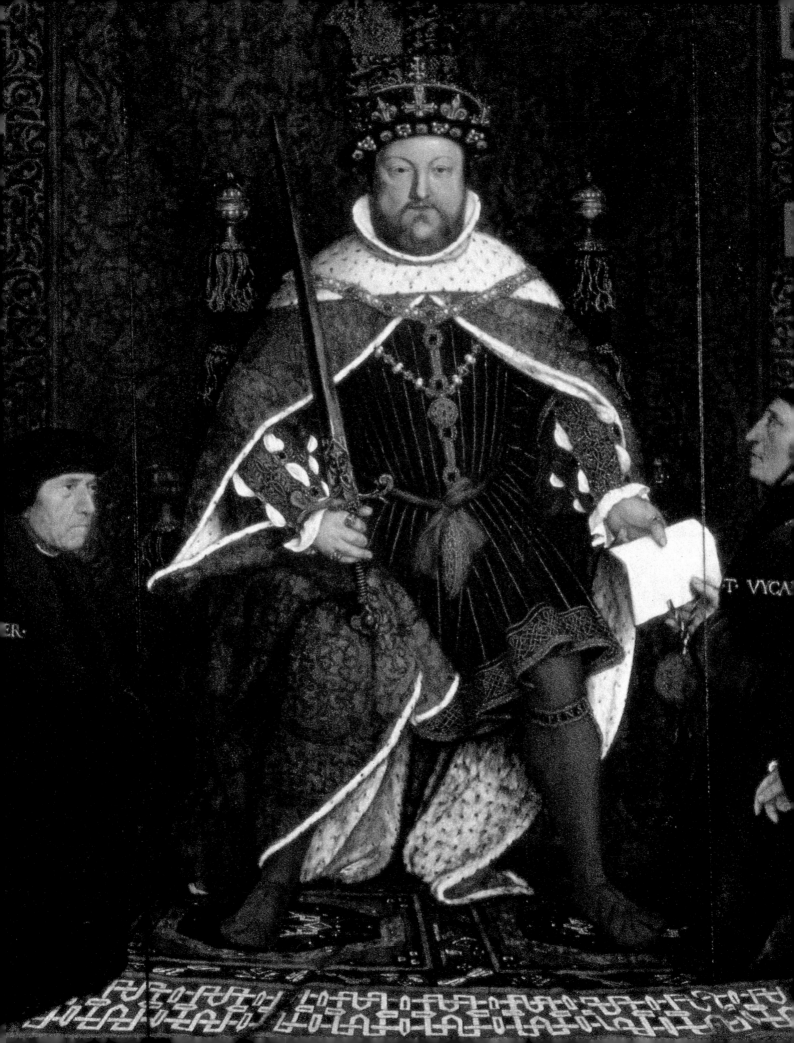

6
Holbein's Workshop and Legacy

English law tried hard to impose restrictions on foreigners working in England in order to limit the way in which they might compete with English workers: in particular they were not permitted to employ others unless they became English denizens or permanent residents. Holbein finally became a denizen in 1541, along with many others, fearing that because of war with France these laws would be more rigorously enforced. This would have allowed him to employ two other foreigners as 'journeymen' or qualified assistants but it is likely that his position as court painter gave him some protection against prosecution. Had the records of the Painter-Stainers company survived for this period it is likely that there would be many records of foreign painters being fined or imprisoned for such breaches, as there are for foreign goldsmiths such as Hans of Antwerp.

Holbein is recorded living in the parish of St Andrew Undershaft in the City of London, some distance from Whitehall palace. There are no documents concerning his workplace, which may have been adjacent to his accommodation, but at times he must have worked on site, when painting the Whitehall mural in 1537 and at Greenwich in 1527. The records of the latter project show some of the painters were employed to grind pigments, probably young apprentices, and it is likely that Holbein would have had some assistance with making paints, and, in the case of large compositions such as the Whitehall mural, with transferring his designs: the large cartoon (no.104) would have been difficult for one person alone to handle. This must also have been the case with the large group portrait for the Barber-Surgeons Company (no.129), likewise created with the aid of a cartoon. This painting, commissioned not long before Holbein's death, is mentioned in van Mander's 1604 life of Holbein as a work completed by another. It is likely that the work was carried out by a painter or painters used to collaborating with Holbein. A painter 'Harry Maynert' witnessed Holbein's will, but nothing more is known of him and he did not inherit Holbein's painter's tools. A workshop assistant fully conversant with

Holbein's manner could have used Holbein's portrait drawings to make additional versions of portraits when these were called for by clients, but it is important to distinguish these from copies which were made at a later date. One such portrait which may be by a workshop assistant appears to have been painted directly after a drawing by Holbein himself (nos.124,125).

Although Holbein's portrait drawings appear to have been preserved together immediately after his death, at least one had an after-life as a portrait pattern which formed part of a painter's studio material in the later sixteenth century, that of Bishop Fisher (nos.132,133). Holbein's portrait image of Henry VIII spawned numerous copies, but the full-length painting owned by the Seymour family (no.131) is one of very few that can claim to have a contemporary connection with the Whitehall image, the cartoon and other preparatory drawings which lie behind it. A German artist, 'Hanns Swarttung', possibly an assistant to Holbein, may have copied the finished image (no.130). The English painter John Bettes (see no.128) may have known something of Holbein's techniques, but Holbein's legacy was ultimately to be admired rather than imitated: the later sixteenth-century miniaturist Nicholas Hilliard paid tribute to Holbein as 'the greatest master' in portraiture, and claimed to follow his technique, but his practice differed considerably as his description of it in 'The Art of Limning' indicates.

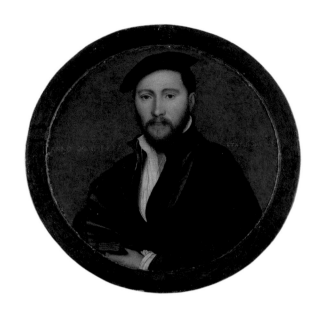

124 *An Unidentified Man* 1535

Coloured chalks, pen and ink on pink primed paper 29.8 × 22.2 cm
The Royal Collection, The Royal Library, Windsor

The drawing is a preparatory study for the portrait dated 1535
which appears to have been produced in Holbein's workshop
(no. 125). There are hard chalk and metalpoint reinforcing lines
over almost all the contours of the drawing, covering the head,
ear and hat as well as the lower part of the body, but omitting the
left-hand side of the face. These must result from the transfer
of the drawing. The sitter has not been identified but the dates
inscribed on the corresponding painted portrait (no. 125) have
plausibly suggested the sitter might be Sir Ralph Sadler
(1507–1587), a protégé of Cromwell who in 1535 became clerk
of the hanaper of chancery; although there are other possible
candidates whose dates of birth would fit those on the painting,
the clothing of the sitter suggests he was probably not of
noble birth.

Provenance: See no. 15
Literature: Parker 1983 (33); Ainsworth 1990, p. 183
Reference: ODNB, 'Sir Ralph Sadler', G. Phillips

Workshop of Hans Holbein the Younger
125 *Portrait of a Man* dated 1535

Oil on oak Diameter 30.5 cm
Inscribed: ANNO DOMI[NI] 1535 ETATIS SVÆ 28
The Metropolitan Museum of Art, New York,
The Jules Bache Collection, 1949

This portrait is based on the drawing by Holbein (no. 124).
Maryan Ainsworth's investigation of the portrait showed that the
contours of the portrait match the drawing precisely, following
its incised lines. As she also noted, the underdrawing is however
unusually extensive and untypical of Holbein's portraits, but does
not suggest the work of a copyist. The painting itself, while very
close to Holbein's manner, is weaker in execution than portraits
that are certainly Holbein's; the hands, which Holbein usually
added to his compositions at a later stage, are disproportionately
small and narrow. This evidence suggests that the portrait was
produced under Holbein's supervision but by an unidentified
assistant who must have been working with him in England.

Provenance: Mr and Mrs Arthur Sachs, New York;
Jules S. Bache; acquired 1949
Literature: Rowlands (R22); Ainsworth 1990, p. 183

Hans Holbein the Younger and Workshop

126 *Portrait of an Unidentified Gentleman* c.1535–40?

Coloured chalks with white chalk heightening, brush and ink
on pink prepared paper 36.2 × 26.8 cm
Victoria and Albert Museum, London

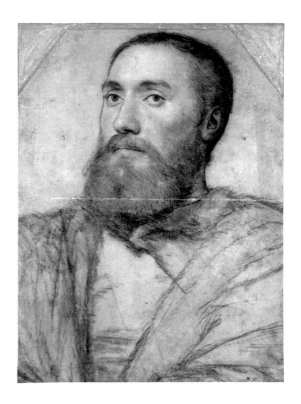

The truncated corners of this drawing may indicate that it shares
a history with other drawings by Holbein (see no. 58). Lois
Oliver has shown that the paper bears a watermark identical to
that of the drawing of John Poyntz at Windsor (Parker 54) and
that of a sword handle at Basel (no. 100). Rowlands was the first
to suggest that the drawing was by Holbein himself, although
the abrupt manner in which the head is attached to the very
broad shoulders is uncharacteristic of other drawings, the ear is
very small and the confused quality of the chalk drawing of the
body lacks Holbein's animating touch, though what remains of
the red chalk modelling of the face is finely done. Examination
with the microscope reveals the drawing is extremely similar
in technique to others in The Royal Collection, including the
manner in which ink and brush are used to define the eyelid and
lashes of the right eye, but the left eye has a curiously ovoid iris
and flattish pupil. These characteristics suggests the drawing
may in part be the work of an assistant completing what Holbein
had begun, which was perhaps not much more than the face.
Some drawings in the Windsor group, including that of John
Poyntz, show reworking in ink which appears to be by artists
other than Holbein, and which may be associated with the
production of painted versions. There is also a small group
of drawings in The Royal Collection as well as one, of the Earl
of Surrey, now in the Pierpont Morgan Collection, that employ
a technique very similar to Holbein's but are not by Holbein
himself, though the Windsor drawings were evidently preserved
as a group from shortly after Holbein's death. This suggests that
these may be the work of Holbein's assistants. Lois Oliver has
drawn attention to the sitter's resemblance to a miniature
of Thomas Seymour (National Maritime Museum).

Provenance: Padre Resta; N. Lanier; Rev. Alexander Dyce,
bequeathed 1869
Literature: London 1987 (201), p. 234; Oliver 2006
Reference: Müller 1996 (234); Foister 1983, pp. 4–6

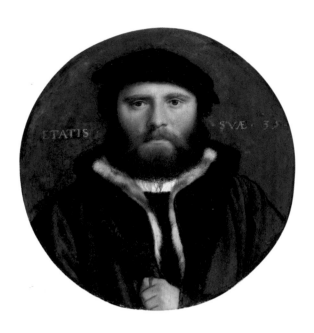

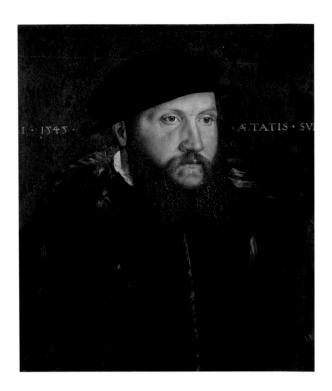

Workshop of Hans Holbein the Younger

127 *An Unidentified Man* c.1535–40?

Oil on oak Diameter 13 cm
Inscribed: AETATIS SVAE 35
Victoria and Albert Museum, London

The subject of this small painting has been identified as the
goldsmith Hans of Antwerp (see no. 91) by comparison with
the portrait of a similar bearded man in The Royal Collection,
although the inscription (now partly illegible) and other details
of that portrait suggest the subject is probably a Hanseatic
merchant; it is conceivable he was both merchant and goldsmith.

The frontal format and deep-blue-green background resemble
Holbein's portraits of the 1530s, especially those of Hanseatic
merchants. The original turned frame has been cut off. Infrared
reflectography shows a number of adjustments to the under-
drawing beneath the painted surface: for example the right eye
was drawn lower (Appendix, fig. iv, p. 155). The end of the nose
is outlined in Holbein's characteristic manner. However,
examination with the microscope reveals a flatter, more descriptive
style of painting than Holbein's, suggesting the possibility that
the artist was a workshop assistant from the Low Countries.

Provenance: Princess Matilde; George Petit; George Salting;
Salting Bequest 1910
Literature: Rowlands 1985 (36b)
Reference: Millar 1963 (29)

John Bettes active 1531–70

128 *An Unknown Man in a Black Cap* 1545

Oil on oak 48.2 × 41.0 cm
Inscribed: [ANNO DOMIN] I.1545 .AETATIS.SV[AE XXVI]; on reverse,
part of original portrait, faict par Jehan Bettes Anglois (twice)
Tate. Purchased 1897

The portrait has been substantially cut down, and would
originally have shown the sitter at three-quarter length. Like
several portraits by Holbein (see nos. 108, 159, 164) it is painted
over a pink priming. The background was originally blue, but
the pigment used, smalt, has discoloured (as in nos. 108, 141).
The painting technique, however, is not very close to Holbein:
the flesh painting uses a narrower range of tones, the fur is
much more loosely painted, the curling hair of the beard flatly
decorative. The underdrawing revealed by infrared reflectography
(see Appendix, fig. v, p. 156) has evidently been drawn and adjusted
freehand, particularly in the nose and eyes, using a dry medium;
the right-hand side shows several contour lines. Bettes is recorded
as a court painter to Henry VIII from 1531, and was also paid for
'limning' portraits, evidently miniatures. He must have known
Holbein. Possibly he imitated his use of pink priming, but on the
evidence of this portrait is unlikely to have assisted him.

Provenance: 2nd Earl Cornwallis by 1780; Thomas Green sale, Christie's,
20 March 1874 (lot 22 or 23); George Richmond by 1875; sold 1897,
purchased for the National Gallery; transferred to Tate 1949
Literature: London 1995–6 (10), pp. 46–7 and pp. 231–5; Hearn and Jones
(forthcoming)

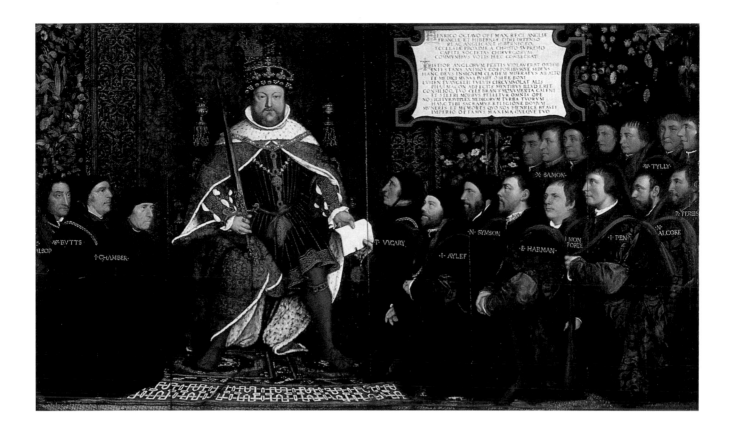

Hans Holbein the Younger and Workshop

129 *Henry VIII and the Barber-Surgeons* begun 1541–3

Oil on panel 180.3 × 312.4 cm
The Worshipful Company of Barbers, Barber-Surgeons' Hall, London

This lifesize painting was commissioned to commemorate the unification of the Company of Barbers and Guild of Surgeons by Act of Parliament in 1540, presumably in 1541 when the Master was Thomas Vicary. The composition, with its overly large seated monarch, follows the type which decorated illuminated parchment charters, and, as Stephanie Buck has suggested, seems to present Henry as a living manifestation of the image seen on his Great Seal. Henry is crowned and wears a magnificent ermine-lined robe of 'cloth of gold of tissue'. To his left are the royal physicians Dr Butts and Dr Chambers, whose individual portraits by Holbein survive today, made up from the images taken for this portrait (see no.165); they were not company members and are therefore shown separately.

The design of the painting was transferred with the aid of a pricked cartoon (the over-painted original cartoon is preserved in the Royal College of Surgeons), and the dots joined in the underdrawing are visible with the aid of infrared reflectography (see Appendix, fig.vi, p.157). By 1601 the painting already needed some repairing, and it underwent further restoration in the seventeenth century (in 1634 by Richard Greenbury, who may be responsible for repainting some of the heads in the second row), suffered heat damage in the Great Fire of 1666 and was restored again in the eighteenth century. Comparison with the cartoon reveals compositional changes, notably to the heads in the second row, where Salmon, who became Master of the Company in 1551 was added and to the end of the first where Ferris, Master in 1552 was added, as well as the omission of a cartouche on the left-hand side, and the enlargement of the cartouche on the right to accommodate the inscription.

The painting is mentioned by van Mander in his life of Holbein, published in 1604, who says it was finished by another artist. The head of Henry VIII is clearly based on Holbein's image (compare no.131), the modelling of nose and cheeks is particularly close to the Munich drawing (no.130); the portraits of Butts and Chambers, the latter one of the better preserved parts of the painting, are likewise related to works by Holbein. Holbein probably drew most of the other portraits, and devised the composition with its original subtle rhythms of heads and cartouches, including a carpet border he used in other paintings, but the execution of parts such as the tapestry background and Henry's golden robe are not typical of his technique for such textiles, and it is difficult to recognise any personal contribution. It is likely that the painting was largely executed by Holbein's workshop assistants and completed after his death in 1543.

Provenance: The Worshipful Company of Barbers
Literature: Strong 1963; Rowlands 1985 (78); Buck 1997, pp.196–252
Reference: Monnas 1998, p.552

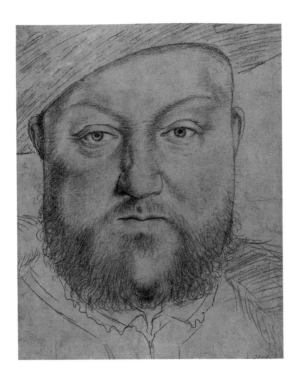

Workshop of Hans Holbein the Younger
130 *Henry VIII c.*1540?

Black, red and white chalk on pink primed paper 30.7 × 24.4 cm
Inscribed on the verso: Hans Swarttung
Staatliche Graphische Sammlung, Munich

This large, bold chalk drawing closely resembles Holbein's lost
frontal image of Henry VIII in the Whitehall mural (see no.103),
though the frilled collar associates it most closely with the version
in Liverpool (no.131). This collar differs from that seen in the
cartoon (no.104) and may reflect what Holbein ultimately painted.
In its close, right-handed shading the drawing differs in character
from the drawings by Holbein preserved at Windsor and
elsewhere, and even more so from the type of portrait pattern
made after them (see no.133). Its degree of finish differentiates
it also from the minimal transfer of outlines typical of the under-
drawing of Holbein's own portraits, as well as the similarly
economical underdrawing seen in the Liverpool and other similar
portraits of Henry VIII, which are likely to reflect the use of face
patterns. Nor do its outlines appear to have been traced. It is there-
fore most likely to be a contemporary copy of Holbein's painted
image. Hans Swarttung, whose name is inscribed on the back
of the drawing, might have been an assistant of Holbein.

Provenance: Discovered in Print Room collection by
J.H. von Hefner Alteneck
Literature: Chamberlain 1913 (II), pp.99–100;
Woodward 1951 (1) p.43; Rowlands 1985 (L14b), p.226;
London 1987, p.252; Buck 1997, p.114; Liverpool 2003, p.87

Workshop or associate of
Hans Holbein the Younger
131 *Henry VIII c.*1540–5?

Oil on oak 237.9 × 134 cm
National Museums Liverpool, Walker Art Gallery

This full-length portrait is one of the earliest of those closely
based on Holbein's image from the 1537 Whitehall wall painting
(see no.103). Dendrochronological analysis has shown the date
of the latest extant growth ring from the boards of the panels
is 1522, indicating that the panel probably dates from after 1530.
Its history suggests it was made for the family of Queen Jane
Seymour (nos.106,107), possibly for her brother Edward,
the Protector Somerset.

Study of the portrait's underdrawing has shown that the artist
adapted aspects of the architectural background of the Whitehall
painting as shown in the cartoon to better suit the composition
framing a single figure. Copies of Holbein's final original working
drawings, differing from the extant cartoon, may have been made
available to the painters of such works; an associate of Holbein's
workshop would have had ready access to them. The Walker
portrait is however less close in its dimensions to the surviving
cartoon (no.104) than that at Petworth, evidently also a near-
contemporary version by a different artist, perhaps from North
Germany. The painter shows a knowledge of some techniques
used by Holbein, such as the use of silver leaf to create the cloth
of silver of the doublet (compare nos.106,108), but painters
both in England and elsewhere in Europe would also have been
familiar with the technique. The use of grey underpainting under
the carpet and curtain perhaps has affinities with the technique
used in the Jane Seymour portrait (no.106). Most striking
is the painting of the chain of the medallion, incorporating the
repeated letter 'H', which, although it does not use gold paint,
closely resembles the similar chain painted by Holbein in the
Thyssen portrait (no.105), as well as the clarity and confidence
with which the (dissimilar) black pattern is executed over the
silver doublet. In this in particular the Walker portrait comes
closest to a style of painting which might have been learnt
in Holbein's workshop, although it should be noted that the
schematic style of underdrawing revealed in the face, clearly
taken from a pattern, does not resemble that of Holbein's
portraits, particularly in the manner in which the outlines
of upper and lower lips are drawn in full.

Provenance: Bought 1940s from East Knoyle, Wiltshire, where the family
descending from Edward Seymour, Duke of Somerset lived from the late
eighteenth century
Literature: Strong 1969 (1), p.159; Liverpool 2003

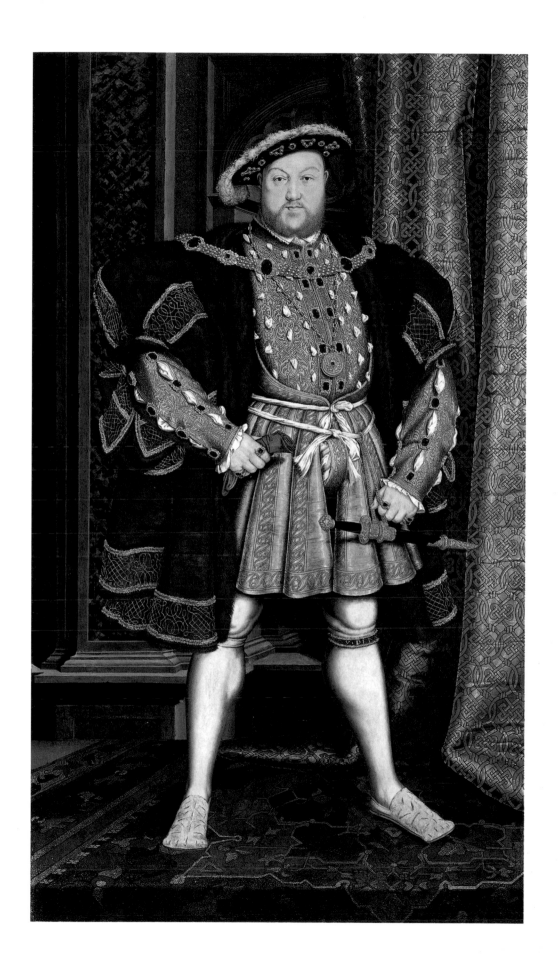

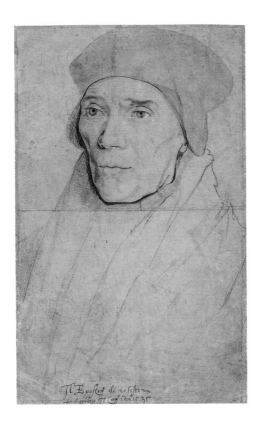

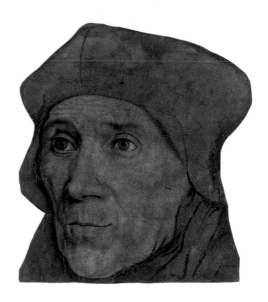

132 *Bishop John Fisher c.*1532–4

> Coloured chalks, watercolour, brush, pen and ink on pink primed paper
> 38.3 × 23.4 cm
> Inscribed with pen: Il Epyscopo de resister fo ... ato Il Capo Iano 1535
> The Royal Collection, The Royal Library, Windsor

John Fisher (*c.*1469–1535) became Bishop of Rochester and
Chancellor of Cambridge University in 1504. As a result of his
opposition to Henry VIII's divorce he was imprisoned along
with Sir Thomas More and beheaded. The pink priming of the
paper suggests that the drawing must date from the early 1530s,
when Fisher was already an opponent of the king's policies and
in poor health. No painted portrait based on the drawing
survives, but the drawing, which has been reinforced with ink in
part by others, served as the basis for patterns for such portraits
(no. 133). The origins of the Italianate inscription which is not
repeated on other Holbein drawings is unknown; it seems to
refer to Fisher's execution.

> Provenance: See no. 15
> Literature: Parker 1983 (13); Houston 1987 (10)

**Unknown English Workshop
after Hans Holbein the Younger**

133 *Bishop John Fisher* 1570s?

> Oil on paper 21 × 19.1 cm
> National Portrait Gallery, London

This is one of a small group of sixteenth-century workshop
patterns otherwise representing subjects from the reign of
Elizabeth I, today preserved in the National Portrait Gallery;
another is in the Yale University Art Gallery. The outlines of this
pattern correspond closely with those of the Holbein drawing
(no. 132), but it was itself transferred from another pattern by
pouncing: the characteristic small charcoal dots have been
observed in the outlines during close examination. Holbein's
original drawing must presumably have been copied to form
the basis of these patterns before the drawings entered the royal
collection, apparently shortly after his death. None of the
surviving portraits of Fisher appears to be based on this likeness.

> Provenance: Noted by Vertue 1734; Mr Chamberlaine; Rev. Thomas
> Bancroft; J. Wolstenholme; Sotheby's 1 April 1936 (lot 6)
> Literature: Woodward 1951 (4), pp. 43–4; Strong 1969, pp. 119–21;
> London 1995–6 (98)

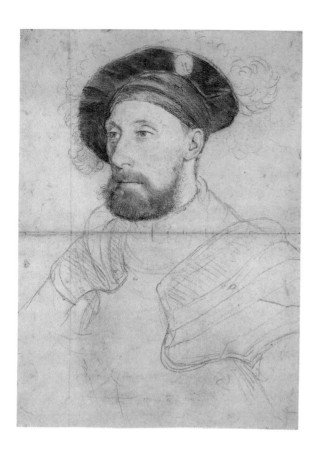

134　*Sir Nicholas Carew*　1527–8

　　Black and coloured chalks on prepared paper　54.8 × 38.5 cm
　　Inscribed on the turban: g[e]l[b] or g[ol[d]
　　Kunstmuseum Basel, Kupferstichkabinett

Sir Nicholas Carew (c.1496–1539) was Henry VIII's Master
of the Horse from 1522, a favourite courtier until his implication
in treasonable plotting by the Marquess of Exeter led to his
execution in March 1539. In format and technique close to the
drawing of Lady Guildford (no. 17), the drawing well shows the
vigour and subtlety of Holbein's use of both black and coloured
chalks, defining the forms and textures of the headgear in
monochrome (though as the colour note indicates the turban
was to be of cloth of gold), deeply shadowing the right eye
socket and recording the varying tones and colours of the beard.

　　Provenance: Amerbach-Kabinett
　　Literature: Basel 1988 (67), p. 216; Müller 1996 (158), p. 108
　　Reference: Starkey 1998 (13985)

Workshop or Associate of Holbein
135 *Sir Nicholas Carew* 1530s?

Panel 95.3 × 112 cm
In the collection of The Duke of Buccleuch & Queensberry KT

This portrait of Sir Nicholas Carew was in the Lumley collection at the end of the sixteenth century, as its characteristic painted 'cartellino' or label lower left demonstrates. The Lumley inventory includes it in a group of eight male portraits, 'drawn by Holbein', but it is one of six from which this description is deleted. It is unclear whether the reference is to an association with preparatory drawings by Holbein (the group also owned by Lumley did not include that of Carew) or indicated the putative authorship of the painting.

The half-length format is original: the portrait was never a full- or three-quarter length composition, and only the right hand edge of the panel is missing. Carew's breeches were evidently originally purple in colour, as is indicated by the penetration of the present brownish colour with the aid of infrared reflectography. The colour that now looks brownish was probably made using dark blue and red lake. There is no clearly observable distinction in the approach to the head and the rest of the painting, and there is no gap between head and neck and the rest of the body as has sometimes been claimed.

The portrait shows many close connections with Holbein's techniques, for example in the two types of gilding used. The highlights of the breeches are hatched using shell gold, and the pommel of the sword is similarly executed. Carew's golden under-cap is formed from gold leaf applied over a base of a brown mordant painted on to give the necessary shape for the cap. In Holbein's *The Ambassadors* (National Gallery) of 1533, the scabbard of the dagger is created by using a chestnut coloured paint, with detail in a greyish-yellow mordant which was then gilded; finishing touches were added with shell gold. The gilded cap of Holbein's *Lais Corinthiaca* (Kunstmuseum, Basel), dated 1526, is created in a similar manner.

The approach to flesh painting is in many respects similar to Holbein's: the outlining of facial features with dark paint, the construction of the eyes and the painting of the hands. The painting of the hands can be compared to the *Lady with a Squirrel and Starling* of 1526–8 (no. 21) and *The Ambassadors*. The painting of the white feathers in the cap is skilfully executed, and reminiscent of the painting of similar feathers in the portrait of *Edward Prince of Wales* (no. 108) especially in the manner in which the brush is dragged through the thick paint to create the sense of the central spine and small fronds of each feather.

The pattern of the background curtain consists of two distinct types, seen in two works by Holbein: a trellis-like pattern visible in the portrait of the *Sieur de Morette* (Gemäldegalerie, Dresden) and the damask pattern including a crown motif used in *The Ambassadors*.

However, the crown pattern of the damask curtain is executed freehand and the outlines are not well-controlled, while in *The Ambassadors,* the similar pattern is probably executed with a stencil to give precise outlines, and the folds created by the skilful use of shadow.

Infrared reflectography reveals some underdrawing around the hands and the features of the face (see Appendix, fig. vii, p. 158), but the artist's use of brown outlines in these areas make it difficult to be certain whether these lines are actually underdrawing. In the breeches (see Appendix, fig. viii, p. 158) the drawing appears to be freehand. The lines have a slightly broken look, caused by the distinctive, broad strokes of the priming, over which the drawing, in a liquid material, was applied. There is some similarity to underdrawn lines seen in the shawl of the *Lady with a Squirrel* (no. 21).

Carew's head is based on the drawing by Holbein (no. 134). Unusually, this is slightly larger than the drawing (my thanks to Christian Müller for his assistance in making the comparison). It seems just conceivable however that the head might have been enlarged by extending a pattern drawing in the manner Holbein appears to have employed to extend the head of Sir Henry Guildford (no. 16).

The painting technique of *Sir Nicholas Carew*, though skilful in many respects, lacks the accuracy evident in comparable paintings by Holbein. For example, the gold hatching of the breeches lacks precision when compared to the sleeves portrait of Sir Henry Guildford (no. 18). Similarly, the lack of definition of the black edges of Carew's shirt sleeve contrasts with the care with which the edge of the shawl are defined in the portrait of the *Lady with a Squirrel*. Otherwise the most distinctive feature of the portrait is a the priming under the main paint surface, clearly evident as a series of broad criss-crossing brushstrokes, (see Appendix, fig. viii, p. 158). Such a priming is not apparent in portraits by Holbein.

The similarities of manner as well as technique suggest that the painting was carried out by a contemporary with a close knowledge and understanding of Holbein's work, though the divergences in the techniques of priming and stencilling suggest that the artist was not fully conversant with Holbein's methods. The unusual composition and format suggest that it may not be a copy of a lost painting. Another possibility should be considered: that the painting is an adaptation of a work originated by Holbein for another medium. Henry VIII owned a similar-sized tapestry portrait of Carew confiscated after his execution described as: 'Item one peace of Arras with Sir Nicholas Carowis half picture [sett] in waynescot conteyning in lengthe oone yerde quarter oone naile and in breadeth oone yerd quarter').

Provenance: John 1st Baron Lumley; purchased Christie's sale, Lumley Castle 11 August 1785 (57) for Elizabeth, Duchess of Buccleuch; by descent.
Literature: Rowlands 1985 (R 25)
Reference: Starkey 1998 (13985)

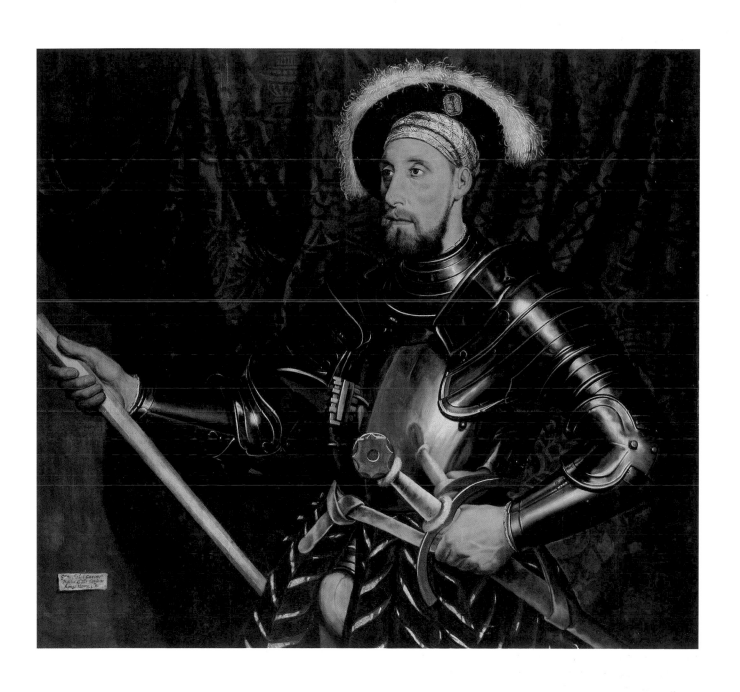

7
Catholic England, Protestant England

When Holbein arrived in England for the first time in 1526 it was a staunchly Catholic country: his own woodcut border had featured in the publication of Henry VIII's defence of the sacraments against Luther (no.10). However, Lutheranism and more extreme forms of Protestantism had already gained hold in Europe, and the belief that religious images were idolatrous began to affect the livelihood of painters and sculptors. On Holbein's return to Basel violent iconoclastic riots in 1529 destroyed many altarpieces (his own survived) and he was required to attend the new Protestant service. At first Holbein said he required a better explanation, before complying.

Returning to England by 1532 the situation was rapidly changing. Henry VIII's desire to divorce Katherine of Aragon and marry Anne Boleyn encouraged those who supported the Protestant revolution: following their marriage in 1533, the Act of Supremacy of 1534 asserted Henry VIII's authority over the Church and its separation from Rome, evidently celebrated in Holbein's miniature of Solomon (no.146). Holbein enjoyed the patronage of Thomas Cromwell, the king's minister, who, with the Archbishop Thomas Cranmer, pressed for the king's permission to produce an English Bible. In 1535 Holbein designed the title-page for the Coverdale Bible, which it was anticipated the King would approve (no.148). A similar design for a New Testament (no.149), apparently never used, may have been intended to accompany it. A third design for an edition of the *Loci Communes* by the German Protestant Philip Melanchthon (no.150), setting out the basic tenets of Protestantism, may have been connected with this, along with the small portrait of the Reformer (no.151). Holbein's painting *The Allegory of the Old and New Law* (no.145) draws on German precedents but includes imagery close to that of the Coverdale Bible title-page, and appears to have been produced in England.

Cromwell encouraged Protestant writers in favour of the English Reformation such as Richard Moryson, who signed the verses on Holbein's portrait of Edward Prince of Wales (no.108). He cultivated a network of intermediaries with good contacts with Europe, especially Germany. In a letter to Cromwell in around 1536 from Holbein's friend Nikolaus Kratzer, the royal astronomer states he has given a book by the German Protestant writer Georg Spalatin 'to Hans Holbein in order that he may give it to you'. The publisher Reynold Wolf, for whom Holbein made woodcuts (nos.52,147) was used by Cromwell and Cranmer on more than one occasion as an agent on visits to Germany in the late 1530s. Cromwell also supported more radical figures including the antiquary and playwright John Bale, whose attacks on the monastic orders within biblical imagery have a close affinity with the small woodcuts which were published only in the more radically Protestant reign of Edward VI (nos.152–6). The publication for which they were originally destined may have fallen foul of the regime, perhaps after the execution of Cromwell in 1540. Holbein was not destined to provide the rich range of designs and imagery in support of the English Reformation of which his Basel work had showed him capable.

Yet traditional religious imagery, such as the badge of the five wounds (no.141), continued to flourish throughout Holbein's residence in England. Only a few of Holbein's surviving portraits show evidence of religious devotion (for example nos.140,142), but it is possible that others were intended to reflect such piety, in ways which might not be evident in the preparatory portrait drawings.

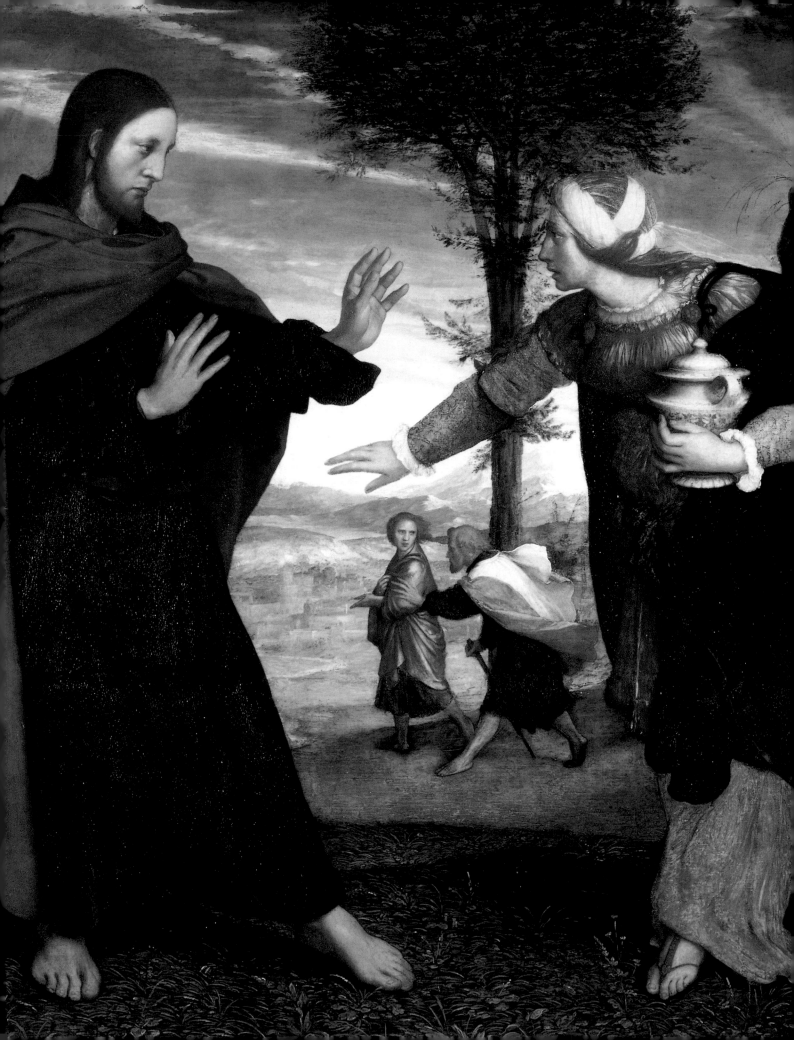

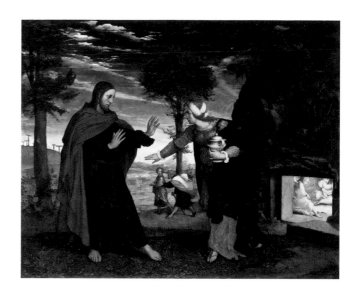

136 *Noli me Tangere* 1526–8?

Oak 76.8 × 94.9 cm
The Royal Collection

According to the New Testament, Mary Magdalen mistook
the resurrected Christ for a gardener: on the right are angels
brilliantly illuminating the empty tomb. In contrast on the left
Holbein beautifully depicts the natural light of dawn gradually
brightening the deep blue night sky. The central figures are
conceived in wholly original poses, Mary Magdalen shown
in a twisting motion in a manner reflecting Holbein's studies
of Italian prints (nos. 70, 71), Christ's hands echoing those of
blind Elymas in Raphael's tapestry design engraved by Agostino
Veneziano (see no. 139). A painting of this subject is recorded in
the inventory of Henry VIII and although there is no reason to
identify it with this picture, the possibility cannot be excluded.
Its style and the fact that it is painted on oak, unlike other
paintings made in Basel, suggests that it might have been made
for an English patron between 1526–8, or even a little later.

Provenance: Queen Henrietta Maria, inherited by Charles II
at her death in 1669
Literature: Millar 1963 (32), p. 61; Pemberton Pigott 2002;
Foister 2004, pp. 42–4; Sander 2005, pp. 301–4
Reference: Starkey 1998 (10601)

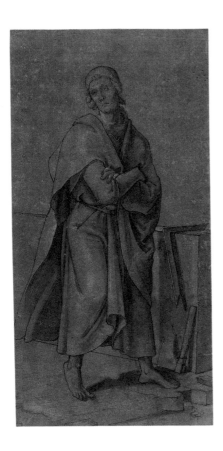

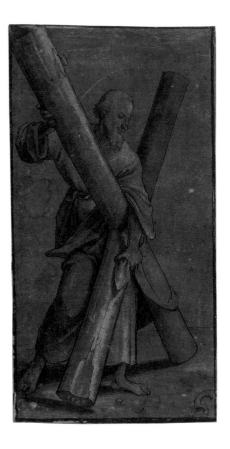

137 *St Thomas* dated 1527

Pen and black ink, brush and grey wash, heightened with white,
on washed-brown paper 20.4 × 10.5 cm
The Metropolitan Museum of Art, New York, Purchase, Pat and John
Rosenwald Gift, Rogers Fund, and Gift of Dr. Mortimer, D. Sackler,
Theresa Sackler and family, 2001
Provenance: Leon Blumenreich, Berlin; Franz Koenigs collection,
on loan to Boymans-van Beuningen Museum, Rotterdam; sold Sotheby's
New York 23 January 2001 (12) purchased, Pat and John Rosenwald Gift,
Rogers Fund, and Gift of Dr Mortimer D. Sackler, Theresa Sackler
and Family, 2001
Literature: See no.138

St Andrew is shown with his saltire cross, St Thomas with his
attributes of the carpenter's set square and axe. These two drawings
are part of a series of the twelve apostles, of which nine are known;
six are dated 1527. Six of the drawings are in Rotterdam (Boymans-
van Beuningen Museum), one is in a private collection. Holbein
used a similar technique with white heightening on primed paper
early in his career, including the drawings also on brown toned
paper representing the sorrowing Christ in Berlin dated 1519,
and the drawing of the Virgin and Child of similar date at Basel.
Rowlands has compared the apostle figures to those of the Passion
altarpiece at Basel, which includes men with similar long noses and
eyes positioned high in narrow faces; the altarpiece was probably
commissioned between 1514, when Maria Zschägkabürlin
specified in her will the tomb in Basel cathedral of which it formed
part, and her death in 1526. The function of the drawings is not
known, but their technique and dating suggests they are most
likely to have been produced as finished studies.

138 *St Andrew Carrying the Cross* dated 1527

Pen and black ink, heightened with white bodycolour on brown
prepared paper 20.3 × 10.5 cm
Inscribed (on the bottom of the cross): 1527
The British Museum, London
Provenance: Sir T. Lawrence; S. Woodburn; Phillips-Fenwick;
presented anonymously
Literature: Hugelshofer 1929; London 1987 (196), pp. 229–30;
Rowlands 1993 (318), pp. 145–6
Reference: Lindemann 1998

Müller has suggested that rather than being executed by Holbein
in England, the drawings were made by a workshop assistant in
Basel during Holbein's absence, citing in particular an unusual
use of cross-hatched highlighting and the absence of left-
handed shading. Others in the set appear considerably weaker in
execution, raising the possibility that if the drawings were indeed
carried out by Holbein in England, he was already working with
an assistant who must have been responsible for at least part
of the series.

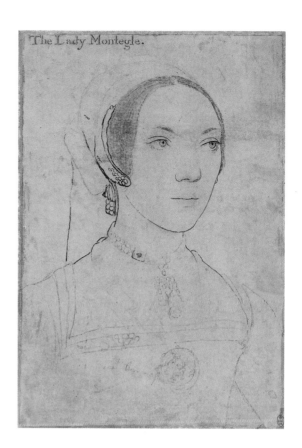

139 *Three Biblical Studies within an Architectural Frame:*
Lot and his Daughters; The Drunkenness of Noah;
Judith and Holofernes c.1535

Brush drawing in black ink, heightened with white bodycolour,
on grey prepared paper 7.7 × 14.8 cm
The British Museum, London

These three Old Testament stories were probably chosen
as symbolic prefigurations of the triumph of Christ (the story
of Lot prefiguring Christ's descent to limbo, that of Noah
Christ's sacrifice in the crucifixion). The figures in all three
scenes are adapted from a single print, Agostino Veneziano's
engraving after Raphael's tapestry design, the *Death of Ananias*
(see no.136). Rowlands has compared the decorative framing
of the drawing to the lid of Holbein's Melanchthon (no.151)
and to the *Loci Communes* (no.150). The sketch was perhaps
for the lid or side of an object such as a small box.

Provenance: T. Kerrich, by descent; presented 1906 by NACF with
contributions from Sir Otto Beit and C.S. Gulbenkian
Literature: London 1987 (200), pp.233–4; Rowlands 1993 (322), p.148

140 *Mary, Lady Monteagle* c.1538–40

Coloured chalks, pen and ink on pink prepared paper 29.8 × 20.2 cm
Inscribed: rot dammas rot rot w ? G; The Lady Monteagle
The Royal Collection, The Royal Library, Windsor

Mary Brandon (*c.*1510 – before 1544) was the first wife of Thomas
Stanley, 2nd Lord Monteagle. Her French hood indicates that this
drawing probably dates from the late 1530s. Like Lady Audley
(no.116), she wears red damask, a textile reserved for the rich.
Around her neck she wears an elaborate jewelled M, while on her
breast is a large medallion on which is sketched in chalk an image
which appears to show the Virgin and Child. On the death of
Jane Seymour in 1537 she received some of the Queen's jewellery,
which, just conceivably, she wears here.

Provenance: See no.15
Literature: Parker 1983 (60)

BRIANVS TVKE, MILES.

AÑ ETATIS SVÆ, LVII

. DROIT ET

AVANT .

NVNQVID NON PAVCITAS DIERVM
MEORVM FINIETVR BREVI ?

M IVSTIFICATIONIS

IVSTIFICATIO NOSTRA

INRI

HOMO

MISER EGO HOMO,
QVIS ME ERIPIET EX
HOC CORPORE MORTI
OB NOXIO ? RO. 7

AS PROPHETA

IOANNES BAPTISTA

IPIET ET PARIET FILIVM . ISA. 7

ECCE AGNVS ILLE DEI QVI TOLLIT PECCATV MVD̄

146 *Solomon and the Queen of Sheba* c.1534

Pen and brush in bistre and grey wash, heightened in white, gold and
oxidised silver with red and green watercolour over black chalk on vellum
22.9 × 18.2 cm

Inscribed: REGINA SABA; BEATI VIRI TVI ... ET BEATI SERVI HI
TVI / QUI ASSISTVNT CORAM TE ... OMNITPTE ET AVDIVNT /
SAPIENTIAM ... TVAM SIT DOMINVS DEVS TVVS BENEDICTVS, /
CVI COMPLACIT IN TE, VT PONERET TE / SVPER THRONVM SVVM,
VT ESSES REX / (CONSTITVTVS) DOMINO DEO TVO VICISTI FAMAM
/ VIRTVTIBVS TVIS

The Royal Collection, The Royal Library, Windsor

The Queen of Sheba in the foreground with her retinue
acknowledges King Solomon, whose face shows some
resemblance to Henry VIII. The text, a conflation from
Chronicles 11 and 1 Kings 10.9 as Ives has shown, praises
Solomon and declares that God has put him directly on his
throne. Henry was directly compared to Solomon by his
propagandists: the text is therefore likely to refer to Henry's
break with Rome in 1534, and the figure of Solomon to allude
to Henry, to whom he bears some resemblance; the Queen of
Sheba may symbolise the church, the clergy who had submitted
to Henry in 1532. Ives has seen an allusion to Anne Boleyn
as Queen of Sheba, while Buck has argued the absence of the
Queen's gesture of homage implies criticism of Solomon.

The miniature makes lavish use of expensive pigments: the blue
background is ultramarine, and both gold and silver have been
used, the latter on the carpet and hanging now tarnished black.
Alan Donnithorne has noted the existence of a black chalk
preparatory underdrawing. The technique otherwise resembles
that of the portrait miniatures, while the poised, rhythmic
beauty of the figures is similar to those of *The Triumph of Riches*
(no. 66). The sphinxes on the architrave and the pose of
Solomon and other figures draw on Holbein's decorative
repertoire of the 1520s, inspired by Italian prints. The miniature
possibly formed part of a richly decorated presentation book
with another miniature, as Buck has suggested.

Provenance: Earl of Arundel; The Royal Collection by 1727
Literature: Parker 1983, p.35; London 1977–8 (88), pp.129–30;
Ives 1994; Buck 1997, pp.253–322; Buck 1998

147 *Charitas device of Reynold Wolf* published 1543

Woodcut 6.8 × 4 cm
Published in D. Ioannis, *Chrysostomi homiliae duae*
The British Library, London

This small design illustrates Holbein's involvement with the
Protestant community in London. It is one of two elegant
printers' marks both on the theme of Charity, depicting small
boys knocking apples from a tree with sticks, which Holbein
produced for the Netherlandish printer Reynold or Reyner Wolf.
The Charity device was in use among radical circles in the
Netherlands in the middle of the sixteenth century, particularly
by the printing firm of Plantin. As well as printing Protestant
texts and using Protestant symbols, Wolf performed duties as
an agent for Cromwell and Cranmer, delivering and collecting
Reformist texts for them to and from Germany. Holbein also
designed a number of woodcut initials used in Wolf's books,
and Wolf may have owned the blocks for Holbein's Reformation
designs (nos. 152–6), though he did not publish them.

Literature: Dodgson 1938–9; Hollstein 14B (107), p. 17

TB

148 *Title page of the* Coverdale Bible published 1535

Woodcut 24 × 16.7 cm
The British Library, London

The *Coverdale Bible* was the first complete Bible translated into
English, produced between 1533 and 1535 by the exiled English
Augustinian friar Miles Coverdale (1488–1569). Unauthorised
Bible translations were banned in England. However, Coverdale's
work had the backing of the Archbishop of Canterbury, Thomas
Cranmer, and the new Vicegerent of the English Church,
Thomas Cromwell.

Holbein's title page features prominently the royal coat of arms
and an image of Henry VIII handing the Bible to the Bishops,
in anticipation of royal approval. The rest of the composition is
based on the opposition of the Old and New Laws – the Old
Testament scenes on the left, and the New Testament ones
on the right. At the top left are Adam and Eve whilst opposite
them the risen Christ tramples over death, the Devil, and the
serpent (sin). Other scenes juxtapose Moses issuing the Ten
Commandments with Christ and his apostles – each of them
holding a key, not just Peter, in accordance with anti-papal
arguments. The whole design emphasises the propagation
of the word of God, highlighting the importance of this first
English Bible.

Literature: Dodgson 1938–9; Hollstein 14A (94), pp. 195–6;
Foister 2004, pp. 159–165

TB

149 *Title-page Design for a New Testament* c.1535

Woodcut 10.9 × 6.2 cm
Staatliche Graphische Sammlung, Munich

The figures of Sts Peter and Paul indicate that the design was
intended for the title-page of a small New Testament. The royal
coat of arms, similar to those included in the Coverdale Bible
title-page (no.148) and the *Loci Communes* (no.150), suggests
that the book was to have been dedicated to Henry VIII, and
that all three books might have been part of a joint project.
The design was adapted in a title-page for Philip Melanchthon's
De Ecclesiae Autoritatie et de veterum scriptis libellus published
by Wendelin Rihel at Strasbourg in 1539, which has led to
the suggestion that the New Testament design and its two
companions might all have been cut there, though the Coverdale
Bible was evidently printed at Antwerp. James Nycolson, the
English-based Netherlandish publisher of the Bible, who also
owned the woodblock for the *Loci Communes*, published a New
Testament, but no edition survives that includes the title-page.
The woodblock for this design was in use in England in 1575.

Literature: Dodgson 1938–9; Hollstein 14B (95), pp.197–8;
Foister 2004, pp.163–5

150 *Title page of* Loci Communes *published 1536*

Woodcut 13.5 × 8 cm
Published in Philip Melanchthon, *Loci Communes* 1536
The British Library, London

The important and influential German protestant reformer
Philip Melanchthon (1497–1560) produced his seminal text
Loci Communes in 1521 – the first complete exposition of
Lutheran doctrine. In 1535 a revised edition was produced by
Melanchthon, dedicated to Henry VIII, and the following year
another version was printed in Antwerp, this time with an
illustrated title-page designed by Holbein incorporating a royal
coat of arms. Around the same time, Holbein painted a small
roundel portrait of Melanchthon, with a decorated lid (no.151).
The printed title-page of *Loci Communes* shares many decorative
features with the painted lid, particularly the fauns playing pipes
and the curved Renaissance foliage motifs. The shared design
and motifs suggest a close association between the painted
portrait and printed book – perhaps they were intended as a
single present for an English admirer of Melanchthon, possibly
Henry VIII, who owned this copy of the book.

Literature: Hollstein 14A (96), p.199; Foister 2004, pp.162–5

TB

151 *Philip Melanchthon* c.1535

Oil on oak Diameter of each 9 cm
Inscribed inside the lid: QVI CERNIS TANTVM NON, VIVA
MELANTHONIS ORA. / HOLBINVS RARA DETERITATE DEDIT
Niedersächsisches Landesmuseum, Hanover

This small portrait of the German reformer Philip Melanchthon
(1497–1560) is evidently based on pre-existing images,
probably by Dürer and Cranach, since Melanchthon did not
visit England: Holbein similarly based his woodcut of Luther
on another portrait image. The style of the portrait is closely
comparable to other English works by Holbein, and the
inscription on the beautifully painted lid is a variant of a poem
by the English humanist John Leland who wrote in praise of
Holbein, and is presumably therefore his work. The decorative
motifs of the lid closely resembles Holbein's title-page for
Melanchthon's *Loci Communes* (no. 150), and the portrait may
be connected with that project.

Provenance: Royal House of Hanover; England 1803;
Windsor Castle from 1812; Schloss Georgengarten 1844;
Landesgalerie Hanover 1925
Literature: Bradner 1956; Reinhardt 1975; Rowlands 1985 (60);
Löcher 1985 (545); Dülberg 1990, pp. 272–3; Hanover 2000;
Mauritshuis 2003 (20), p. 102; Foister 2004, pp. 164–5

152–6 *Small Reformation Woodcuts*

These small prints by Holbein relate to the dissolution of the
monasteries, a key episode in the English Reformation. The
figures depicted – the pharisee, the pharisitical onlookers, and
the hireling shepherd – are all shown as monks, in less than
flattering situations. *Christ Before Pilate* is the exception and is
not known to have been used in any publication. *The Hireling
Shepherd*, published as the title-page to Urbanus Rhegius's *A lytle
treatise*, shows a hapless monk failing in his attempts to shepherd
his flock as they scatter in disarray and are attacked by a wolf,
Christ looking on disapprovingly. Attacks on monks and the
monasteries were made in propaganda writings as a prelude
to the dissolution, but, except where treason on the part of
the monk was involved, the more personal attacks were found
in the work of unofficial writers, some under the protection of
Cromwell. However, when Edward VI acceded to the throne in
1547 he ushered in a much more radical Protestant regime, under
which the anti-monastic designs of Holbein were published.
Much of Holbein's characterising of the monks is analogous to
the work of the fervent Protestant cleric and playwright John Bale,
who satrised monks in his plays such as *King John*, which was
performed before Cranmer in 1539.

Literature: Dodgson 1938–9; Strong 1967; Hollstein 14B (162),
pp.162–4; Foister 2004, pp.165–9

TB

152 *The Hireling Shepherd* published 1548

Woodcut 4.2 × 5.8 cm
Title-page to Urbanus Regius, *A lytle treatise after the maner of an Epistyle*,
London 1548
Bodleian Library, University of Oxford

153 *Christ Before Pilate* c.1538–40

Woodcut 4.2 × 5.9 cm
The British Museum, London

154 *Christ Casting out the Devil* c.1538–40

Woodcut 4.2 × 4.9 cm
The British Museum, London

155 *Christ Casting out the Devil* c.1538–40

[NOT ILLUSTRATED]

Woodcut 4.3 × 4.9 cm
Published in Thomas Cranmer, *Catechismus* 1548
The British Library, London

156 *The Pharisee and the Publican* c.1538–40

Woodcut 4.3 × 4.9 cm
Published in Thomas Cranmer, *Catechismus* 1548
The British Museum, London

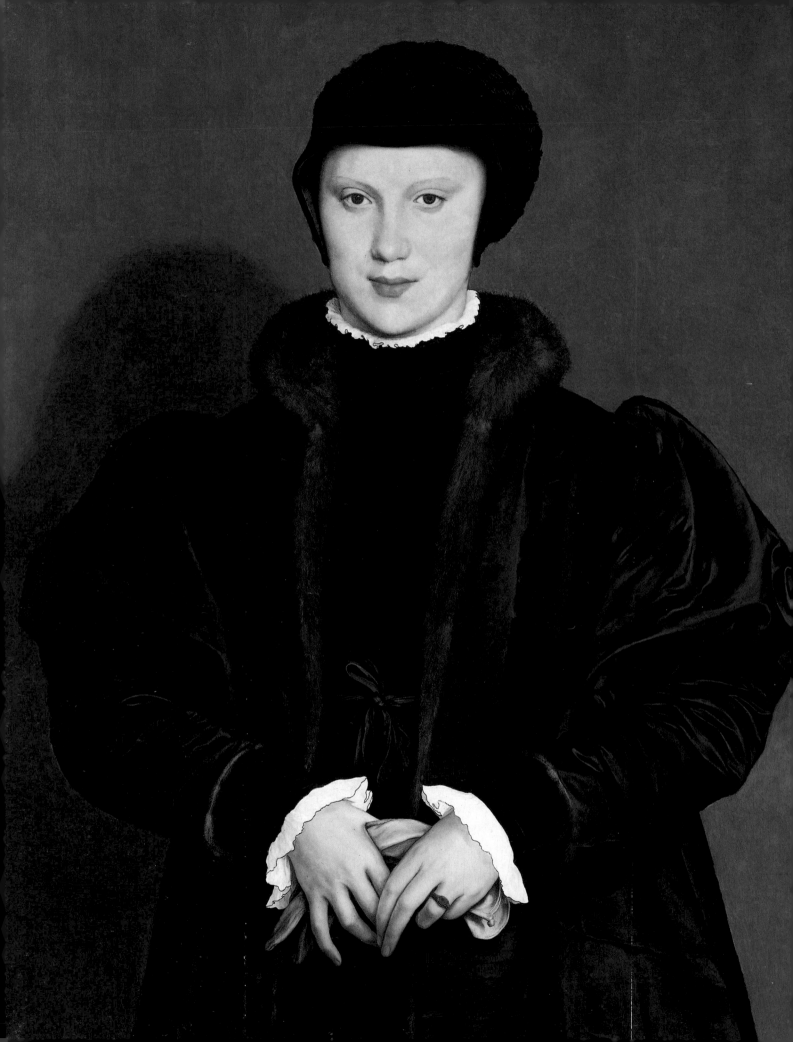

8

The Art of Illusion

Holbein's portraits were celebrated in their own time. When on 23 March 1538 Holbein returned from taking the likeness of Christina of Denmark (no. 157), which can only have been a drawing, it was reported that this 'singularly pleased the King, so much so that, since he saw it he has been in much better humour than he ever was, making musicians play on their instruments all day long.' Although the king failed to marry Christina he kept the seductive full-length painted portrait in his collection.

An informative portrait of a prospective bride might be very different in character from a portrait which a monarch might wish to send to other courts, and in turn different from a portrait celebrating a marriage achieved or a life well lived. Holbein's skill was to satisfy these differing demands with sympathetic, unidealised likenesses, particularly of old age and of women, which give the illusion of presence. This is especially forceful in those portraits, many from the latter part of his career, in which the subjects are presented in full-face to the viewer.

Holbein's portraits both announce and conceal the extent to which they are the creation of the artist. Holbein pays great attention to convincing individual detail such as the differences between the sides of the face, the direction of eyebrows, the precise shapes of lips and the line of the mouth, all of which are recorded in the preparatory drawings. But he emphasises the size of the features in comparison to the size of the head, a common trait with many portraitists of the period. The paintings are evenly lit and ambiguous in their employment of intense blue backgrounds: the hint of outdoors, encouraged in earlier portraits with their use of stylised foliage, is negated later on by the presence of shadows and lettering which emphasise the painted surface, but which also, by limiting the space they occupy, make the subjects appear closer to our own world. This sensation is heightened by the way in which in the smaller, late portraits Holbein devotes proportionally more of the picture surface to the head, moving the subject still further towards to us. Above all Holbein's portraits are extraordinarily still: gesture or movement could too easily seem arrested, spoiling the illusion of presence. The paintings pivot between acknowledging the spell of their subjects and the power of their creator.

This sensation is recognised in the Latin inscription to the portrait of Derich Born (no. 158), in which the viewer is invited to consider the portrait as the work of the artist or the sitter's father. Throughout his career Holbein attracted the praise of humanists from Erasmus and Bonifacius Amerbach in Basel, to Thomas More, the Frenchman Nicolas Bourbon and John Leland in London, satisfying their desire to imitate the rhetorical devices of the classical tradition by comparing contemporary artists to the great artists of the past who confused humans, animals and insects into thinking their works were real. Holbein offered ample opportunity for such praise with his ability to depict likeness, texture, light and stillness in a manner that was genuinely admirable and deceptive.

157 *Christina of Denmark, Duchess of Milan* 1538

Oil on oak 119 × 82 cm
The National Gallery, London. Presented by The Art Fund with the
aid of an anonymous donation, 1909

Holbein was sent to Brussels in March 1538 to take the portrait
of the sixteen-year-old Christina as a prospective bride for Henry
VIII. She was in mourning for her first husband, the Duke of
Milan. On 12 March at one o'clock in the afternoon, Holbein was
conducted to the duchess's presence, and Christina sat to Holbein
for 'but thre owers space'.

The full-length format was apparently thought desirable for
such situations: in 1446 Henry VI specified that portraits of his
potential French brides should be full-length, while Henry VIII
was insistent on informative portraits after the King of France
refused him a beauty parade of bridal candidates at Calais.
Holbein has ensured that face and hands are clearly presented
against the black costume but has suppressed the sense of the
space Christina occupies: the train of her dress blurs the line
where wall and floor meet. The placing of her shadow on the
left and the strong vertical shadow to the right subtly implies
movement, as though Christina sways forward towards the
viewer. The marriage did not take place, but Henry VIII retained
the portrait in his collection, the only Holbein portrait certainly
identifiable there.

Provenance: Henry VIII 1542; Earl of Arundel; ?Earl of Pembroke;
Lord Lumley; Earl of Arundel; William Lord Stafford; Earl of Stafford
(1648–1719); Henry Charles Howard of Greystoke (d.1730); Charles
Howard, later 10th Duke of Norfolk; by descent to 15th Duke of Norfolk;
bought by NACF with the aid of a Treasury grant and an anonymous
donation; presented to the National Gallery in 1909
Literature: Levey 1959, pp.54–7; Rowlands 1985 (66), pp.116–7 (with
incorrect reference to cartellino); Goldring 2002; Foister 2004, pp.200–3
Reference: Starkey 1998 (10580)

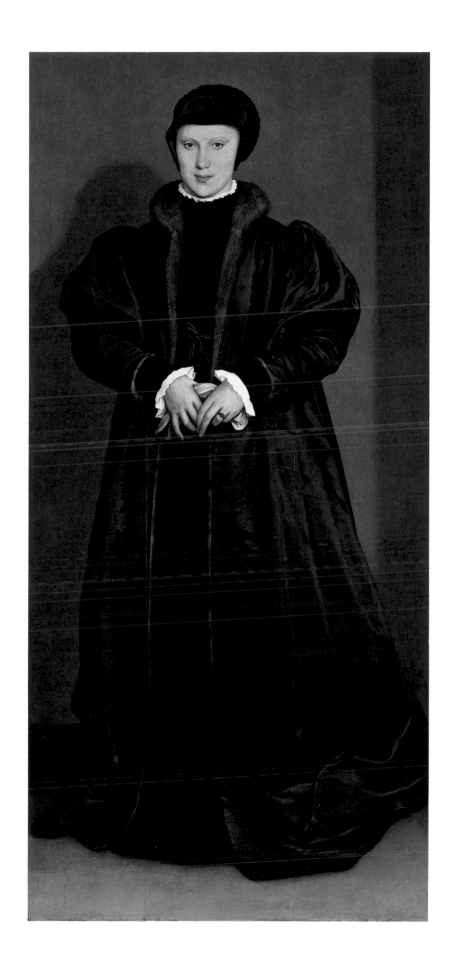

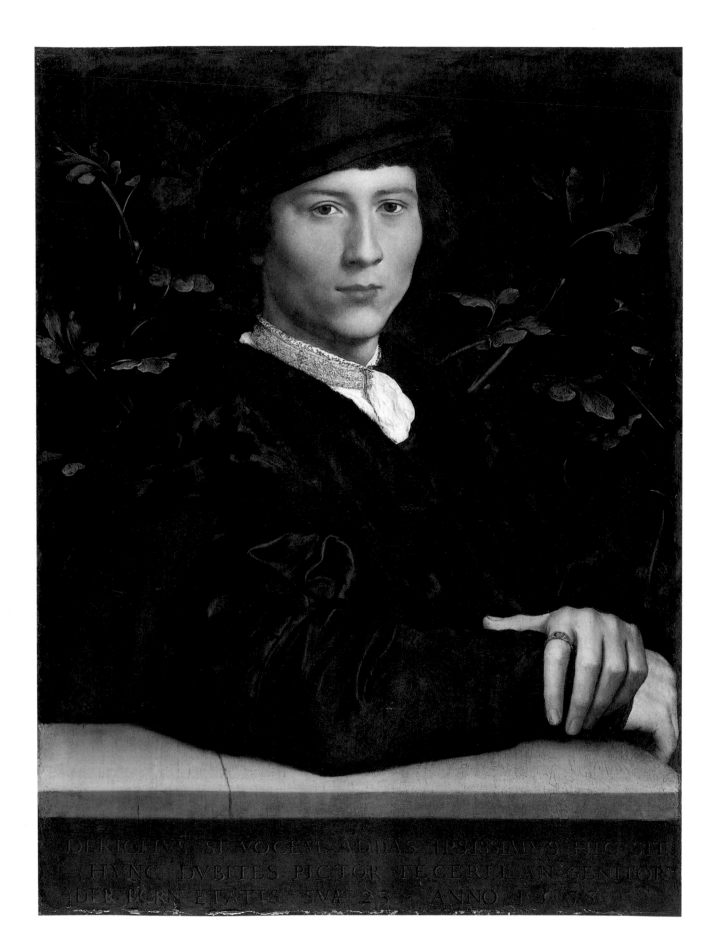

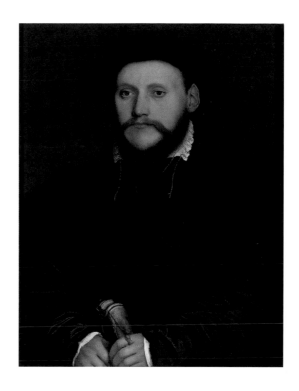

158 *Derich Born* dated 1533

> Panel 60.3 × 45.1 cm
> Inscribed: DERICHVS SI VOCEM ADDAS IPSISSIMVS HIC SIT / HVNC
> DVBITES PICTOR FECERIT AN GENITOR / DER BORN ETATIS SVAE
> 23. ANNO 1533
> The Royal Collection

Derich Born (1509/10 – after 1549), a Hanseatic merchant from
Cologne, supplied Henry VIII's armourer, Erasmus Kyrkener,
with military equipment in 1536 for the suppression of the
Northern Rebellion. In 1541 he was expelled from the Steelyard
following a trading dispute. As with other Hanseatic portraits
there are inscriptions of a type which do not occur in portraits
of English sitters, here resembling the poems the humanist John
Leland wrote to celebrate Holbein's art (no. 52): this asserts that
if a voice was added the picture would seem to be Derich himself
and that it is doubtful whether the painter or the subject's father
produced the image, that is, whether this is the real Derich or
a picture. Born is posed as though to challenge the viewer, in a
confident frontal pose, his body swivelled, his chin lined up with
the point of his elbow. Holbein took care with this composition:
underneath the painted surface the underdrawing shows
adjustments to the outlines of hair, cap and shoulders.

> Provenance: Charles I; probably Earl of Arundel; Charles II
> Literature: Grossmann 1951, p. 40; Millar 1963 (26); Rowlands 1985 (44);
> Bätschmann and Griener 1997, p. 31; Hague 2003 (17), p. 94
> Reference: LP XI (686)

159 *An Unknown Man* c.1540

> Oak 44.4 × 34.2 cm
> English Heritage (Audley End). Purchased with the assistance
> of the Heritage Lottery fund.

The portrait offers few clues to the identity of the sitter, but his
high-necked shirt and short hair suggest it was painted in the
latter part of Holbein's career in England, around 1540.

The panel has been slightly trimmed all around but the near-
frontal composition appears to centre on the line of the white
cuff of the left hand, which aligns with the inner corner of the
left eye. The blue background is painted with the pigment
smalt, which Holbein used for other portraits late in the second
visit (nos. 108, 141), and there is a pink underpainting similar
to that of the portrait of Edward Prince of Wales and others
(nos. 108, 164). The gloves were painted over the black coat,
suggesting they were a late addition; changes to the under-
drawing of the left hand indicate that the fingers were adjusted
to accommodate this (see Appendix, fig. ix, p. 159).

> Provenance: 1st Lord Braybrooke by 1797; S. Courtauld 1956;
> purchased English Heritage 1998 with support from HLF
> Literature: Grossmann 1951, p. 43; Manchester 1961 (96);
> Rowlands (71), Bryant 1999

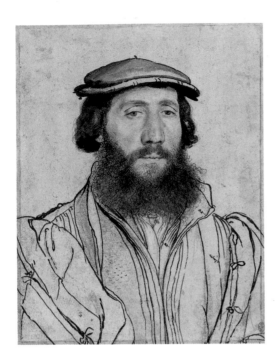

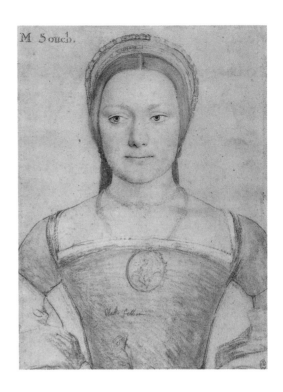

160 *An Unidentified Man* c.1535

Black and coloured chalks and pen and ink and brush
on pink prepared paper 27.5 × 21.1 cm
Inscribed: atlass at[lass] twice, and S
The Royal Collection, The Royal Library, Windsor

The notes record textures of satin and velvet rather than colour
(though S may stand for 'schwarz' black), possibly an indication
that the sitter's clothes were to be all of black. The drawing is
exceptionally well preserved and striking for the bold and extensive
use of wash (especially in the hat) and chalk modelling, particularly
around the eyes, suggesting great depth to the eye sockets. There
is great variety in the use of both pen and brush, from the very fine
wisps of hair on the left over a washed background to the more
extensive indication of the hair of the beard, again over a wash,
using a technique very similar to the way in which Holbein paints
the beard (compare no.159). An etching by Hollar made when
the drawing was in the Arundel collection shows the drawing
in circular format, suggesting the drawing served to produce
a painted roundel or miniature. This might conceivably be
identifiable in the inventory of Arundel's collection among
paintings by Holbein as one of two portraits of a man with a black
beret, one which of was small in size. Jane Roberts has suggested
that the absence of identification on the drawing or in the
Arundel inventory might indicate that the sitter was a foreigner.

Provenance: See no.15
Literature: Parker 1983 (32); Foister 1983, pp.10–11; Edinburgh 1993 (17);
Foister 1996, p.54; Hague (16), p.92

161 *?Mary Zouch* c.1538

Black and coloured chalks pen and ink on pink prepared paper
29.6 × 21.2 cm
Inscribed: M Souch
The Royal Collection, The Royal Library, Windsor

The sitter may be the daughter of Lord Zouch who begged to run
away because she was ill-treated by her stepmother, and became
lady in waiting to Jane Seymour. Or, she may be Anne Gainsford,
lady in waiting to Anne Boleyn, who married George Zouche of
Codnor; in that case the inscription would indicate a 'Mistress
Zouch'. This well-preserved drawing is exceptional for the
brilliance of the salmon- and yellow-coloured chalks used to
represent both the sitter's colouring and in her headdress and
dress. The sitter holds a flower, a rose or possibly a carnation for
marriage, like that held by Mrs Small (no.41). John Rowlands
has suggested that her brooch shows fortune sailing on dolphins,
as in a small woodcut by the school of Dürer (Hollstein 7, p.270);
Holbein represented Fortune somewhat similarly in a woodcut
design for a dagger (Hollstein, 14.6). An illustration to a French
manuscript by François Demoulins of 1522–3 (Stirling Maxwell
MS 6, f.13r, Glasgow University), showing blind fortune seated on
a weather-vane, is perhaps even closer to Holbein's small sketch.

Provenance: See no.15
Literature: Parker 1983 (72); Rowlands 1978; London 1991, VII.10, p.101;
Edinburgh 1993 (27), p.78
Reference: Hackenbroch 1996, p.24, fig.24

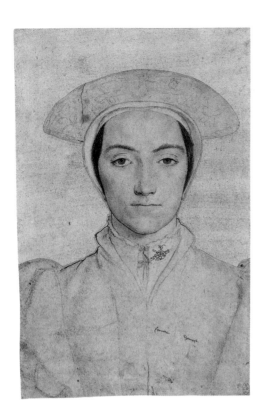

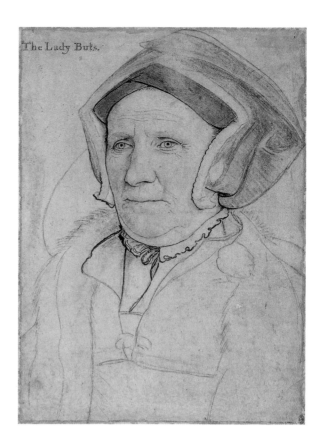

162 *An Unidentified Woman* c.1540

Black and coloured chalks, pen and ink and brush and white bodycolour
on pink prepared paper 27.1 × 16.9 cm
Inscribed: Samat Damast, inscribed on the verso hans holbein in ink,
and in chalk ?Holbeyn
The Royal Collection, The Royal Library, Windsor

The sitter's identity is unknown. There has been speculation that
this drawing represents Anne of Cleves' sister Amelia, but her
dress is quite different and clearly English. Her hat has the large
cross-shaped jewels seen in some male portraits. The full-frontal
view was used for the portraits Henry VIII required of Christina
of Denmark and Anne of Cleves (nos. 157, 111) to make sure no
defect escaped him, and possibly this portrait too might have
been intended as a marriage portrait. Like those of Thomas
Wriothesley and an unknown woman (nos. 54, 56), this drawing
left the group preserved in The Royal Collection and was
silhouetted and stuck to another sheet of paper. However, much
of the effect of the drawing remains. The sitter's glinting brown
eyes are worked up in unusual detail with a variety of media:
her pupils have catch-lights, her irises show clearly the radiating
muscles and her lower eyelids are partciularly prominent. Her
very long and minutely observed eyebrows are also drawn with
ink in great detail. By contrast Holbein is economical in showing
a single pattern repeat for the embroidery of her collar.

Provenance: J. Richardson the Elder; Richard Mead; Walter Chetwynd;
Benjamin Wray, by whom presented to The Royal Collection before 1792

163 *Lady Butts* c.1541–3

Black and coloured chalks and metalpoint and pen and brush
and ink on pink prepared paper 38 × 27.2 cm
Inscribed: The Lady Butts
The Royal Collection, The Royal Library, Windsor

Margaret Bacon, Lady Butts was the wife of Sir William Butts
(c.1485–1545), the royal physician portrayed in the Barber-
Surgeons portrait (no. 129), and a member of the group at court,
including Holbein, to which Nicolas Bourbon sent greetings
(no. 48). William Butts is also shown in an individual portrait
made to be paired with the portrait for which this is a study
(both Boston, Isabella Stewart Gardner Museum). The rough
indication of a carnation-like flower here became what appears
to be an enamelled flower brooch in the portrait. The inscription
to the portrait gives Lady Butts's age as fifty-seven. The drawing
is unsparing in the delineation of her wrinkles, but these appear
to have been slightly reduced in the painted portrait. The whole
drawing has been traced over with metalpoint for transfer, and
the underdrawn lines correspond closely with these contours
on the drawing.

Provenance: See no. 15
Literature: Parker 1983 (67); Houston (34), p. 104

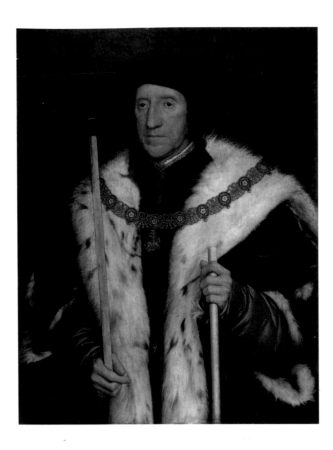

164 *Thomas Howard, 3rd Duke of Norfolk* c.1539

Oak 80.3 × 61.6 cm
Inscribed: [.THOMAS. DVKE OF.] NORFOLK. MARSH[ALL.] / . AND .]
TRESVRER OF INGLOND[E] / THE [.L] X [VI.] YERE [O]F HIS AGE
The Royal Collection

The Duke of Norfolk (1473–1554) held a succession of high
posts at Henry VIII's court: in this portrait of about 1539 he
carries the white staff of Lord High Treasurer and the gold
baton of Earl Marshal as well as wearing the Order of the
Garter. Norfolk was the father of the poet Earl of Surrey
(no.50); both were imprisoned for treason in 1546, but only
Norfolk escaped execution. Norfolk had a lively interest in
portraiture (see no.49). His mistress, Bess Holland, possessed
a portrait of him in 1546, conceivably a version of this one. The
duke, apparently 'small and spare of stature', appears broad and
imposing as he stands in this three-quarter-length portrait, a
format Holbein used only rarely. As with other English portraits
(nos.108,159) Holbein used a pink preparatory underpainting.

Provenance: Thomas Howard, Earl of Arundel; sale Amsterdam
23 April 1732; sale London 1744; Frederick Prince of Wales by 1750
Literature: Millar 1963 (30), pp.60–1; Rowlands 1985 (68);
Hague 2003 (34); Foister 2004, p.95

165 *Dr John Chambers* c.1541–2

Oil on oak 51 × 44 cm
Inscribed: AETATIS. SVE. 88
Kunsthistorisches Museum, Vienna, Gemäldegalerie

Dr Chambers or Chamber (1470–1549) was a cleric and
physician to Henry VIII, one of the founders of the Royal
College of Physicians in 1518, and Dean of St Stephen's,
Westminster. He died before the age of eighty, and the age
recorded on the portrait is evidently incorrect, as is SVE for
SVAE, but the present inscription lies directly on top of the
original greyish blue background. This background, consisting
of lead white and the blue pigment smalt, possibly with some
azurite, is overpainted with dark green. With the infrared
reflectography a background apparently representing a veined
marble wall is visible, which would be unparalleled in Holbein's
portraits; it is not known whether this is original. The portrait is
clearly related to the image of Chambers in the Barber-Surgeons
portrait (no.129). As is the case with Dr Butts in the same
picture, the individual portrait appears to have been made from
the image taken for the group: in the preparatory underdrawing
for this portrait Chambers looks upwards as he does in the group
portrait; this glance was then adjusted, and the hands gripping
the gloves were added.

Provenance: Thomas Howard, Earl of Arundel;
Archduke Wilhelm Leopold
Literature: Rowlands 1985 (82); Ainsworth 1990, pp.184–5;
Buck 1997, pp.232–3; Mauritshuis 2003 (38)

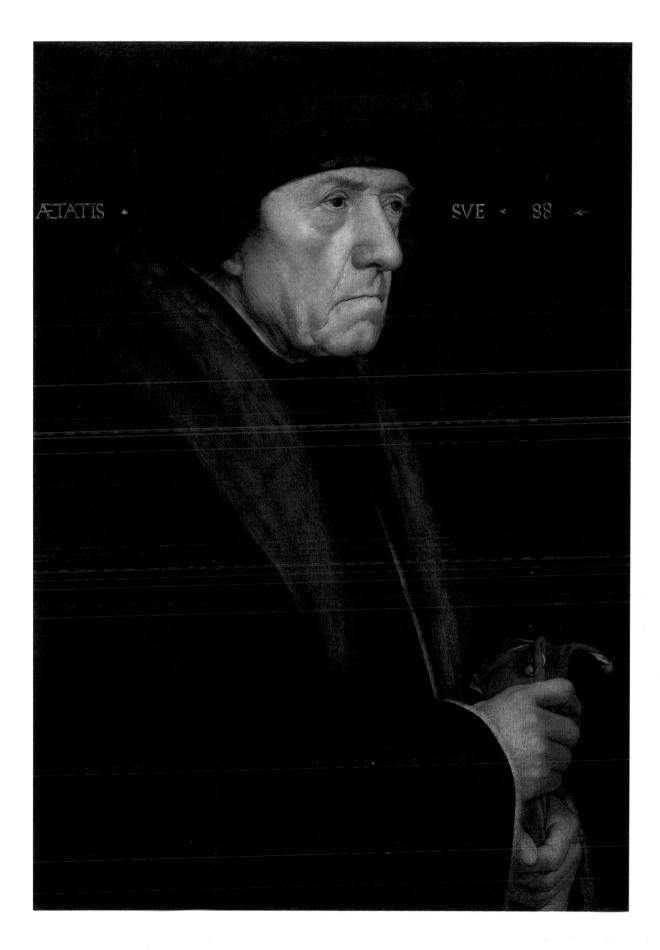

ÆTATIS · ◆ · SVE ◆ 88 ◆

Appendix: Images of Underdrawings

Note: the preparatory underdrawing made visible here via the means of infrared reflectography lies underneath the painted surface of the portraits. Its purpose is to establish the design of the painting before painting begins. Only underdrawing executed in an infra-red absorbing material, especially carbon black, will be revealed by infrared reflectography. For remarks on these underdrawings see the catalogue entries on the individual portraits.

Reflectograms nos. i–iv and vi–viii were made by Rachel Billinge, National Gallery London; no. v was made by Jacqueline Ridge, Tate.

i. Infrared reflectogram detail of Hans Holbein the Younger, *Sir Henry Guildford*, The Royal Collection (see no. 18, p. 28)

ii. Infrared reflectogram detail of Hans Holbein the Younger, *Mary, Lady Guildford*, 1527 (see no. 17, p. 27)
Oil on panel, 87 × 70.6 cm, Saint Louis Art Museum. Museum Purchase (1.1943)

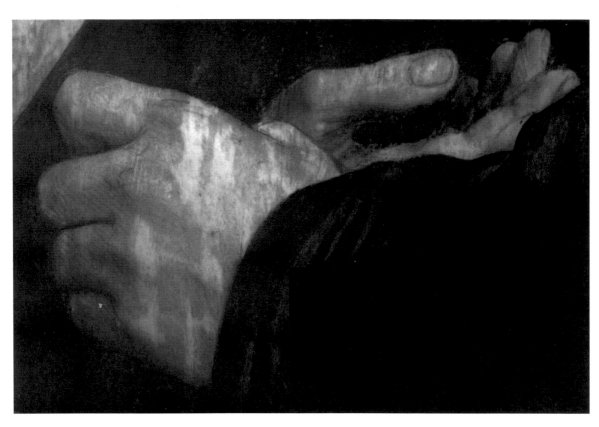

iii. Infrared reflectogram detail of Hans Holbein the Younger, *William Reskimer*, The Royal Collection (see no. 34, p. 42)

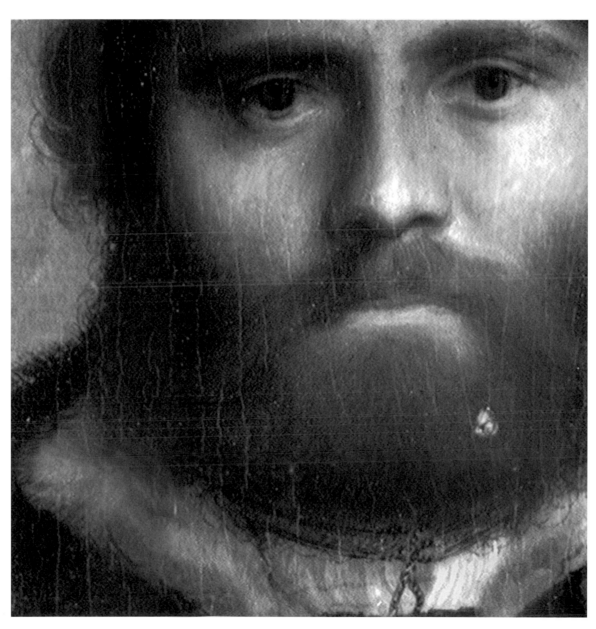

iv. Infrared reflectogram detail of Workshop of Hans Holbein the Younger, *An Unknown Man*, Victoria and Albert Museum, London (see no.127, p.116)

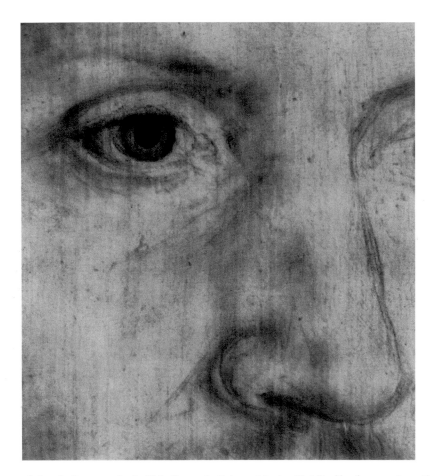

v. Infrared reflectogram detail of John Bettes, *An Unknown Man in a Black Cap*, Tate (see no. 128, p. 116)

vi. Infrared reflectogram detail of Hans Holbein the Younger and Workshop,
Henry VIII and the Barber-Surgeons, Worshipful Company of Barbers (see no.129, p.117)

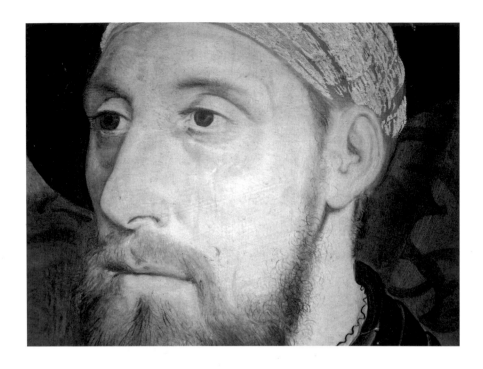

vii, viii. Infrared reflectogram details of Workshop or Associate of Hans Holbein the Younger, *Sir Nicholas Carew*, in the collection of The Duke of Buccleuch & Queensberry KT (see no. 135, p. 123)

ix. Infrared reflectogram detail of Hans Holbein the Younger, *Portrait of an Unknown Man*, English Heritage (see no. 159, p. 147)

Chronology

	Holbein	England	Europe
1497/8	Hans Holbein the Younger is born in Augsburg, southern Germany, son of the painter Hans Holbein the Elder		Hans Holbein the Elder takes on apprentices at his large workshop in Augsburg Leonardo da Vinci completes *The Last Supper* for the refectory of S. Maria delle Grazie, Milan
1499		Sir Thomas More and Desiderius Erasmus meet the young Prince Henry on a visit to Eltham Palace	Hans Holbein the Elder is commissioned by the Katharinenkloster church in Augsburg, along with other Augsburg artists such as Hans Burgkmair, to paint images of the main seven churches of Rome
1500			Around this time, Leonardo da Vinci paints the *Mona Lisa* Albrecht Dürer paints his *Self-Portrait* (Alte Pinakothek, Munich)
1501		Arthur, Prince of Wales, marries Catherine of Aragon	Hans Holbein the Elder and Sigmund Holbein paint the altarpiece of the Passion for the Dominican church in Frankfurt-am-Main
1502		Arthur, Prince of Wales, dies of a fever in Ludlow Castle; Prince Henry becomes heir apparent John Brown, John Gaynes and others paint heraldic paintings for the funeral of Prince Arthur The separate livery guilds of Painters and Stainers merge to form the Painter-Stainers Company	Hans Holbein the Elder is commissioned to produce an altarpiece for the Dominican Klosterkirche at Kaisheim, with panels of the *Passion of Christ* and the *Life of the Virgin*
1503		Elizabeth of York, Queen Consort of Henry VII, dies on her thirty-seventh birthday, shortly after giving birth to her eighth child, Katherine Tudor, who died the day of her birth John Gaynes, Thomas Mastall, John Wanlasse and others paint heraldic paintings for the funeral of Elizabeth of York	Pope Alexander VI (Rodrigo Borgia) dies; election of Pope Pius III (Francesco Piccolomini) Pope Pius III dies; election of Pope Julius II (Giuliano della Rovere)
1504	His father paints himself with his two sons Hans and Ambrosius in *San Paolo fuori le mure* (Staatsgalerie, Augsburg)	William Warham is appointed Archbishop of Canterbury John Fisher is appointed Bishop of Rochester and Chancellor of Cambridge University	Lucas Cranach the Elder is called to Wittenberg by Duke Frederick the Wise, and appointed court painter to the Electors of Saxony
1507			Gentile Bellini dies in Venice
1508			Michelangelo begins painting the ceiling of the Sistine Chapel at the Vatican (completed 1512)

Holbein	England	Europe
1509 Around this time, Holbein perhaps begins training in the studio of his father, Hans Holbein the Elder, along with his elder brother, Ambrosius	Henry VII dies, and is succeeded by Henry VIII; his funerary monument is designed by the Florentine sculptor Pietro Torrigiano Following the special dispensation of a Papal Bull, shortly before his coronation Henry VIII marries his brother's widow, Catherine of Aragon Desiderius Erasmus arrives in England, and writes *In Praise of Folly* whilst staying with Thomas More in London	Hans Holbein the Elder travels to Alsace, probably to undertake a commission for an altarpiece for the Hohenburg Klosterkirche on the Odilienberg, near Strasbourg
1510 Is drawn by his father, together with Ambrosius (Kupferstichkabinett, Berlin)	Edmund Dudley and Sir Richard Empson, prominent councillors to Henry VIII and members of the Council Learned in the Law, are imprisoned for treason and beheaded	Raphael decorates the Stanza della Segnatura at the Vatican, painting the *Disputa* and the *School of Athens*
1511	Catherine of Aragon gives birth to Henry, Prince of Wales, but he dies after fifty-two days Henry VIII joins the Holy League, an alliance of European rulers opposed to Louis XII of France Treaty of Westminster signed with Ferdinand II of Aragon, Henry VIII's father-in-law, to provide mutual support and aid against France during the Valois dynasty	
1512	Marquess of Dorset sails with an army against the French in alliance with Ferdinand II, but are let down by the Spanish and the English troops mutiny and desert The Florentine sculptor Pietro Torrigiano signs a contract to undertake the tomb for Henry VII and Elizabeth of York in Westminster Abbey (completed 1518/19) The Neapolitan painter Vincent Volpe is recorded as heraldic painter to the Navy	Ferdinand II takes Navarre
1513	Battle of Flodden: Thomas Howard, Earl of Surrey, defeats the Scots under James IV of Scotland, who is killed in battle and succeeded by James V Edmund de la Pole, Yorkist pretender to the English crown, is executed Vincent Volpe is granted an annuity of 20l during the 'King's pleasure'	Maximilian I, Holy Roman Emperor, joins the Holy Alliance Ferdinand II secures secret peace treaty with France, allowing him to keep Navarre Battle of the Spurs: Henry VIII leads the English army in victory over the French at Thérouanne, and goes on to take Tournai Pope Julius II dies; election of Pope Leo X (Giovanni de' Medici) Erasmus first visits Basel, possibly to make contact with the publisher Johannes Froben Dürer produces his engraved series *Knight, Death and the Devil*
1514	Thomas Wolsey is appointed Archbishop of York, after accompanying Henry VIII in France as his aide-de-camp Vincent Volpe receives payment for work on the ship 'Harry Grace à Dieu'	Louis XII of France marries Mary Tudor, younger sister of Henry VIII
1515 Probably in the spring or early summer, Holbein arrives in Basel With his brother, illustrates a copy of Erasmus's *In praise of Folly* (Kupferstichkabinett, Basel) with drawings in the margins of the book; the copy was owned by the schoolmaster Oswald Geisshüsler, known as Myconius	Mary Tudor, Dowager Queen of France, marries Charles Brandon, Duke of Suffolk Wolsey rises to the positions of Cardinal and Chancellor	Louis XII dies; is succeeded as King of France by Francis I

Holbein	England	Europe
1516 Paints the portraits of Jakob Meyer zum Hansen and his wife, Dorothea Kannengiesser (Kunstmuseum, Basel), probably to commemorate Jakob's appointment as Burgomaster of Basel that year	Mary, later Queen Mary I, is born at the Palace of Placentia, Greenwich Vincent Volpe is painter to the Navy (until 1519)	Ferdinand II dies; is succeeded as King of Spain by Charles V Erasmus completes his editions of both St Jerome's New Testament and the letters of St Jerome, which were dedicated to William Warham, Archbishop of Canterbury Matthias Grünewald completes the *Isenheim Altarpiece* Hans Holbein the Elder leaves Augsburg, possibly travelling to Isenheim to work for the monastery of St Anthony Giovanni Bellini dies in Venice
1517 Probably in the spring, Holbein travels to Lucerne With his father, Holbein decorates the exterior of the house of Jacob von Hertenstein, chief magistrate of Lucerne Paints the portrait of Benedict von Hertenstein (Metropolitan Museum of Art, New York) and the Adam and Eve (Kunstmuseum, Basel) Produces stained glass window design representing the arms of Hans Fleckenstein of Lucerne (Gemäldegalerie, Braunschweig) 10 December, Holbein and Caspar, a goldsmith, are each fined five livres for fighting in the street	May Day riots in London, protesting against foreign workers and the importation of foreign goods Nikolaus Kratzer arrives in England, to study as a Fellow of Fox's new College of Corpus Christi, Oxford Erasmus leaves England for Leuven Pietro Torrigiano is commissioned to produce the high altar for Henry VIII's chapel in Westminster Abbey	Martin Luther nails his *95 Theses* to the door of the Schlosskirche, Wittenberg Quentin Massys paints the portrait of Erasmus, as a diptych with a portrait of Peter Aegidius, learned traveller and town clerk of Antwerp; 16 September, the painting is sent as a gift to Sir Thomas More, who was then in Calais; 6 October, Sir Thomas More writes to Erasmus expressing delight at the gift
1518	Treaty of London, engineered by Wolsey, places England at the heart of European diplomacy, with the aim of repelling Moorish invasion in Spain Dr John Chambers and others found the Royal College of Physicians Around this time, the Flemish painter Jan Raf (John Corvus) arrives in England	Thomas More's *Utopia* is published by Johannes Froben in Basel, with woodcut illustrations by Ambrosius Holbein Titian's *Assumption of the Virgin* altarpiece is installed in S Maria Gloriosa dei Frari, Venice
1519 19 February, is paid twelve schillings for two small flags of painted cloth 21 May, is paid one livre, one schilling and six heller, for banners for the fountain near the convent of the Franciscans Holbein returns to Basel; 25 September, pays to be admitted into the Basel painters' guild, the Zunft zum Himmel Around this time Holbein marries Elsbeth Schmid, widow of a tanner who has one son, Franz Paints the portrait of Bonifacius Amerbach (Kunstmuseum, Basel) Nothing more is heard of Ambrosius Holbein from this date	Elizabeth Blount, 'Bessie', gives birth to Henry Fitzroy, illegitimate son of Henry VIII The humanist scholar, and founder of St Paul's School, Dean John Colet dies Around this time, the Italian painter Antonio Toto arrives in England	Maximillian I dies; is succeeded as Holy Roman Emperor by Charles V Leonardo da Vinci dies at Amboise, near Tours
1520 15 June, is elected Chamber-master of the painters' guild 3 July, obtains rights of citizenship of Basel 1 August, the wife of the painter Michel Schuman sues Holbein for a debt of eight pounds Around this time, probably begins work on the *Oberried Altarpiece* at Freiburg im Breisgau Cathedral Around this time, begins to paint the façades of house belonging to the goldsmith, Balthasar Angelroth, on the corner of the Eisengasse, Basel, the *House of the Dance*	Charles V, Holy Roman Emperor, King of Spain, and nephew of Catherine of Aragon, pays a state visit to England, meeting Henry VIII at Dover and Canterbury John Brown is employed as designer, supervisor and painter of the English decorations for the Field of the Cloth of Gold at Guisnes Vincent Volpe goes on a mission to Antwerp as the 'King's Painter'	Field of the Cloth of Gold – Henry VIII and Francis I meet in lavish surroundings between Guisnes and Ardres near Calais to seal a new friendship Martin Luther publishes *De Captivitate Babylonica – The Babylonian Captivity* Raphael dies in Rome

	Holbein	England	Europe
1521	15 June, is paid forty guldens as an advance upon signing the contract for the commission to paint the interior of the newly build Council Chamber of the 'Rathaus' (Town Hall) in Basel Paints the *Body of the Dead Christ in the Tomb* (Kunstmuseum, Basel) *Assertio septem sacramentorum* (Defence of the Seven Sacraments) is published by Richard Pynson in London, the border of the title-page using a design by Holbein first produced in 1516	Henry VIII is awarded the title *Fidei Defensor* (Defender of the Faith) by Pope Leo X	Treaty of Bruges allies England with Charles V against France Edict of Worms declares Martin Luther a heretic Erasmus settles in Basel from Leuven following accusations of heresy Pope Leo X dies
1522	Paints the *Solothurn Madonna* (Museum der Stadt, Solothurn) 29 November, receives the final payment for the decoration of the Council Chamber	John Corvus paints the portrait of Bishop Foxe	Election of Pope Adrian VI (Adrian Dedel of Utrecht) The *Victoria*, one of Magellan's ships, returns to Spain, the first ship to circumnavigate the globe Titian paints *Bacchus and Ariadne* for Alfonso d'Este's 'camerino' at Ferrara
1523	Paints three portraits of the humanist scholar, Desiderius Erasmus	Vincent Volpe is recorded as a resident in 'St Martyns Owtwych'	Pope Adrian VI dies; election of Pope Clement VII (Giulio de' Medici) Erasmus completes his *Commentary on the Gospel of St Mark*, dedicated to Francis I of France
1524	Probably in the spring, Holbein travels to France, possibly in an attempt to secure commissions from Francis I 3 June, Erasmus writes to Wilibald Pirkheimer in Nuremburg: 'Only recently I have sent two portraits of me to England, painted by a not unskilful artist. He has also taken a portrait of me to France.'; one of the portraits sent to England is a gift to William Warham, Archbishop of Canterbury, a patron of Erasmus Holbein's father, Hans Holbein the Elder, dies	Sir Henry Wyatt is appointed Treasurer of the Bedchamber (until 1528) The Italian sculptor Benedetto da Rovezzano begins working on Cardinal Wolsey's tomb (until 1529)	Construction begins on the Palazzo del Te, Mantua, designed by Giulio Romano
1525		Wolsey introduces the Amicable Grant, a compulsory levy on all men of property to raise funds, leading to widespread resistance; on signs of rebellion it is retracted by Henry VIII Lucas Horenbout is first recorded as working for Henry VIII	Battle of Pavia: Charles V defeats Francis I, holding the French king captive Vittorio Carpaccio dies in Venice
1526	Paints the *Lais Corinthiaca* (Kunstmuseum, Basel) About this time, commissioned by Jakob Meyer to paint the *Virgin and Child* (Hessische Hausstiftung) 4 July, Heinrich Meltinger, Burgomaster of Basel, writes on Holbein's behalf to Antoine Abbey, Isenheim, requesting the return of his father's painting materials 29 August, Erasmus writes a letter of introduction for Holbein to Peter Aegidius in Antwerp, asking him to introduce Holbein to Quentin Massys, and stating that: 'The arts are freezing in this part of the world, and he is on his way to England to pick up some angels there.' Holbein travels, via Antwerp, to England 18 December, Sir Thomas More writes to Erasmus: 'Your painter, dearest Erasmus, is a wonderful artist, but I fear that he is not likely to find England so abundantly fertile as he had hoped; although I will do what I can to prevent him finding it quite barren.'		Francis I is released by Charles V

Holbein	England	Europe
1527 Holbein undertakes a large-scale painting, on linen, of the More family (now lost), and a portrait of Thomas More (The Frick Collection, New York) 8 February, 'Master Hans' (Holbein) receives his first payment for work carried out in preparation for the entertainment of Henry VIII and Francis I at Greenwich; the payments are repeated, with only four days interval, until Sunday 3 March; Holbein paints a battle scene and cosmic ceiling design, in collaboration with Nikolaus Kratzer, for the court banqueting hall and theatre as part of the Greenwich festivities which take place on Sunday 5 May Paints Mary Wotton, Lady Guildford (St Louis Art Museum) and Sir Henry Guildford (The Royal Collection, Windsor) who, as Comptroller of the Household, was in charge of organising the festivities at Greenwich Paints William Warham, Archbishop of Canterbury (Musée du Louvre, Paris), which is sent to Erasmus as a gift in reciprocation of the painting he received in 1524 Around this time he possibly paints *Noli me Tangere* (The Royal Collection, Windsor), which may have been for an English patron	5 May, Henry VIII and Francis I meet at Greenwich to renew their friendship with an alliance; John Brown, Serjeant Painter, and Vincent Volpe, one of the king's salaried Italian painters, provide paintings, along with other English painters including William Fox, Richarde Gates, and Anthony Wilsher; sculpture was provided by the Italian sculptor John de Mayn (Giovanni da Maiano), assisted in the gilding by the Italian Ellys Carmyan The title of the 'King's Painter' is changed to 'Serjeant Painter', with raised fees	Charles V and Imperial troops sack Rome, making Pope Clement VII a virtual prisoner
1528 Paints his friend, the royal astronomer Nikolaus Kratzer (Musée du Louvre, Paris), and Thomas and John Godsalve (Gemäldegalerie Alte Meister, Dresden) Returns to Basel; 29 August, purchases a house in the St Johann Quarter on the banks of the Rhine next door to Johannes Froben's bookshop, bought from the cloth-weaver Eucharius Rieher for 300 guldens Around this time, paints his wife Elsbeth and their two children, Philipp and Katherina (Kunstmuseum, Basel) Around this time, reworks Jakob Meyer's *Virign and Child* (Hessische Hausstiftung)	Cardinal Lorenzo Campeggio, Papal Legate, arrives in London, to preside over the ecclesiastical court at Blackfriars, which was to hear the matrimonial dispute between Henry VIII and Catherine of Aragon, the King's 'Great Matter' Sir Brian Tuke is made Treasurer of the Bedchamber Plague breaks out in the hot summer, killing thousands Lucas Horenbout begins to receive a monthly annuity from the crown of 55s. 6d., which continues until 1542	Basel Council are obliged to allow worship according to reformed ritual in some churches, and permit the removal of sacred pictures from their walls Albrecht Dürer dies in Nuremberg *The Courtier* by Baldassare Castiglione is published
1529 1 January, the *Canones Horoptri*, by Nikolaus Kratzer, illuminated by Holbein whilst in England, is presented to Henry VIII as a New Year's Day gift Holbein secures few other commissions owing to the Reformation in Basel, as result of which religious images were forbidden	Henry VIII's marriage tribunal finally opens at Blackfriars, Catherine of Aragon strongly represented and defended by John Fisher, Bishop of Rochester; the court adjourns over the summer and the matter appealed to Rome, to the frustration of Henry Cardinal Wolsey falls from grace, and forfeits York Place (later developed as Whitehall Palace) and Hampton Court to the King; Sir Thomas More succeeds him as Lord Chancellor John Rastell's *Pastyme of People* is published	Catholic members of the Basel Council are removed by a mob of armed citizens, and a number of excesses follow On Shrove Tuesday, furious iconoclasm breaks out in Basel, the Cathedral is attacked and pictures pulled down and smashed Erasmus retires to Freiburg im Breisgau
1530 In the summer Holbein is employed to finish the interior decoration of the Council Chamber, which he had left incomplete some years earlier, receiving the first payment on 6 July and final payment on 18 November; subjects of the decoration include *Rehoboam rebuking the Elders of Israel*; *The Meeting of Samuel and Saul* and *Hezekiah ordering the Idols to be broken into pieces* 26 June appears before the Town Council because he had not taken Reformed Communion	Henry attempts to secure support of scholars across Europe for his divorce, to challenge the position of the Papacy Wolsey is charged with treason, and dies at Leicester on his way to trial Antonio Toto produces paintings of religious pictures and decorative work at Hampton Court, assisted by Philyp Arkeman Giovanni da Maiano and Benedetto da Rovezzano begin working on Henry VIII's tomb at Windsor (until 1536) Vincent Volpe paints a 'plat' (map) of Rye and Hastings	Diet of Augsburg attempts to calm tension over Protestantism in Germany Alessandro de' Medici appointed ruler of Florence

Holbein	England	Europe
1531 28 March, purchases the small cottage next to his house for 70 gulden from the fisherman Uly von Rynach 7 October, receives 17 pfund, 10 schilling (14 gulden), for repainting the two clocks on the Rhine Gate in Basel	Sir Thomas Elyot's *A Boke called the Governor* is published Around this time, or earlier, the French painter Nicholas Lizard arrives in England Lizard begins work on a coronation picture for Westminster Palace (recorded as Nicholas Lasora), along with the English painters John Adye, John Bettes, John Beare, Thomas Chamley and others William Brewer produces a heraldic painting for the revels entertaining foreign ambassadors	Religious wars in the Swiss Cantons: Battle of Kappel, the Catholic Cantons defeat the Protestant forces of Zurich Great Comet (Halley's Comet) sighted in Europe
1532 Probably in the spring, Holbein leaves Basel for England On his arrival in London Holbein makes contact with the Hanseatic merchants, painting Georg Gisze (Gemäldegalerie, Berlin) and Hermann von Wedigh (Metropolitan Museum of Art, New York); around this time he is also commissioned to paint two murals for Guildhall of the Hanseatic merchants, of the *Triumphs of the Riches and Poverty* (now lost) 2 September, Jakob Meyer zum Hirschen, Burgomaster of Basel, writes to Holbein in an attempt to persuade him to return to Basel, offering him: '… thirty pieces of money, until we are able to take care of you better.'	Anne Boleyn is created Marquess of Pembroke, and appears in public effectively as Queen Sir Thomas More resigns from public office Sir Henry Guildford and William Warham, Archbishop of Canterbury, die Thomas Cromwell appointed Master of the King's Jewels John Brown dies; Andrew Wright is appointed Serjeant Painter Robert Amadas is recorded as Goldsmith and Master of the Jewels By this time, Vincent Volpe is a resident of the Parish of St Andrew Undershaft	Niccolò Machiavelli's *The Prince* is published (written 1513), five years after his death
1533 Holbein designs *Apollo and the Muses on Parnassus* (Kupferstichkabinett, Berlin) as decoration for the Hanseatic merchants' triumphal arch, forming part of the city pageant for the procession of Anne Boleyn from the Tower of London to her coronation at Westminster, which takes place on Saturday 31 May 11 July, Chapuys, Imperial Ambassador in London, writes to Emperor Charles V: 'I understand my lady (ie. Anne) complains daily to the Easterlings (ie. Germans), who on the day of her entry had set the Imperial eagle predominant over the King's arms and hers … This may serve as an indication of her perverse and malicious nature.' Paints the Hanseatic merchants Derich Born (The Royal Collection, Windsor) and Cyriacus Kale (Herzog Anton-Ulrich Museum, Braunschweig), and probably members of the royal court such as Sir Thomas Elyot and the Earl of Surrey Paints *Jean de Dinteville and Georges de Selve: The Ambassadors* (The National Gallery, London) Designs a table fountain for Anne Boleyn, probably to be presented as a New Year's Day gift for Henry VIII in January 1534	Henry VIII marries Anne Boleyn, his second wife Thomas Cranmer is appointed Archbishop of Canterbury, and declares the marriage of Henry to Catherine of Aragon void, and Anne Boleyn his lawful wife Anne Boleyn gives birth to a daughter, Elizabeth, later Elizabeth I Thomas Cromwell is appointed Chancellor of the Exchequer, and, by April 1534, the King's Secretary Miles Coverdale begins to produce the first complete English bible, in exile on the continent (finished in 1535)	Nicolas Bourbon is imprisoned in Paris following the publication of his Latin poems *Nugae* Ludovico Ariosto dies

	Holbein	England	Europe
1534	Holbein receives payment for painting a gilded image of Adam and Eve by the royal goldsmith Cornelis Hayes Around this time, or slightly earlier, paints Thomas Cromwell (The Frick Collection, New York) Sebastian Münster's *Canones super novum instrumentum luminarum* is published, with large-scale designs by Holbein	Act of Supremacy declares that Henry VIII is 'the only Supreme Head in Earth of the Church of England'; Treasons Act made it high treason, punishable by death, to refuse to acknowledge the King as such Act of Succession validates the marriage between Henry and Anne; Catherine's daughter, the Lady Mary, was declared illegitimate, and Anne's issue were declared next in the line of succession; refusal to acknowledge the act resulted in life imprisonment Various other Acts restrict the power of the Pope and bolster the power of the King Bishop Fisher and Sir Thomas More are imprisoned at the Tower of London Lucas Horenbout becomes an English denizen, receives the Grant for life of the office of 'King's painter', and the Grant of a tenement in the Parish of St. Margaret, Westminster	Pope Clement VII dies; election of Pope Paul III (Alessandro Farnese)
1535	Around this time, paints the portrait of Charles de Solier, Sieur de Morette (Gemäldegalerie Alte Meister, Dresden), successor to Jean de Dinteville as French Ambassador Designs the title-page for the *Coverdale Bible*	Sir Thomas More and John Fisher, recently appointed Cardinal, fail to take the Oath of Supremacy, are found guilty of treason and beheaded Cromwell oversees the *Valor Ecclesiasticus*, detailing the wealth of the Church Following his release from prison in Paris, Nicolas Bourbon travels to England where Anne Boleyn secures him employment	Charles V conquers Tunis
1536	Paints Sir Richard Southwell (Galleria degli Uffizi, Florence) A revised edition of Philip Melancthon's *Loci Communes* is published in Antwerp with a title-page designed by Holbein *Paidagogeion* by Nicolas Bourbon is published, with a portrait of the author by Holbein dated 1535 In the prefatory letter Bourbon, recently returned to France from England, writes to Thomas Solimar, the King's Secretary: 'I have yet to beg you to greet in my name as heartily as you call all with whom you know me connected by intercourse and friendship: Mr Thomas Cranmer, the Archbishop of Canterbury … Mr Cornelis Hayes, my host the King's goldsmith; Mr Nikolaus Kratzer, the King's astronomer, a man who is brimful of wit, jest and humorous fancies; and Mr Hans [Holbein], the royal painter, the Apelles of our time. I wish them from my heart all joy and happiness.'	Anne Boleyn is found guilty of adultery and beheaded; eleven days later Henry VIII marries Jane Seymour, his third wife Dissolution of the Monasteries; Sir Richard Southwell is appointed receiver for the Court of Augmentations, dealing with the proceeds of the dissolution 'Modon', or Nicholas of Modena, a sculptor specialising in stucco, arrives in England and begins work at Whitehall Palace Peter Richardson is appointed by Henry VIII to make jewels for Jane Seymour The Pilgrimage of Grace; uprising of Roman Catholics in the north of England Vincent Volpe dies in London before 4 December when his will was proved	William Tyndale is strangled and burnt at the stake, outside Brussels Erasmus dies
1537	Probably in this year, Holbein paints the mural of Henry VII and Henry VIII at Whitehall Palace, and paints the individual portraits of Jane Seymour (Vienna) and Henry VIII (Thyssen, Madrid) Designs a book cover for Sir Thomas Wyatt, in celebration of his marriage	Edward VI is born; Jane Seymour dies twelve days after childbirth Rebellion against the Reformation in the north of England (Pilgrimage of Grace) is put down, Cromwell setting up the Council of the North to keep order Antonio Toto produces a heraldic painting for the funeral of Jane Seymour	Alessandro de' Medici is assassinated; Cosimo de' Medici (Cosimo the Great) becomes ruler of Florence Jacopo Sansovino begins building his *Logetta* and *Library of St Mark's* in Venice Serlio's *Five Books of Architecture* are published

	Holbein	England	Europe

Holbein

1538

Holbein travels to Europe to take the portraits of potential brides for Henry VIII:
2/3 March, Holbein travels with Philip Hoby to Brussels with instructions from Cromwell to obtain the portrait of Christina of Denmark, Duchess of Milan, reaching Brussels on 10 March
12 March, at one o'clock Holbein begins his drawing of the Duchess of Milan, which is completed within three hours, and returns home with Hoby later the same day arriving in London on 18 March
April and May, Holbein works on the full-length portrait of Christina of Denmark, Duchess of Milan (The National Gallery, London)
14 March, Hutton writes to Cromwell with a full outline of the visit and the sitting
Lady Day (c. 25 March), the earliest surviving records of regular payment to Holbein from the royal purse: 'Item, for Hans Holben, painter, vii*li*.xs', a sum of £30 per year, paid quarterly, and continued yearly until his death
29 May, Holbein receives a royal licence to export 600 tuns of beer
3 June, Holbein and Hoby leave London for Le Havre to obtain the portrait of Louise of Guise, and some other lady, possibly Marie or Margaret of Vendôme
30 June, Holbein receives three-quarters of a years salary in advance
11/22 Aug, on one of these dates Holbein and Hoby leave London for Nancy and Joinville to obtain the portraits of Renée of Guise (Nancy) and Anne of Lorraine (Joinville), receiving £6, 13s, 4d for their travelling expenses
30 Aug, arrive in Joinville to find Renée absent, but were successful at Nancy in getting a likeness of Anne From Joinville, Hoby returns to London but Holbein travels to Basel, which he reaches before 10 September, and remains there until after 16 October; in Basel he displays his new found prosperity: 'he was attired in silk and velvet; before this he was obliged to buy his wine at the tap.'
December, upon returning to London Holbein receives a special reward of £10 for 'his costis and charges at this tyme sent absente certeyn his gracis affares into the parties of high Burgony, by way of his Graces rewarde.'
About this time Nikolaus Kratzer writes to Thomas Cromwell that he has given a book by the German Lutheran Georg Spalatin to Holbein so that he may give it to Cromwell

England

Following the alliance of Francis I and Charles V, fear of invasion leads to defences being built at key points on the south and east coasts, such as Dover Henry VIII begins his search for a new bride in Europe
The King begins to develop Nonsuch Palace in Surrey, a palace of fantasy to rival Francis I's château at Chambord; brings over European craftsmen to work on the building, such as Nicholas Bellin of Modena, who had worked at Fontainebleau
Antonio Toto is granted denizenship

Europe

Francis I and Charles V seal a ten-year truce
Titian paints the *Venus of Urbino* and *François I*

1539

1 January, Holbein presents a portrait of Prince Edward (National Gallery of Art, Washington) to Henry VIII as a New Year's Day gift, recorded in the roll of gifts: 'By Hans Holbyne a table pictour of the pince (Prince's) grace'; in return Holbein received a silver-gilt covered cup by Cornelis Hayes: 'To Hans Holbeyne, painter, a gilte cruse wt a cover (Cornelis) weing x oz. quarter'
July, Holbein travels to Düren in Cleves, west Germany, with Richard Beard, to take the portrait of Anne of Cleves, receiving £40 travelling expenses, and Holbein an extra £13, 6s, 8d, for his own personal outlay
Early Aug, reach Düren, where he paints Anne of Cleves and her sister, Amelia, by 11 August
September, returns from Cleves and receives a whole years salary in advance
Around this time, paints Thomas Howard, 3rd Duke of Norfolk (The Royal Collection, Windsor)

England

John Bale's satirical play *King John* is performed before Thomas Cranmer
Susanna Horenbout accompanies Anne of Cleves, as her lady-in-waiting, on her journey to England

| 1540 | Possibly paints the portrait miniature of Jane Small (Victoria and Albert Museum, London) in this year | Anne of Cleves becomes Henry VIII's fourth wife; seven months later the marriage annulled, and Henry marries Catherine Howard, his fifth wife | |
| | November, Holbein's uncle, Sigmund Holbein, dies in Berne; Holbein is represented for the acceptance of his inheritance by his wife and her guardian and brother-in-law, Anthonin Schmid | Thomas Cromwell is executed
Around this time, Giovanni da Maiano and Benedetto da Rovezzano return to Italy | |
| 1541 | Around this time, Holbein is commissioned by the Barber-Surgeons' Company to paint Henry VIII presenting their new charter to the Company members (The Worshipful Company of Barbers, London) | William Cure, of Amsterdam, is recorded as working as a sculptor at Nonsuch Palace
Antonio Toto receives a licence to export 600 tons of beer | John Calvin's *Institutes of the Christian Religion* is published in French
Michelangelo completes the *Last Judgement* above the altar in the Sistine Chapel
Jean Clouet, painter to Francis I, dies |
	Probably paints the miniature portraits of Charles and Henry Brandon, sons of the Duke of Suffolk (The Royal Collection, Windsor)		
	June, becomes an English denizen		
	24 October, the subsidy roll for the City of London records Holbein as a 'stranger' living in the parish of St Andrew Undershaft, in Aldgate Ward, and taxed £30		
1542	John Leland's *Naeniae in mortem Thomae Viati*, a selection of poems commemorating the death of Sir Thomas Wyatt, is published by Reynold Wolf, with a portrait of Wyatt on the frontispiece by Holbein	Catherine Howard is beheaded	Battle of Solway Moss – the Scots, under James V of Scotland, are defeated by the English; James V dies soon after, leaving his week-old daughter, Mary, Queen of Scots
	Paints Henry Howard, Earl of Surrey (Museu de Arte de São Paulo)		
	Around this time, draws a self-portrait (Galleria degli Uffizi, Florence)		
1543	Designs a clock salt for Sir Anthony Denny (The British Museum, London), to be presented to Henry VIII as a New Year's gift in January 1545	Henry VIII marries Catherine Parr, his sixth wife	
Treaty of marriage between the infant Queen Mary and Edward, Prince of Wales, is signed with the Scottish Ambassadors	English troops cross the channel to France, in preparation for a campaign against Charles V		
Nicolaus Copernicus publishes *De Revolutionibus Orbium Coelestium (On the Revolutions of the Heavenly Spheres)* in Nuremberg, and dies shortly afterwards			
	7 October, Holbein makes a will, providing for payments of his debts to 'Mr Anthony, the King's servant, of Greenwich, £10, 13s, 7d', and 'Mr John of Antwarpe [Hans of Antwerp], goldsmith, £6', and allocating 7s, 6d, every month for the keeping of the his two children (in England) and 'nurse', witnessed by Anthoney Snecher, armourer, Mr John of Antwarpe [Hans of Antwerp], goldsmith, Olrycke Obynger, merchant, and Harry Maynert, painter	Andrew Wright dies, his will listing property in Stratford le Bow, Southwark and Cowden, and bequeaths his 'tools belonging to the Painter's craft' to John Child; Antonio Toto is appointed Serjeant Painter in January of the following year	Andreas Vesalius publishes his *De Humanis Corporis Fabrica (On the Fabric of the Human Body)*
	Some time between 7 October and 29 November Holbein dies, almost certainly of plague; Holbein is probably buried either in the Church of St Andrew Undershaft or the Church of St Katherine Cree, both of which still stand on Leadenhall Street in the City of London		
	29 November, Hans of Antwerp, appointed executor in Holbein's will, appears before Master John Croke, Commissionary-General, and the will is executed		

Compiled by Tim Batchelor, drawing upon the work of Erna Auerbach, A.B. Chamberlain and Susan Foister

Notes to Introduction

1. For the text of the letter sent to Holbein by
the Basel Town Council on 2 September 1532,
see Chamberlain 1813 (vol. 2), pp. 34–5.
2. See Foister 2004, pp. 11–12.
3. For Holbein's will see Rowlands 1985,
p. 122 and fig. 21.
4. For the contents of Henry VIII's Whitehall
Palace and other royal palaces and possessions,
see Starkey 1998.
5. On foreign competition, see London 2003,
pp. 91–4.
6. For the Painter-Stainers, see Foister 1993;
for foreign painters on the royal payroll,
see Auerbach 1954, Foister 2004, pp. 15–17.
7. For the portrait of Cromwell and other
references to individual paintings by Holbein,
see Rowlands 1985.
8. Foister 2004, p. 95.
9. See Foister 2001.
10. On the court goldsmiths, see Chamberlain 1913
(vol. 2), pp. 287–8; Glanville 1990, Rowlands 1993,
pp. 152–5.
11. See London 1997.

Bibliography

Ainsworth 1990
M. Ainsworth, '"Paternes for Phiosioneamyes" Holbein's Portraiture Reconsidered', *Burlington Magazine*, CXXXII, 1990, pp. 173–86

Ainsworth and Faries 1986
M. Ainsworth and M. Faries, 'Northern Renaissance Paintings: The Discovery of Invention', *The St Louis Art Museum Bulletin*, n.s. XVIII, vol. 1, 1986, pp. 4–7

Anglo 1969
S. Anglo, *Spectacle, Pageantry and Early Tudor Policy*, Oxford 1969

Auerbach 1954
E. Auerbach, *Tudor Artists*, London 1954

Augsburg 1965
Hans Holbein der Ältere und die Kunst der Spätgotik, exh. cat., Augsburg 1965

Basel 1960
Die Malerfamilie Holbein in Basel, exh. cat., Kunstmuseum Basel 1960

Basel 1988
C. Müller, *Hans Holbein d.J. Zeichnungen aus dem Kupferstichkabinett der Öffentlichen Kunstsammlung Basel*, exh. cat., Kunstmuseum Basel 1988

Basel 2006
C. Müller, S. Kemperdick, *Hans Holbein the Younger the Basel Years 1515–1532*, exh. cat., Kunstmuseum Basel 2006

Bätschmann and Griener 1997
O. Bätschmann and P. Griener, *Hans Holbein*, London 1997

Berlin 1997–8
Dürer Holbein Grunewald, Meisterzeichnungen der deutschen Renaissanceaus Berlin und Basel, exh. cat., Basel and Berlin 1997–8

Bimbenat-Privat 1992
M. Bimbenat-Privat, *Les Orfèvres Parisiens de la Renaissance 1506–1620*, Paris 1992

Bomford 2004
K. Bomford, 'Friendship and immortality: Holbein's *Ambassadors* Revisited', *Renaissance Studies*, vol. 18, 2004, pp. 54–581

Bradner 1956
L. Bradner, 'Some Unpublished Poems by J. Leland', *Publications of the Modern Language Society of America*, LXXI, 1956, pp. 827–36

Briels 1980
J. Briels, 'Amator Pictoriae Artis. De Antwerpse kunsthandelaar Pieter Stevens (1590–1608) en zijn Constkamer', *Jaarboek van het Koninklijk Museum voor Schone Kunsten Antwerpen*, 1980

Brinkmann and Kemperdick 2005
B. Brinkmann and S. Kemperdick, *Deutsche Gemälde im Städel, 1500–1550*, Mainz am Rhein 1995

Brown 1982
D.B. Brown, *Ashmolean Museum Oxford, Catalogue of the Collection of Drawings: IV, The Earlier British Drawings*, Oxford 1982

Bryant 1999
J. Bryant, 'Acquisitions', *English Heritage Collections Review*, 1999, pp. 24–6

Buck 1997
S. Buck, *Holbein am Hofe Heinrichs VIII*, Berlin 1997

Buck 1998
S. Buck, 'Text versus Bild: Holbeins Interpretation Heinrichs VIII. Am Beispiel der "Salamo Miniatur"', *Hans Holbein der Jüngere, Akten des Internationalen Symposums Kunstmuseum Basel, 26.–28. Juni 1997, Sonderausgabe von Band 55, 1998, Hefte 2–4, der Zeitschrift für Schweizerische Archäologie und Kunstgeschichte*, Zürich 1998, pp. 281–92

Campbell 1987
L. Campbell, 'Holbein's Miniature of "Mrs Pemberton": the identity of the sitter', *Burlington Magazine*, CXXIV, 1987, pp. 366–71

Campbell 1990
L. Campbell, 'Holbein's miniature of Jane Pemberton: a further note', *Burlington Magazine*, CCXXVII, 1990, pp. 213–4

Campbell 1990
L. Campbell, *Renaissance Portraits. European Portrait-Painting in the Fourteenth, Fifteenth and Sixteenth Centuries*, New Haven and London, 1990

Campbell and Foister 1986
L. Campbell and S. Foister, 'Gerard, Lucas and Susanna Horenbout', *Burlington Magazine*, CXXVIII, 1986, pp. 719–27

Chamberlain 1913
A.B. Chamberlain, *Hans Holbein the Younger*, London 1913

Collins 1955
A.J. Collins, *Jewels and Plate of Queen Elizabeth I*, London 1955

Cooper n.d.
T. Cooper, Unpublished catalogue entries on drawings in the collection of University College, London, typescript

Dodgson 1938–9
C. Dodgson, 'Woodcuts Designed by Holbein for English Painters', *The Walpole Society*, XXVII, 1938–9, pp. 1–10

Dülberg 1990
A. Dülberg, *Privatporträts: Geschichte und Ikonologie einer Gattung in 15 und 16 Jahrhundert*, Berlin 1990

Edinburgh 1993
J. Roberts, *Holbein and the Court of Henry VIII Drawings and miniatures from the Royal Library Windsor Castle*, exh. cat., National Gallery of Scotland, Edinburgh 1993

Eissenhauer 1996
M. Eissenhauer, 'Hans Asper', *Grove Dictionary of Art*, 1996, 2nd ed., p. 606

Fairbrass and Holmes 1986
S. Fairbrass and K. Holmes, 'The Restoration of Hans Holbein's Cartoon of Henry VIII and Henry VII', *Conservator*, no. 10, 1986, pp. 12–6

Foister 1981
S. Foister, 'Holbein and his English Patrons', unpublished Ph.D. thesis, Courtauld Institute, University of London 1981

Foister 1983
S. Foister, *Drawings by Holbein from the Royal Library, Windsor Castle*, London and New York 1983

Foister 1993
S. Foister, 'Foreigners at Court: Holbein, Van Dyck and the London Painter-Stainers Company', in D. Howarth (ed.), *Art and Patronage at the Caroline Courts*, Cambridge 1993, pp. 32–50

Foister, Roy and Wyld 1994
S. Foister, M. Wyld and A. Roy, 'Hans Holbein's *A Lady with a Squirrel and a Starling*', *National Gallery Technical Bulletin*, vol. 15, 1994, pp. 6–19

Foister 1996
S. Foister '"My foolish curiosity": Holbein in the Collection of the Earl of Arundel', *Apollo*, August 1996, pp. 51–6

Foister 2001
S. Foister, 'Holbein's paintings on canvas: the Greenwich festivities of 1527' (with an appendix by J. Kirby), in M. Roskill and J.O. Hand (eds.), *Hans Holbein: Paintings, Prints and Reception. Studies in the History of Art*, 60, National Gallery of Art, Washington, New Haven and London 2001, pp.108–23

Foister 2003
Holbein: Portraits of Sir Henry and Lady Guildford, exh. leaflet, National Gallery, London 2003

Foister 2004
S. Foister, *Holbein and England*, London and New Haven 2004

Frankfurt 2004
S. Buck, *Wendepunkte deutscher Zeichenkunst. Spätgotik und Renaissance im Städel*, exh. cat., Frankfurt am Main 2004

Frederickson 1982
B. Frederickson, 'E Cosi Desia Me Mena', *J. Paul Getty Museum Journal*, no.10, 1982, pp.21–38

Gamber 1963
O. Gamber, 'Die Königlich Englische Hofplattnerei, Martin van Royne und Erasmus Kirkener', *Jahrbuch der Kunsthistorischen Sammlung in Wien*, no.59, 1963, pp.11–30

Ganz 1922
P. Ganz, 'An English Portrait-Painter in Holbein's Atelier', *Art in America*, no.19, 1922, pp.153–8

Ganz 1925
P. Ganz, 'An Unknown Portrait by Holbein the Younger', *Burlington Magazine*, no.47, 1925, pp.113–5

Ganz 1937
P. Ganz, *Die Handzeichnungen Hans Holbein d. J. Kritischer Katalog, Berlin, 1911–1937*, exh. cat., 1937

Ganz 1950
P. Ganz, *The Paintings of Hans Holbein: First Complete Edition*, London 1950

Glanville 1990
P. Glanville, *Silver in Tudor and Early Stuart England: a social history and catalogue of the national collection 1480–1660*, London 1990

Goldring 2002
E. Goldring, 'An important early picture collection: The Earl of Pembroke's 1561/62 inventory and the provenance of Holbein's "Christina of Denmark"', *Burlington Magazine*, CXLIV, 2002, pp.157–160

Grossmann 1950
F. Grossman, 'Holbein, Torrigiano and Dean Colet', *Journal of the Warburg and Courtauld Institute*, xiii, 1950, pp.202–36

Grossmann 1951
F. Grossman, 'Holbein Studies I', *Burlington Magazine*, XCIII, 1951, pp.39–44; 'Holbein Studies II', ibid, pp.111–4

Grossmann 1961
F. Grossmann, 'A Religious Allegory by Hans Holbein the Younger', *Burlington Magazine*, CIII, 1961, pp.491–4

Habich 1929
G. Habich, 'Schaumünzen des XVI', *Jahrhunderts*, Munich 1929

Hackenbroch 1996
Y. Hackenbroch, *Enseignes: Renaissance Hat Jewels*, Florence 1996

Hague 2003
Hans Holbein, *Portraitist of the Renaissance*, exh. cat., The Mauritshuis, The Hague 2003

Hand 1993
J.O. Hand with the assistance of S.E. Mansfield, *The Collections of the National Gallery of Art Systematic Catalogue. German Paintings of the Fifteenth through Seventeenth Centuries*, National Gallery of Art, Washington and Cambridge 1993

Hand 1980
John Oliver Hand, 'The Portrait of Sir Brian Tuke by Hans Holbein the Younger', *Studies in the History of Art*, no.9, 1980, pp.33–49

Hanover 2000
M. Trudzinski, *Hans Holbein. Edward VI als Kind. Ein Wiedersehen*, exh. cat., Niedersächsischen Landesmuseum, Hanover 2000

Hearn and Jones (forthcoming)
K. Hearn and R. Jones, *Tudor and Stuart Paintings and Drawings: Works in the Tate Collection*

Heckscher 1967
W. Heckscher, 'On the Portrait of Erasmus at Longford Castle', *Essays on Painting Presented to Rudolf Wittkower*, 1967, pp.128–48

Hollstein 1954
F.W.H. Hollstein, *German Engravings, Etchings and Woodcuts c.1400–1700*, Amsterdam 1954

Holman 1979
T.S. Holman, 'Holbein's Portraits of the Steelyard Merchants: An Investigation', *Metropolitan Museum Journal*, no.14, 1979, pp.139–58

Houston 1987
J. Roberts, *Drawings by Holbein from the Court of Henry VIII*, exh. cat., Museum of Fine Arts, Houston 1987

Hugelshofer 1929
W. Hugelshofer, 'A Set of Drawings of the Apostles by Hans Holbein the Younger', *Old Master Drawings*, no.iv, June 1929, pp.1–3

Ives 1994
E. Ives, 'The Queen and the Painter: Anne Boleyn, Holbein and Tudor Royal Portraits', *Apollo*, July 1994, pp.36–45

James 1998
S.E. James, '*Lady Margaret Douglas* and *Sir Thomas Seymour* by Holbein: Two Miniatures Re-identified', *Apollo*, May 1998, pp.15–20

Jardine 1993
L. Jardine, *Erasmus, Man of Letters*, Princeton 1993

Jones 1995–6
R. Jones, 'The Methods and Materials of Three Tudor Artists: Bettes, Hilliard and Ketel', in K. Hearn (ed.), *Dynasties*, exh. cat., Tate Gallery, London 1995–6, pp.231–40

King 2004
D. King, 'Who was Holbein's *Lady with a Squirrel and a Starling*?', *Apollo*, May 2004, pp.43–8

Koegler 1931–2
H. Koegler, 'Holbeins Triumphzüge des Reichtums und der Armut', *Jhresberichte des Öffentliche Kunstsammlingen Basel*, n.f. xxviii–xxix, 1931–2 pp.57–95

Koepplin 2003
D. Koepplin, 'Ein Cranach Prinzip', in W. Schade (ed.), *Lucas Cranach: Glaube, Mythologie und Moderne*, exh. cat., Bucerius Kunstforum, Hamburg 2003, pp.144–65

Krause 2002
K. Krause, *Hans Holbein der Altere*, Munich and Berlin 2002

Levey 1959
M. Levey, *The German School*, exh. cat., National Gallery, London, 1959

Lieb and Stange 1960
N. Lieb and A. Stange, *Hans Holbein der Ältere*, 1960

Lindemann 1998
B. Lindemann, 'Die Passionstafeln von Hans Holbein dem Jüngeren', in Hans Holbein der Jüngere, *Akten des Internationalen Symposums Kunstmuseum Basel, 26–28 June 1997, Sonderausgabe von Band 55, 1998, Hefte 2–4, der Zeitschrift für Schweizerische Archäologie und Kunstgeschichte*, Zurich 1998, pp.219–26

Liverpool 2003
X. Brooke and D. Crombie, *Henry VIII Revealed. Holbein's Portrait and its Legacy*, The Walker Art Gallery, Liverpool 2003

Löcher 1985
K. Löcher, *Stadt im Wandel: Kunst und Kulture des Bürgertums in Norddeutschland 1150–1650*, C. Meckseper (ed.), exh. cat., Niedersachsen 1985

London 1977
Holbein and the Court of Henry VIII, exh. cat., Queen's Gallery, London 1977

London 1977–8
J.B. Trapp and H. Schulte Herbrüggen, 'The King's Good Servant', *Sir Thomas More*, exh. cat., National Portrait Gallery, London 1977–8

London 1980
Princely Magnificence, exh. cat.,
Victoria and Albert Museum, London 1980

London 1988
J. Rowlands and Giulia Bartrum, *The Age of Dürer
and Holbein German Drawings 1400–1550*, exh. cat.,
British Museum, London 1988

London 1991
D. Starkey (ed.), *Henry VIII: A European Court in
England*, exh. cat., National Maritime Museum,
London 1991

London 1993
M. Jaffe, *Old Master Drawings from Chatsworth*,
exh. cat., British Museum, London 1993

London 1995
G. Bartrum, *German Renaissance Prints 1490–1550*,
exh. cat., British Museum, London 1995

London 1995–6
K. Hearn (ed.), *Dynasties*, Tate Gallery, London
1995–6

London 1997–8
S. Foister, A. Roy and M. Wyld, *Making and
Meaning, Holbein's Ambassadors*, exh. cat.,
National Gallery, London, 1997

London 2003
R. Marks and P. Williamson (eds.), *Gothic Art for
England 1400–1547*, exh. cat., Victoria and Albert
Museum, London 2003

LP
Brewer, Brodie and Gairdner (eds.),
Letters and Papers of the Reign of Henry VIII,
London 1862–1910

Lubbeke 1991
I. Lübbeke, *The Thyssen-Bornemisza collection:
early German painting 1350–1550*, London 1991

Manchester 1961
F. Grossmann, *German Art 1400–1800*, exh. cat.,
Manchester 1961

Marks 2004
R. Marks, *Image and Devotion in Late Medieval
England*, Stroud 2004

Manuth 1998
V. Manuth, 'Zum Nachleben der Werke Hans
Holbeins d.J. in der holländischen Malerei und
Graphik des 17. Jahrhunderts', *Hans Holbein
der Jüngere, Akten des Internationalen Symposums
Kunstmuseum Basel, 26.–28. Juni 1997, Sonderausgabe
von Band 55, 1998, Hefte 2–4, der Zeitschrift für
Schweizerische Archäologie und Kunstgeschichte*,
Zürich 1998, pp. 323–336

Marsham 1875
R. Marsham, 'On a Manuscript Book of Prayers
in a Binding of Gold Enamelled', *Archaeologia*,
xliv, 1875

Martens 2005
D. Martens, 'Un temoin oublie de la Renaissance
colonaise au musée des Beaux-arts de Lille:
le triptyque du Calvaire par Barthel Bruyn le Jeune',
Revue du Louvre, 2005, no. 55, pp. 49–58

McKerrow and Ferguson
R.B. McKerrow and F.S. Ferguson,
'Titlepage Borders printed in England and
Scotland', *Bibliographical Society Monographs*,
xxi, London 1932

Millar 1963
O. Millar, *Tudor, Stuart and Early Georgian
Pictures in the Collection of Her Majesty the Queen*,
London 1963

Monnas 1998
L. Monnas, 'Making and Meaning: Holbein's
Ambassadors', exh. review, *Renaissance Studies*,
12, 1998, pp. 550–7

Müller 1990
C. Müller, 'Holbein oder Holbein-Werkstatt? Zu
einem Pokalentwurf der Gottfried Keller-Stiftung
im Kupferstichkabinett Basel', *Zeitschrift für
Schweizerische Archäologie und Kunstgeschichte*,
no. 47, 1990, pp. 33–42

Müller 1996
C. Müller, *Oeffentliche Kunsammlung Basel,
Kupferstichkabinett. Katalog der Zeichnungen
von Hans Holbein dem Jüngeren*, Basel 1996

Nichols 1857
J.G. Nichols, *The Literary Remains of King
Edward VI*, 1857

ODNB
Oxford Dictionary of National Biography

Oliver 2006
L. Oliver with V. Button, A. Derbyshire,
N. Frayling and R. Withnall, 'New Evidence
towards an attribution to Holbein of a drawing
in the Victoria and Albert Museum', *Burlington
Magazine*, no. 148, March 2006,
pp. 168–72

Pächt
O. Pächt, 'Holbein and Kratzer as collaborators',
Burlington Magazine, no. 84, 1944, pp. 134–9

Paris 1985
E. Foucart, *Les peintures de Hans Holbein
le Jeune au Louvre*, Musée du Louvre,
Paris 1985

Paris 1991–2
Dessins de Dürer et de la Renaissance germanique,
exh. cat., Musée du Louvre, Paris 1991

Parker 1983
K. Parker, *The Drawings of Hans Holbein in the
Collection of Her Majesty the Queen at Windsor Castle*,
2nd ed., appendix by S. Foister, London and
New York 1983

Pemberton Pigott 2002
V. Pemberton Pigott, 'Holbein's *Noli me Tangere:
"*So much reverence expressed in Picture*"'*, *Apollo*,
August 2002, pp. 35–9

Pennington 1982
R. Pennington, *A descriptive catalogue of the etched
work of Wenceslas Hollar*, Cambridge 1982

Phillips 1984
M.M. Phillips, 'The *Paedagogion* of Nicolas
Bourbon', in G. Castor and T. Cave (eds.),
Neo-Latin and the Venacular in Renaissance France,
Oxford 1984, pp. 71–82

Reynolds 1999
G. Reynolds, *The Sixteenth and Seventeenth Century
Miniatures in the Collection of Her Majesty the Queen*,
London 1999

Reinhardt 1975
Hans Reinhardt, 'Ein unbekannter Holzschinitt
Hans Holbein d.J. von 1536 und Holbeins
Melanchthon-Bildnis', *Zeitschrift für Schweizerische
Archäologie und Kunstgeschichte*, xxxii, 1975,
pp. 135–140

Rowlands 1978
J. Rowlands, 'Holbein and the Court of Henry
VIII', exh. review, *Master Drawings*, no. 17 1979,
pp. 53–6

Rowlands 1985
J. Rowlands, *The Paintings of Hans Holbein
the Younger*, London 1985

Rowlands 1993
J. Rowlands and G. Bartrum, *Drawings by German
Artists and Artists from German-Speaking Regions
of Europe in the Department of Prints and Drawings
in the British Museum. The Fifteenth Century and
the Sixteenth Century by Artists born before 1530*,
London 1993

Sander 2005
J. Sander, *Hans Holbein. Tafelmaler in Basel
1515–1532*, Munich 2005

Sjogren 1980
G. Sjögren, 'Portrait of a young lady, 1569:
an identification', *Burlington Magazine*,
1980, p. 699

Starkey 1998
D. Starkey, *The Inventory of King Henry VIII Vol 1.
The Transcript*, London 1998

Strolz 2004
M. Strolz, 'Zu Maltechnik und Restaurierung des
Porträts der Jane Seymour von Hans Holbein d.J.',
Technologische Studien. Kunsthistorisches Museum,
no. 1, 2004, pp. 8–31

Strong 1963
R. Strong, 'Holbein's Cartoon for the
Barber-Surgeons Group Rediscovered –
A Preliminary Report', *Burlington Magazine*,
CV, 1963, pp. 4–14

Strong 1967
R. Strong, *Holbein and Henry VIII*, London 1967

Strong 1969
R. Strong, *Tudor and Stuart Portraits, National Portrait Gallery*, exh. cat., National Portrait Gallery, London 1969

Syson and Thornton 2001
L. Syson and D. Thornton, *Objects of Virtue*, exh. cat., British Museum, London 2001

Szafran 1999
Y. Szafran, '*Allegory of Horse and Rider:* Holbein? A New Look at the Underdrawing', in H. Verougstraet and R Van Schoute with A. Dubois (eds.), *Le dessin sous-jacent et la technologie dans la peinture, Colloque XII, 11–13 Septembre 1997*, Leuven 1999, pp. 293–302

Tait 1962
H. Tait, 'Historiated Tudor Jewelley', *The Antiquaries Journal*, 42, 1962, pp. 226–246

Tait 1985
H. Tait, 'The girdle-prayerbook or 'tablett': an important class of Renaissance jewellery at the court of Henry VIII', *Jewellery Studies*, 2, 1985, pp. 29–58

Thurley 1993
S. Thurley, *The Royal Palaces of Tudor England*, New Haven and London 1993

Weniger 2003
M. Weniger, '"Durch und durch Lutherisch"? Neues zum Ursprung der Bilder von Gesetz und Gnade', *Münchner Jahrbuch der Bildenden Kunst*, 3rd series, no. 55, 2003, pp. 115–34

Winner 2001
M. Winner, 'Holbein's *Portrait of Erasmus with a Renaissance Pilaster*', in M. Roskill and J. O. Hand (eds.), *Hans Holbein: Paintings, Prints and Reception. Studies in the History of Art*, 60, National Gallery of Art, Washington, New Haven and London 2001, pp. 154–73

Woodward 1951
J. Woodward, *Tudor and Stuart Drawings*, London 1951

List of Works

Hans Holbein the Elder (c.1460/70–1524)
1 *Jakob Fugger* c.1509
Silverpoint with black ink, grey wash and
white bodycolour on light grey prepared paper
13.4 × 9.3 cm
Inscribed: Jacob Furtger
Staatliche Museen zu Berlin
(Kupferstichkabinett) (KdZ 2518)

Hans Holbein the Elder (c.1460/70–1524)
2 *Portrait of Sigmund Holbein* dated 1512
Metalpoint with black ink and white chalk,
white bodycolour, on white prepared paper
12.9 × 9.6 cm
Inscribed in metalpoint: 1512 / Sigmund
holbain maler hans [?s] / pruder des alten
The British Museum, London (1895-9-15-987)

Workshop of Hans Holbein the Elder
3 *Studies of Four Heads* c.1500–15
Pen and black ink with grey wash and white
body colour on reddish-brown prepared paper
27.5 × 17.8 cm
Inscribed: vach qui / destruis demp / lum
UCL Art Collections, University College,
London (G.1223)

Hans Holbein the Elder (c.1460/70–1524)
4 *Study of Four Hands* c.1500?
Metalpoint; three hands reinforced with
black ink and red chalk on prepared paper
13.9 × 18.5 cm
Staatliche Museen zu Berlin
(Kupferstichkabinett) (no.2580)

Unidentified Augsburg Goldsmiths
5 *Reliquary of St Sebastian* dated 1497
Silver, parcel-gilt, hammered, cast and engraved,
set with glass, pearls, sapphires and rubies
Height 50 cm; base 15.2 cm
Victoria and Albert Museum, London.
Purchased with the assistance of the National
Art Collections Fund and the National Heritage
Memorial Fund (M.27–2001)

6 *Reliquary of St Christopher* dated 1493
Silver, parcel gilt, hammered, cast and engraved
Height 46 cm; base 18 cm
Private collection

Hans Holbein the Elder (c.1460/70–1524)
7 *St Sebastian* c.1497
Metalpoint on white prepared paper
13.1 × 9.6 cm
Inscribed upper right in pencil: 69
Verso (not exhibited): *Head of a Man turned
to the Left*
The British Museum, London (1885-5-9-1612)

Workshop of Hans Holbein the Younger?
8 *Copy of a design for the façade of
House of the Dance* 1520s?
Pen and ink with watercolour washes on paper
57.1 × 33.9 cm
Staatliche Museen zu Berlin
(Kupferstichkabinett) (3104)

Ambrosius Holbein (1494?–1519)
9 *Utopia*, Sir Thomas More published 1518
[NOT ILLUSTRATED]
Johannes Froben, Basel 1518
The British Library, London (C.67.d.8)

After Hans Holbein the Younger
10 *Assertio Septem Sacramentorum* published 1521
[NOT ILLUSTRATED]
Richard Pynson, London 1521
The British Library, London (9.a.9)

11 *Erasmus* c.1523
Limewood 42 × 33 cm
Musée du Louvre, Paris,
Département des Peintures (1345)

12 *Erasmus* dated 1523
Oil on oak 76 × 51 cm
Inscribed: M D XX III; [IL]LE EGO IOANNES
HOLBEIN NON FACILE[VLL]VS / TAM MICHI
MIMUS ERIT QVAM MICHI MOMVS ERAT.
HPAKLEIOI PONOI ERASMI ROTERO
Private collection

13 *Study of the Head and
Right Hand of Erasmus*
Metalpoint, red and black chalk
on white prepared paper 20.1 × 27.9 cm
Musée du Louvre, Paris,
Département des Arts Graphiques (18698)

Holbein and workshop?
14 *Erasmus* c.1532
Oil on wood 18.7 × 14.6 cm
The Metropolitan Museum of Art,
New York, Robert Lehman Collection, 1975
(1975.1.138)

15 *William Warham, Archbishop of Canterbury* 1527
Coloured chalks on paper 40.1 × 31 cm
The Royal Collection, The Royal Library,
Windsor (RL 12272)

16 *Sir Henry Guildford* 1527
Black and coloured chalks on paper
38.8 × 29.8 cm
The Royal Collection, The Royal Library,
Windsor (RL 12266)

17 *Mary Wotton, Lady Guildford* 1527
Black and coloured chalks on paper
55.2 × 38.5 cm
Kunstmuseum Basel, Kupferstichkabinett
(1662.35)

18 *Sir Henry Guildford* dated 1527
Panel 82.6 × 66.4 cm
Inscribed: in later cartellino Anno.
d:mcccccxvii. / Etatis / Suae.xl ix:
The Royal Collection (RCIN 400046)

19 *Portrait of an Unknown Englishman* c.1527
Black and coloured chalk and leadpoint
on prepared paper; outlines traced blind
38.9 × 27.7 cm
Kunstmuseum Basel, Kupferstichkabinett
(1662.122)

20 *Portrait of an Unknown Englishwoman*
Black and coloured chalk and leadpoint
on prepared paper; outlines traced blind
38.9 × 27.7 cm
Inscribed: atlas (silk) g[e]l[b] rot s[chwarz]
w[eiss] (yellow, red, black, white)
Kunstmuseum Basel, Kupferstichkabinett
(1662.123)

21 *A Lady with a Squirrel and a Starling
(Anne Lovell?)* c.1527
Oil on oak 56 × 38.8 cm
The National Gallery, London. Bought with
contributions from the National Heritage
Memorial Fund and The Art Fund and Mr J.
Paul Getty Jnr (through the American Friends
of the National Gallery), 1992 (NG 6540)

22 *Thomas and John Godsalve* dated 1528
Oak 35 × 36 cm
Inscribed lower right: 'Thomas Godsalve de
Norwico Etatis sue Anno / quadragesimo septo;
upper left Anno. Dmi M.D. xxviii
Gemäldegalerie Alte Meister, Staatliche
Kunstsammlungen Dresden (1889)

23 *Design for the More Family Group* 1526–7
Pen and brush with black ink over chalk
preparatory drawing on paper; inscriptions and
additional motifs in brown ink 38.9 × 52.4 cm
(on the right two projecting pieces about 2 × 4 cm)
Inscribed with identifications and ages in the
hand of Nikolaus Kratzer; presumably in
Holbein's hand (on the right): Dise soll sitze;
upper left: Claficordi und ander / seyte spill
uf dem buvet
Kunstmuseum Basel, Kupferstichkabinett
(1662.31)

24 *Sir Thomas More* 1526–7
Black and coloured chalks on paper
40.2 × 30.1 cm
Inscribed: Tho: Moor Ld Chancelour
The Royal Collection, The Royal Library,
Windsor (RL 12268)

25 *Sir John More* 1526–7
Black and coloured chalks on paper
35.4 × 27.6 cm
Inscribed: Iudge More Sr Tho: Mores Father
The Royal Collection, The Royal Library,
Windsor (RL 12224)

26 *John More the Younger* 1526–7
Black and coloured chalks on paper
38.3 × 28.4 cm
Inscribed: Iohn More Sr Thomas Mores Son
The Royal Collection, The Royal Library,
Windsor (RL 12226)

27 *Anne Cresacre* 1526–7
Black and coloured chalks on paper
37.5 × 26.8 cm
The Royal Collection, The Royal Library,
Windsor (RL 12270)

28 *Cecily Heron* 1526–7
Black and coloured chalks on paper
38.4 × 28.3 cm
The Royal Collection, The Royal Library,
Windsor (RL 12269)

29 *Elizabeth Dauncey* 1526–7
Black and coloured chalks on paper
37.1 × 26.2 cm
Inscribed: The Lady Barkley; rot [red]
The Royal Collection, The Royal Library,
Windsor (RL 12228)

30 *Margaret Giggs* 1526–7
Black and coloured chalks on paper
38.5 × 27.3 cm
Inscribed: Mother Iak
The Royal Collection, The Royal Library,
Windsor (RL 12229)

31 *Map of the World* 1532
Woodcut 35.3 × 55 cm
The British Museum, London (1895-1-22-113)

32 *Battle Scene* c.1523–4?
Pen and brush, black ink, grey wash on paper
28.6 × 44.1 cm
Kunstmuseum Basel, Kupferstichkabinett
(1662.140)

Hans Holbein the Younger
and Peter Meghen 1528
33 *Canones Horoptri*
Manuscript with bodycolour and gold on vellum
33 × 28 cm
Bodleian Library, University of Oxford
(MS Bodley 504)

34 *William Reskimer* c.1534
Panel 46.4 × 33.7 cm
The Royal Collection (RCIN 404422)

35 *Simon George* c.1535
Oak Diameter 31 cm (the original
roundel cut down and reconstituted)
Städelches Kunstinstut, Frankfurt
(inv. no.1065)

36 *Robert Cheseman* dated 1533
Wood 58.8 × 62.8 cm
Inscribed: ROBERTVS CHESEMAN. ETATIS.
SVAE XLVIII. / ANNO DM M. D. XXXIII
Royal Cabinet of Paintings, Mauritshuis,
The Hague (inv.176)

37 *William Roper* c.1536
Bodycolour on vellum mounted on card
Diameter 4.5 cm
Inscribed: AN AETATIS SVAE XLII
The Metropolitan Museum of Art, New York,
Rogers Fund, 1950 (50.69.1)

38 *Margaret Roper* c.1536
Bodycolour on vellum mounted on card
Diameter 4.5 cm
Inscribed: AO AETATIS XXX
The Metropolitan Museum of Art, New York,
Rogers Fund, 1950 (50.69.2)

39 *An Unidentified Man* c.1534
Wood (possibly limewood)
Diameter 11.8 cm
Inscribed: AETATIS SVAE 30.ANNO 1534;
Kunsthistorisches Museum, Vienna,
Gemäldegalerie (5432)

40 *An Unidentified Woman* c.1534
Wood (possibly limewood)
Diameter 11.8 cm
Inscribed: AETATIS SVAE 28. ANNO.1534
Kunsthistorisches Museum, Vienna,
Gemäldegalerie (6262)

41 *Mrs Nicholas Small* c.1540
Bodycolour on vellum Diameter 5.3 cm
Inscribed: ANNO.AETATIS SVAE 23
Victoria and Albert Museum, London
(VAM P.40-1935)

42 *Portrait of a Young Man with a Carnation*
dated 1533
Oak Diameter 12.5 cm
Inscribed: ANNO 1533
Upton House, The Bearsted Collection
(The National Trust)

43 *Portrait of a Man in a Red Cap* c.1532–5
Oil on wood Diameter including engaged
frame 12.7 cm; painted surface 9.5 cm
The Metropolitan Museum of Art, New York,
Bequest of Mary Stillman Harkness, 1950
(50.145.24)

44 *Sir John Godsalve* c.1532–3
Black and coloured chalks, watercolour
and body colour, brush, pen and ink
on pink prepared paper 36.7 × 29.6 cm
Inscribed: Sr Iohn Godsalve (twice)
The Royal Collection, The Royal Library,
Windsor (RL 12265)

45 *Margaret a Barow, Lady Elyot* c.1532–4
Black and coloured chalks, bodycolour, ink
with pen and brush on pink prepared paper
28 × 20.9 cm
Inscribed: The Lady Eliot
The Royal Collection, The Royal Library,
Windsor (RL 12204)

46 *Sir Thomas Elyot* c.1532–4
Black and coloured chalks, bodycolour,
ink with pen and brush on pink prepared paper
28.6 × 20.6 cm
Inscribed: Th: Eliott Knight
The Royal Collection, The Royal Library,
Windsor (RL 12203)

47 *Nicolas Bourbon* 1535
Black and coloured chalks, pen and ink
on pink prepared paper 38.4 × 28.3 cm
Inscribed: Nicholas Borbonius Poeta
The Royal Collection, The Royal Library,
Windsor (RL 12192)

48 *Nicolas Bourbon* dated 1535
[NOT ILLUSTRATED]
Woodcut 7.3 × 5.9 cm
Published in Nicolas Bourbon, *Paidagogeion*,
Lyon 1536
The British Library, London (11403.III.14)

49 *Mary, Duchess of Richmond and Somerset* c.1533
Black and coloured chalks, ink with brush
on pink prepared paper 26.7 × 20.1 cm
Inscribed: The Lady of Richmond and samet rot
[red velvet] and Schwarz felbet [black velvet]
The Royal Collection, The Royal Library,
Windsor (RL 12212)

50 *Henry Howard, Earl of Surrey* c.1533
Black and coloured chalks, pen and ink,
watercolour on pink prepared paper
25.1 × 20.5 cm
Inscribed: Thomas Earl of Surry
The Royal Collection, The Royal Library,
Windsor (RL 12215)

51 *Sir Thomas Wyatt* c.1535–7
Black and coloured chalks, pen and ink
on pink prepared paper 37.3 × 27.2 cm
Inscribed: Tho: Wiatt Knight
The Royal Collection, The Royal Library,
Windsor (RL 12250)

52 *Sir Thomas Wyatt* 1542
[NOT ILLUSTRATED]
Woodcut Diameter 6.2 cm
Published in John Leland, *Naeniac in mortem
Thomae Viati*, London 1542
The British Library, London (11408.aaa.1)

53 *George Neville, 3rd Baron Bergavenny* c.1532–5
Black and coloured chalks, black pen
and ink, yellow wash, white bodycolour
on pink prepared paper 27.3 × 24.1 cm
Inscribed by a later hand in pen and brown ink
lower left: Lord Cromwell; lower right:
Holbein The Earl of Pembroke, Wilton House,
Wilton, Salisbury

54 *Thomas Wriothesley, Earl of Southampton*
c.1536–40
Black and coloured chalks on
pink-primed paper; silhouetted
24.2 × 19.2 cm
Musée du Louvre, Paris, Département
des Arts Graphiques (RF 4651)

55 *Portrait of a Lady, thought to be Anne Boleyn*
c.1532–5
Black and red chalk, black ink and brush,
yellow wash on pink prepared paper
32.1 × 23.5 cm
Inscribed in a seventeenth-century hand:
Anna Bullen de collato / Fuit Londoni
19 May 1536
The British Museum, London (1975-6-21-22)

56 *Portrait of an Englishwoman* c.1532–5
Black and red chalk, white bodycolour,
black ink with brush on pink prepared paper;
silhouetted 27.6 × 19.1 cm
The British Museum, London
(1910-2-12-105)

57 *Portrait of a Man* c.1532–5
Black and red chalk with pen and brush
and black ink on pink prepared paper
21.9 × 18.4 cm
Inscribed: HH; a pricked initial H
The J. Paul Getty Museum, Los Angeles
(84.GG.93)

58 *An Unidentified Man* c.1534–6
Black and coloured chalk and ink
on pink primed paper 32.1 × 23.9 cm
Staatliche Museen zu Berlin
(Kupferstichkabinett) (2392)

59 *A Boy with a Marmoset* c.1532–6
Chalk, black ink and wash with pen or brush,
red chalk on paper 40 × 30.7 cm
Kunstmuseum Basel, Kupferstichkabinett
(1823.139)

60a *A Courtly Couple* c.1532–6
Pen and ink over chalk on paper 3.4 × 4.5 cm
Kunstmuseum Basel, Kupferstichkabinett
(1662.165.88)

60b *A Nobleman holding an Astronomical Globe* 1530s
Pen and black ink on paper 3 × 2.9 cm
Kunstmuseum Basel, Kupferstichkabinett
(1662.165.86)

61 *E Cosi Desio me Mena* c.1533–6
Oil on oak 45 × 45 cm
The J. Paul Getty Museum, Los Angeles
(80.PB.72)

62 *Hermann von Wedigh* dated 1532
Oil on wood 42.2 × 32.4 cm
Inscribed: ANNO.1532. AETATIS.SVAE.29.;
HH; HER WID.; Veritas odiu[m] parit:
The Metropolitan Museum of Art, New York,
Bequest of Edward S. Harkness, 1940
(50.135.4)

63 *Cyriacus Kale* dated 1533
Panel 60 × 44 cm
Inscribed: IN ALS GEDOLTIG / SIS ALTERS.32 /
ANNO.1533. Dem Ersame[n] syriacus / Kalen yn
Lu[n]den up stulhof / sy desse breff Deme
Ersamenn F[u]rssichtig Kallenn te lunde[n] [up]
Staelhuef sy desse …'
Herzog Anton Ulrich-Museum,
Kunstmuseum des Landes Niedersachsen,
Braunschweig (18)

64 *A Member of the von Wedigh Family*
(called Hermann Hillebrandt von Wedigh)
dated 1533
Oak 39 × 30 cm
Inscribed: ANNO 1533. ATATIS SVAE. 39
Staatliche Museen zu Berlin (Gemäldegalerie)
(586 B)

65 *Parnassus* 1533
Pen and black ink, grey brown wash
and blue green watercolour on paper
42.3 × 38.4 cm
Staatliche Museen zu Berlin
(Kupferstichkabinett) (KdZ 3105)

66 *The Triumph of Riches* c.1533–5
Pen and brown ink and wash with white
heightening over black chalk; squared in
black chalk 25.1 × 56.9 cm
Inscribed: BONA FIDES / LIBERALITAS /
AEQVALITAS / NOTITIA / VOLVNTAS /
SIMONIDES / CONTRACTVS / SICHEVS /
PITHIVS / CRISFINS / BASSA / RATIO /
VIVIDVS / LEO BIZANTIVS / FORTVNA /
THEMISTOCLES / VENTIDIVS / GADAREVS /
NARCISSVS / PLVTVS / TANTALVS / MYDAS /
CRESVS / CLEOPATRA / NEMESIS
Musée du Louvre, Paris, Département
des Arts Graphiques (Inv. no. 18694)

After Hans Holbein the Younger
67 *The Triumph of Riches* published by
Johannes Borgiani Florentino, Antwerp 1561
[NOT ILLUSTRATED]
Etching 16.3 × 33.8 cm
Kunstmuseum Basel, Kupferstichkabinett
(inv 1999.671)

Attributed to Lucas Vorsterman the Elder
(1595–1675) after Hans Holbein
68 *The Triumph of Riches* 1624–30
Pen and black ink with black and red chalk
and blue bodycolour with touches of green,
heightened with white bodycolour on paper
44.4 × 119.3 cm
Ashmolean Museum, Oxford
(WA 1970.93)

69 *The Triumph of Poverty* 1624–30
Pen and brown ink with brown wash
and black and red chalk heightened with
cream bodycolour; green wash and blue
bodycolour on paper
43.7 × 58.5 cm
The British Museum, London
(1894-7-21-2)

Agostino dei Musi (Agostino Veneziano)
(c.1490–after 1536) after Baccio Bandinelli
(1493–1560)
70 *Cleopatra* 1515
[NOT ILLUSTRATED]
Engraving on paper 21.5 × 17.5 cm
The British Museum, London
(1863-1-114-749)

Marcantonio Raimondi (c.1470–82 – c.1527–34)
after Raphael (1483–1520)
71 *Adam and Eve* c.1513–15
[NOT ILLUSTRATED]
Engraving on paper 23.9 × 17.6 cm
The British Museum, London
(B XIV.3.1)

72 *The Stone Thrower* c.1532–4
Grey brush and pen and black ink, grey wash
and white heightening on red prepared paper
20.3 × 12.2 cm
Kunstmuseum Basel, Kupferstichkabinett
(1662.60)

Wenceslaus Hollar (1607–1677)
after Hans Holbein the Younger
73 *Hans von Zürich* 1647
[NOT ILLUSTRATED]
Etching 18.5 × 13 cm
The British Museum, London
(1870-6-25-41)

74 *The Rochester Cathedral Tazzas*
and Cover 1528–9; cover 1532–3
[NOT ILLUSTRATED]
a) Tazza made in London 1528–9; cover 1532–3
Silver-gilt Diameter 21.5 cm
The British Museum, London (1971-5-2, 1-2)
b) Tazza made in London 1528–9
Silver-gilt Diameter 20.7 cm
The British Museum, London (1971-5-2, 3)

75 *The Barber Surgeons Grace Cup* 1543–4
[NOT ILLUSTRATED]
London hallmark 1543–4
Silver-gilt Height 26.7 cm
The Worshipful Company of Barbers,
Barber-Surgeons' Hall, London

76 *The Barbers Instrument Case* c.1520–5
[NOT ILLUSTRATED]
English
Silver, parcelgilt and enamel, with wood and
leather lining and with original leather case
Height 18 cm
The Worshipful Company of Barbers,
Barber-Surgeons' Hall, London

77 *The Croke Girdle Book* c.1530s
[NOT ILLUSTRATED]
Illuminated manuscript on vellum
in a gold filigree and black enamel binding
4 × 3.5 cm
The British Library, London
(Stowe MS 956)

78 *Pair of Panels from the Speke Girdle Prayer Book*
c.1530s
[NOT ILLUSTRATED]
Gold panels, embossed and enamelled
6.6 × 4.4 cm
The British Museum, London
(MME AF 2852-3)

79 *Hat Badge depicting Christ and the*
Woman of Samaria c.1540
[NOT ILLUSTRATED]
Gold with coloured enamel Diameter 5.7 cm
The British Museum, London
(MME 1955.05-07.0001)

80 *Design for Anthony Denny's Clocksalt* 1543
Pen and black ink on paper with grey wash
and red wash on the compass 41 × 21.3 cm
Inscribed by Nikolaus Kratzer: coniunctis /
sive novi / lunium pro / 20 Annis and
compassa / superiarus; oppöscu.
Inscribed in another hand: [s]trena facta
pro Anthony / deny camerario Regis quod
/ in intio novi anni 1544 / regi dedit
The British Museum, London
(1850-7-13-14)

81 *Sir Anthony Denny* 1647
[NOT ILLUSTRATED]
Etching 13.3 × 10.8 cm
The British Museum, London;
Pennington (1387)

82 *Henry VIII's Clocksalt c.1530-5*
French
Silvergilt, enamel, set with precious stones
and agates Height 39 cm
The Worshipful Company of Goldsmiths,
London

83 *William Parr, Marquess of Northampton*
c.1538-40
Black and coloured chalks with pen
and Indian ink, white bodycolour
on pink primed paper 31.7 × 21.2 cm
Inscribed: wis felbct burpur felbet wis satin W,
gl gros; MORS; William Pa.. Marquis o(f)
Northam(p): ton
The Royal Collection, The Royal Library,
Windsor (RL 12231)

84 *Roundels with Old Testament Scenes c.1534-8*
Pen and black ink and chalk on paper
20.2 × 10.4 cm
Kunstmuseum Basel, Kupferstichkabinett
(1662.165.37)

85 *Lady Meutas c.1536*
Black and coloured chalks
on pink prepared paper 28.2 × 21.2 cm
Inscribed: Gl (for gold) on headdress;
The Lady Meutas
The Royal Collection, The Royal Library,
Windsor (RL 12222)

86 *Three Drawings of the Penitent Mary Magdalen*
c.1536
a) Pen and black ink with grey wash on paper
5.2 × 4.8 cm
Kunstmuseum Basel, Kupferstichkabinett
(1662.165.58)
b) Pen and black ink with grey wash on paper
4.4 × 5.7 cm
Kunstmuseum Basel, Kupferstichkabinett
(1662.165.55)
c) Pen and black ink with grey wash on paper
4.2 × 5.7 cm
Kunstmuseum Basel, Kupferstichkabinett
(1662.165.56)

87 *Designs for Pendants c.1540-3*
[I OF II ILLUSTRATED]
a) *Pendant with a half-length female figure*
and two cornucopias, set with stones and pearls,
and a hanging pearl
Pen and black ink with black wash background
5.8 × 4.3 cm
The British Museum, London (5308-96)
b) *Pendant with lady holding a stone*
[NOT ILLUSTRATED]
Pen and black ink with wash and watercolour
6.6 × 3.4 cm
Inscribed by a later hand: WELL / LAYDI /
WELL
The British Museum, London (5308-43)
c) *Pendant with leaf ornament, entwined ribbons*
and a pendant pearl, set with a central stone
surrounded with pearls
[NOT ILLUSTRATED]
Pen and black ink with black wash background
4.7 × 4.1 cm
The British Museum, London (5308-92)
d) *Pendant with central leaf ornament, flanked*
by ribbons, set with stone and pearls
[NOT ILLUSTRATED]
Pen and black ink with black wash background
5.9 × 4.3 cm
The British Museum, London (5308-90)
e) *Pendant as a stylised plant, with leaf*
ornament entwined with ribbons, and four
stones and three pearls as flowers, surmounted
by a grotesque figure
[NOT ILLUSTRATED]
Pen and black ink with black wash background
6.7 × 4.4 cm
The British Museum, London (5308-15)
f) *Pendant with leaf ornament entwined with*
ribbons, and set with stones and pearls and
a single hanging pearl
[NOT ILLUSTRATED]
Pen and black ink with black wash background
5.6 × 3.8 cm
The British Museum, London (5308-94)
g) *Pendant with inscribed scrolls in the form*
of a lyre, surmounted by a grotesque head, and
at the centre, a stone within leaf ornament,
and below a hanging pearl
[NOT ILLUSTRATED]
Pen and black ink with black wash background
6 × 4.1 cm
The British Museum, London (5308-89)

h) *Pendant with ribbon work set with four stones*
and five pearls, and a hanging pearl
[NOT ILLUSTRATED]
Pen and black ink with black wash background
5.8 × 4.9 cm
The British Museum, London (5308-35)
i) *Pendant with leaf ornament, set with four stones*
and three pearls, and a hanging pearl
[NOT ILLUSTRATED]
Pen and black ink with black wash background
5.7 × 4.3 cm
The British Museum, London (5308-93)
j) *Lozenge-shaped pendant entwined with*
ribbon work, set with stones and pearls,
and a hanging pearl
[NOT ILLUSTRATED]
Pen and black ink with grey and
light yellow wash 6.3 × 4.1 cm
The British Museum, London (5308-33)
k) *Pendant, set with a lozenge and an oval stone,*
with three hanging pearls
[NOT ILLUSTRATED]
Pen and black ink 5.3 × 5 cm
The British Museum, London (5308-98)
l) *Pendant, set with a lozenge and an oval stone,*
with three hanging pearls
[NOT ILLUSTRATED]
Pen and black ink 5 × 3.2 cm
The British Museum, London (5308-97)

88 *Designs for Pendants Jewels c.1536-8*
[I OF 5 ILLUSTRATED]
a) *Pendant set with sapphires and pearls*
Pen and black ink with black, grey and light
brown wash, touched with white bodycolour.
Silhouetted. 13.5 × 6.6 cm
The British Museum, London (5308-95)
b) *Pendant set with a ruby and sapphires*
[NOT ILLUSTRATED]
Pen and black ink with grey and black wash and
watercolour, touched with white bodycolour.
Silhouetted. 11.6 × 6.4 cm
The British Museum, London (5308-107)
c) *Pendant set with sapphires and pearls*
[NOT ILLUSTRATED]
Pen and black ink with black, grey and light
brown wash, touched with white bodycolour.
Silhouetted. 9 × 5.3 cm
The British Museum, London (5308-104)
d) *Pendant set with sapphires and pearls*
[NOT ILLUSTRATED]
Pen and black ink with black, grey and light
brown wash, touched with white bodycolour.
Silhouetted. 11.2 × 6.2 cm
The British Museum, London (5308-101)
e) *Pendant set with sapphires and pearls*
[NOT ILLUSTRATED]
Pen and black ink, with black, grey and light
brown wash, touched with white bodycolour.
Silhouetted. 12.2 × 6.3 cm
The British Museum, London (5308-91)

89 *Design for a Frame c.1533-6*
Pen and black ink over chalk on paper
15.4 × 10.4 cm
Kunstmuseum Basel, Kupferstichkabinett
(1662.165.95)

90 *Designs for Metalwork Covers and Caskets* c.1537
[1 OF 4 ILLUSTRATED]
a) Pen and black ink with black,
grey and yellow wash on paper 8.1 × 6 cm
The British Museum, London
(5308-10)
b) Pen and black ink with black,
grey and yellow wash on paper 7.9 × 5.9 cm
[NOT ILLUSTRATED]
The British Museum, London
(5308-8)
c) Pen and black ink with black
and yellow wash on paper 11.5 × 7.9 cm
[NOT ILLUSTRATED]
The British Museum, London
(5308-1)
d) Pen and black ink with black
and yellow wash on paper 11.3 × 7.9 cm
[NOT ILLUSTRATED]
The British Museum, London
(5308-5)

91 *Covered Cup, Inscribed with the
Name of Hans of Antwerp* c.1537?
Pen and black ink over chalk,
grey wash on paper; right-hand side
offset 25.1 × 16.4 cm
Inscribed: HANS VON ANT
Kunstmuseum Basel, Kupferstichkabinett
(1661.165.104)

92 *Covered Cup with Dolphins* 1532–6
Pen and black ink and grey wash
over chalk on paper 18.3 × 10 cm
Kunstmuseum Basel, Kupferstichkabinett
(1662.165.101)

93 *Design for a Table Fountain with
the Badge of Anne Boleyn* 1533
Pen and black ink over chalk on paper
25.1 × 16.4 cm
Kunstmuseum Basel, Kupferstichkabinett
(1661.165.89)

94 *Table Ornament with Jupiter* c.1533–6
Pen and black ink over chalk on paper
26.5 × 12.5 cm
Kunstmuseum Basel, Kupferstichkabinett
(1662.165.99)

Holbein and workshop?
95 *Design for a Cup for Jane Seymour* 1536–7
Pen and point of the brush and
black ink on white paper 37.6 × 15.5 cm
Inscribed: BOVND TO OBEY AND [SERVE] and
BOVND TO OBEY
The British Museum, London (1848-11-25-9)

Holbein and workshop?
96 *Design for a Cup for Jane Seymour* 1536–7
Ink and chalk on paper with grey and pink
washes and gold heightening 37.6 × 15.5 cm
Inscribed: BOVND TO OBEY AND [SERVE]
on the cover and BOVND TO OBEY twice
on the cup
Ashmolean Museum, Oxford, Douce Bequest,
1834 (WA 1863.424)

97 *Five Designs for Dagger Hilts and Pommels*
c.1536–8
[1 OF 5 ILLUSTRATED]
a) *Guard of a ballock-dagger with top
mount of the scabbard into which the knife
and bodkin could have fitted*
Pen and black ink with grey wash
on paper 7.3 × 7.1 cm
The British Museum, London (5308-60)
b) *Pommel of a dagger with the head
of a man and leaf ornament*
Pen and black ink with grey wash
on paper 5.2 × 4.6 cm
[NOT ILLUSTRATED]
The British Museum, London (5308-56)
c) *Vase-shaped pommel of a dagger*
Pen and black ink with grey wash
on paper 5.3 × 4.6 cm
[NOT ILLUSTRATED]
The British Museum, London (5308-57)
d) *Dagger hilt with mushroom-shaped
pommel and recurved quillions with ends
scrolled like rams' horns towards the pommel*
Pen and black ink with grey wash
on paper 12.7 × 8.6 cm
[NOT ILLUSTRATED]
The British Museum, London (5308- 58)
e) *Guard of a ballock-dagger*
Pen and black ink with grey wash
on paper 6 × 7.8 cm
[NOT ILLUSTRATED]
The British Museum, London (5308-59)

98 *Design for a Dagger*
Brush drawing in black ink on paper
45.5 × 12.6 cm
The British Museum, London
(1874-8-8-33)

99 *Design for a Dagger Hilt*
Pen and ink over chalk preparatory
drawing on paper; brown ink by
another hand 18.4 × 14.1 cm
Kunstmuseum Basel, Kupferstichkabinett
(1662.165.97)

100 *Design for a Sword Hilt*
Pen and ink over chalk preparatory
drawing on paper 20.1 × 15.1 cm
Kunstmuseum Basel, Kupferstichkabinett
(1662.165.96)

101 *Offset of a Design for part
of a Dagger or Knife*
Pen and ink, grey wash on paper
20.8 × 9 cm
Kunstmuseum Basel, Kupferstichkabinett
(1662.165.97)

102 *Design for a Chimney-piece* c.1538–40
Pen and black ink with grey,
blue and red wash on paper
53.9 × 47 cm
The British Museum, London
(1854-7-8-1)

Remigius van Leemput d.1675
103 *Copy after Holbein's Whitehall Mural* 1667
Oil on canvas 88.9 × 98.7 cm
Inscribed: SI IVVAT HEROVM CLARAS
VIDISSE FIGVRAS, / SPECTA HAS, MAIORES
NVLLA TABELLA TVLIT. / CERTAMEN
MAGNVM, LIS, QVAESTIO MAGNA
PATERNE, / FILIVS AN VINCAT. VICIT.
VTERQVE QVIDEM. / ISTE SVOS HOSTES,
PATRIAEQVE INCENDIA SAEPE / SVSTVLIT,
ET PACEM CIVIBVS VSQVE DEDIT. / FILIVS
AD MAIORA QVIDEM PROGNATVS AB ARIS
/ SVBMOVET INDIGNOSI SVBSTITVITQVE
PROBOS. / CERTAE, VIRTVTI, PAPARVM
AVDACIA CESSIT, / HENRICO OCTAVO
SCEPTRA GERENTE MANV / REDDITA
RELIGIO EST, ISTO REGNANTE DEIQVE
/ DOGMATA CEPERVNT ESSE IN
HONORE SVO.
[If it pleases you to see the illustrious images
of heroes, look on these: no picture ever
bore greater. The great debate, competition
and great question is whether father or son
is the victor. For both indeed were supreme.
The former often overcame his enemies
and the conflagrations of his country, and
finally brought peace to its citizens. The son,
born indeed for greater things, removed the
unworthy from their altars and replaced them
by upright men. The arrogance of the Popes
has yielded to unerring virtue, and while
Henry VIII holds the sceptre in his hand
religion is restored and during his reign the
doctrines of God have began to be held
in his honour.]
The Royal Collection (RCIN 405750)

104 *King Henry VII and
King Henry VIII* 1537
Ink and watercolour on paper
257.8 × 137.2 cm
National Portrait Gallery,
London (NPG 4027)

105 *Henry VIII* c.1537
Oak 28 × 20 cm
Museo Thyssen-Bornemisza,
Madrid (1934.39)

106 *Queen Jane Seymour* 1536–7?
Oil on oak 65.4 × 40.7 cm
Kunsthistorisches Museum,
Vienna, Gemäldegalerie
(GG Inv. no.881)

107 *Jane Seymour* 1536–7
Coloured chalks reinforced with
pen and ink and metalpoint on
pink prepared paper 50.3 × 28.7 cm
with a join 6.4 cm from lower edge
Inscribed: Iane Seymour Queen
The Royal Collection, The Royal Library,
Windsor (RL 12267)

108 *Edward Prince of Wales* 1538
Oil on panel 56.8 × 44 cm
Inscribed: PARVVLE PATRISSA, PATRIÆ
VIRTVTIS ET HÆRES / ESTO, NIHIL MAIVS
MAXIMVS ORBIS HABET. / GNATVM VIX
POSSVNT COELVM ET NATVRA DEDISSE, /
HVIVS QVEM PATRIS, VICTVS HONORET
HONOS. / ÆQVATO TANTVM, TANTI TV
FACTA PARENTIS, / VOTA HOMINVM, VIX
QVO PROGREDIANTVR, HABENT / VINCITO,
VICISTI. QVOT REGES PRISCVS ADORAT /
ORBIS, NEC TE QVI VINCERE POSSIT, ERIT.
Ricard: Morysini. Car: [Little one, emulate
your father and be the heir of his virtue; the
world contains nothing greater. Heaven and
earth could scarcely produce a son whose glory
would surpass that of such a father. Only equal
the deeds of your parent and men can wish for
no more. Surpass him and you have surpassed
all the kings the world ever revered and none
will surpass you.]
National Gallery of Art, Washington,
Andrew W. Mellon Collection (1937.1.64)

109 *Edward Prince of Wales* 1538
Coloured chalks, retouched with
pen and ink 26.7 × 22.6 cm
Inscribed: Edward Prince
The Royal Collection, The Royal Library,
Windsor (RL 12200)

110 *Portrait of Prince Edward in a Roundel* 1538
Pen and black ink on paper, compass point
Diameter 5.1 cm
Kunstmuseum Basel, Kupferstichkabinett
(1662.154.82)

111 *Anne of Cleves* 1539
Gum on vellum in ivory case
Diameter 4.6 cm
Victoria and Albert Museum,
London (VAM P153:1, 2-1910)

112 *Queen Catherine Howard*? c.1540
Vellum on playing card
Diameter 6.4 cm
The Royal Collection (RCIN 422293)

113 *Sir Richard Southwell* dated 1536
Coloured chalks, pen and ink, metalpoint
on pink prepared paper 37 × 28.1 cm
Inscribed: ANNO ETTATIS SVAE / 33
and Die augen ein wenig gelbatt Rich:
Southwell Knight
The Royal Collection,
The Royal Library, Windsor (RL 12242)

114 *Sir Richard Southwell* 1536
Oil on panel 47.5 × 38 cm
Inscribed: .X°. IVLII.ANNO. / .H. VIII. XXVIII°.
ETATIS SVAE / ANNO XXXIII.
Galleria degli Uffizi, Florence (765)

115 *Lady Audley* c.1538
Vellum on playing card Diameter 5.6 cm
The Royal Collection (RCIN 422292)

116 *Lady Audley* c.1538
Coloured chalks, metalpoint, pen and ink
on pink primed paper 29.2 × 20.7 cm
Inscribed: The Lady… Audley; annotated
samet rot damast w Gl and with the
symbol for green
The Royal Collection, The Royal Library,
Windsor (RL 12191)

117 *John Colet* c.1535
Coloured chalks, reinforced with
pen and ink and metalpoint on
pink prepared paper 26.8 × 20.5 cm
Inscribed: Iohn Colet Dean of St Paul's
The Royal Collection, The Royal Library,
Windsor (RL 12199)

After Pietro Torrigiano (1472–1528)
118 *John Colet* after original of c.1519
Plaster cast Height 83.8 cm
National Portrait Gallery, London
(NPG 4823)

119 *Charles Brandon, 3rd Duke of Suffolk* c.1541
Inscribed: ANN / 1541 / ETATIS.SVAE.3 /
.IO MARCI
Vellum on playing card Diameter 5.6 cm
The Royal Collection (RCIN 422295)

120 *Henry Brandon, 2nd Duke of Suffolk* 1541
Inscribed: ETATIS SVAE 5.6 SEPDEM.
/ ANNO / 1535
Vellum on playing card Diameter 5.6 cm
The Royal Collection (RCIN 422294)

121 *A Woman Seated on a Settle
with Four Children* c.1540
Pen and black ink, with grey and black
wash over traces of an underdrawing
in black chalk 13.4 × 16.9 cm
Inscribed by a later hand:
exaltate Cedrus H. Holbein
The British Museum, London (1852-5-19-1)

122 *Two Views of a Lady wearing
an English Hood* 1526–8 or c.1532–5
Brush drawing in black ink,
tinted with pink and grey wash
on off-white paper 15.9 × 11 cm
Inscribed by a later hand: HHB and HH
The British Museum, London
(1895-9-15-991)

123 *A Young Englishwoman* 1526–8 or c.1532–5
Pen and black ink and watercolour on paper
16 × 9.2 cm
Ashmolean Museum, Oxford,
Douce Bequest, 1834 (WA 1863.423)

124 *An Unidentified Man* 1535
Coloured chalks, pen and ink
on pink primed paper 29.8 × 22.2 cm
The Royal Collection, The Royal Library,
Windsor (RL 12259)

Workshop of Hans Holbein the Younger
125 *Portrait of a Man* dated 1535
Oil on oak Diameter 30.5 cm
Inscribed: ANNO DOMI[NI] 1535 ETATIS SVÆ 28
The Metropolitan Museum of Art, New York,
The Jules Bache Collection, 1949 (49.7.28)

Hans Holbein the Younger and Workshop
126 *Portrait of an Unidentified Gentleman* c.1535–40?
Coloured chalks with white chalk heightening,
brush and ink on pink prepared paper
36.2 × 26.8 cm
Victoria and Albert Museum, London
(Dyce 363)

Workshop of Hans Holbein the Younger
127 *An Unidentified Man* c.1535–40?
Oil on oak Diameter 13 cm
Inscribed: AETATIS SVAE 35
Victoria and Albert Museum, London
(P158-1910)

John Bettes active 1531–70
128 *An Unknown Man in a Black Cap* 1545
Oil on oak 48.2 × 41.0 cm
Inscribed: [ANNO DOMIN] I.1545
.AETATIS.SV[AE XXVI]; on reverse, part
of original portrait, faict par Jehan Bettes
Anglois (twice)
Tate. Purchased 1897 (N01496)

Hans Holbein the Younger and Workshop
129 *Henry VIII and the Barber-Surgeons*
begun 1541–3
Oil on panel 180.3 × 312.4 cm
The Worshipful Company of Barbers,
Barber-Surgeons' Hall, London

Workshop of Hans Holbein the Younger
130 *Henry VIII* c.1540?
Black, red and white chalk on
pink primed paper 30.7 × 24.4 cm
Inscribed on the verso: Hans Swarttung
Staatliche Graphische Sammlung, Munich
(12785 z)

Workshop or associate of
Hans Holbein the Younger
131 *Henry VIII* c.1540–5?
Oil on oak 237.9 × 134.0 cm
National Museums Liverpool,
Walker Art Gallery (WAG 1350)

132 *Bishop John Fisher* c.1532–4
Coloured chalks, watercolour, brush, pen
and ink on pink primed paper 38.3 × 23.4 cm
Inscribed with pen: Il Epyscopo de resister
fo … ato Il Capo Iano 1535
The Royal Collection, The Royal Library,
Windsor (RL 12205)

Unknown English Workshop
after Hans Holbein the Younger
133 *Bishop John Fisher* 1570s?
Oil on paper 21 × 19.1 cm
National Portrait Gallery, London (NPG 2821)

134 *Sir Nicholas Carew* 1527–8
Black and coloured chalks on prepared paper
54.8 × 38.5 cm
Inscribed on the turban: g[e]l[b] or g[ol[d]
Kunstmuseum Basel, Kupferstichkabinett
(1662.34)

Workshop or Associate of Holbein
135 *Sir Nicholas Carew* 1530s?
Panel 95.3 × 112 cm
In the collection of The Duke of Buccleuch
& Queensberry KT

136 *Noli me Tangere* 1526–8?
Oak 76.8 × 94.9 cm
The Royal Collection (RCIN 400001)

137 *St Thomas* dated 1527
Pen and black ink, brush and grey wash,
heightened with white, on washed-brown paper
20.4 × 10.5 cm
The Metropolitan Museum of Art, New York,
Purchase, Pat and John Rosenwald Gift, Rogers
Fund, and Gift of Dr. Mortimer, D. Sackler,
Theresa Sackler and family, 2001 (2001.188)

138 *St Andrew Carrying the Cross* dated 1527
Pen and black ink, heightened with white
bodycolour on brown prepared paper
20.3 × 10.5 cm
Inscribed (on the bottom of the cross): 1527
The British Museum, London (1946-7-13-128)

139 *Three Biblical Studies within an Architectural
Frame: Lot and his Daughters; The Drunkenness
of Noah; Judith and Holofernes* c.1535
Brush drawing in black ink, heightened
with white bodycolour, on grey prepared paper
7.7 × 14.8 cm
The British Museum, London (1926-4-10-2)

140 *Mary, Lady Monteagle* c.1538–40
Coloured chalks, pen and ink on
pink prepared paper 29.8 × 20.2 cm
Inscribed: rot dammas rot rot w ? G;
The Lady Monteagle
The Royal Collection, The Royal Library,
Windsor (RL 12223)

141 *Sir Brian Tuke* c.1533–5
Oil on oak 49.1 × 38.5 cm
Inscribed: BRIANVS TVKE, MILES, ANO ETATIS
SVAE, LVII; DROIT ET AVANT.; lower left, on
folded paper NVNQVID NON PAVCITAS DIERVM
/ MEORVM FINIETVR BREVI?
National Gallery of Art, Washington, Andrew
W. Mellon Collection (1937.1.65)

142 *Sir Henry Wyatt* c.1537
Oil on oak 39 × 31 cm
Musée du Louvre, Paris, Département des
Peintures (inv.1347)

143 *Design for a Cruciform and other Pendants* 1530s
[1 OF 6 ILLUSTRATED]
a) *Design for a Cruciform*
Pen and black ink 6.8 × 5 cm
The British Museum, London (5308-50)

b) *Design for a pendant set with five emeralds
and a single suspended pearl*
[NOT ILLUSTRATED]
Pen and black ink with green, yellow
and grey wash 8.6 × 5.5 cm
The British Museum, London (5308-37)
c) *Design for a pendant in the form of a
monogram RE, set with various stones and
three suspended pearls*
[NOT ILLUSTRATED]
Pen and black ink with watercolour 8.4 × 4.1 cm
The British Museum, London (5308-117)
d) *Design for a pendant in the form of a monogram
HI, set with an emerald and three suspended pearls*
[NOT ILLUSTRATED]
Pen and brown ink with watercolour
7.2 × 4.8 cm
The British Museum, London (5308-116)

French, c.1570
e) *Design for heart-shaped pendant*
[NOT ILLUSTRATED]
Watercolour and gold 5.6 × 3.5 cm
The British Museum, London (5308-32)

French, c.1570
f) *Design for heart-shaped pendant*
[NOT ILLUSTRATED]
Watercolour 5.4 × 3.4 cm
The British Museum, London (5308-30)

144 *Designs for Medallions with the Trinity,
the Annunciation and other subjects* 1530s
[1 OF 11 ILLUSTRATED]
a) *Trinity*
Pen and black ink and coloured wash
Diameter 5.8 cm
Inscribed: TRINITATIS GLORIA SATIABIMUR
The British Museum, London (5308-13)
b) *Annunciation*
[NOT ILLUSTRATED]
Pen and black ink and coloured wash
Diameter 5.8 cm
Inscribed: ORIGO MVNDI MELIORIS
The British Museum, London (5308-19)
c) *Design for Holbein's coat of arms*
[NOT ILLUSTRATED]
Pen and black ink with blue wash 2.1 × 2.1 cm
The British Museum, London (5308-154)
d) *Design for Holbein's coat of arms*
[NOT ILLUSTRATED]
Pen and black ink, touched with gold
and blue wash Diameter 4.3 cm
The British Museum, London (5308-42)
e) *Design for Holbein's coat of arms*
[NOT ILLUSTRATED]
Pen and black ink Diameter 2 cm
The British Museum, London (5308-164)
f) *Design for a seal of Charles Brandon,
Duke of Suffolk*
[NOT ILLUSTRATED]
Pen and black ink with gre wash 4.7 × 4.7 cm
The British Museum, London (5308-44)
g) *Design for medallion with a device, a hand
issuing from a cloud resting on a closed book*
[NOT ILLUSTRATED]
Pen and black ink with grey wash 5.5 × 5.5 cm
The British Museum, London (5308-22)

h) *Design for medallion with a device: a hand
issuing from a cloud resting on a closed book*
[NOT ILLUSTRATED]
Pen and black ink with brown wash
Diameter 5.5 cm
The British Museum, London (5308-34)
i) *Design for a medallion set with a single central
stone (perhaps with the death of Pyramus)*
[NOT ILLUSTRATED]
Pen and black ink with grey wash
Diameter 5.5 cm
The British Museum, London (5308-28)
j) *Design for a circular pendant, with the death,
probably of Queen Didi*
[NOT ILLUSTRATED]
Pen and black ink with grey wash, and touched
with yellow wash, heightened with white
bodycolour (oxidised) 5.3 × 4.2 cm
The British Museum, London (5308-15)
k) *Design for a medallion with a pair of compasses,
serpents, dolphins and cornucopias*
[NOT ILLUSTRATED]
Pen and black ink wash 4.9 × 5.1 cm
The British Museum, London (5308-40)

145 *Allegory of the Old and New Law* c.1533–5
Oil on oak 49 × 60 cm
Inscribed: LEX; MYSTERIVM
IVSTIFICATIONIS; PECCATVM; MORS;
ESAYAS PROPHETA; ECCE VIRGO CONCIPET
FILIVM; HOMO; MISER EGO HOMO, QVIS ME
ERIPIET EX HOC CORPORE MORTI OBNOXIO?
RO. 7; GRATIA; IVSTIFICATIO NOSTRA;
AGNVS DEI, QVI TOLLIT PECCATA MVDI 10.1
National Gallery of Scotland, Edinburgh
(inv. 2407)

146 *Solomon and the Queen of Sheba* c.1534
Pen and brush in bistre and grey wash,
heightened in white, gold and oxidised silver
with red and green watercolour over black chalk
on vellum 22.9 × 18.2 cm
Inscribed: REGINA SABA; BEATI VIRI TVI …
ET BEATI SERVI HI TVI / QVI ASSISTVNT
CORAM TE … OMNITPTE ET AVDIVNT /
SAPIENTIAM … TVAM SIT DOMINVS DEUS
TVVS BENEDICTVS, / CVI COMPLACIT IN TE,
VT PONERET TE / SVPER THRONVM SVVM,
VT ESSES REX / (CONSTITVTVS) DOMINO
DEO TVO VICISTI FAMAM / VIRTVTIBVS
TVIS
The Royal Collection, The Royal Library,
Windsor (RL 12188)

147 *Charitas device of Reynold Wolf* published 1543
Woodcut 6.8 × 4 cm
Published in D. Ioannis, *Chrysostomi
homiliae duae*
The British Library, London (C53.c.10)

148 *Title page of the* Coverdale Bible published 1535
Woodcut 24 × 16.7 cm
The British Library, London (C125cc24)

149 *Title-page Design for a New Testament* c.1535
Woodcut 10.9 × 6.2 cm
Staatliche Graphische Sammlung, Munich
(154 854 D)

150 *Title page of* Loci Communes published 1536
Woodcut 13.5 × 8 cm
Published in Philip Melanchthon, *Loci
Communes* 1536
The British Library, London (C.125cc24)

151 *Philip Melanchthon* c.1535
Oil on oak Diameter of each 9 cm
Inscribed inside the lid: QVI CERNIS TANTVM
NON, VIVA MELANTHONIS ORA. / HOLBINVS
RARA DETERITATE DEDIT
Niedersächsisches Landesmuseum, Hanover
(PAM 798)

152 *The Hireling Shepherd* published 1548
Woodcut 4.2 × 5.8 cm
Title-page to Urbanus Regius, *A lytle treatise
after the maner of an Epistyle*, London 1548
Bodleian Library, University of Oxford; Douce
(R 261)

153 *Christ Before Pilate* c.1538–40
Woodcut 4.2 × 5.9 cm
The British Museum, London (H.162.e)

154 *Christ Casting out the Devil* c.1538–40
Woodcut 4.2 × 4.9 cm
The British Museum, London (H.162.c)

155 *Christ Casting out the Devil* c.1538–40
[NOT ILLUSTRATED]
Woodcut 4.3 × 4.9 cm
Published in Thomas Cranmer,
Catechismus 1548
The British Library, London (C 21.a.18)

156 *The Pharisee and the Publican* c.1538–40
Woodcut 4.3 × 4.9 cm
Published in Thomas Cranmer,
Catechismus 1548
The British Museum, London (36.c.10)

157 *Christina of Denmark, Duchess of Milan* 1538
Oil on oak 119 × 82 cm
The National Gallery, London.
Presented by The Art Fund with the aid of
an anonymous donation, 1909 (NG 2475)

158 *Derich Born* dated 1533
Panel 60.3 × 45.1 cm
Inscribed: DERICHVS SI VOCEM ADDAS
IPSISSIMVS HIC SIT / HVNC DVBITES
PICTOR FECERIT AN GENITOR / DER BORN
ETATIS SVAE 23. ANNO 1533
The Royal Collection (RCIN 405681)

159 *An Unknown Man* c.1540
Oak 44.4 × 34.2 cm
English Heritage (Audley End).
Purchased with the assistance of the
Heritage Lottery fund.

160 *An Unidentified Man* c.1535
Black and coloured chalks and pen and ink and
brush on pink prepared paper 27.5 × 21.1 cm
Inscribed: atlass at[lass] twice, and S
The Royal Collection, The Royal Library,
Windsor (RL 12258)

161 *?Mary Zouch* c.1538
Black and coloured chalks pen and ink
on pink prepared paper 29.6 × 21.2 cm
Inscribed: M Souch
The Royal Collection, The Royal Library,
Windsor (RL 12252)

162 *An Unidentified Woman* c.1540
Black and coloured chalks, pen and ink
and brush and white bodycolour on
pink prepared paper 27.1 × 16.9 cm
Inscribed: Samat Damast; inscribed on
the verso hans holbein in ink, and in chalk
?Holbeyn
The Royal Collection, The Royal Library,
Windsor (RL 12190)

163 *Lady Butts* c.1541–3
Black and coloured chalks and metalpoint and
pen and brush and ink on pink prepared paper
38 × 27.2 cm
Inscribed: The Lady Butts
The Royal Collection, The Royal Library,
Windsor (RL 12264)

164 *Thomas Howard, 3rd Duke of Norfolk* c.1539
Oak 80.3 × 61.6 cm
Inscribed: [.THOMAS. DVKE OF.] NORFOLK.
MARSH[ALL.] / . AND .] TRESVRER OF
INGLOND[E] / THE [.L] X [VI.] YERE [O]F
HIS AGE
The Royal Collection (RCIN 404439)

165 *Dr John Chambers* c.1541–2
Oil on oak 51 × 44 cm
Inscribed: AETATIS. SVE. 88
Kunsthistorisches Museum, Vienna,
Gemäldegalerie (882)

Lenders

Public Collections

Basel, Kunstmuseum Basel, Kupferstichkabinett
17, 19, 20, 23, 32, 59, 60, 67, 72, 84, 86, 89,
91, 92, 93, 94, 99, 100, 101, 110, 134
Berlin, Staatliche Museen zu Berlin,
Gemäldegalerie 64
Berlin, Staatliche Museen zu Berlin,
Kupferstichkabinett 1, 8, 58, 65
Braunschweig, Herzog Anton Ulrich-Museum,
Kunstmuseum des Landes Niedersachsen 63
Dresden, Gemäldegalerie Alte Meister,
Staatliche Kunstsammlungen Dresden 22
Edinburgh, National Gallery of Scotland 145
Florence, Galleria degli Uffizi 114
Frankfurt am Main, Städel Museum, Städelsches
Kunstinstitut und Städtische Galerie 35
Hanover, Niedersächsisches Landesmuseum 151
Liverpool, National Museums Liverpool,
Walker Art Gallery 131
London, The British Library 9, 10, 48, 52, 77,
147, 148, 150, 155
London, The British Museum 2, 4, 7, 31, 55,
56, 69, 70, 71, 73, 74, 78, 79, 80, 81, 87, 88,
90, 95, 97, 98, 102, 121, 122, 138, 139, 143,
144, 153, 154, 156
London, The National Gallery 21, 157
London, National Portrait Gallery 104, 118, 133
London, Tate 128
London, UCL Art Collections,
University College 3
London, Victoria and Albert Museum 5, 41, 111,
126, 127
Los Angeles, The J. Paul Getty Museum 57, 61
Madrid, Museo Thyssen-Bornemisza 105
Munich, Staatliche Graphische Sammlung 130, 149
New York, The Metropolitan Museum of Art
14, 37, 38, 43, 62, 125, 137
Oxford, Ashmolean Museum 68, 96, 123
Oxford, Bodleian Library,
University of Oxford 33, 152
Paris, Musée du Louvre, Département
des Arts Graphiques 13, 54, 66
Paris, Musée du Louvre, Département
des Peintures 11, 142
The Hague, Royal Cabinet of Paintings,
Mauritshuis 36
Vienna, Kunsthistorisches Museum,
Gemäldegalerie 39, 40, 106, 165
Washington, National Gallery of Art 108, 141

Private Collections

Private collection 6, 12
English Heritage (Audley End) 159
The Duke of Buccleuch & Queensberry KT 135
The Earl of Pembroke, Wilton House,
Wilton, Salisbury 53
The Royal Collection 18, 34, 103, 112, 115, 119, 120,
136, 158, 164
The Royal Collection, The Royal Library, Windsor
15, 16, 24, 25, 26, 27, 28, 29, 30, 44, 45, 46, 47,
49, 50, 51, 83, 85, 107, 109, 113, 116, 117, 124, 132,
140, 146, 160, 161, 162, 163
The Worshipful Company of Barbers,
Barber-Surgeons' Hall, London 75, 76, 129
The Worshipful Company of Goldsmiths,
London 82
Upton House, The Bearsted Collection
(The National Trust) 42

Photo Credits

ARTOTHEK 35
Ashmolean Museum, Oxford 123, 96, 68
The Bearsted Collection, Upton House,
 The National Trust © NTPL /
 Angelo Homak 42
© Bildarchiv Preussischer Kulturbesitz,
 Berlin, 2006 64, 65, 58, 8, 4, 1
The Bodleian Library, University of Oxford
 © Bodleian Library 33, 152
The British Library 147, 150, 148, 156, 154
© The Trustees of The British Museum
 7, 102, 80, 95, 138, 139, 122, 31, 98, 97a,
 144a, 90a, 153, 88a, 143a, 87a
© English Heritage Photo Library Photographer:
 Jeremy Richards 159
Herzog Anton Ulrich-Museums Braunschweig.
 Kunstmuseum des Landes Niedersachsen /
 Photo by Bernd-Peter Keiser 63
The J. Paul Getty Museum, Los Angeles 57, 61
Kunsthistorisches Museum, Wien oder KHM,
 Wien 39, 106, 40, 165
Kunstmuseum Basel. Kuperstichkabinett /
 Photocredit: Kunstmuseum Basel. Martin Bühler
 23, 17, 134, 59, 19, 20, 72, 32, 91, 93, 94, 89, 92, 100,
 99, 101, 60a, 60b, 84, 86a–c
Photograph © 1994 The Metropolitan Museum
 of Art 37, 38, 43, 125, 62, 14
Photograph © 2001 The Metropolitan Museum
 of Art 137
© Museo Thyssen Bornemisza, Madrid 105
Photo © The National Gallery, London 12, 157, p. 12
Image © 2006 Board of Trustees, National Gallery
 of Art, Washington 141, 108
The National Gallery of Scotland 145
National Portrait Gallery, London 104, 118, 133
Niedersächsisches Landesmuseûm, Hanover 151
© Photo RMN 66, 13, 54
© Photo RMN, Hervé Lewandowski 142, 11
Royal Cabinet of Paintings, Mauritshuis,
 The Hague 36
The Royal Collection © 2006 Her Majesty Queen
 Elizabeth II 15, 25, 24, 29, 28, 25, 26, 27, 30, 16,
 47, 45, 46, 49, 50, 44, 51, 103, 107, 109, 112, 136,
 140, 146, 34, 113, 124, 115, 116, 163, 83, 120, 119,
 117, 158, 164, 160, 85, 161, 162, 132
The Royal Collection © 2006 Her Majesty Queen
 Elizabeth II / Photographer:
 Stephen Chapman 18
Staatliche Graphische Sammlung München 130, 149
© Staatliche Kunstsammlungen, Dresden / Foto:
 H. P. Klut 22
© UCL Art Collections, University College
 London 3
The V&A Picture Library 111, 41, 127, 126, 5, 6
Walker Art Gallery, National Museums
 Liverpool 131
Courtesy of the Worshipful Company
 of Barbers 21, 129, 135
© Worshipful Company of Goldsmiths 82

Index

Numbers in bold indicate main catalogue entries.

Supporting Tate

Tate relies on a large number of supporters – individuals, foundations, companies and public sector sources – to enable it to deliver its programme of activities, both on and off its gallery sites. This support is essential in order to acquire works of art for the Collection, run education, outreach and exhibition programmes, care for the Collection in storage and enable art to be displayed, both digitally and physically, inside and outside Tate. Your donation will make a real difference and enable others to enjoy Tate and its Collection both now and in the future. There are a variety of ways in which you can help support Tate and also benefit as a UK or US taxpayer. Please contact us at:

The Development Office
Tate, Millbank, London, SWIP 4RG
Tel: 020 7887 8945 Fax: 020 7887 8098

American Patrons of Tate
1285 6th Avenue (35th fl), New York, NY 10019, USA
Tel: 001 212 713 8497 Fax: 001 212 713 8655

Donations
Donations, of whatever size, from individuals, companies and trusts are welcome, either to support particular areas of interest, or to contribute to general running costs.

Gifts of Shares
We can accept gifts of quoted share and securities. These are not subject to capital gains tax. For higher rate taxpayers, a gift of shares saves income tax as well as capital gains tax. For further information please contact the Development Office.

Gift Aid
Through Gift Aid you can provide significant additional revenue to Tate. Gift Aid applies to gifts of any size, whether regular or one-off, since we can claim back the tax on your charitable donation. Higher rate taxpayers are also able to claim additional personal tax relief. Contact us for further information and a Gift Aid Declaration.

Legacies
A legacy to Tate may take the form of a residual share of an estate, a specific cash sum or item of property such as a work of art. Legacies to Tate are free of Inheritance Tax, and help to secure a strong future for the Collection and galleries.

Offers in lieu of tax
Inheritance Tax can be satisfied by transferring to the Government a work of art of outstanding importance. In this case the amount of tax is reduced, and it can be made a condition of the offer that the work of art is allocated to Tate. Please contact us for details.

Tate Annual Fund
A donation to the Annual Fund at Tate benefits a variety of projects throughout the organisation, from the development of new conservation techniques to education programmes for people of all ages and abilities.

American Patrons of Tate
American Patrons of Tate is an independent charity based in New York that supports the work of Tate in the United Kingdom. It receives full tax exempt status from the IRS under section 501(c)(3) allowing United States taxpayers to receive tax deductions on gifts towards annual membership programmes, exhibitions, scholarship and capital projects. For more information contact the American Patrons of Tate office.

Membership Programmes
Tate Members enjoy unlimited free admission throughout the year to all exhibitions at Tate Britain, Tate Liverpool, Tate Modern and Tate St Ives, as well as a number of other benefits such as exclusive use of our Members' Rooms and a free annual subscription to *Tate Etc*.

Whilst enjoying the exclusive privileges of membership, you are also helping secure Tate's position at the very heart of British and modern art. Your support actively contributes to new purchases of important art, ensuring that the Tate's Collection continues to be relevant and comprehensive, as well as funding projects in London, Liverpool and St Ives that increase access and understanding for everyone.

Tate Patrons
Tate Patrons are people who share a strong enthusiasm for art and are committed to giving significant financial support to Tate on an annual basis. The Patrons support the acquisition of works from across Tate's broad collecting remit, as well as other areas of Tate activity such as conservation, education and research. The scheme provides a forum for Patrons to share their interest in art and to exchange knowledge and information in an enjoyable environment. United States taxpayers who wish to receive full tax exempt status from the IRS under section 501(c)(3) are able to support the Patrons through our American office. For more information on the scheme please contact the Patrons office.

Corporate Membership
Corporate Membership at Tate Modern, Tate Liverpool and Tate Britain offers companies opportunities for corporate entertaining and the chance for a wide variety of employee benefits. These include special private views, special access to paying exhibitions, out-of-hours visits and tours, invitations to VIP events and talks at members' offices.

Corporate Investment
Tate has developed a range of imaginative partnerships with the corporate sector, ranging from international interpretation and exhibition programmes to local outreach and staff development programmes. We are particularly known for high-profile business to business marketing initiatives and employee benefit packages. Please contact the Corporate Fundraising team for further details.

Charity Details
The Tate Gallery is an exempt charity; the Museums & Galleries Act 1992 added the Tate Gallery to the list of exempt charities defined in the 1960 Charities Act. Tate Members is a registered charity (number 313021). Tate Foundation is a registered charity (number 1085314).

Tate Britain Donors to the
Centenary Development Campaign

FOUNDER
The Heritage Lottery Fund

FOUNDING BENEFACTORS
Sir Harry and Lady Djanogly
The Kresge Foundation
Sir Edwin and Lady Manton
Lord and Lady Sainsbury of Preston Candover
The Wolfson Foundation

MAJOR DONORS
The Annenberg Foundation
Ron Beller and Jennifer Moses
Alex and Angela Bernstein
Ivor Braka
Lauren and Mark Booth
The Clore Duffield Foundation
Maurice and Janet Dwek
Bob and Kate Gavron
Sir Paul Getty KBE
Nicholas and Judith Goodison
Mr and Mrs Karpidas
Peter and Maria Kellner
Catherine and Pierre Lagrange
Ruth and Stuart Lipton
William A Palmer
John and Jill Ritblat
Barrie and Emmanuel Roman
Charlotte Stevenson
Tate Gallery Centenary Gala
The Trusthouse Charitable Foundation
David and Emma Verey
Clodagh and Leslie Waddington
Mr and Mrs Anthony Weldon
Sam Whitbread

DONORS
The Asprey Family Charitable Foundation
The Charlotte Bonham-Carter Charitable
 Trust
CHK Charities Limited
Sadie Coles
Giles and Sonia Coode-Adams
Alan Cristea
Thomas Dane
The D'Oyly Carte Charitable Trust
The Dulverton Trust
Alan Gibbs
Mr and Mrs Edward Gilhuly
Richard and Odile Grogan
Pehr and Christina Gyllenhammar
Jay Jopling
Howard and Lynda Karshan
Madeleine Kleinwort
Brian and Lesley Knox
Mr and Mrs Ulf G. Linden
Anders and Ulla Ljungh
Lloyds TSB Foundation for England and Wales
David and Pauline Mann-Vogelpoel
Nick and Annette Mason
Viviane and James Mayor
Sir Peter and Lady Osborne
Maureen Paley
Mr Frederick Paulsen
The Pet Shop Boys

The P F Charitable Trust
The Polizzi Charitable Trust
Mrs Coral Samuel CBE
David and Sophie Shalit
Mr and Mrs Sven Skarendahl
Pauline Denyer-Smith and Paul Smith
Mr and Mrs Nicholas Stanley
The Jack Steinberg Charitable Trust
Tate Friends (Members)
Carter and Mary Thacher
Mr and Mrs John Thornton
Dinah Verey
Gordon D Watson
The Duke of Westminster OBE TD DL
Mr and Mrs Stephen Wilberding
Michael S. Wilson
and those donors who wish to remain anonymous

Tate Collection

FOUNDERS
Sir Henry Tate
Sir Joseph Duveen
Lord Duveen
The Clore Duffield Foundation
Heritage Lottery Fund
The Art Fund

FOUNDING BENEFACTORS
Sir Edwin and Lady Manton
The Estate of Richard B. Fisher
The Kreitman Foundation
The American Fund for the Tate Gallery
National Heritage Memorial Fund
The Nomura Securities Co Ltd

BENEFACTORS
Gilbert and Janet de Botton
The Deborah Loeb Brice Foundation
Tate Patrons
The Dr Mortimer and Theresa Sackler
 Foundation
Tate Members
The Mary Joy Thomson Bequest

MAJOR DONORS
Aviva plc
The Estate of Tom Bendhem
Big Lottery Fund
Mr Edwin C Cohen
The Estate of Dr Vera J Daniel
The Estate of Andre Deutsch
Lynn Forester de Rothschild
The Getty Foundation
Antony Gormley
Noam and Geraldine Gottesman
Mr and Mrs Jonathan Green
The Leverhulme Trust
Hartley Neel
Richard Neel
Ophiuchus SA
Tate International Council

DONORS
Abstract Select Limited
Acrewood Property Group plc
Howard and Roberta Ahmanson

Katherine Ashdown and Julian Cox
Lord and Lady Attenborough
The Charlotte Bonham-Carter Charitable
 Trust
Bettina Bonnefoy
Mr and Mrs Pontus Bonnier
Louise Bourgeois
Silver Bramham and Tony Gibbon
Melva Bucksbaum and Raymond Learsy
Rattan Chadha
Charities Advisory Trust
John and Tina Chandris
Ella Cisneros
Sir Ronald and Lady Cohen
Alastair Cookson
Danriss Property Corporation Plc
Dimitris Daskalopoulos
Sir Harry Djanogly
Mr and Mrs Doumar
Brooke Hayward Duchin
Yelena Duncan
Mimi Floback
Mr and Mrs Koenraad Foulon
Glenn R. Fuhrman
Kathy and Richard S. Fuld Jr
Gabo Trust for Sculpture Conservation
The Gapper Charitable Trust
Nanette Gehrig
Liz Gerring and Kirk Radke
Zak and Candida Gertler
Marian Goodman
Agnes Gund and Daniel Shapiro
Calouste Gulbenkian Foundation
Mimi and Peter Haas
Stanley and Gail Hollander
HSBC Artscard
Leili and Johannes Huth
Angeliki Intzides
Lord and Lady Jacobs
Peter and Maria Kellner
Ellen Kern
C. Richard and Pamela Kramlich
Henry R. Kravis Foundation, Inc.
The Samuel H Kress Foundation
Leche Trust
Robert Lehman Foundation
Mr and Mrs Diamantis M Lemos
Richard Long
William Louis-Dreyfus
Brett and Laura Miller
Lucy Mitchell-Innes
The Henry Moore Foundation
Mary Moore
The Estate of Father John Munton
Guy and Marion Naggar
Angela Nikolakopoulou
Peter and Eileen Norton, The Peter Norton
 Family Foundation
Outset Contemporary Art Fund
William Palmer
Yana and Stephen Peel
The Honorable Leon B and
 Mrs Cynthia Polsky
Karen and Eric Pulaski
The Radcliffe Trust
Mr and Mrs John Rafter
The Rayne Foundation
Julie and Don Reid

Joyce Reuben
Barrie and Emmanuel Roman
Ken Rowe
Claire and Nicola Savoretti
Debra and Dennis Scholl
Michael and Melanie Sherwood Charitable
 Foundation
Harvey S. Shipley Miller
Peter Simon
John A. Smith and Vicky Hughes
Mr and Mrs Ramez Sousou
The Foundation for Sports and the Arts
The Freda Mary Snadow Bequest
Kimberly and Tord Stallvik
David Teiger
Mr and Mrs A Alfred Taubman
The Mary Joy Thomson Bequest
Peter Touche and Alicia Keyes
Andreas Waldburg-Wolfegg
Ziba and Pierre de Weck
Angela Westwater and David Meitus
Poju and Anita Zabludowicz
Shirly and Yigal Zilkha
and those donors who wish to remain anonymous

Donors, Tate Britain

MAJOR DONORS
Mr and Mrs James Brice
Calouste Gulbenkian Foundation
The Henry Moore Foundation
The Horace W. Goldsmith Foundation
John Lyon's Charity

DONORS
The Basil Samuel Charitable Trust
Alex and Angela Bernstein
Blackwall Green
Ivor Braka
Ricki and Robert Conway
Mr David Cohen CBE
Sarah and Gerard Griffin
The Hite Foundation
ICAP plc
The Judith Rothschild Foundation
Robert and Mary Looker
Mr and Mrs David Mirvish
Anthony and Deirdre Montagu
Paul and Alison Myners
Oliver Prenn
Mr and Mrs James Reed
Simon and Virginia Robertson
Keith and Kathy Sachs
Pauline Denyer-Smith and Paul Smith
The Starr Foundation
Hugh and Catherine Stevenson
Aroldo Zevi
and those who wish to remain anonymous

Tate Britain Corporate Members 2006

Accenture
American Express
Apax Partners Ltd
Aviva plc
Barclays PLC

BNP Paribas
Clifford Chance
Credit Suisse
Deutsche Bank
Drivers Jonas
EMI
Ernst & Young
Fidelity Investments International
Freshfields Bruckhaus Deringer
Friends Provident PLC
GAM
GLG Partners
HSBC
Linklaters
Nomura
Pearson
Reckitt Benckiser
Reuters
Shearman & Sterling LLP
Sotheby's
Tishman Speyer
UBS

Tate Britain Corporate Supporters

FOUNDING SPONSORS

BP plc
Campaign for the creation of Tate Britain
 (1998–2000)
BP British Art Displays at Tate Britain
 (1990–2007)
Tate Britain Launch (2000)

BT
Tate Online (2001–2008)

Channel 4
The Turner Prize (1991–2003)

Ernst and Young
Picasso: Painter/Sculpture (1994)
Cézanne (1996)
Bonnard (1998)
Art of the Garden (2004)
Turner Whistler Monet (2005)

BENEFACTOR SPONSORS

Egg Plc
Tate & Egg Live (2003)

GlaxoSmithKline plc
Turner on the Seine (1999)
William Blake (2000)
*American Sublime: Landscape Painting in the
 United States, 1820–1880* (2002)

Gordon's Gin
Turner Prize (2004, 2005)

Prudential PLC
*The Age of Rosetti, Burne-Jones and Watts:
 Symbolism in Britain 1860–1910* (1997)
The Art of Bloomsbury (1999)
Stanley Spencer (2001)

Tate & Lyle plc
Tate Members (1991–2000)
Tate Britain Community Education
 (2001–2007)

MAJOR SPONSORS

AIG
Constable: The Great Landscapes (2006)

Barclays PLC
Turner and Venice (2003)

The British Land Company PLC
Joseph Wright of Derby (1990)
Ben Nicholson (1993)
Gainsborough (2002)
Degas, Sickert, Toulouse-Lautrec (2005)

The Daily Telegraph
Media Partner for *American Sublime* (2002)
Media Partner for *Pre-Raphaelite Vision:
 Truth to Nature* (2004)
Media Partner for *In-A-Gadda-Da-Vida* (2004)

The Guardian
Media Partner for *Intelligence* (2000)
Media Partner for *Wolfgang Tillmans if one thing
 matters, everything matters* (2003)
Media Partner for *Bridget Riley* (2003)
Media Partner for *Tate & Egg Live Series* (2003)
Media Partner for *20 years of the Turner Prize* (2003)
Media Partner for *the Turner Prize* (2004, 2005)

Tate Members
Exposed. The Victorian Nude (2001)
Bridget Riley (2003)
A Century of Artists' Film in Britain (2003–2004)
In-A-Gadda-Da-Vida (2004)
Art Now: Nigel Cooke (2004)
Gwen John and Augustus John (2004)
Michael Landy – Semi Detached (2004)
Picture of Britain (2005)

Volkswagen
*Days like these: Tate Triennial of Contemporary
 Art* (2003)

SPONSORS

Diesel
Late at Tate Britain (2004)
Art Now (2004, 2005)

The Times
Media partner for Art and the 60s:
 This Was Tomorrow (2004)